SOCIETY OF
PUBLICATION
DESIGNERS

41

THE SOCIETY
OF PUBLICATION DESIGNERS

41ST PUBLICATION DESIGN
ANNUAL

THIS YEAR'S COMPETITION WAS CHAIRED BY
AMID CAPECI, BRUCE RAMSAY, AND WALTER BERNARD

MAGAZINE OF

THE YEAR

SPD

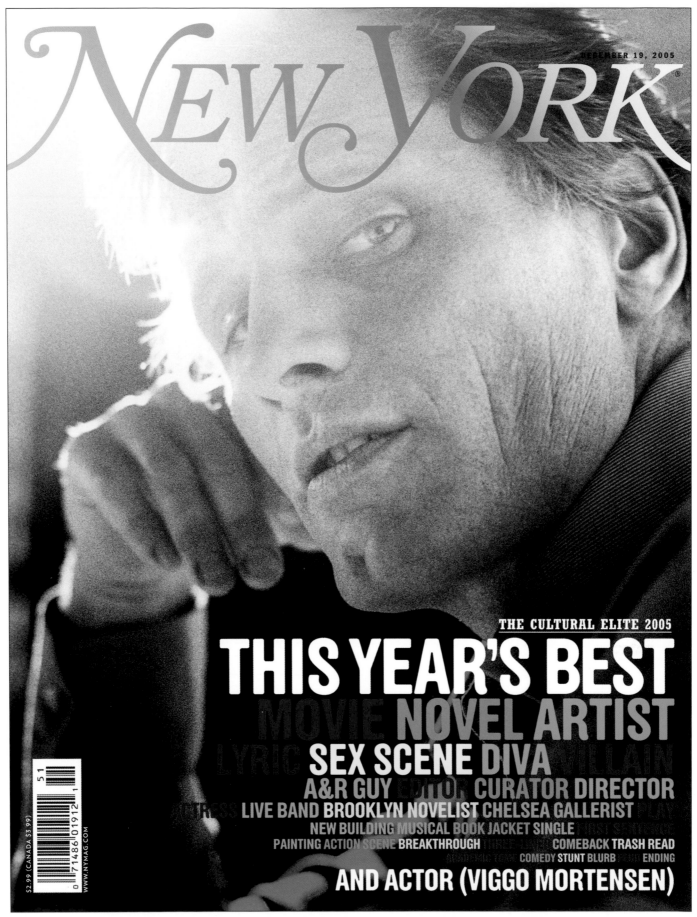

NEW YORK

DECEMBER 19, 2005

THE CULTURAL ELITE 2005

THIS YEAR'S BEST
MOVIE NOVEL ARTIST
LYRIC SEX SCENE DIVA VILLAIN
A&R GUY EDITOR CURATOR DIRECTOR
ACTRESS LIVE BAND BROOKLYN NOVELIST CHELSEA GALLERIST PLAY
NEW BUILDING MUSICAL BOOK JACKET SINGLE FIRST SENTENCE
PAINTING ACTION SCENE BREAKTHROUGH THREE-NAMED COMEBACK TRASH READ
ACADEMIC TOME COMEDY STUNT BLURB PERP ENDING
AND ACTOR (VIGGO MORTENSEN)

$2.99 (CANADA $3.99)
WWW.NYMAG.COM

001 ✳ NEW YORK

Design Director: Luke Hayman / *Art Director:* Chris Dixon / *Designers:* Randy Minor, Kate Elazegui, Emily Anton / *Illustrators:* Christopher Sleboda, Nathan Fox, Thomas Fuchs, Kagan McLeod, Number 17, Shane Harrison, Joe Darrow, John Burgoyne, Scott Dadich, Karen Caldicott, David Wong, Zohar Lazar, Yuko Shimizu, Atélier 444, Jack Unruh, Jason Gnewikow, Fernando Gutierrez / *Director of Photography:* Jody Quon / *Photo Editors:* Amy Hoppy, Leana Alagia, Justin O'Neill, Lea Golis, Alex Pollack, Lisa Corson / *Editor-In-Chief:* Adam Moss / *Publisher:* New York Magazine Holdings, LLC / *Issues:* November 14, 2005, November 21, 2005, December 19, 2005 / *Category:* Design Magazine of the Year

THE NEW MONOGAMY

Until death
do us part—except
every other
Friday.
BY EM & LO

C

LAIRE IS A PRETTY, 31-year-old Park Sloper who studies furniture design. Her husband, Alex, is a 32-year-old Web-design consultant with a fondness for floral shirts. He's the center of attention at a party; she's the one off to the side, seemingly aloof but really just shy. That's why she was shocked when, more than a year into their relationship, she was the one who found herself attracted to someone else.

"I was totally confused, because I'd assumed that once I found 'the one,' I would be done with all that," says Claire. "Going through all this was hard for us as a couple." But when her husband subsequently got a crush of his own, she was more prepared. "Now that it was his turn, I was in a position to understand," explains Claire. "So I told him, if he wanted to kiss her, that was okay—but I wanted to know about it, and I wanted that to be as far as things went without him talking to me first."

For much of human history, monogamy (or, at least, presumed monogamy) has been the default setting for long-term love. Hack the system, goes the theory, refuse to forsake all others, open the door even a crack—and the whole relationship will crash. Any dissenters have been pathologized as delusional idealists or

28

Photographs by Phillip Toledano

BOOKS

It wasn't just E. L. Doctorow who looked into the past this year—though some didn't look too far, with **one 9/11 novel** outshining the rest. Brooklyn writers kept themselves busy (**when not feuding**), graphic books continued to pop, **Joan Didion** redeemed the memoir, **Mary Gaitskill** made us happy-sad, and **Donald Trump** defended his authorial honor.

BEST LITERARY FICTION
'THE MARCH,'
BY E. L. DOCTOROW

(RANDOM HOUSE)
In reimagining Sherman's Civil War march to the sea as a tubular, tentacled, all-consuming dragon-serpent, Doctorow assumes the prophetic role of the nineteenth-century writers he so admires (Emerson, Melville, Whitman, Poe) to write an alternate creation myth for the Republic. Among infantry, nurses, shutterbugs, profiteers, and 25,000 freed slaves, we find not only prototypes of coming attractions in Faulkner, Flannery O'Connor, and Toni Morrison (as well as the young surgeon in Doctorow's *Historia* as and the sculor of the Coalhouse Walker Jr. we will meet in *Ragtime*), but also an elegy for and a bone-scan of an opportunity tragically lost. The fluidity of this second American revolution—of free agency, class mobility, and self-invention, of black slave girls passing for white drummer boys—was strangled in its crib after Reconstruction.

2 **'PEARL,'** by Mary Gordon (PANTHEON)
On Christmas Day, 1998, 50-year-old Maria Meyers, a supervisor of day-care centers in upper Manhattan and a Tabar's of fierce opinion on almost every imaginable topic, is informed by the State Department that her daughter, Pearl, who went to Trinity College to study the Irish language, has refused drink for six days and declared her intention to die in Dublin, chained to the American Embassy flagpole. Maria is on the next flight. What follows is another of Gordon's fearless inquiries into the hydra-headed nature of truth—about history, religion, politics, justice, violence, and martyrdom, about the death wish, yes, but also, of course, mother love.

3 **'THE WRITING ON THE WALL,'** by Lynn Sharon Schwartz (COUNTERPOINT)
After the attack on the World Trade Center, Renata, a linguist at the New York Public Library, is suddenly asked by the Feds to add Arabic to her other exotic languages (Bliondan, Etinoi), even as she tries to cope with a crazy mother, an importunate lover, a teenage mute, a dead twin, and the child she thinks she lost on a merry-go-round. As starkly elegant as the Chinese calligraphy Renata practices—and superior to the 9/11 fictions of both Ian McEwan and Jonathan Safran Foer in its melding of psychological and geopolitical dream worlds.
—*John Leonard*

NONFICTION
'THE RISE OF AMERICAN DEMOCRACY: JEFFERSON TO LINCOLN,' BY SEAN WILENTZ

(NORTON)
This barge of a book (992 pages) confirms Sean Wilentz as the Richard Hofstadter of our day—the supreme political historian. But where Hofstadter wrote history in dazzling generalities, Wilentz both expounds on massive themes and pillages the archives for little-known characters and forgotten movements. (Long live the Locofocos!) He tells a story that parallels George Packer's book about Iraq—the sweaty, excruciating delivery of democracy—except with a happy ending.

2 **'THE ORIENTALIST: SOLVING THE MYSTERY OF A STRANGE AND DANGEROUS LIFE,'** by Tom Reiss (RANDOM HOUSE)
Though Reiss isn't a perfect storyteller, he has found the perfect story: a Jewish fabulist named Lev Nussimbaum who re-created himself as a Muslim prince and scholar called Essad Bey (or sometimes Kurban Said). Nussimbaum's biography includes proto-Fascism, persecution by Fascism, and a childhood in strangely cosmopolitan pre-WWI Azerbaijan. In addition to the charms of its digressions (Kurdish devil-worship, early German film) and the twisted psyche of its subject, *The Orientalist* is a triumph of research. Piecing together Nussimbaum's life makes for its own epic tale.

3 **'FREAKONOMICS: A ROGUE ECONOMIST EXPLORES THE HIDDEN SIDE OF EVERYTHING,'** by Steven D. Levitt and Stephen J. Dubner (WILLIAM MORROW)
This book has no thesis, an annoying title, a phony humility, and sundry other grating tropes. Yet it makes such interesting arguments and compiles such counterintuitive data that you can't help but hang a medal around its neck. Economics, it turns out, can become quite a readable subject when writers connect the Ku Klux Klan to car prices or cheating schoolteachers to sumo wrestling.
—*Franklin Foer*

BEST DEBUT NOVEL
'BEASTS OF NO NATION,'
BY UZODINMA IWEALA

(HARPERCOLLINS)
As arresting as the language is in Iweala's first novel—a hard, clipped pidgin African English punctuated by onomatopoeic "KPAWA's—it's the horrific plot, and its numb preteen teller, that makes the book such a rough and dizzying ride. Iweala's boy narrator, drafted by a guerrilla army on pain of death, is both a victim and, by the book's end, a repentant butcher. Iweala, born in Washington, D.C., to members of the Nigerian elite, and barely a year out of Harvard, makes an unbelievably imaginative leap out of little more than a few interviews with child soldiers. His confidence in outlining the capacity for evil under extreme circumstances without resorting to do-gooder clichés preempts the inevitable lament—by now itself a cliché—over our tendency to fall for first efforts by privileged young writers.

2 **'INDECISION,'** by Benjamin Kunkel (RANDOM HOUSE)
Kunkel's hilarious and skillful work confronts the bugaboos of autobiographical slacker fiction head-on. His protagonist, Dwight Wilmerding, emerges from his urban postreligious ennui with something even Holden Caulfield couldn't quite muster: a fully fledged social conscience.

3 **'SUMMER CROSSING,'** by Truman Capote (RANDOM HOUSE) Harp all you want about this being no *Breakfast at Tiffany's*, Capote's rediscovered first novel, published for the first time, makes a great breezy read. His story of Upper East Side debutante Grady's sultry affair with a lower-class Brooklyn Jew teems with Capote's trademark wit, but also with genuine youthful awe at the exhilaration of late-forties New York.
—*Boris Kachka*

BEST ACADEMIC BOOK
'THE ECONOMY OF PRESTIGE: PRIZES, AWARDS, AND THE CIRCULATION OF CULTURAL VALUE,' BY JAMES F. ENGLISH

(HARVARD)
English, the chair of guess which department at the University of Pennsylvania, has written a book about the manufacture of cultural prestige that is both intellectually shrewd and consistently entertaining. The main currency of this prestige, he submits, is the wildly proliferating number of prizes in the arts—the 4,500 feature films released every year compete for some 9,000 of them. As at least one critic (A. O. Scott) has commented, English's book deserves to win some sort of award itself, and now it has.

2 **'THE EVOLUTION-CREATION STRUGGLE,'** by Michael Ruse (HARVARD)
How can intellectually sophisticated blue-staters like us bear to live in a nation where more than half the citizens are benighted enough to think God created man in his present form a few thousand years ago? Michael Ruse, a philosopher of science at Florida State University, is one of the most stimulating writers on the never-ending cultural debate over evolution. Here, this self-professed "ardent Darwinian" arrives at a surprisingly sympathetic view of the anti-Darwin crowd. They may be wrong, but they're not quite as crazy as we smugly imagine.

THE YEAR OF HISTORICAL FICTION

L

LITERATURE IS DEAD, but genre fiction survives, and in 2005, one particular branch emerged from the pack. Of the five books nominated for the National Book Award for fiction, the most prestigious of the annual awards, four were historical novels. The fifth was set in the eighties—by the standards of television also a historical period.

Why would this happen now, of all times, when the present is so thick with occurrence? Maybe American writing has gone into retreat, accepting its role in what George Steiner once called a "museum culture"—one that accumulates the treasures of the past, sifting and weighing and measuring them, while producing nothing on its own. Certainly this would account for the strain of nostalgia that runs through some of these novels: They *really* wrote books, these books say; in Greenwich Village (Rene Steinke's *Holy Skirts*) and on the Lower East Side (Nicole Krauss's *History of Love*).

But America itself is not currently in retreat. Across the world in 2005, you could hardly go outside without being strafed by an American Black Hawk.

No, the efflorescence of historical fiction is an imperial phenomenon. It is the extension of one's dominion in time as well as space. E. L. Doctorow has always written historical fiction, but his *The March* appears in a new context: We can now imagine General Sherman, like an Iraqi villager, just minding his own business, when along comes Doctorow in a gleaming new F-16 and just blows his little house down. How depraved one has to be to resurrect Carthage, Flaubert said after resurrecting Carthage during the Second Empire; but also how hungry, how greedy, how large.

The past, too, will prove not inexhaustible. What will be left for 2006, when we have established bases throughout the Asian republics and extracted all the oil and written novels about all the major and minor figures of the past, especially in Greenwich Village? The historical novel will have to seek a more recent time frame and a narrower canvas. It will have to become memoir. Just as there was a second Gulf War, so there will be a second coming of the memoirs; some people will have to write more than one.
—KEITH GESSEN

Uzodinma Iweala, chronicler of a murderous boy.

General William T. Sherman, at rest.

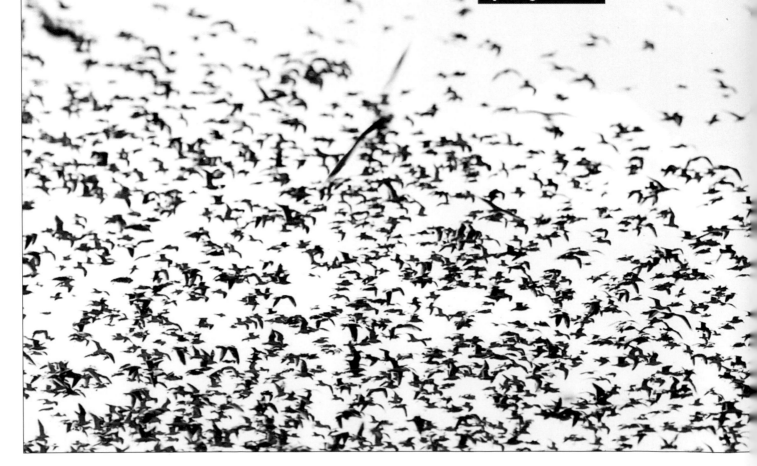

New York

Avian flu, hurricane, chemical spill, terrorist bomb, earthquake:
Whatever the next apocalypse is, New York—and New Yorkers—are getting ready for it.
But have we done enough? The strategies and tactics of survival.

REMAIN CALM

By Craig Horowitz

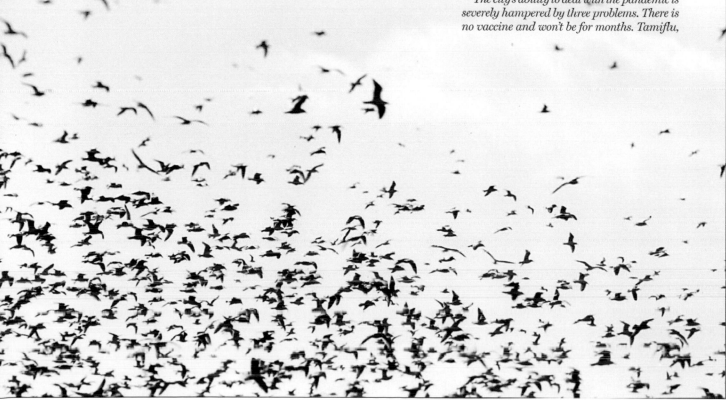

ON AN EARLY-WINTER MONDAY MORNING *in Hong Kong, a businessman boards a plane for New York. The man, who'd spent a few days touring the Chinese countryside during his trip, is not feeling great. He's tired and achy. He can't decide if it's the wear and tear of his travels or the beginning of a cold, but after coughing and sneezing throughout his sixteen-hour flight, he's certain he's getting sick.*

By the time he goes through Customs at JFK, gets his bags, and finds a cab, he has only enough energy left to check into his midtown hotel and collapse on the bed in his room. The next day, feeling even sicker, he heads to the nearest emergency room. By now, he's got a high fever and he's coughing up blood. Given his robust flulike symptoms and his international travel, alarm bells go off in the ER.

Though word hasn't yet reached the U.S., there have been several dozen confirmed cases of human-to-human transmission of the H5N1 virus—better known as avian flu—in the Chinese countryside and several other spots in Asia. But even without the new information, the ER doctors, who've been drilled on what to watch for, are convinced it's avian flu. Taking no chances, they isolate the patient. But the damage has been done—the businessman has infected people on the plane, at JFK, in his hotel, and even in the hospital's waiting room.

The city's ability to deal with the pandemic is severely hampered by three problems. There is no vaccine and won't be for months. Tamiflu,

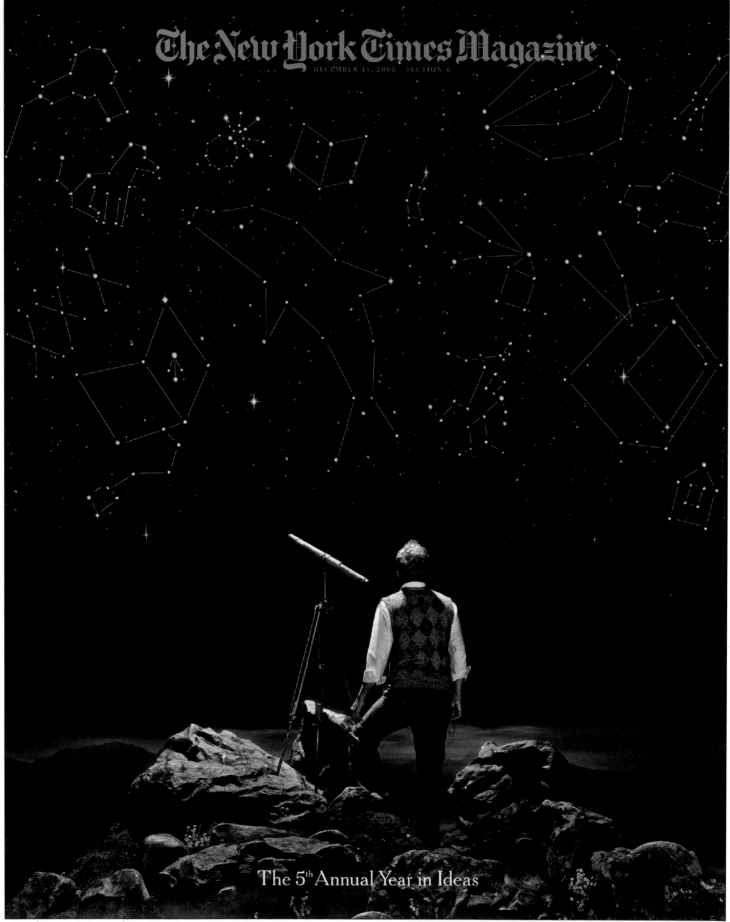

The 5th Annual Year in Ideas

+ Merit / Newsstand Magazine / Over Million Circulation (Design Entire Issue)

002 ✻ THE NEW YORK TIMES MAGAZINE
Creative Director: Janet Froelich / *Art Director:* Arem Duplessis /
Designers: Arem Duplessis, Jeff Glendenning, Kristina DiMatteo,
Nancy Harris Rouemy, Cathy Gilmore-Barnes, Todd Albertson,
Gail Bichler, Claudia DeAlmeida / *Director of Photography:* Kathy
Ryan / *Photo Editors:* Kira Pollack, Cavan Farrell, Joanna Milter /
Editor-In-Chief: Gerald Marzorati / *Publisher:* The New York Times /
Issues: May 15, 2005, October 3, 2005, December 11, 2005 /
Category: Design Magazine of the Year

The 5th Annual Year in Ideas

This issue marks the fifth anniversary of what is becoming a venerable tradition at the magazine: the Year in Ideas. As always, we seek to gain some perspective on what has transpired since January by compiling a digest of the most noteworthy ideas of the past 12 months. Like the biographer Lytton Strachey surveying the Victorian Age, we row out over the great ocean of accomplishment and lower into it a little bucket, which brings up to the light characteristic specimens from the various depths of the intellectual sea — ideas from politics

ALL POLITICAL IDEAS ARE LOCAL

WHY LIBERALISM—AND MOST OTHER AMERICAN WAYS OF THINKING ABOUT POLITICS— HAVE THEIR ROOTS IN MANHATTAN.

IDEOLOGY

By **RUSSELL SHORTO**
Photographs by **PLATON**

LA GUARDIA
The celebrated mayor was larger than life, but he was no Boss Tweed.

IN JANUARY 1861, as Southern states were in the process of seceding from the union, Fernando Wood, the mayor of New York, made a modest proposal to his city council. New Yorkers — whose city profited from the shipping of Southern cotton — weren't crazy about the idea of a civil war. Wood's idea was that if the South severed its ties to the United States, New York should, too. Under his plan, the city would re-fashion itself into the free city called Tri-Insula — comprising Manhattan, Staten Island and Long Island — which would do business with both the North and South as they fought each other, thus sidestepping carnage and substituting business sense for patriotic fervor.

Tri-Insula never happened, but Americans have always tended to treat New York as if it had. The "it feels like a foreign country" line is a standard souvenir that visitors from other parts of the nation take home with them. New York is different — both literally and metaphorically insular. And, for more than a generation, it has been far from the center of American politics.

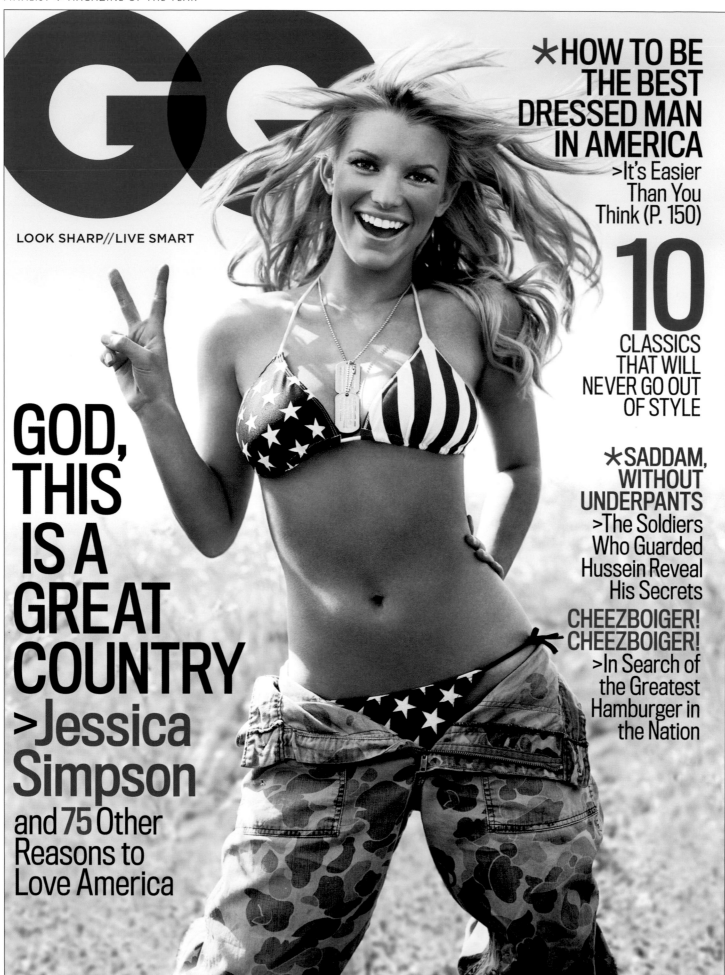

GQ

LOOK SHARP//LIVE SMART

✳**HOW TO BE THE BEST DRESSED MAN IN AMERICA**
>It's Easier Than You Think (P. 150)

10
CLASSICS THAT WILL NEVER GO OUT OF STYLE

✳**SADDAM, WITHOUT UNDERPANTS**
>The Soldiers Who Guarded Hussein Reveal His Secrets

CHEEZBOIGER! CHEEZBOIGER!
>In Search of the Greatest Hamburger in the Nation

GOD, THIS IS A GREAT COUNTRY

>**Jessica Simpson**
and 75 Other Reasons to Love America

+A¼n Gr⅔n-...span Tak⅗... a Bath

For the past eighteen years, the Oz-like ALAN GREENSPAN has used his position as chairman of the Federal Reserve to push, behind the scenes, for strict budgetary discipline. Now, in his final year in office, he has watched the Bush administration destroy the budget surplus and drive the deficit to record highs. So the mysterious chairman must decide: Will he continue to fight for his economic principles, even if it means fighting his own party?

by WIL S. HYLTON

●●● Illustration by NOLI NOVAK

+ Merit / Newsstand Magazine / 500,000 to 1 Million Circulation (Design Spread-Single Page)

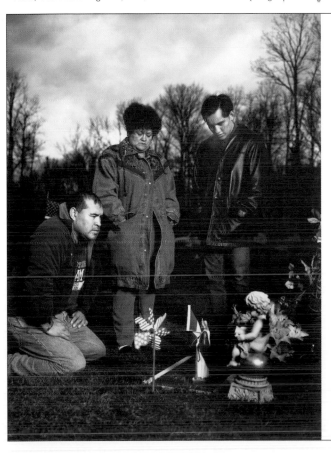

[GQ165]

HE CAME TO AMERICA—illegally, from Mexico—in 1985 and fell in love with his new country. He found work, bought a house, and all three of his kids enlisted in the U.S. military. Then Iraq happened, and one of them got killed. Now JORGE MEDINA wants somebody to pay

by SEAN FLYNN / PHOTOGRAPHS *by* JEFF RIEDEL

FATHERS WAR

003 ✳ GQ

Design Director: Fred Woodward / *Designers:* Ken DeLago, Anton Ioukhnovets, Sarah Viñas, Thomas Alberty, Chloe Weiss, Michael Pangilinan, Drue Wagner / *Illustrators:* Tavis Coburn, Tomer Hanuka, Noli Novak, John Ritter, John Ueland / *Director of Photography:* Bradley Young / *Photo Editors:* Kristen Schaefer, Monica Bradley / *Photographers:* Richard Burbridge, Nathaniel Goldberg, Frederike Helwig, Kurt Markus, Jeff Riedel, Tom Schierlitz, Martin Schoeller, Mark Seliger, Peggy Sirota, Carter Smith, Michael Thompson, Max Vadukul, Bruce Weber / *Director of Photography:* Dora Somosi / *Creative Director:* Jim Moore / *Fashion Director:* Madeline Weeks / *Editor-In-Chief:* Jim Nelson / *Publisher:* Condé Nast Publications Inc. / *Issues:* April 2005, July 2005, December 2005

FINALIST ✳ MAGAZINE OF THE YEAR

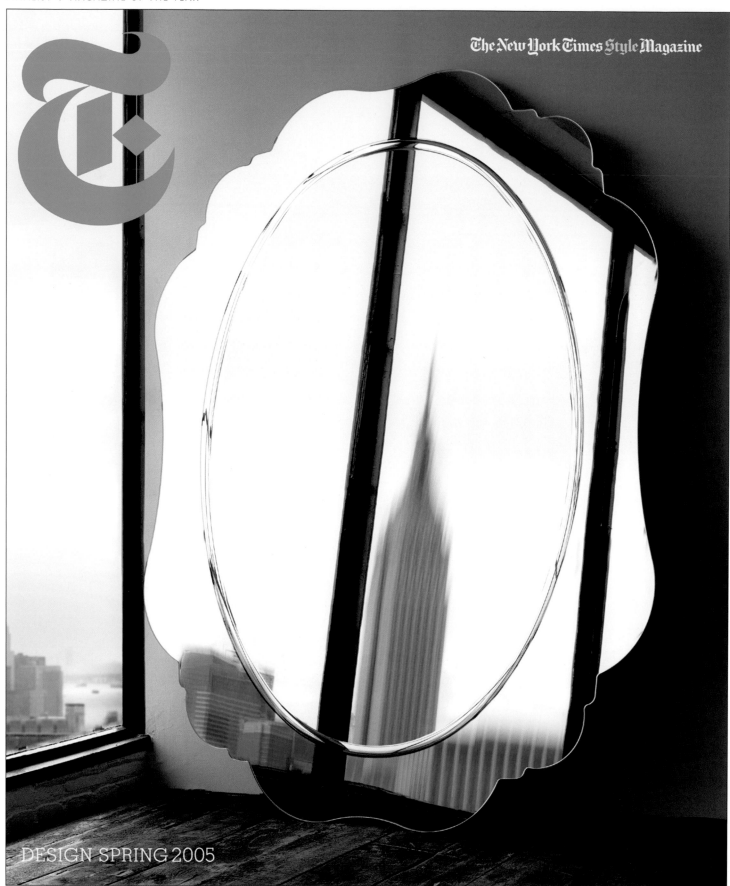

DESIGN SPRING 2005

004 ✳ T: THE NEW YORK TIMES STYLE MAGAZINE
Creative Director: Janet Froelich / *Art Director:* David Sebbah / *Designers:* Janet Froelich, David Sebbah, Luise Stauss, Gail Bichler, Elizabeth
Spiridakis / *Photo Editors:* Kathy Ryan, Judith Puckett-Rinella, Scott Hall, Jennifer Pastore / *Photographers:* Raymond Meier, Jean-Baptiste
Mondino, David Slijper, Ilan Rubin / *Editor-In-Chief:* Stefano Tonchi / *Publisher:* The New York Times / *Issues:* April 3, 2005, August 28,
2005, September 18, 2005 / *Category:* Design Magazine of the Year

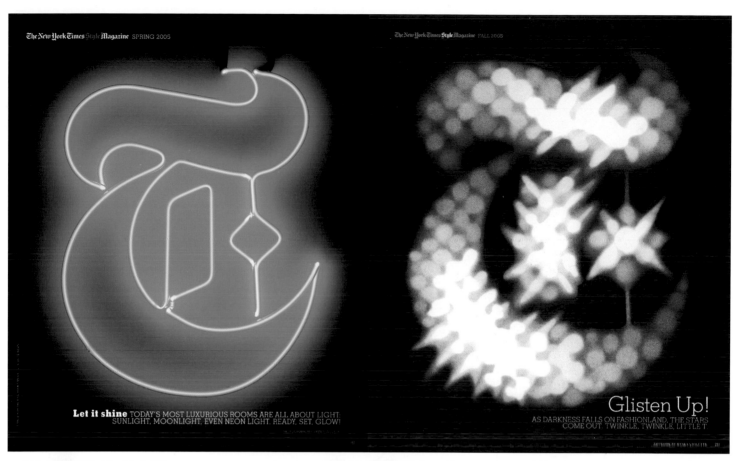

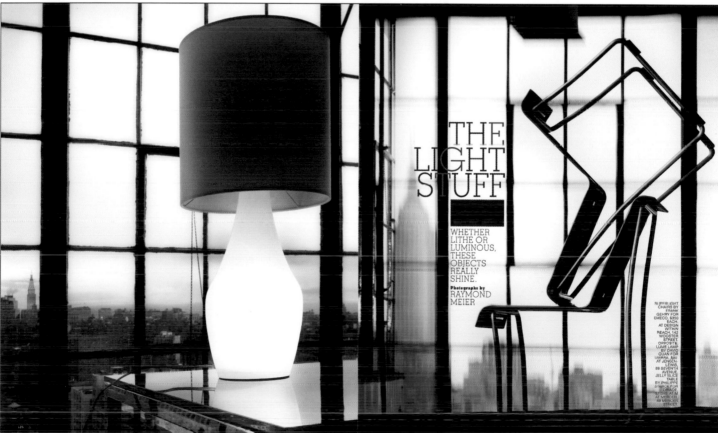

FINALIST ✳ MAGAZINE OF THE YEAR

carl's cars

a magazine about people

Ⓝ 69,-
Ⓖ🅑 4.95

P16-BTG

TRANS AM

005 ✳ CARL*S CARS
Creative Director: Stéphanie Dumont / *Photographers:* Camilla Isene, GM Archives,
Nils Vik, Jørn Tomter, Douglas Kent Hall / *Editor-In-Chief:* Karl Eirik Haug /
Publisher: Carl*s Cars / *Issues:* Summer #12, Fall #13, Winter #14

KAISER'S CARS

Text Lars Eriksen
Photo Jørn Tomter

My life is an Adventure

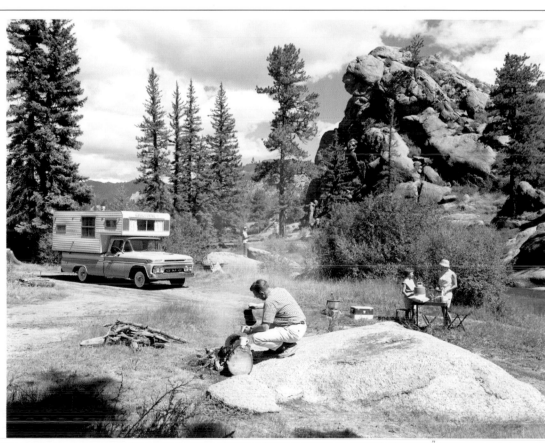

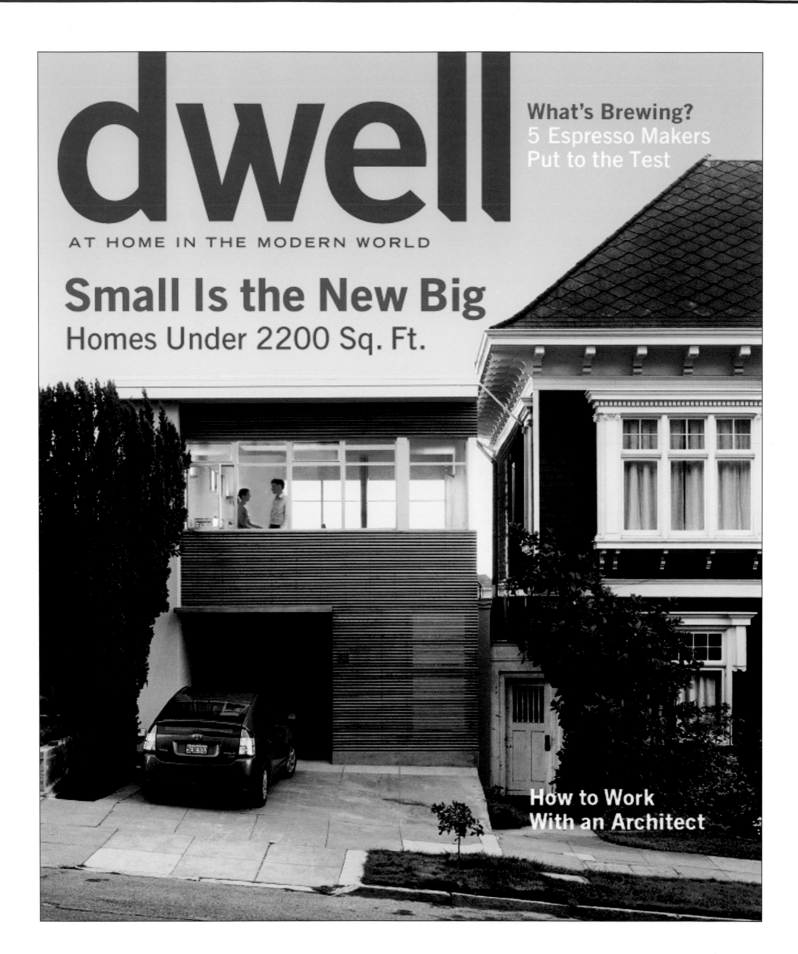

006 ✳ DWELL
Creative Directors: Jeanette Hodge Abbink, Claudia Bruno / *Designers:* Kyle Blue, Craig Bromley, Bryan Burkhart, Craig Snelgrove, Gayle Chin, Azi Rad /
Illustrators: Arthur Mount, Michael Gillette, Calvin Rambler / *Director of Photography:* Kate Stone / *Photo Editor:* Aya Brackett / *Photographers:* Grant Delin,
Todd Hido, Robert Schlatter, Misty Keasler, Emily Nathan, Grant Scott, Andreas Larsson, Philip Newton, Ralph Richter, Daniel Hennessy, Paul Warchol,
Zubin Shroff, Bärbel Miebach, Peter Hyatt, Diana Koenigsberg, Andy Boone, Joe Fletcher, John M. Hall, Paul Rivera, Sarah B. Lee, Elizabeth Felicella,
Peter Belanger, Quirin Leppert / *Editor-In-Chief:* Allison Arieff / *Publisher:* Dwell LLC / *Issues:* January-February 2005, June 2005, October-November 2005 /
Category: Design Magazine of the Year

Dwellings Story by Amos Klausner Photos by Todd Hido

Sitting above the tie-dye-dipped corner of Haight and Ashbury streets in San Francisco is Buena Vista Park, the city's oldest and most beautiful hilltop recreation spot. The park, which was established in 1867, was eventually encircled by large, ornate Victorian homes. Infill throughout the 20th century resulted in an odd assortment of lot sizes and a mix of architectural styles. It was here that inveterate bachelor Martin Roscheisen recently found a small house squeezed between two grand old painted ladies.

"The house was built in 1946 and really wasn't much of anything," explains Roscheisen. "What I did see was potential. The lot is situated high up on the hill and it's adjacent to the park. It has amazing views of Cole Valley, the Golden Gate Bridge, and the Pacific Ocean."

It was keen foresight that brought Roscheisen from

Germany to the United States in 1988, and it was that same vision that helped him drive several Silicon Valley technology ventures to success a few years later. His knack for seeing potential where others might not, and his ability to move from concept to completion, propelled him to purchase the house and take on the daunting renovation project.

A mutual friend introduced Roscheisen to Cass Calder Smith, a graduate of the University of California at Berkeley's architecture program, and one of the Bay Area's rising architectural stars. Known for designing sleek modern interiors at standout restaurants in and around San Francisco, Smith was excited to take on the project and add to his growing list of residential work. "The existing house was typical of its period: a postwar shoe box with lots of tiny rooms and very few ▶

The houses that circle San Francisco's Buena Vista Park run the gamut from wedding-cake Victorian to Scandinavian modern. Architect Cass Calder Smith aimed to create a facade that contextually relates to the adjacent ornate ones yet is purely modern.

Standout in a Crowd

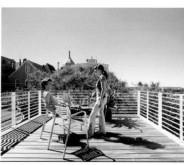

In architecturally conservative San Francisco, this house built on a 20-foot-wide lot proves that modern design can fit—literally and figuratively—in any neighborhood.

Project: Haus Martin
Architect: CCS Architecture
Location: San Francisco, California

First Floor

A Backyard E Bathroom
B Deck F Garage
C Bedroom G Entry
D Closets H Driveway

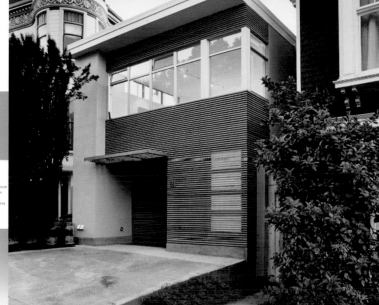

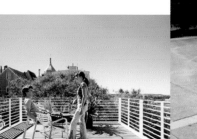

110 **Dwell** Jan/Feb 2005

Dwellings

MAXIMILIANO

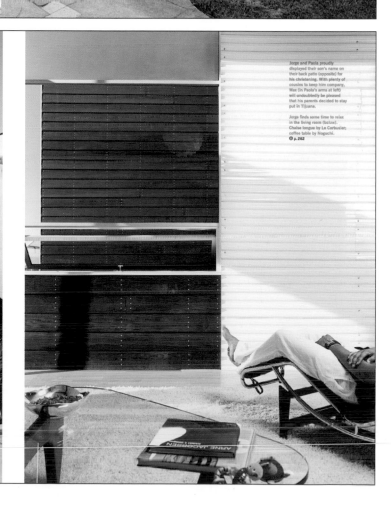

Jorge and Paola proudly displayed their son's name on their back patio (opposite) for his christening. With plenty of cousins to keep him company, Max (in Paola's arms at left) will undoubtedly be pleased that his parents decided to stay put in Tijuana.

Jorge finds some time to relax in the living room (below). Chaise longue by Le Corbusier; coffee table by Noguchi.
⊕ p.282

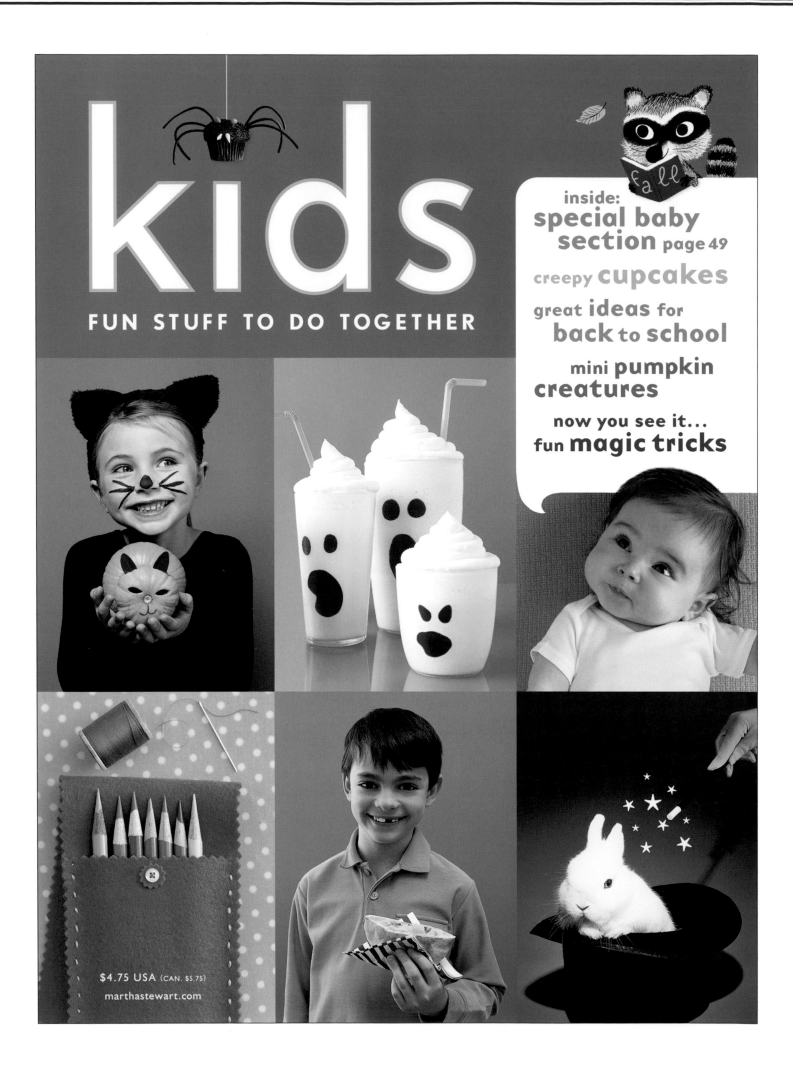

kids

FUN STUFF TO DO TOGETHER

inside:
special baby section page 49

creepy **cupcakes**

great **ideas** for **back** to **school**

mini **pumpkin creatures**

now you see it...
fun **magic tricks**

fall

$4.75 USA (CAN. $5.75)

marthastewart.com

007 ✳ KIDS

Creative Director: Eric A. Pike / *Design Directors:* Deb Bishop, Robin Rosenthal / *Art Directors:* Tina Chang, Jennifer Merrill / *Stylists:* Anna Beckman, Charlyne Mattox, Silke Stoddard, Megan Hedgpeth, Sarah Conroy, Tara Bench, Melissa Perry / *Illustrators:* Kristen Ulve, Calef Brown, Melinda Beck, Greg Clarke, Jessie Hartland, Marc Boutavant, MK Mabry / *Director of Photography:* Heloise Goodman / *Photo Editors:* Mary Cahill, Rebecca Donnelly, Lina Watanabe / *Photographers:* Sang An, Anna Williams, Catherine Ledner, Stephen Lewis, Gentl & Hyers, Tosca Radigonda, Sivan Lewin, Bill Batten, Victor Schrager, Dwight Eschliman, Philip Newton, Frank Heuers, Kirsten Strecker / *Editor-In-Chief:* Jodi Levine / *Publisher:* Martha Stewart Living Omnimedia / *Issues:* Summer 2005, Fall 2005, Winter 2005-2006 / *Category:* Design Magazine of the Year

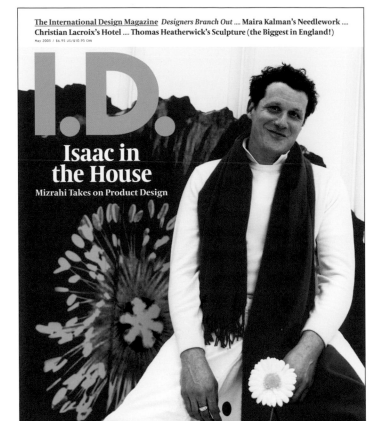

The International Design Magazine *Designers Branch Out* Maira Kalman's Needlework Christian Lacroix's Hotel Thomas Heatherwick's Sculpture (the Biggest in England!)
May 2005 / $6.95 US/$10.95 CAN

I.D.
Isaac in the House
Mizrahi Takes on Product Design

The International Design Magazine *New from Japan* Kenya Hara Cosmic Wonder Scary Toys Hiroshi Sugimoto Power Unit Studio Ancient Crafts Revived November 2005 / $6.95 US/$10.95 CAN

I.D.
Keeping Up with Japanese Design
So beautifully strange and oddly familiar—we can't take our eyes off it.

008 ✱ I. D.

Art Director: Kobi Benezri / *Designer:* Thomas Porostocky / *Illustrators:* Yoko Inoue, Georgina Richardson, Mark Weiss, Christopher Lane, Jimmy Cohrssen / *Editor-In-Chief:* Julie Lasky / *Publisher:* F&W Publications / *Issues:* May 2005, September-October 2005, November 2005 / *Category:* Design Magazine of the Year

It's Lacroix, Darling
The fashion maestro designs an absolutely fabulous hotel.

BY BARBARA MURDOCH

Christian Lacroix, the French couturier who delights in extravagant palettes and foaming streams of material, has a new collection. You won't see it on the catwalk or in any boutique. It can't even be worn. It consists of 17 rooms and a few public spaces in the Hotel du Petit Moulin, a dizzy little bed-and-breakfast that opened in January on the northern edge of Paris's Marais district.

Photography by Jimmy Cohrssen

The Artful Remnant
A rustic textile makes a comeback.

BY MARISA BARTOLUCCI

+ Merit / Newsstand Magazine / Under 500,000 Circulation (Design Cover)

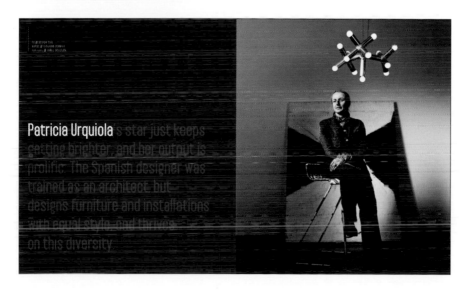

009 ✱ POL OXYGEN
Art Director: Marcus Piper / *Photographers:* James Mollison,
Karl Lagerfeld, Julian Anderson, Keetja Allard, Erwin Olaf, Alec Soth /
Editor-In-Chief: Jan Mackey / *Publisher:* POL Publications /
Issues: February 2005, August 2005, November 2005 /
Category: Design Magazine of the Year

THE GOLD &
SILVER AWARDS

THE MEMBERS'
CHOICE AWARD

010 ❋ THE NEW YORK TIMES MAGAZINE
Creative Director: Janet Froelich / *Art Director:* Arem Duplessis / *Designer:* Kristina DiMatteo /
Director of Photography: Kathy Ryan / *Photographer:* Tom Schierlitz / *Editor-In-Chief:* Gerald Marzorati /
Publisher: The New York Times / *Issue:* August 21, 2005 / *Category:* Design Cover

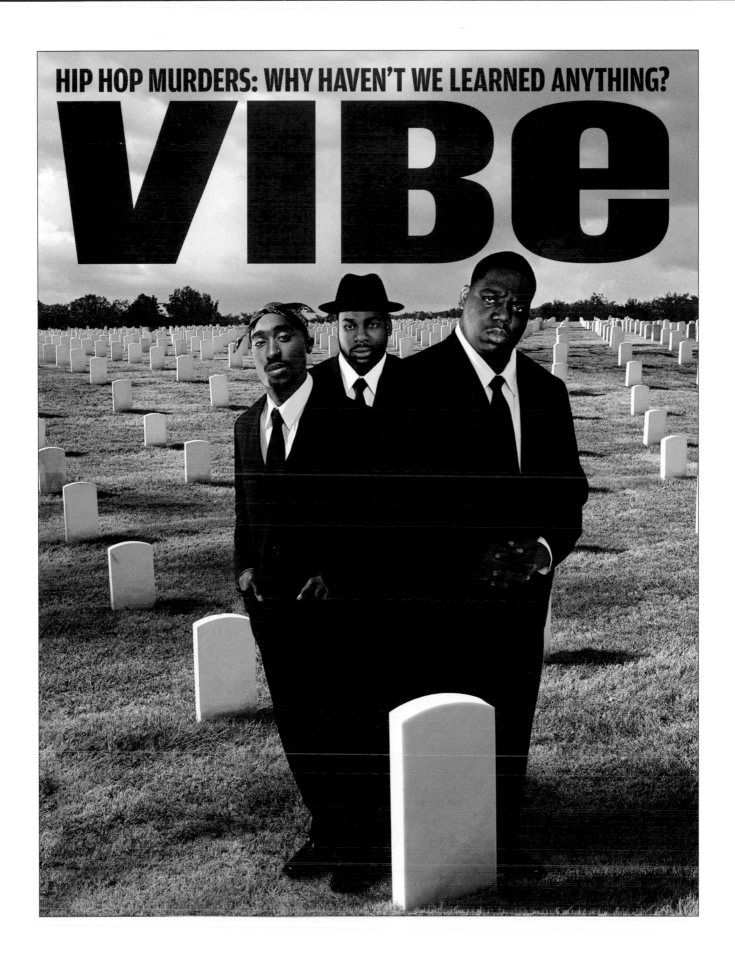

HIP HOP MURDERS: WHY HAVEN'T WE LEARNED ANYTHING?

VIBe

011 ✳ VIBE
Design Director: Florian Bachleda / *Art Director:* Wyatt Mitchell / *Photo Editor:* Liane Radel /
Photographer: James Porto / *Creative Guru:* George Lois / *Editor-In-Chief:* Mimi Valdés /
Publisher: Vibe-Spin Ventures LLC / *Issue:* May 2005 / *Category:* Design Cover

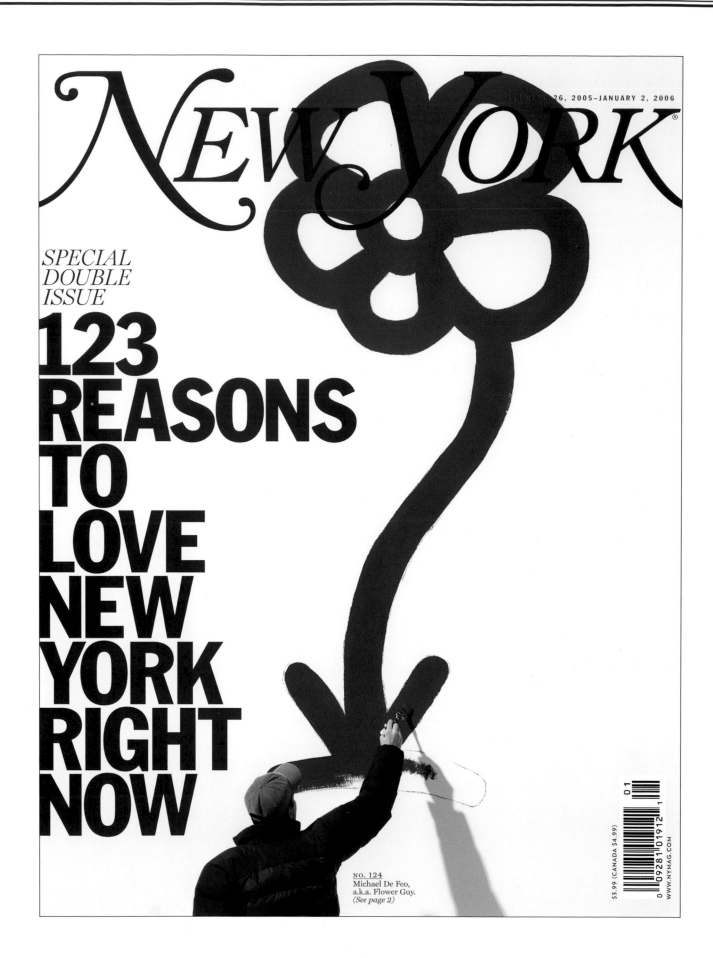

012 ❋ NEW YORK

Design Director: Luke Hayman / *Director of Photography:* Jody Quon / *Photographer:* David Harry Stewart /
Editor-In-Chief: Adam Moss / *Publisher:* New York Magazine Holdings, LLC / *Issue:* December 26, 2005-January 6, 2006 /
Category: Design Cover

013 ❋ TIME OUT NEW YORK
Art Director: Joe Angio / *Designer:* Matt Guemple / *Photo Editor:* Courtenay Kendall /
Editor-In-Chief: Joe Angio / *Publisher:* Time Out New York Partners, L.P. / *Issue:* June 16-22, 2005 /
Category: Design Cover

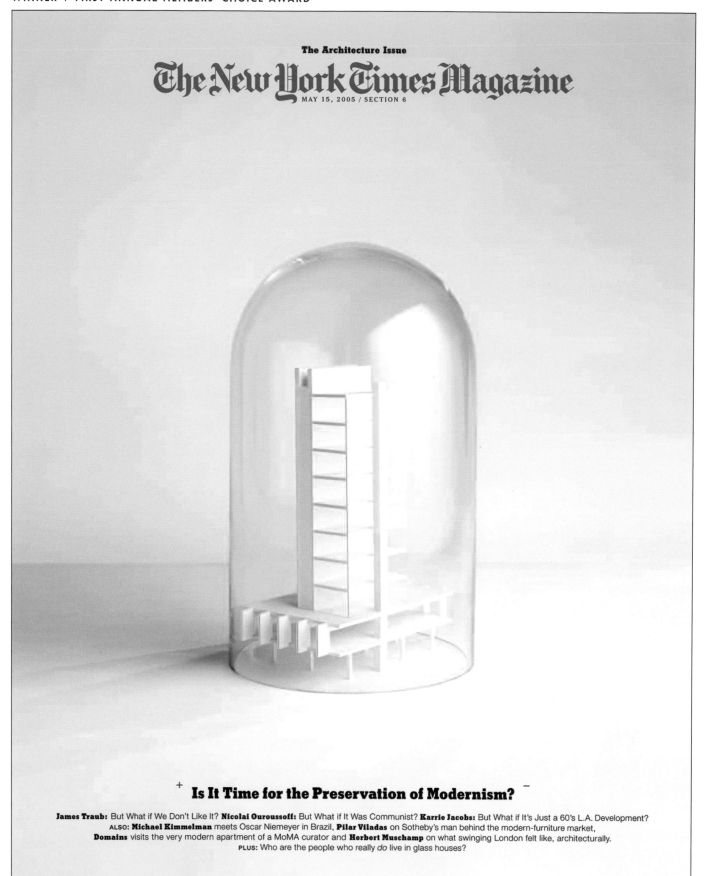

The Architecture Issue

The New York Times Magazine
MAY 15, 2005 / SECTION 6

⁺ Is It Time for the Preservation of Modernism? ⁻

James Traub: But What if We Don't Like It? **Nicolai Ouroussoff:** But What if It Was Communist? **Karrie Jacobs:** But What if It's Just a 60's L.A. Development?
ALSO: Michael Kimmelman meets Oscar Niemeyer in Brazil, **Pilar Viladas** on Sotheby's man behind the modern-furniture market,
Domains visits the very modern apartment of a MoMA curator and **Herbert Muschamp** on what swinging London felt like, architecturally.
PLUS: Who are the people who really *do* live in glass houses?

+ Merit / Newsstand Magazine / Over 1 Million Circulation (Photography Cover)

014 ✳ THE NEW YORK TIMES MAGAZINE
Creative Director: Janet Froelich / *Art Director:* Arem Duplessis / *Designers:* Kristina DiMatteo,
Todd Albertson, Jeff Glendenning, Cathy Gilmore-Barnes, Luise Stauss, Nancy Harris Rouemy /
Director of Photography: Kathy Ryan / *Editor-In-Chief:* Gerald Marzorati / *Publisher:* The New York Times /
Issue: May 15, 2005 / *Category:* Design Entire Issue

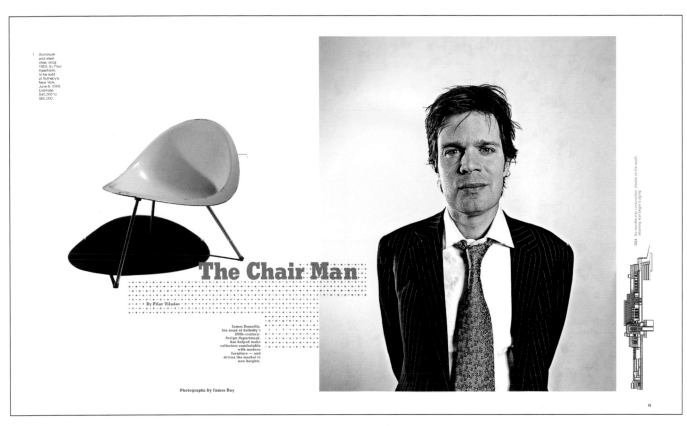

1 Aluminum-
and-steel
chair, circa
1953, by Poul
Kjaerholm,
to be sold
at Sotheby's,
New York,
June 8, 2006.
Estimate:
$40,000 to
$60,000.

The Chair Man

By Pilar Viladas

James Zemaitis,
the head of Sotheby's
20th-century-
design department,
has helped make
collectors comfortable
with modern
furniture — and
driven the market to
new heights.

Photographs by James Day

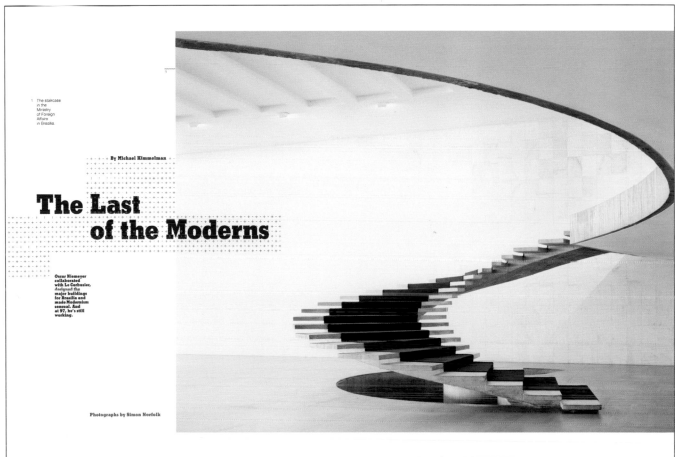

1 The staircase
in the
Ministry
of Foreign
Affairs
in Brasília.

By Michael Kimmelman

The Last
of the Moderns

Oscar Niemeyer
collaborated
with Le Corbusier,
designed the
major buildings
for Brasília and
made Modernism
sensual. And
at 97, he's still
working.

Photographs by Simon Norfolk

Martha Stewart **Living**

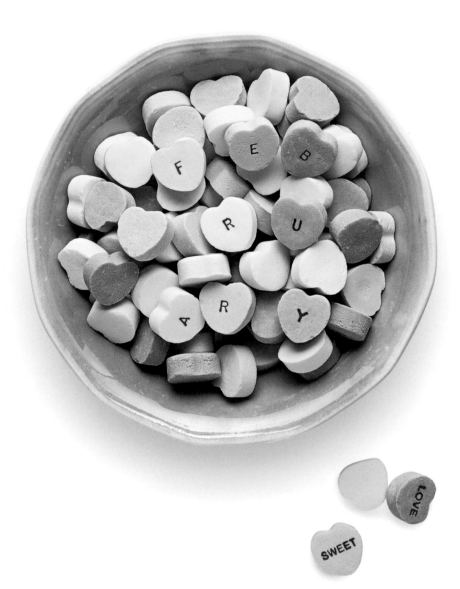

ANNA WILLIAMS

81

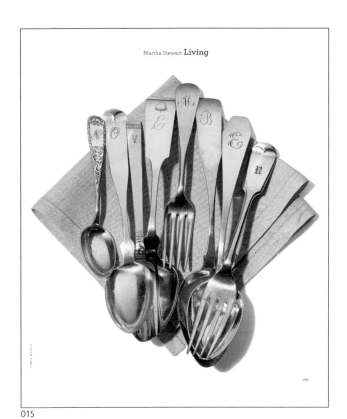

Martha Stewart **Living**

015

015 ✻ MARTHA STEWART LIVING
Creative Director: Eric Pike / *Art Directors:* James Dunlinson, Joele Cuyler /
Deputy Design Director: Mary Jane Callister / *Senior Art Director:* Cybele Grandjean /
Stylists: Laura Normandin, Anna Beckman, Randi Brookman-Harris, Fritz Karch,
Quy Nguyen / *Photo Editors:* Heloise Goodman, Andrea Bakacs / *Photographers:*
Anna Williams, Victor Schrager, James Wojcik / *Editor-In-Chief:* Margaret Roach /
Publisher: Martha Stewart Living Omnimedia / *Issue:* 2005 / *Category:* Design Story

016 ✻ ABSOLUTE NEW YORK
Creative Director: Michael Grossman / *Design Director:* Deanna Lowe / *Designers:*
Deanna Lowe, Jessica Erixon / *Director of Photography:* Catherine Talese / *Associate
Photo Editor:* Hali Tara Feldman / *Photographer:* Christopher Griffith / *Editor-In-Chief:*
Andrew Essex / *Publisher:* Absolute Publishing / *Issue:* Summer 2005 / *Category:*
Photography Contents & Departments

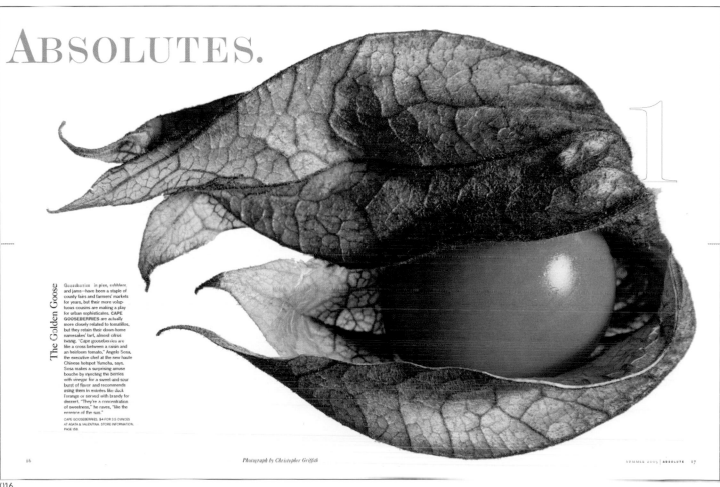

ABSOLUTES.

The Golden Goose

Gooseberries in pies, cobblers, and jams—have been a staple of county fairs and farmers' markets for years, but their more voluptuous cousins are making a play for urban sophisticates. CAPE GOOSEBERRIES are actually more closely related to tomatillos, but they retain their down-home namesakes' tart, almost citrus twang. "Cape gooseberries are like a cross between a raisin and an heirloom tomato," Angelo Sosa, the executive chef at the new haute Chinese hotspot Yumcha, says. Sosa makes a surprising amuse bouche by injecting the berries with vinegar for a sweet-and-sour burst of flavor and recommends using them in entrées like duck l'orange or served with brandy for dessert. "They're a concentration of sweetness," he raves, "like the essence of the sun."
CAPE GOOSEBERRIES, $4 FOR 3.5 OUNCES AT AGATA & VALENTINA. STORE INFORMATION, PAGE 158.

Photograph by Christopher Griffith

016

293 BREAKING 528
378621273461037
6 THE 6423986545
825123715 CODE 97
940948097 2403

Deftly, year by year, step by step, the Bush administration has been reinventing the American system of taxation. And the story of this revolution is not over. By Nicholas Confessore

478639438 0672
063842564 54204

017

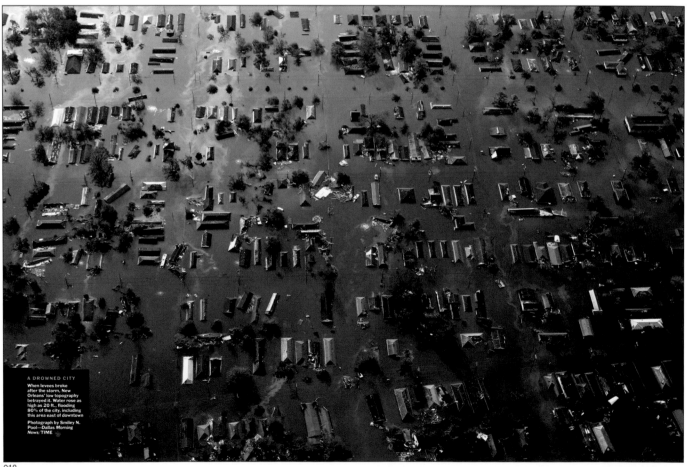

A DROWNED CITY
When levees broke after the storm, New Orleans' low topography betrayed it. Water rose as high as 20 ft., flooding 80% of the city, including this area east of downtown

Photograph by Smiley N. Pool—Dallas Morning News/TIME

018

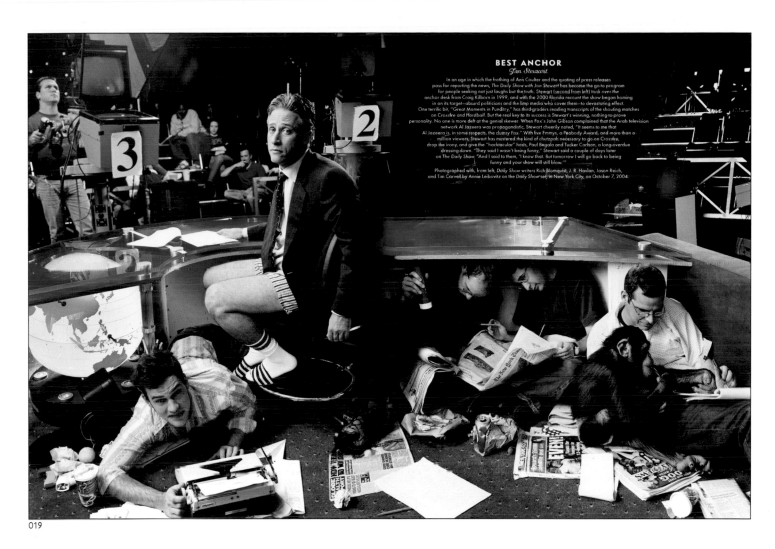

019

017 ✻ THE NEW YORK TIMES MAGAZINE
Creative Director: Janet Froelich / *Art Director:* Arem Duplessis /*Designer:* Todd
Albertson / *Editor-In-Chief:* Gerald Marzorati / *Publisher:* The New York Times /
Issue: January 16, 2005 / *Category:* Design Spread Single Page

018 ✻ TIME
Art Director: Arthur Hochstein / *Deputy Art Directors:* Cynthia A. Hoffman,
D.W. Pine / *Director of Photography:* Michele Stephenson / *Photo Editors:* MaryAnne
Golon, Jay Colton / *Photographers:* Smiley N. Pool, Dallas Morning News / *Publisher:*
Time Inc. / *Issue:* September 12, 2005 / *Category:* Photography Spread-Single Page

019 ✻ VANITY FAIR
Design Director: David Harris / *Art Director:* Julie Weiss / *Designer:* Chris Mueller /
Director of Photography: Susan White / *Photo Editors:* Lisa Berman, Kathryn
MacLeod / *Photographer:* Annie Leibovitz / *Editor-In-Chief:* Graydon Carter /
Publisher: Condé Nast Publications Inc. / *Issue:* January 2005 / *Category:*
Photography Spread-Single Page

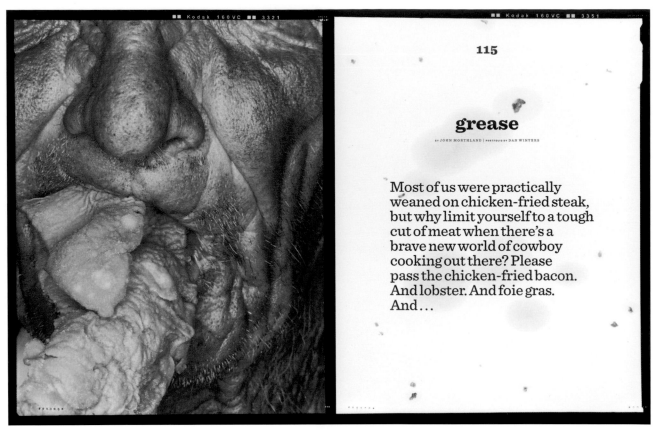

115

grease

BY JOHN MORTHLAND | PORTFOLIO BY DAN WINTERS

Most of us were practically weaned on chicken-fried steak, but why limit yourself to a tough cut of meat when there's a brave new world of cowboy cooking out there? Please pass the chicken-fried bacon. And lobster. And foie gras. And…

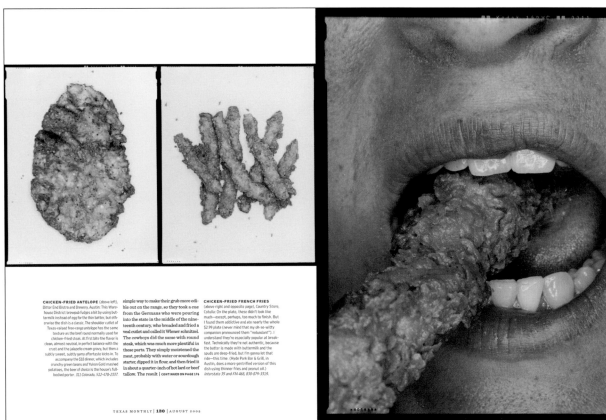

CHICKEN-FRIED ANTELOPE (above left), Bitter End Bistro and Brewery, Austin. This Warehouse District brewpub fudges a bit by using buttermilk instead of egg for the thin batter, but otherwise the dish is a classic. The shoulder cutlet of Texas-raised free-range antelope has the same texture as the beef round normally used for chicken-fried steak. At first bite the flavor is clean, almost neutral, in perfect balance with the crust and the jalapeño cream gravy, but then a subtly sweet, subtly gamy aftertaste kicks in. To accompany the $18 dinner, which includes crunchy green beans and Yukon Gold mashed potatoes, the beer of choice is the house's full-bodied porter. *321 Colorado, 512–478–2337.*

simple way to make their grub more edible out on the range, so they took a cue from the Germans who were pouring into the state in the middle of the nineteenth century, who breaded and fried a veal cutlet and called it Wiener schnitzel. The cowboys did the same with round steak, which was much more plentiful in these parts. They simply moistened the meat, probably with water or sourdough starter, dipped it in flour, and then fried it in about a quarter-inch of hot lard or beef tallow. The result | **CONTINUED ON PAGE 174**

CHICKEN-FRIED FRENCH FRIES (above right and opposite page), Country Store, Cotulla. On the plate, these didn't look like much—except, perhaps, too much to finish. But I found them addictive and ate nearly the whole $2.99 plate (never mind that my oh-so-witty companion pronounced them "redundant"). I understand they're especially popular at breakfast. Technically they're not authentic, because the batter is made with buttermilk and the spuds are deep-fried, but I'm gonna let that ride—this time. (Hyde Park Bar & Grill, in Austin, does a more gentrified version of this dish using thinner fries and peanut oil.) *Interstate 35 and FM 468, 830–879–3319.*

020 ✳ TEXAS MONTHLY
Creative Director: Scott Dadich / *Art Director:* TJ Tucker / *Designers:* Scott Dadich, TJ Tucker /
Photo Editor: Leslie Baldwin / *Photographer:* Dan Winters / *Publisher:* Emmis Communications Corp. /
Issue: August 2005 / *Category:* Design Story

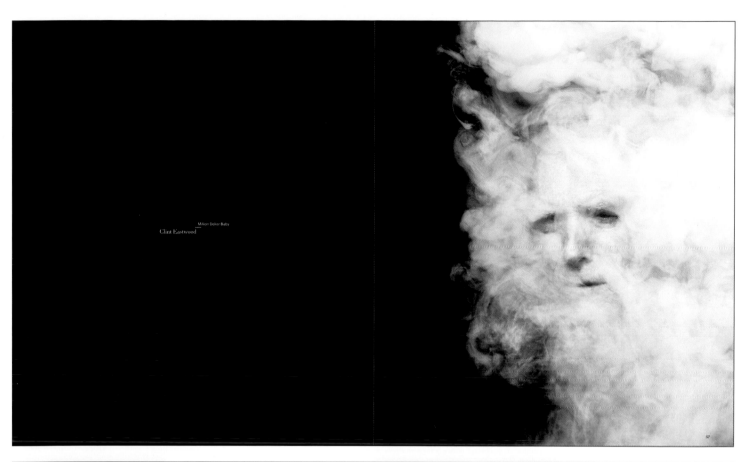

Clint Eastwood Million Dollar Baby

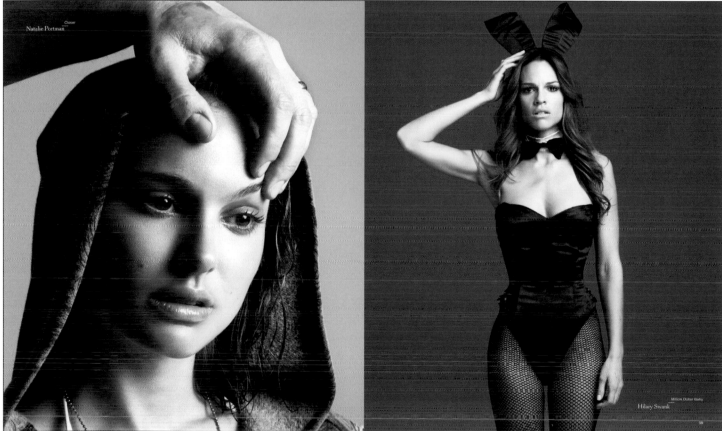

Natalie Portman Closer

Hilary Swank Million Dollar Baby

071 ✳ THE NEW YORK TIMES MAGAZINE
Creative Director: Janet Froelich / *Art Director:* Arem Duplessis / *Designer:* Guillermo Nagore /
Director of Photography: Kathy Ryan / *Photo Editor:* Kira Pollack / *Photographers:* Inez van Lamsweerde,
Vinoodh Matadin / *Editor-In-Chief:* Gerald Marzorati / *Publisher:* The New York Times / *Issue:* February 27, 2005 /
Category: Photography Story

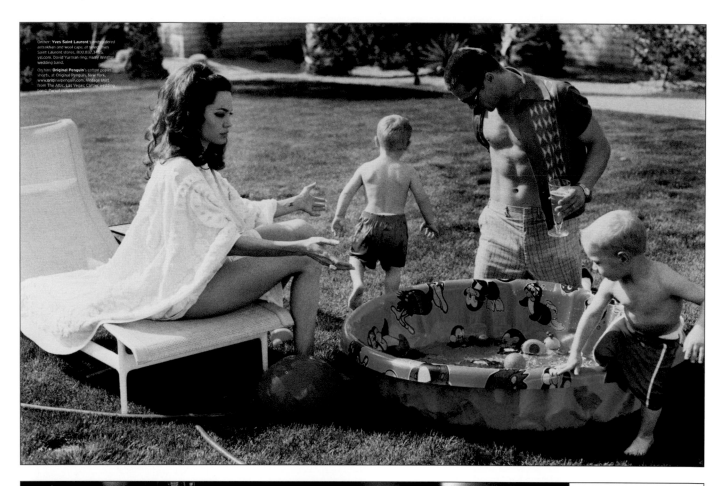

On her: **Yves Saint Laurent**'s embroidered astrakhan and wool cape, at select Yves Saint Laurent stores, 800.832.3456, ysl.com. David Yurman ring; Harry Winston wedding band.

On him: **Original Penguin**'s cotton poplin shorts, at Original Penguin, New York, www.originalpenguin.com. Vintage shirt from The Attic, Las Vegas; Cartier wedding band; Persol sunglasses.

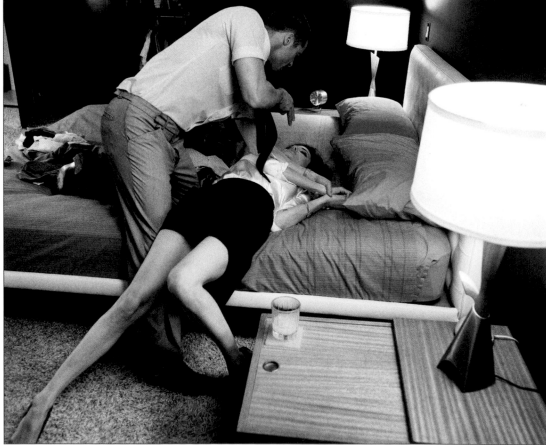

On her: **Michael Kors**'s cream silk charmeuse blouse, at Saks Fifth Avenue; Bergdorf Goodman and Michael Kors, New York; **Ralph Lauren**'s black wool skirt, at Bergdorf Goodman, New York; select Ralph Lauren stores, runway.polo.com. Christian Louboutin shoes.

On him: **Alexander McQueen**'s white cotton shirt, at Barneys New York, Bergdorf Goodman and Alexander McQueen, New York; **Thom Browne**'s gray wool pants, at Bergdorf Goodman and Jeffrey, New York; Ron Herman, Los Angeles.

JULY 2005 W | 333

022 ✳ W
Creative Director: Dennis Freedman / *Design Director:* Edward Leida / *Designers:* Edward Leida,
Shanna Greenberg, Carmen Chan / *Photographer:* Steven Klein / *Publisher:* Fairchild Publications /
Category: Photography Story

The Politics of

How did a political refugee
who became a popular cafe owner in
a small Michigan town suddenly
become a terrorist in the
eyes of the government?
A post-9/11 story.

Ibrahim Parlak

By Alex Kotlowitz

This is a story about the trickery of time. Sometimes the world changes on a dime, as it did on Sept. 11, and with the transformation of the present, the past, too, can suddenly take on a different hue. This, it seems, is what happened to Ibrahim Parlak. Indeed, it's tough to choose the tense in which to tell his story. He runs — or ran — a Middle Eastern restaurant. It's in Harbert, Mich., a small summer resort town, an hour and a half by car from Chicago, along the Lake Michigan shoreline. Parlak is a Kurd from Turkey and had been in this country for 13 years when, on the morning of July 29 last year, he was arrested by officers with the Department of Homeland Security and taken into custody. He was charged

Illustrations by Tomer Hanuka Turkish troops discovered Parlak in his mountain hideaway.

with crimes relating to his time in Turkey, when he had been involved with a Kurdish separatist group.

D.H.S. declared that he was — and consequently still is — a terrorist. A spokeswoman told the Associated Press at the time of his arrest, "We think that if most people knew the details they would see him as someone they wouldn't want living in their community." Those details included the fact that before immigrating to the U.S., he had illegally crossed the Turkish border and, armed with an AK-47, a pistol and a grenade, was involved in a firefight in which two Turkish soldiers were killed. He was compared to former Nazis who had hidden their pasts to become U.S. citizens. A nearby newspaper in LaPorte County, Ind., The Herald-Argus, ran the headline "Terrorist 22 Miles Away?" A D.H.S. prosecutor mentioned him in the same breath as Osama bin Laden.

But the people around Parlak — not just his close friends but customers and former employees, business competitors and neighbors — saw things differently.

After Parlak's arrest, one of his closest friends, Martin Dzuris, who had fled Communist Czechoslovakia and who is now a loyal George W. Bush supporter, built a Web site and organized a letter-writing campaign to politicians. Parlak's tennis partner, Marty Goldrick, a square-jawed, retired Whirlpool executive, drove 120 miles to Lansing to lobby a U.S. senator on Parlak's behalf, the first political act he had ever undertaken. Jo Ann Jansky, a tough-talking waitress who worked for Parlak when he managed a truck stop, attached a plastic flag to her car's antenna. It read: "Free Ibrahim" — as did signs that sprouted on front lawns like daisies. In their windows, businesses taped posters with a similar plea; they featured a picture of Parlak in his chef's apron. To help cover Parlak's legal costs, a competitor down the road sponsored a fund-raiser, which brought in $25,000. (A friend contributed $750, but told me he did it anonymously, not because he was afraid to take a public stand, but rather because he says that otherwise Parlak would insist on repaying him.) A police officer in town, David Duis, took a day off work to testify at Parlak's bond hearing. "If Ibrahim moved next to me," he told me, "I'd welcome it. He's just a classy guy."

Even people who knew him only peripherally offered their support. A plumber who had done some work in the restaurant stopped by and, holding back tears, told Parlak's brother not to worry about the bill. Carol Marin, a TV journalist who had dined at the restaurant, wrote editorials in The Chicago Sun-Times urging the government to drop the charges. I was at the restaurant one afternoon when two faculty members from a nearby university dropped off a small contribution and a card. They explained that their school had warned them about getting involved and forbade them to associate the school in any way with the case, so they left the card unsigned. One friend commented that it was like a contemporary version of the film "It's a Wonderful Life," at Parlak's small, everyday gestures had suddenly taken on added significance. In the wake of 9/11, his friends were fairly certain that they knew evil, and in their minds Parlak wasn't it. Not even close.

How is it that two groups of individuals — Parlak's small-town friends and the U.S. government — can look at one man, at one case, at one situation and come to such disparate conclusions? Are his friends so close to him that they can't see what might have been ugliness in his past? Or is the government so intent on proving that it's tough on terrorism that it has lost its moral bearing?

The Flight

On April 13, 1991, Ibrahim Parlak, who was 28 at the time, arrived in the United States. He was on the run, and so was both relieved and tired. He had recently been released from a Turkish prison, and the authorities there had been putting pressure on him to rat out friends. Moreover, his family had received death threats, so he fled. His father sold a tractor and other farm equipment, and his sisters sold some of their jewelry to raise the several

Alex Kotlowitz is a regular contributor to the magazine and the author of "There Are No Children Here" and "Never a City So Real."

First Date
When Parlak first met Michelle Gazzolo, he sketched out a map of an imagined Kurdistan for her.

Stopover
Parlak managed a truck stop and was known for his cooking, especially his lentil soup.

Café Gulistan
Parlak opened his restaurant in 1994. It was there that he built up the community of friends who would become staunch supporters after his arrest.

thousand dollars needed for plane tickets and a false passport. Parlak remembers clearly something his father told him before he left: "You're old enough and have been through enough to know what is right and what is wrong. But no matter what you do, don't stay in the front or the back; find a place in the middle." By that he meant find a place of comfort and safety.

Parlak told me he had planned his departure carefully. The day before leaving, he went to a Turkish barber and asked for "an American haircut," and he purchased new clothes, including a leather jacket, so that he wouldn't attract attention. Accompanying Parlak on the flight was a Turkish businessman, whom Parlak had just met and whose travel expenses he paid in exchange for carrying newspaper clippings and other documents that could help Parlak establish an asylum claim. Parlak didn't want to transport the papers himself for fear that he might be stopped and searched along the way. He was also traveling on a false passport, and so brought papers that could establish his real identity.

In Chicago, the businessman took him to a city college, where there was a language program for new refugees. There they met Ruth Lambach, its director. Lambach was immediately drawn to Parlak. "I looked at Ibrahim in my office," she recalls. "I could feel that he was on the edge of his life, that he didn't have that many options. He had this amazing warmth and fire in his eyes." Parlak is a slender, handsome man, but it's his eyes that most people comment on. They're deep-set and simultaneously sad and sparkling. "Dancing eyes," Lambach calls them. "Alert, curious, alive." Lambach offered to let him stay on her couch for the night. He spent much of the next year there, becoming good friends with Lambach and her son. In those days, Lambach and Parlak, who spoke no English, communicated in German.

Rebellion and Capture

Parlak immediately applied for political asylum, and two weeks after his arrival went downtown to the immigration building where he was interviewed about his claim. There are a number of critical moments in Parlak's story, and this one has taken on added significance, especially when looked back on through the prism of today's reordered world. In 1980,

Congress passed legislation formalizing the asylum process, in part to be in compliance with the longstanding United Nations Convention on refugees and in part to respond to the influx of Soviet citizens fleeing Communist rule. Over time, the process for asylum seekers has become more demanding and systematic, but in 1991 it was a rather straightforward one that relied heavily on the intuition of the immigration officer. Asylum is given to people who can show a reasonable likelihood that if they were to return to their countries, they'd be persecuted because of their religion, race, nationality, social group or political beliefs; it cannot, however, be given to people who have persecuted others. Applicants must provide what documentation and narrative they can to substantiate their claims, though in the end, at least in 1991, much of it came down to a matter of trust. The immigration officer had to decide whether the applicant's story was believable.

There is a place on the application where Parlak had to list his residences of the last five years, the most recent first. It reads like a haiku of his experience:

Istanbul
Aksaray
Prison in Gaziantep
Mountains of Maras
P.K.K. Camp, Halvi, Lebanon

It's unclear whether Parlak told the officer about his childhood, since the notes from that interview begin with high school. But Parlak grew up on a farm with four brothers and five sisters; his father grew wheat, cotton and watermelon. It was not an easy time to be a Kurd in Turkey, especially for someone as independent-minded as Parlak. In the 1970's, Turkey refused to recognize the Kurds as a distinct ethnic group even though half the world's Kurds — an estimated 10 to 12 million — lived in the country. The Kurds were concentrated in the mountainous regions in the east and south, where few of their villages had electricity or running water. It has generally been Turkey's belief that the Kurds need to assimilate and become Turks, in language, culture and identity. In the 1970's and 1980's,

the Kurdish language was forbidden for official use. Schools taught only in Turkish. Newspapers or television could not use the Kurdish language. Parents could not give their children Kurdish names. Kurdish songs and books were banned. Parlak tells the story of the time the military came through his village, and while his father threw three books into a fire, Parlak and one of his brothers tried to salvage what they could, burying them in a nearby field. When Parlak was in first grade, a classmate reported to the authorities that Parlak spoke Kurdish in his home. When he got to school, his teacher hit him with a wooden cane and then humiliated him by making him stand by the blackboard all day.

Parlak's father sent him to the nearby city, Gaziantep, for high school, and it's here that Parlak's asylum testimony picks up. Parlak told the immigration officer that it was in Gaziantep that he became involved with the burgeoning Kurdish rights movement, attending meetings and political protests. At one rally, where he was distributing leaflets and hanging posters, the police arrested him. He was held for three months — without ever appearing in front of a judge — before being released. He was 16. Realizing the danger of his involvement in Kurdish affairs, Parlak left for the safety of Germany, where he lived for the next seven years.

During that time, the mid-1980's, the Kurdish Workers' Party, or P.K.K., emerged as the leading force for Kurdish rights. It was a Marxist-Leninist insurgent group (though with no ties to Moscow) that advocated an independent Kurdish state and was led by Abdullah Ocalan, who would eventually earn a reputation for his zealotry and brutality (including against P.K.K. members when he lost trust in them). The P.K.K. conducted guerrilla raids in southeast Turkey, killing soldiers and police officers as well as civilians who sympathized with the Turkish authorities. In Europe, Parlak became active in the P.K.K.'s political arm and organized Kurdish cultural festivals throughout the continent. They had a dual purpose: to fuel a sense of Kurdish identity as well as to raise money for P.K.K. activities. Parlak used a pseudonym, Ayhan.

Parlak missed his family, and he carried around their photographs, trying to memorize their faces so that he wouldn't forget them. He couldn't call them because his parents' village didn't have telephones. After seven

ILLUSTRATIONS BY TOMER HANUKA 49

023 ✻ THE NEW YORK TIMES MAGAZINE

Creative Director: Janet Froelich / *Art Director:* Arem Duplessis / *Designer:* Kristina DiMatteo / *Illustrator:* Tomer Hanuka / *Editor-In-Chief:* Gerald Marzorati / *Publisher:* The New York Times / *Issue:* March 20, 2005 / *Category:* Illustration Story

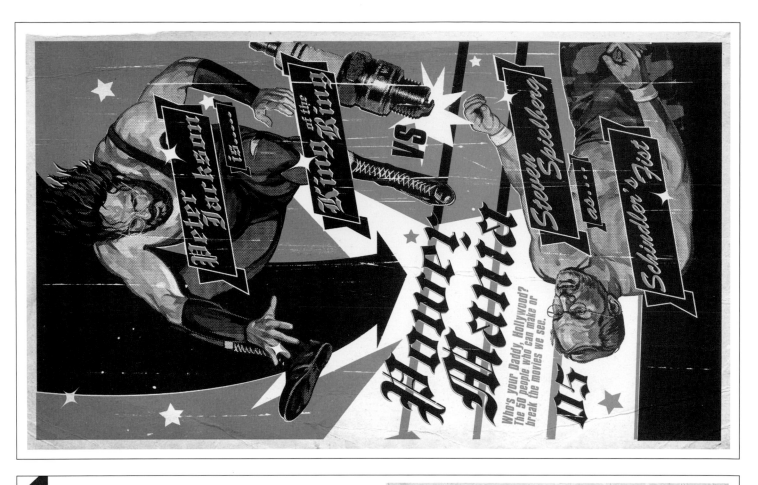

024 ✦ PREMIERE
Art Director: Dirk Barnett / *Designer:* Dirk Barnett / *Illustrator:* Tavis Coburn /
Director of Photography: David Carthas / *Editor-In-Chief:* Peter Herbst / *Publisher:*
Hachette Filipacchi Media U.S. / *Issue:* June 2005 / *Category:* Illustration Story

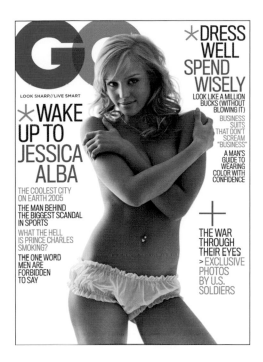

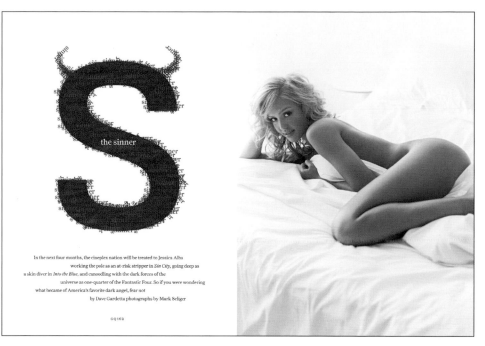

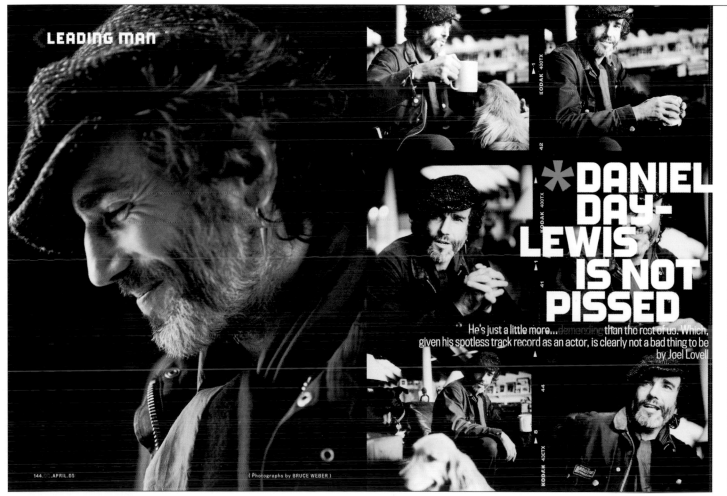

025 ✳ GQ

Design Director: Fred Woodward / *Designers:* Ken DeLago, Anton Ioukhnovets, Sarah Viñas, Thomas Alberty, Chloe Weiss / *Illustrators:* Tavis Coburn, John Ritter / *Director of Photography:* Bradley Young / *Photo Editors:* Kristin Schaefer, Monica Bradley / *Photographers:* Richard Burbridge, Frederike Helwig, Tom Schierlitz, Mark Seliger, Peggy Sirota / *Creative Director:* Jim Moore / *Fashion Director:* Madeline Weeks / *Editor-In-Chief:* Jim Nelson / *Publisher:* Condé Nast Publications Inc. / *Issue:* April 2005 / *Category:* Design Entire Issue

ACADEMY OF ACHIEVEMENT

★ ★ ★ *ESTABLISHED 1961* — **A MUSEUM OF LIVING HISTORY** — *WASHINGTON D.C.* ★ ★ ★

ACHIEVER GALLERY ⋎ KEYS TO SUCCESS ⋎ ACHIEVEMENT STORE ⋎ ABOUT THE ACADEMY ⋎ FOR TEACHERS

- OPRAH WINFREY -

"It doesn't matter WHO YOU ARE, where you come from. The ability to TRIUMPH BEGINS WITH YOU. Always."

PROFILE | BIOGRAPHY | INTERVIEW

FEATURED MEMBER

Oprah Winfrey — *ENTERTAINMENT EXECUTIVE*

NEXT ⋎
BACK ⬉

OUR MISSION:
The Academy of Achievement brings students face-to-face with the extraordinary leaders, thinkers and pioneers who have shaped our world. Learn more

FIND A MEMBER:
[Select Achiever ▾]

SEARCH THE SITE:
[] GO

ACADEMY NEWS:
- Explore highlights from the 2004 International Achievement Summit.
- Master the six elements that help drive success.
- Discover an Academy mentor with dreams and challenges similar to your own.

Passion

WHAT INSPIRES AN ACHIEVER?
Click to find out!

LEARN ABOUT THE GREATEST THINKERS AND ACHIEVERS OF OUR AGE

The Arts	Business	Public Service	Science & Exploration	Sports
Johnny Cash	Jeff Bezos	Hamid Karzai	Robert Ballard	Sir Roger Bannister
John Grisham	George Lucas	Rosa Parks	Sir Edmund Hillary	Willie Mays
Wynton Marsalis	Oprah Winfrey	Desmond Tutu	David Ho	Dorothy Hamill
more..	more...	more...	more...	more...

Sponsors | Privacy Policy | Technical Questions | Editorial Questions | AOL Users | Site Credits | Site Map

©2005 Academy of Achievement. All Rights Reserved

026 ✳ AMERICAN ACADEMY OF ACHIEVEMENT
Creative Director: Geoff Mark / *Design Director:* Ian Watts / *Designers:* Mike Hindman,
Johnny Mei / *Programmer:* Sanjin Cancar / *Issue:* www.achievement.org /
Category: New Media News & Information Site Daily

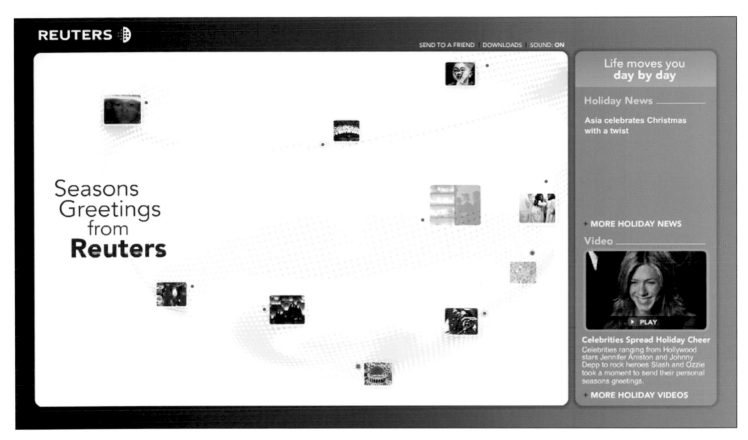

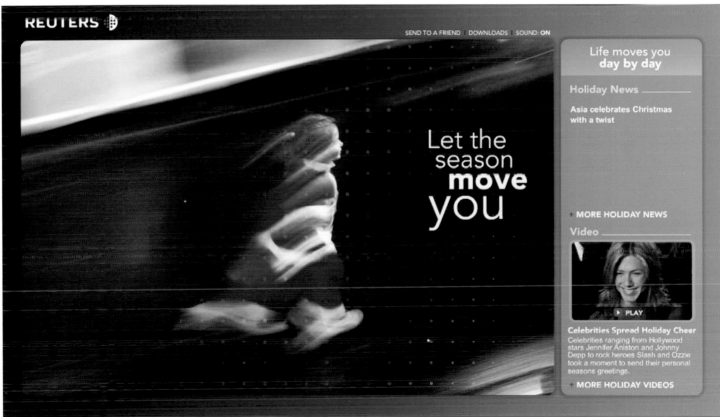

027 ✳ REUTERS
Creative Directors: Jeff Wagener, Daniel Bernard / *Design Director:* Carin Castillo / *Designers:* Arne Kudson, Neeld Tanksley, Leo Kin, Omar Yousif,
John Travers, Brandon Whightsel, Zuad Oropeza, Nancy DePiano, Rose Karpel / *Account Director:* Esther Lim / *Publisher:* Reuters America LLC /
Issue: www.today.reuters.com/seasonsgreetings / *Category:* New Media Special Site Feature

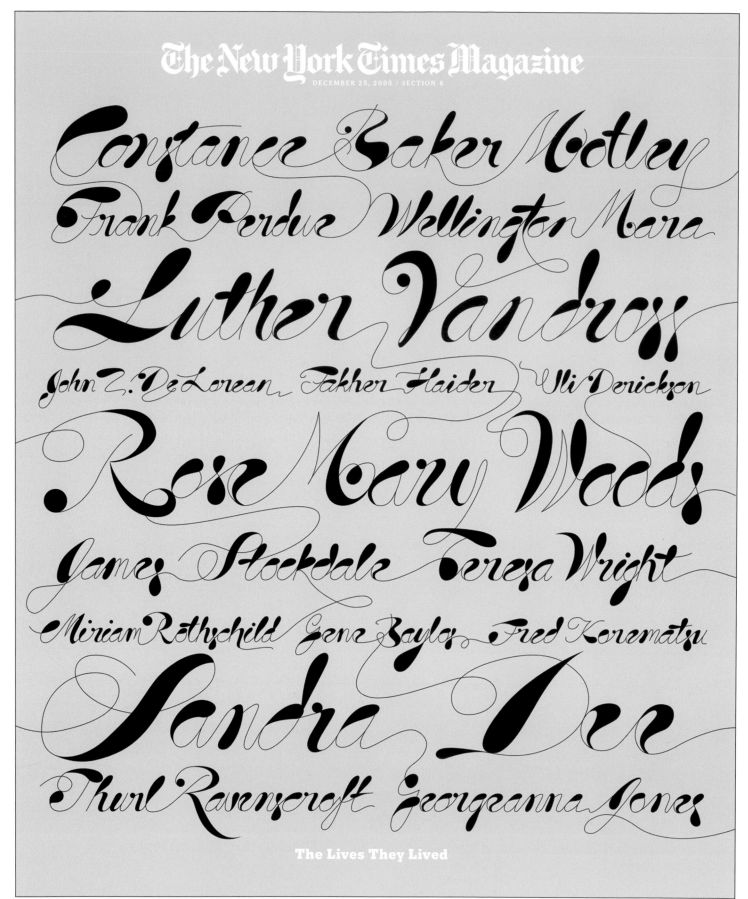

The New York Times Magazine
DECEMBER 25, 2005 / SECTION 6

Constance Baker Motley
Frank Perdue Wellington Mara
Luther Vandross
John Z. DeLorean Fakher Haider Uli Derickson
Rose Mary Woods
James Stockdale Teresa Wright
Miriam Rothschild Gene Bayles Fred Korematsu
Sandra Dee
Thurl Ravenscroft Georganna Jones

The Lives They Lived

+ Merit / Newsstand Magazine / Over 1 Million Circulation (Design Entire Issue)

028 ✳ THE NEW YORK TIMES MAGAZINE
Creative Director: Janet Froelich / *Art Director:* Arem Duplessis / *Designer:* Nancy Harris Rouemy /
Editor-In-Chief: Gerald Marzorati / *Publisher:* The New York Times / *Issue:* December 25, 2005 /
Category: Design Cover

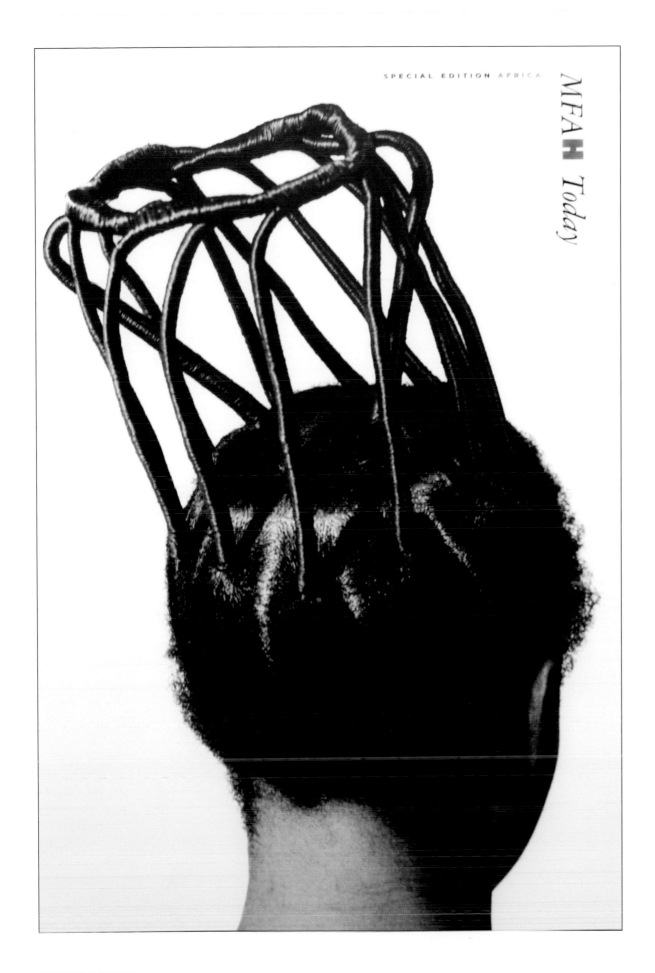

SPECIAL EDITION AFRICA

MFAH Today

029 ✳ MFAH TODAY

Creative Director: DJ Stout / *Designers:* Julie Savasky, Erin Mayes / *Studio:* Pentagram Design, Inc. /
Publisher: Museum of Fine Arts, Houston / *Client:* MFAH / *Issue:* 2005 / *Category:* Design Cover

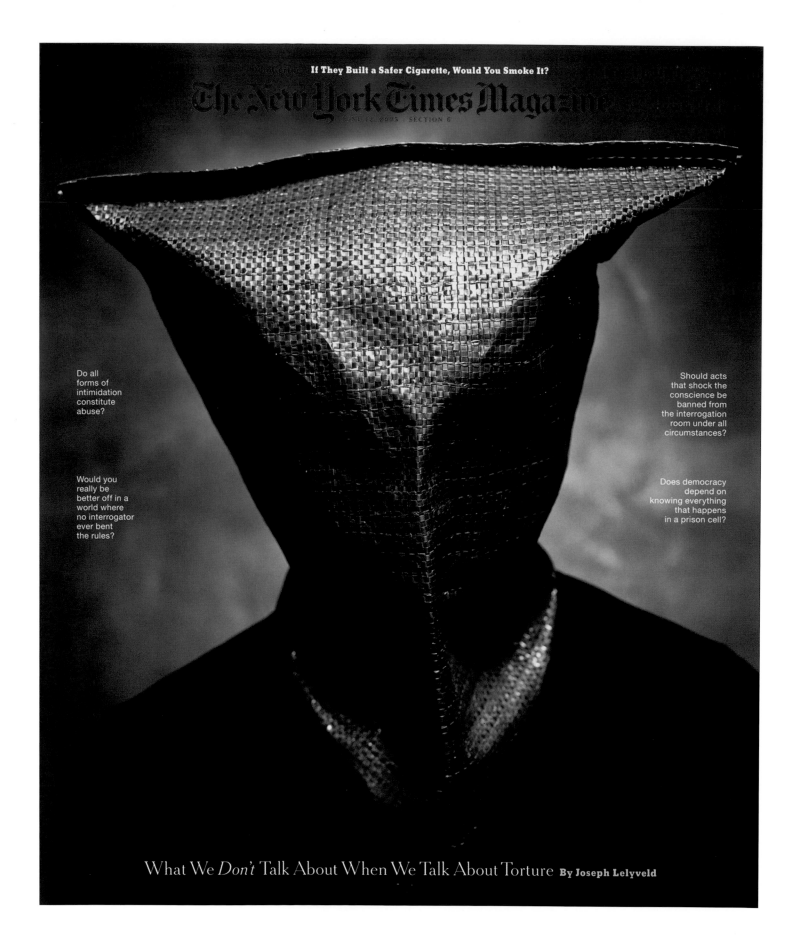

If They Built a Safer Cigarette, Would You Smoke It?

The New York Times Magazine

JUNE 12, 2005 / SECTION 6

Do all
forms of
intimidation
constitute
abuse?

Would you
really be
better off in a
world where
no interrogator
ever bent
the rules?

Should acts
that shock the
conscience be
banned from
the interrogation
room under all
circumstances?

Does democracy
depend on
knowing everything
that happens
in a prison cell?

What We *Don't* Talk About When We Talk About Torture By Joseph Lelyveld

030 ✳ THE NEW YORK TIMES MAGAZINE
Creative Director: Janet Froelich / *Art Director:* Arem Duplessis / *Designer:* Kristina DiMatteo /
Director of Photography: Kathy Ryan / *Photo Editor:* Joanna Milter / *Photographer:* Andres Serrano /
Editor-In-Chief: Gerald Marzorati / *Publisher:* The New York Times / *Issue:* June 12, 2005 /
Category: Photography Cover

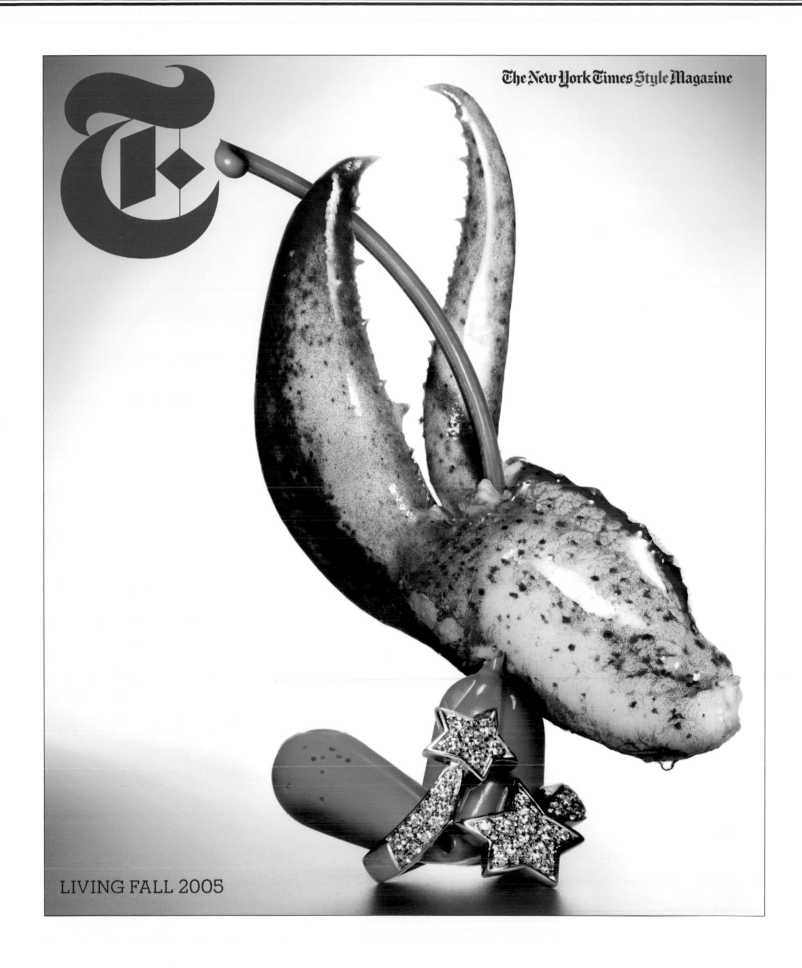

T

The New York Times Style Magazine

LIVING FALL 2005

031 ✱ T: THE NEW YORK TIMES STYLE MAGAZINE
Creative Director: Janet Froelich / *Art Director:* David Sebbah / *Designers:* Janet Froelich, David Sebbah /
Photo Editors: Kathy Ryan, Judith Puckett-Rinella / *Photographer:* Raymond Meier / *Editor-In-Chief:* Stefano Tonchi /
Publisher: The New York Times / *Issue:* November 6, 2005 / *Category:* Photography Cover

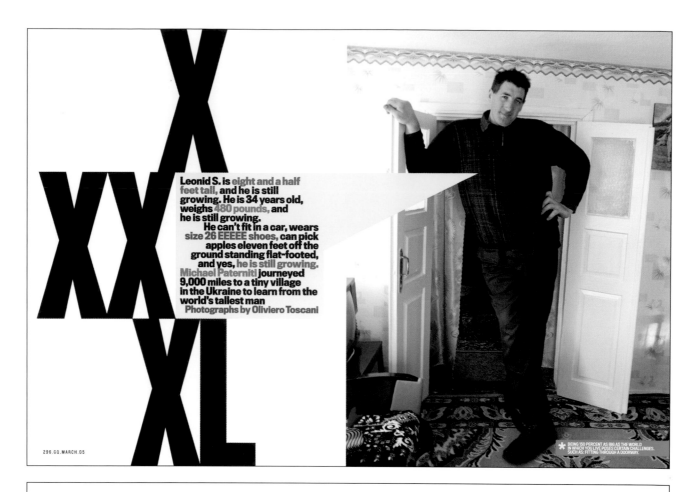

Leonid S. is eight and a half feet tall, and he is still growing. He is 34 years old, weighs 480 pounds, and he is still growing.
He can't fit in a car, wears size 26 EEEEE shoes, can pick apples eleven feet off the ground standing flat-footed, and yes, he is still growing. Michael Paterniti journeyed 9,000 miles to a tiny village in the Ukraine to learn from the world's tallest man
Photographs by Oliviero Toscani

XXXXL

296.GQ.MARCH.05

*BEING 150 PERCENT AS BIG AS THE WORLD IN WHICH YOU LIVE POSES CERTAIN CHALLENGES. SUCH AS: FITTING THROUGH A DOORWAY.

> JOURNEY TO THE
(REVOLUTIONARY, EVIL-HATING, CASH-CRAZY, AND POSSIBLY SELF-DESTRUCTIVE)
CENTER OF

$GOO,000,000,000,00
0,000,000,000,000,00
000,000,000,000,000
0,000,000,000,000,00
000,000,000,000,000
0,000,000,000,GLE.00

> You've heard the story. Larry and Sergey
drop out of school, start a company in a garage,
refuse to play nice with Silicon Valley, then
become billionaires by defying Wall Street. >

260.GQ.03.05

> The problem is, it leaves out the most
important chapter—the mystery
about whether Larry and Sergey
will actually grow up by John Heilemann >

+ Merit / Newsstand Magazine / 500,000 to 1 Million Circulation (Design Spread-Single Page)

032 ✳ GQ

Design Director: Fred Woodward / *Designers:* Ken DeLago, Anton Ioukhnovets, Sarah Viñas, Thomas Alberty, Chloe Weiss / *Illustrators:* Tavis Coburn, John Ritter / *Director of Photography:* Bradley Young / *Photo Editor:* David Carthas / *Photographers:* Nathaniel Goldberg, David Bailey, Terry Richardson, Bruce Weber, Satoshi Saikusa, David Armstrong, Brigitte Lacombe, Ellen Von Unwerth, Mark Seliger, Peggy Sirota, Tom Schierlitz, Oliviero Toscani / *Creative Director:* Jim Moore / *Fashion Director:* Madeline Weeks / *Editor-In-Chief:* Jim Nelson / *Publisher:* Condé Nast Publications Inc. / *Issue:* March 2005 / *Category:* Design Entire Issue

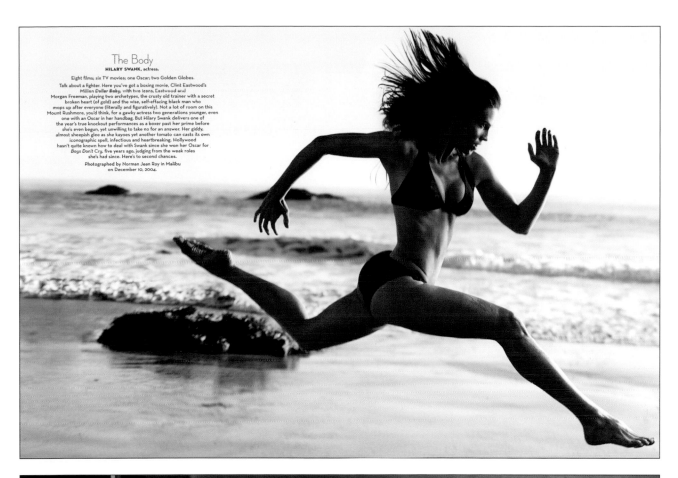

The Body
HILARY SWANK, actress.

Eight films; six TV movies; one Oscar; two Golden Globes.
Talk about a fighter. Here you've got a boxing movie, Clint Eastwood's
Million Dollar Baby, with two icons, Eastwood and
Morgan Freeman, playing two archetypes, the crusty old trainer with a secret
broken heart (of gold) and the wise, self-effacing black man who
mops up after everyone (literally and figuratively). Not a lot of room on this
Mount Rushmore, you'd think, for a gawky actress two generations younger, even
one with an Oscar in her handbag. But Hilary Swank delivers one of
the year's true knockout performances as a boxer past her prime before
she's even begun, yet unwilling to take no for an answer. Her giddy,
almost sheepish glee as she kayoes yet another tomato can casts its own
iconographic spell, infectious and heartbreaking. Hollywood
hasn't quite known how to deal with Swank since she won her Oscar for
Boys Don't Cry, five years ago, judging from the weak roles
she's had since. Here's to second chances.
Photographed by Norman Jean Roy in Malibu
on December 10, 2004.

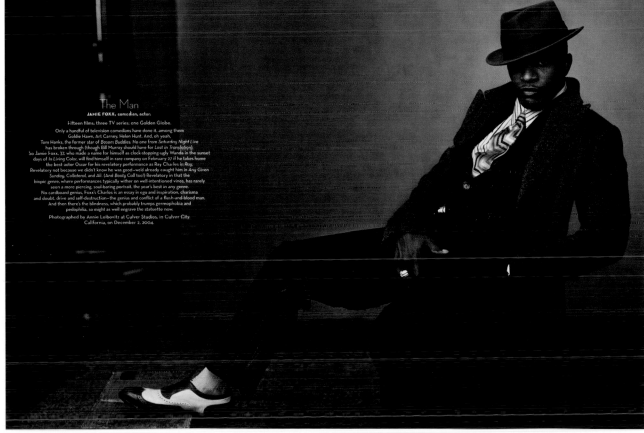

The Man
JAMIE FOXX, comedian, actor.

Fifteen films; three TV series; one Golden Globe.
Only a handful of television comedians have done it, among them
Goldie Hawn, Art Carney, Helen Hunt. And, oh yeah,
Tom Hanks, the former star of *Bosom Buddies*. No one from *Saturday Night Live*
has broken through (though Bill Murray should have for *Lost in Translation*).
So Jamie Foxx, 37, who made a name for himself as clock-stopping-ugly Wanda in the sunset
days of *In Living Color*, will find himself in rare company on February 27 if he takes home
the best-actor Oscar for his revelatory performance as Ray Charles in *Ray*.
Revelatory not because we didn't know he was good—we'd already caught him in *Any Given
Sunday*, *Collateral*, and *Ali*. (And *Booty Call* too!) Revelatory in that the
biopic genre, where performances typically wither on well-intentioned vines, has rarely
seen a more piercing, soul-baring portrait, the year's best in any genre.
No cardboard genius, Foxx's Charles is an essay in ego and inspiration, charisma
and doubt, drive and self-destruction—the genius and conflict of a flesh-and-blood man.
And then there's the blindness, which probably trumps germophobia and
pedophilia, so might as well engrave the statuette now.
Photographed by Annie Leibovitz at Culver Studios, in Culver City,
California, on December 2, 2004.

033 ❖ VANITY FAIR
Design Director: David Harris / *Art Director:* Julie Weiss / *Director of Photography:* Susan White / *Photo Editor:* Lisa Berman /
Photographers: Annie Leibovitz, Norman Jean Roy, Mark Seliger, Jason Schmidt, Snowdon, David Bailey, Brigitte Lacombe,
Bruce Weber, Patrick Demarchelier, Julian Broad, Jonathan Becker, Ben Watts / *Editor-In-Chief:* Graydon Carter / *Publisher:*
Condé Nast Publications Inc. / *Issue:* March 2005 / *Category:* Photography Entire Issue

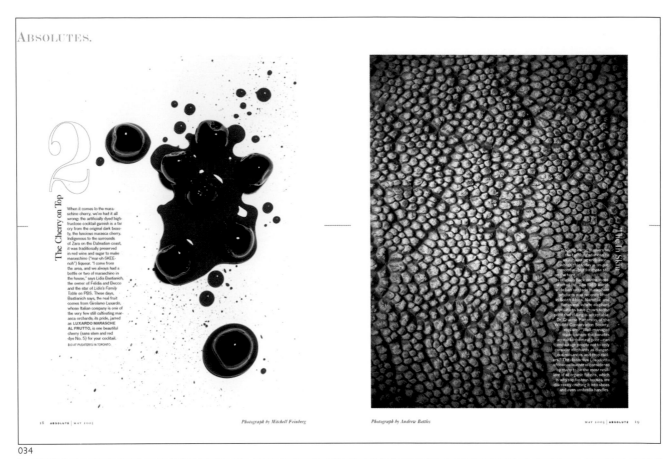

034

035

034 ✷ ABSOLUTE NEW YORK
Creative Director: Michael Grossman / *Design Director:* Deanna Lowe / *Designers:* Deanna Lowe, Jessica Erixon / *Director of Photography:* Catherine Talese /
Associate Photo Editor: Hali Tara Feldman / *Photographers:* Mitchell Feinberg, Andrew Bettles / *Editor-In-Chief:* Andrew Essex / *Publisher:* Absolute Publishing /
Issue: May 2005 / *Category:* Photography Contents & Departments

035 ✷ GQ
Design Director: Fred Woodward / *Designer:* Ken DeLago / *Director of Photography:* Bradley Young / *Photographer:* Nathaniel Goldberg / *Fashion Director:*
Madeline Weeks / *Editor-In-Chief:* Jim Nelson / *Publisher:* Condé Nast Publications Inc. / *Issue:* March 2005 / *Category:* Design Spread-Single Page

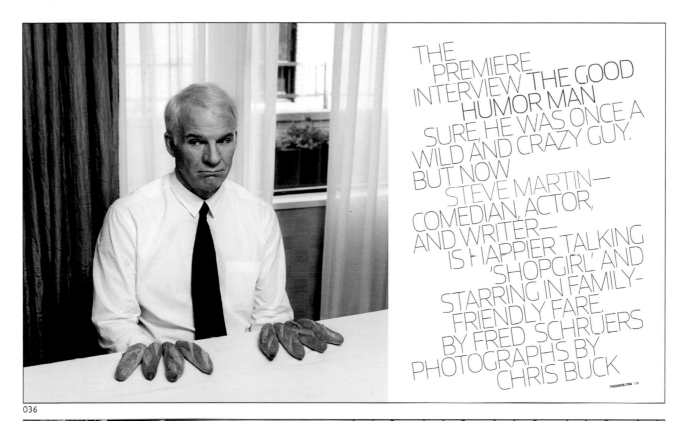

THE PREMIERE INTERVIEW THE GOOD HUMOR MAN SURE, HE WAS ONCE A WILD AND CRAZY GUY. BUT NOW STEVE MARTIN— COMEDIAN, ACTOR, AND WRITER— IS HAPPIER TALKING 'SHOPGIRL' AND STARRING IN FAMILY-FRIENDLY FARE. BY FRED SCHRUERS PHOTOGRAPHS BY CHRIS BUCK

036

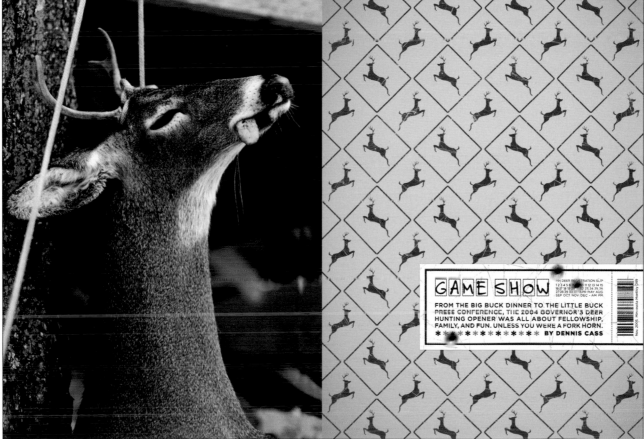

GAME SHOW
FROM THE BIG BUCK DINNER TO THE LITTLE BUCK PRESS CONFERENCE, THE 2004 GOVERNOR'S DEER HUNTING OPENER WAS ALL ABOUT FELLOWSHIP, FAMILY, AND FUN. UNLESS YOU WERE A FORK HORN.
*************** BY DENNIS CASS

037

036 ✳ PREMIERE
Art Director: Dirk Barnett / *Designer:* Dirk Barnett / *Director of Photography:* David Carthas / *Photo Editor:* Linda Liang / *Photographer:* Chris Buck / *Editor-in-Chief:* Peter Herbst / *Publisher:* Hachette Filipacchi Media U.S. / *Issue:* October 2005 / *Category:* Design Spread-Single Page

037 ✳ MINNESOTA MONTHLY
Art Director: Brian Johnson / *Photographer:* Raymond Gehman (Corbis) / *Publisher:* Greenspring Media Group / *Issue:* November 2005 / *Category:* Design Spread-Single Page

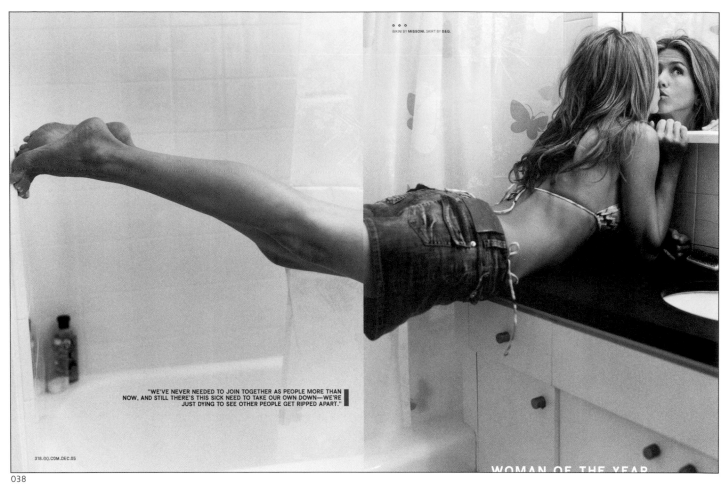

BIKINI BY MISSONI. SKIRT BY D&G.

"WE'VE NEVER NEEDED TO JOIN TOGETHER AS PEOPLE MORE THAN NOW, AND STILL THERE'S THIS SICK NEED TO TAKE OUR OWN DOWN—WE'RE JUST DYING TO SEE OTHER PEOPLE GET RIPPED APART."

318.GQ.COM.DEC.05

WOMAN OF THE YEAR

038

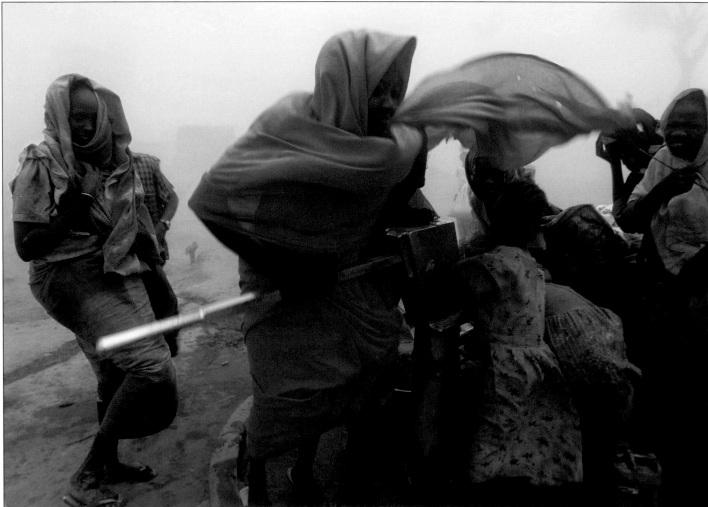

039

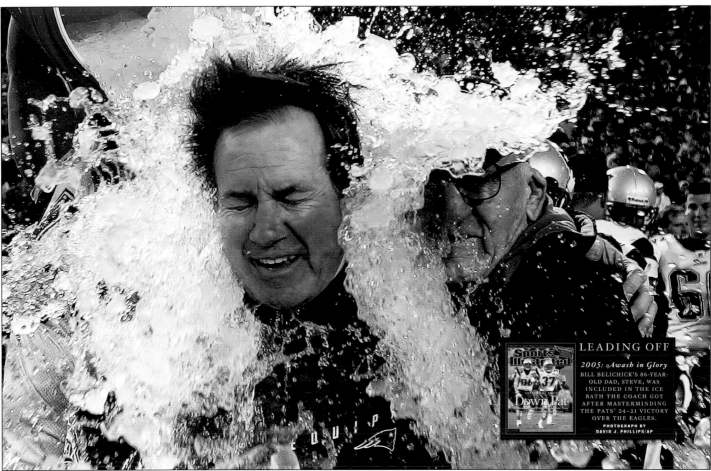

LEADING OFF

2005: Awash in Glory
BILL BELICHICK'S 86-YEAR-
OLD DAD, STEVE, WAS
INCLUDED IN THE ICE
BATH THE COACH GOT
AFTER MASTERMINDING
THE PATS' 24–21 VICTORY
OVER THE EAGLES.
PHOTOGRAPH BY
DAVID J. PHILLIPS/AP

040

038 ✳ G Q
Design Director: Fred Woodward / *Designer:* Ken DeLago / *Director of Photography:* Dora Somosi /
Photo Editors: David Carthas, Kristin Schaefer, Monica Bradley / *Photographer:* Peggy Sirota / *Fashion
Director:* Madeline Weeks / *Editor-In-Chief:* Jim Nelson / *Publisher:* Condé Nast Publications Inc. /
Issue: December 2005 / *Category:* Photography Spread-Single Page

039 ✳ M A R I E C L A I R E
Creative Director: Paul Martinez / *Art Director:* Jenny Leigh Thompson / *Designer:* Paul Martinez /
Director of Photography: Alix Campbell / *Photo Editor:* Melanie Chambers / *Photographer:* Evelyn
Hockstein / *Publisher:* The Hearst Corporation-Magazines Division / *Issue:* September 2005 /
Category: Photography Spread-Single Page

040 ✳ S P O R T S I L L U S T R A T R E D P R E S E N T S
Art Director: Craig Gartner / *Designer:* Karen Meneghin / *Photo Editor:* Jeff Weig / *Photographer:*
David J. Phillips (AP) / *Issue:* February 16, 2005 / *Category:* Photography Spread-Single Page

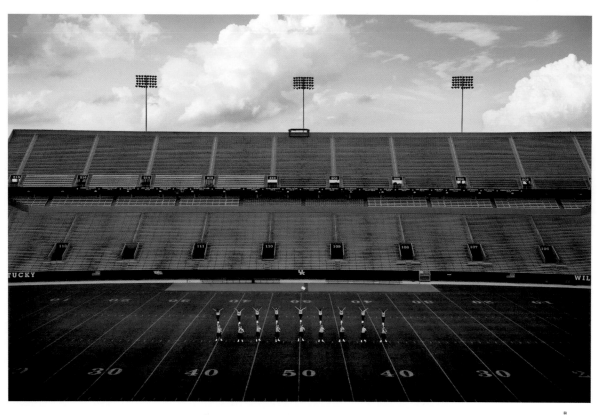

The New York Times Magazine
Portfolio

Sideline Acrobats

The raw power and athletic grace of the country's best collegiate cheerleading squad.

Photographs by
Joachim Ladefoged

CHEERLEADING IS, in the popular imagination, the soft, sweet stuff of fall afternoons — the bright colors and big smiles, the irony-free heartland enthusiasm, the sideshow aspect of exhorting players and crowds by way of pompoms and short skirts. But the truth is that cheerleaders, at the college level at least, happen to be serious athletes. The University of Kentucky squad, whose current members are featured in the following photographs, is the best in the country, having won the national championships of the Universal Cheerleaders Association 14 times since 1985. To watch them in training or competition (or at play in a lake) is to see acrobatic artistry at a literally sky-high level — the women soaring through the air, the men hoisting them up on single upturned palms.

To capture the greatness of the Kentucky cheerleaders, the magazine commissioned the Danish photographer Joachim Ladefoged, whose varied body of work includes photojournalism from Albania and Kosovo as well as images of bodybuilders. Ladefoged had the advantage of coming completely fresh to the American cheerleading milieu. "In Denmark, we don't have this kind of tradition," he says. "The guys are always throwing the girls in the air, and from the ground you don't see the guys' faces, because they look up all the time. I had to get around this problem by shooting down from a ladder. It was the only way to capture the faces and their concentration and at the same time completely fill the frame with flying bodies."

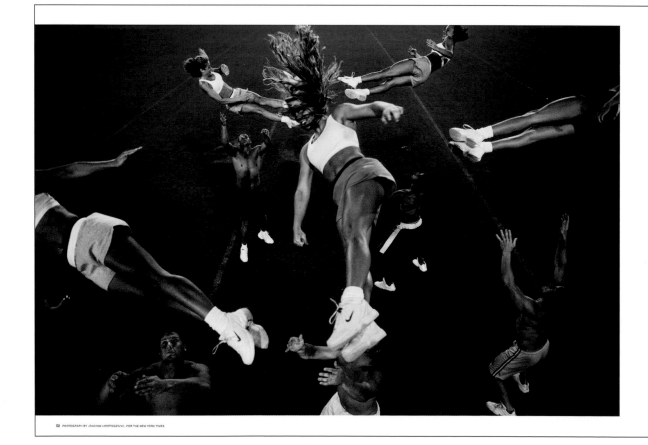

52 PHOTOGRAPH BY JOACHIM LADEFOGED/VII, FOR THE NEW YORK TIMES

041 ✱ THE NEW YORK TIMES MAGAZINE
Creative Director: Janet Froelich / *Art Director:* Arem Duplessis / *Designer:* Claudia DeAlmeida / *Director of Photography:* Kathy Ryan /
Photo Editor: Kathy Ryan / *Photographer:* Joachim Ladefoged / *Editor-In-Chief:* Gerald Marzorati / *Publisher:* The New York Times /
Issue: September 18, 2005 / *Category:* Photography Story

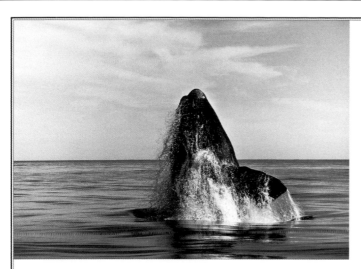

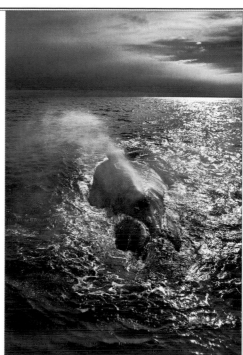

But if the young was bigger, the mother would let it play near the boat and would also approach herself, sometimes to a point where she would almost brush against the boat, with her head so close that we could have touched it with our hands.

When the whales would open their mouths wide, we could see the lateral plates of whalebone that they use to filter their food. (Contrary to popular belief, these whales are not meat-eating fish but mammals that feed on immense amounts of

Three centuries ago there were as many as 300,000 right whales in the seas. Today there are fewer than 3,000.

plankton and small marine crustaceans called krill.) Sometimes we would see a whale jumping out of the water—it's surely one of the most impressive sights in nature, to witness this huge creature weighing more than forty tons leaping toward the sky and splashing back into the water with a deafening sound that can be heard several miles away. No one knows why the whales jump. Some say it is to get rid of parasites or old skin; others say they jump to communicate with other whales. Whatever the explanation, I observed that when one whale jumped, others in the distance jumped shortly after. Some days almost all the whales would jump, even the young ones. At other times we would see a whale keeping still for several minutes, body unmoved, his enormous tail spread above the water like a huge sail, as if he wanted the wind to push him. Then he would suddenly strike his tail down onto the water with an immense strength and noise, as if he were momentarily infuriated.

Once, as we were eating lunch a little distance off the coast, we saw an enormous whale swimming toward us at full speed with her young alongside her. "Here come visitors," said Diego, the captain of the boat. But when the whales were about fifteen feet away, Diego leapt up in alarm. "They're swimming in their sleep!" he yelled. "They'll

THE WEEKS I SPENT IN PROXIMITY AND CONVIVIALITY WITH the right whales of Peninsula Valdés, off the Patagonian coast of Argentina, were the most complete and intense of my existence. We would leave in the early hours of the morning, as light was first starting to appear, and would spend the entire day at sea. As soon as we would move a short distance away from the coast and cut the engine of our small wooden boat, the whales would approach, exhibiting a curiosity about us as deep as the one we have for them. First a young one would move toward the engine at the rear, perhaps to find the origin of the noise, which without a doubt disturbed it considerably. Then the mother would arrive. If the young was still a baby, the mother would push it to follow her.

PREVIOUS PAGE: The tail of a right whale points toward the sky, leaving the fifty-foot-long animal suspended vertically beneath the water's surface. Salgado calls the spectacle one of the most beautiful in Peninsula Valdés. "Some say that the whales use their tails as a sail, as if to be pushed and directed by the wind," he says. **ABOVE:** A whale erupts out of the calm waters off the coast of Patagonia. "A mass of forty tons comes out of the ocean through an enormous whirl of foaming water," Salgado says. "As it falls, it causes a deafening sound that can be heard miles away."

As dawn breaks over the Atlantic, a whale releases a cloud of mist from its blowhole. "Whales are so huge," says Salgado, comparing it to prehistoric animals. "The body of the whale is impressive. The adults are up to sixty feet long and weigh as much as fifty tons. When you have them in front of you, you feel the power of life." Up close, you can see hair on their faces. "It is said that, 40 to 50 million years ago, the ancestors of these whales lived on land," Salgado says. "With time, metamorphosis occurred. The hind legs disappeared, the forelimbs became flippers, the head got larger and most of the hair vanished."

ROLLING STONE, FEBRUARY 10, 2005

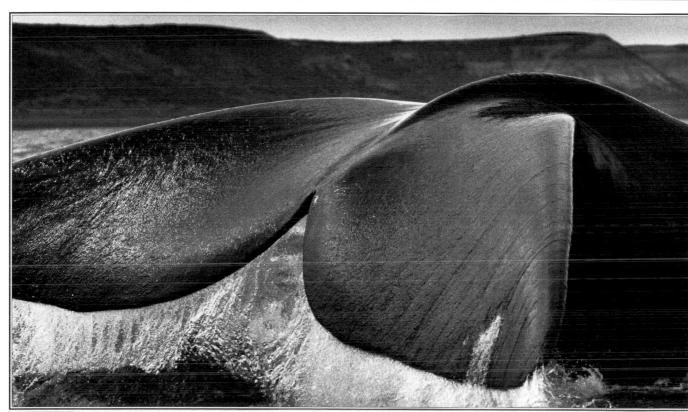

ROLLING STONE, FEBRUARY 10, 2005

042 �֍ ROLLING STONE

Art Director: Amid Capeci / *Director of Photography:* Jodi Peckman / *Photographer:* Sebastião Salgado / *Publisher:* Wenner Media / *Issue:* February 10, 2005 / *Category:* Photography Story

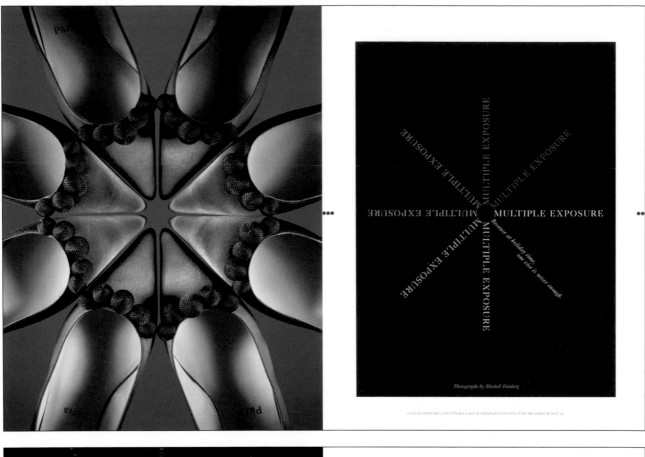

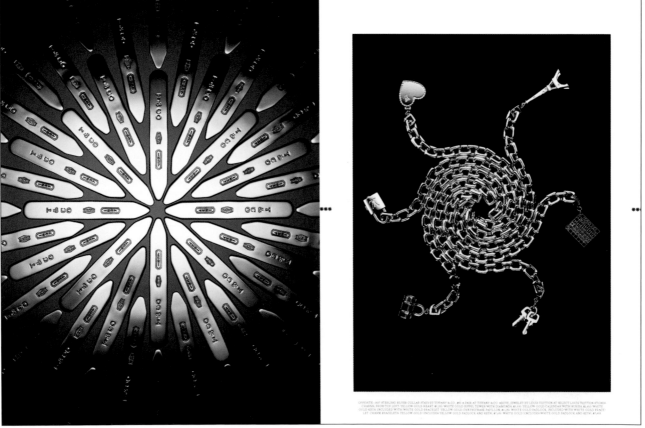

043 �֎ ABSOLUTE NEW YORK
Creative Director: Michael Grossman / *Design Director:* Deanna Lowe / *Designers:* Deanna Lowe,
Jessica Erixon / *Director of Photography:* Catherine Talese / *Associate Photo Editor:* Hali Tara Feldman /
Photographer: Mitchell Feinberg / *Editor-In-Chief:* Andrew Essex / *Publisher:* Absolute Publishing /
Issue: Winter 2005 / *Category:* Photography Story

SPECIAL
REPORT

what
no one
is telling
you
about
identity
theft

1 The thieves aren't who you think.
2 Your data can never be fully safe.
3 But ID theft can be stopped once and for all. Here's how.

ON A SUNNY MAY MORNING ON CAPITOL HILL, power suits were hard at work spinning members of Congress. There to testify were representatives of the financial giant Visa and of data brokers Acxiom and Thomson West. You may not know those last two outfits, but they know you better than you could ever imagine. Both are part of an industry that gathers personal data about millions of Americans and sells it to lenders, retailers, employers, government agencies or other parties. The speakers delivered much the same message: Don't worry; we're committed to keeping you and your most sensitive information safe from cyberpredators.

"Visa aggressively protects the cardholder information of its members," lobbyist Oliver Ireland stated in his testimony. And here's Acxiom executive Jennifer Barrett: "We employ a world-class information-security staff to help us fend off criminals."

by Michael Sivy Pat Regnier and Carolyn Bigda

illustration by Daniel Bejar

011

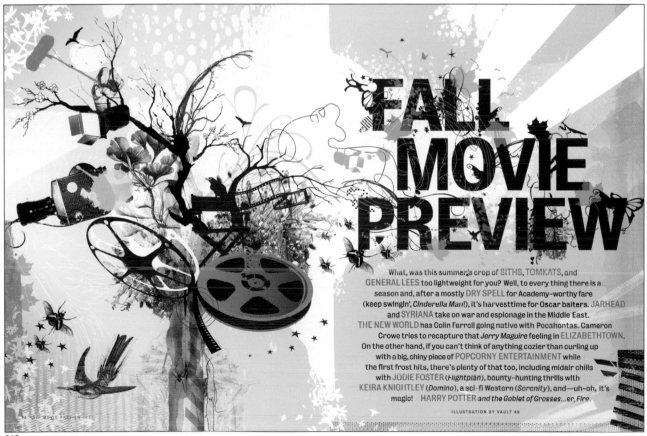

045

044 ✴ MONEY
Art Director: David Smith / *Designer:* Mary Ann Salvato / *Illustrator:* Daniel Bejar / *Publisher:* Time Inc. / *Issue:* July 2005 /
Category: Illustration Spread-Single Page

045 ✴ ENTERTAINMENT WEEKLY
Design Director: Geraldine Hessler / *Designer:* Brian Anstey / *Illustrator:* Vault 49 / *Director of Photography:* Fiona McDonagh /
Editor-In-Chief: Rick Tetzeli / *Publisher:* Time Inc. / *Issue:* August 19, 2005 / *Category:* Illustration Spread-Single Page

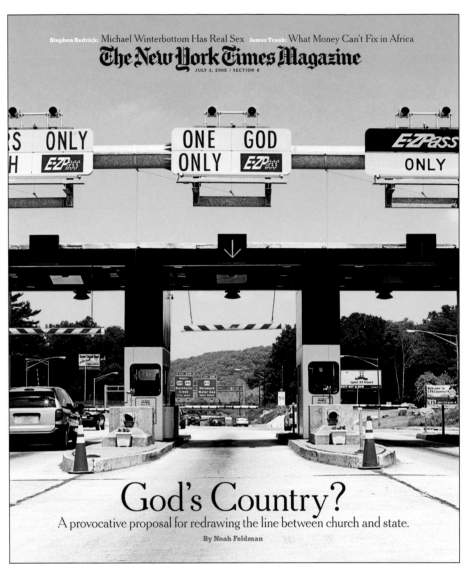

046 ✳ THE NEW YORK TIMES MAGAZINE
Creative Director: Janet Froelich / *Art Director:* Arem Duplessis /
Designer: Kristina DiMatteo / *Director of Photography:* Kathy Ryan /
Photo Editor: Cavan Farrell / *Photographers:* Jason Fulford, Statik
Digital / *Editor-In-Chief:* Gerald Marzorati / *Publisher:* The New York
Times / *Issue:* July 3, 2005 / *Category:* Photo-Illustration Story,
Spread-Single Page

*At the heart of the culture wars
is the failure of both sides
to accept America's rules for religious expression
in public life and public money in religious life.
Maybe that's because those rules are wrong.*

A Church-State Solution

BY NOAH FELDMAN

[I. THE EXPERIMENT]

For roughly 1,400 years, from the time the Roman Empire became Christian to the American Revolution, the question of church and state in the West always began with a simple assumption: the official religion of the state was the religion of its ruler. Sometimes the king fought the church for control of religious institutions; other times, the church claimed power over the state by asserting religious authority over the sovereign himself. But the central idea, formally enshrined at Westphalia in 1648 by the treaty that ended the wars of religion in Europe, was that each region would have its own religion, namely that of the sovereign. The rulers, meanwhile, manipulated religion to serve their own ends. Writing just before the American

Photomontages by Jason Fulford. Digital manipulation by Statik Digital.

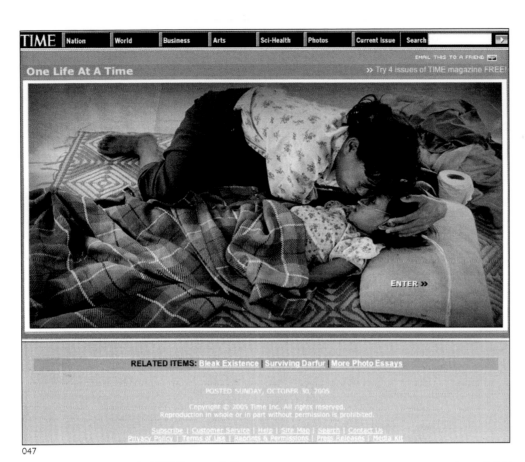

047

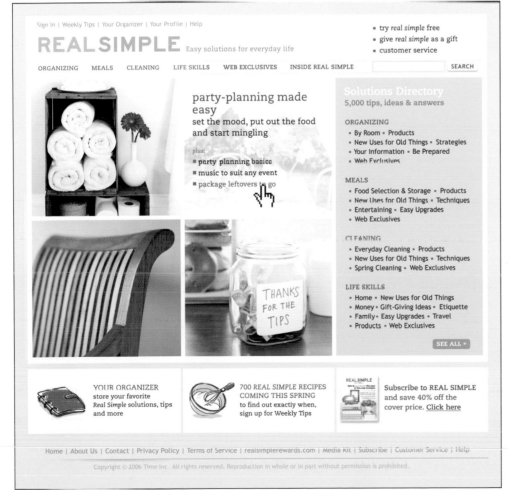

048

047 ✳ TIME.COM
Art Director: Garrett Rosso / *Senior Programmer:*
Catherine Shneick / *Illustrator:* Gregory Tomlinson /
Photo Editors: Maria S. Bunai, Samantha Harmon /
Photographer: James Nachtwey / *Editor-In-Chief:* Josh
Macht / *Publisher:* Time Inc. New Media / *Online Address:*
www.time.com/time/photoessays/james_nachtwey_global /
Category: New Media Online magazine associated with
a print publication

048 ✳ REAL SIMPLE
Creative Director: Lisa Michurski / *Design Director:* Dimitry
Paperny / *Designers:* Jeff Jouppi, Adam Berninger /
Interaction Deisgner: Erin Lynch / *Publisher:* Time Inc. /
Category: New Media Site Redesign

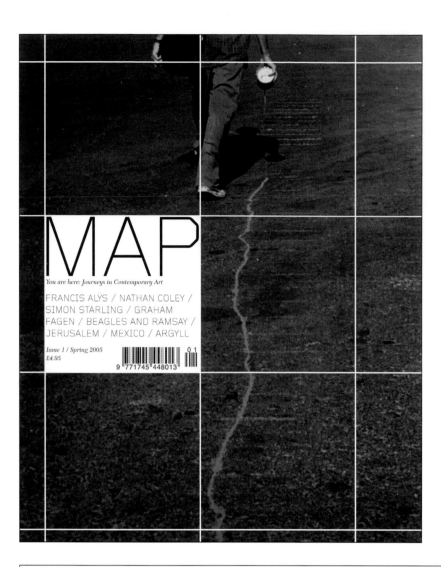

MAP

You are here: Journeys in Contemporary Art

FRANCIS ALŸS / NATHAN COLEY /
SIMON STARLING / GRAHAM
FAGEN / BEAGLES AND RAMSAY /
JERUSALEM / MEXICO / ARGYLL

Issue 1 / Spring 2005
£4.95

9 771745 448013

049 ✳ MAP
Creative Directors: Matt Willey, Zoe Bather / *Art Directors:* Matt Willey,
Zoe Bather, Matthew Ball / *Designer:* Matthew Ball / *Editor-In-Chief:* Alice Bain /
Publisher: MAP Magazine Limited / *Issues:* Spring 2005, Summer 2005, Fall 2005 /
Category: Design Magazine of the Year

REVIEW

the writing on which informed us that he had divinely received the gift of painting that very day. Amidst the sarcasm, Ashfaq's timely axiomatic observation was: although anyone can, few actually do.

Not to discuss the other artists involved in Urban Atlas (Lim Bull trouble-shooters Jim Ewen and Justin Orde, Charlie McCulloch, Duncan Hart and doctoral composer Bill Thompson) gives room to note that there appears now to be the chance in Aberdeen that artists of all media will actually do in response to UrbanNovember's exemplar and Ashfaq's particular rallying cries.

Crucially for this possibility, which even a simple exercise of psychogeography tells us, the city is not the familiar post-industrial case study waiting to be beneficently mapped out by cultures in the image of a blessed Newcastle, informed on the journey 'back up north' by the culture industries of Glasborough. Aberdeen's is an extant industrial-financial urban landscape being imaginatively explored and charted by the creative vigour of those artists who have resisted expatriation by recognising that the politicogeography of the city presents one of the remaining urban spaces in Scotland which can be work-lived according to the rambling lines of an artist's napkin map without the proprietary blueprint of culture managers or even insistent critics.

on the part of its willing host, Limousine Bull – too long a timid, hierarchical holding-centre for worried newly-grads; now a credible artists' group with a developing track record. For the first of the seven daily events, Eva Merz and Andy Dobson, as the New Social Art School, installed their invitingly hideous 'Tribute to the Monkey' – a disgusting variation on that instrument of juvenile management which is the games console, bovine controllers lay in front of a smashed VDU, the corporeality of the abattoir brutalising the duh-reality of the computer game world. This piece and its complementary video – a recording of the public flogging of the television set – served as non-site access points to Merz and Dobson's room-the-toon critical drifting.

Peter Troxler made a direct, deferential link to Situationism with 'Sous les Pavés', an unearthing of Aberdeen's original master-mapping. The utopian vision once harboured for the 'Garden City of Torry' functioned as touchstone for the deadening nowhere/everywhere spaces of Aberdeen's retail megaplexes as well as for today's Torry. Too much attention to theoretical mapping, Troxler evidenced, generates hopelessly hopeful civic administration, which, in turn, indefinitely deters promised urbanlands, bringing about instead substitutive social limbo zones.

Commendably impatient Gas Ashfaq showed guerilla tendency by spray-stencilling his Beuyslanesque declaration, 'I heard someone say that anyone can do what I am doing; that's the whole point, I am just anyone after all'. This he did adjacent to his miniature graffitied wall.

Ken Neil is a critic, artist and director of the MFA Course at Gray's School of Art

*Limousine Bull
23 - 30 Nov 2004*

Above left: 'Tribute to the Monkey', New Social Art School, Eva Merz and Andy Dobson, 2004

Camilla Løw
London

Modernist abstraction meant the reduction of visible elements in an object. This process of simplification was further pursued by conceptual art, in which material presence had to be reconstructed mentally, through language. Camilla Løw folds a conceptualist method back into the history of abstraction. In the past few years the young Norwegian has drawn notice for her leaning and suspended sculptures - geometric pictures with no plane that give the impression of stumbling into a three-dimensional Kandinsky.

In the Glasgow-based artist's first show in London, she retraces 20th-century developments in art through compositions that stand midway between painting and sculpture. Focusing on the role and constitution of the object, her strategy seems to lean towards the rigorous formalist principles of modernist godfathers such as Clive Bell but in reality, it follows less conventional schemes. She expands her former style to intoxicate the purist views of abstract modernism and, tricking such mannerisms with their own means, suggests a DIY attempt to open visual perception with a group of static objects that, whether hanging or free-standing, precariously rise upright. These mainly consist of painted wooden sticks assembled in long and lean rectangular shapes of varying scale and format.

'Viva' (2004) seems to have a go at Scandinavian domestic furniture although its shape is perhaps more reminiscent of a handcrafted necklace tumbling down onto the floor. In both 'Lectro' and 'Magneto' (2004), a silhouette is interrupted while floating on the bare architecture of the gallery, which acts as backdrop to intensify the lightness of their design and brilliancy of the palette. In 'Xerox' (2004) a pair of lozenges show the same structure and format apart from a detail: the most external segment has migrated from the black to the bright yellow, made of Perspex, and vice versa. The plot repeats.

All these are clearly reminiscent of De Stijl and Concrete Art but they also intuitively consider the fact that now, there are no mysteries about the object anymore and that quotation has worn down modernism. Yet no direct recycling of sources appears in this exhibition. What can be perceived instead is Løw's inspiration from pioneering ideas by artists as different as the British sculptor Henry Moore with his concept of the hole having equal status to solid mass and the American conceptualist Robert Barry's interest in the void and emptiness as the most potent things in the world. In this sense she shares the same commitment to her style as the Swiss artist John Armleder did to Neo-Geo, when he started making para-Suprematist paintings that sardonically demystified Theo van Doesburg's straight lines. But differently from the 1980's appropriationist for whom surface was all, the young artist wises up to the concealed aspects behind abstract objects.

According to the Czech philosopher Vilém Flusser, the word 'design' occurs in contexts associated with cunning and deceit: beyond the creation of harmonious graphic effects, all the works at Sutton Lane erupt with a claustrophobic sense of gravity eclipsing symbiotic relations in art and life. Neither discoveries nor inventions but containers for feeling, Løw's sculptures pervert the idealism implied in their vertical and diagonal orientations, their total perspective in which lines meet through space, and their basic colours, as in the case of an oily, glossy black varnish alternating with bright blue, green and yellow as 'impure' as the tones of poison. In evidence that the heroic and orderly systems of 20th century abstraction have now expired in contemporary artists' appreciation for electronic music and movie culture, one is left with signs of grace and the desire to wait for magic ciphers of things to come.

Diana Baldon is an Italian freelance curator working in London

*Sutton Lane
26 Nov - 21 Dec 2004*

*Left: Installation, Camilla Løw, 2004
Above right: 'Dancing in Peckham',
Gillian Wearing, 1994*

REVIEW

Faces in the Crowd:
Picturing Modern Life from Manet to Today
London

Faces in the Crowd sets out to uncover one of the repressed themes of modernism, allegedly eclipsed by its tendency to privilege abstraction. The show opens with Manet's 'Masked Ball at the Opera' (1873) - a neat rendering of the bourgeoisie crowd at play - followed by Umberto Boccioni's 'The City Rises' (1910) in which the crowd's pace and presence begins to affect the way it is rendered by the artist - all blurs and brushstrokes. Turn the corner and the theme develops and expands, as the exhilarating psychological tale of the individual in the crowd becomes the focus in works such as James Ensor's 'Death and the Masks' (1897). Ensor's painting takes the subject matter of Manet's - the masked character relishing the anonymity of the crowd - and transforms it into one of terror. This theme is echoed later in archetypal works from the 1950s by Francis Bacon. In these, the subject is completely unmasked and isolated. Between these two themes, the crowd as a revolutionary force takes centre stage in the propaganda poster and magazine works of Aleksandr Rodchenko and John Heartfield. In Rodchenko's 'Five Year Plan' (1932) the crowd is uplifted and brought into unison by its communist leader. Heartfield's 'Dr Goebbels, the Future Healer' (1934) on the other hand, pictures the crowd forced to its knees by a Nazi dictator.

The everyday crowd as epic continues in photographs by Americans Robert Capa and Walker Evans, both of whom examine the plight of the individual within a capitalist economy. Evans' 'Subway Portraits' (1938-41) isolates each subject from his immediate environment. He is lost.

Upstairs, the gallery layout is more open. Works can be cross-referenced more easily. The cabinet picture of the turn of the 19th century makes way for the late 20th century installation. The result is a fluid space, easily slipped through, full of work which echoes earlier themes, such as the way gender holds up against a variety of metropolitan backdrops and scenery. So, the startled women in Cindy Sherman's 'Untitled Film Stills' (1980) play off against their mole counterparts in Richard Prince's 'Untitled, the Same Man Looking in Different Directions', (1978) while also evoking Claude Cahun's self-portraits hanging downstairs and anticipating Nan Goldin's 'Joey on the Balcony, Hotel Ritz, Paris' (2001) further on.

The exhibition's premise that figurative representation is crucial to the representation of modern life is misleading, as modernist abstraction too was concerned with representing the individual and society, albeit through the use of a complex set of codes and indexical signs. Broad historical and theoretical disagreements about abstract versus figurative aside, this is a strong exhibition and a considerable feat in the art of gathering work together for a small institution like the Whitechapel. Perhaps Prince's work best sums up the exhibition's central theme. An unusual choice, but consider how Prince's photographs show a unique response to the city and yet are borrowed representations being photographs taken from advertisements. And here lies the fulcrum of Faces in the Crowd: where the modern subject of the individual in the city becomes a postmodern representation of itself—a cipher, a sort of abstraction. Prince's photographs clarify how postmodernism established multiple points of continuity with modernism and in so doing brought forward previously neglected trends from within it – the representation of the figure in the crowd being chief amongst them.

Alex Coles is the author of DesignArt forthcoming from Tate Publishing

*Whitechapel Art Gallery
3 Dec 2004 - 6 Mar 2005*

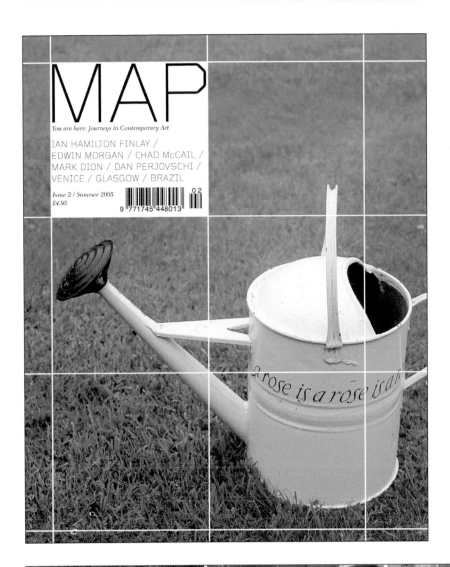

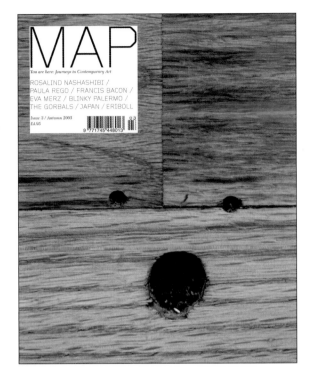

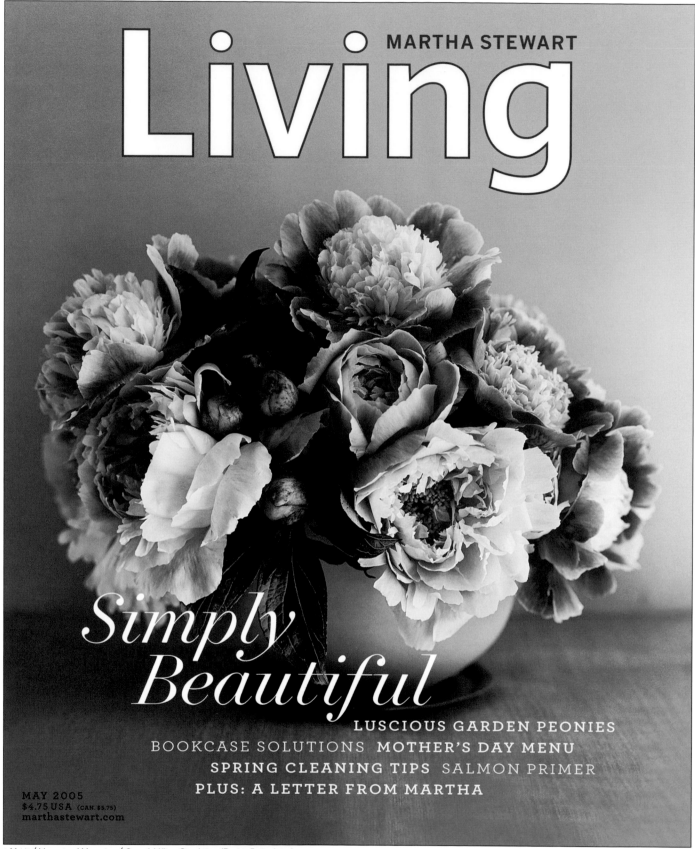

MARTHA STEWART

Living

Simply Beautiful

LUSCIOUS GARDEN PEONIES

BOOKCASE SOLUTIONS MOTHER'S DAY MENU

SPRING CLEANING TIPS SALMON PRIMER

PLUS: A LETTER FROM MARTHA

MAY 2005
$4.75 USA (CAN. $5.75)
marthastewart.com

+ Merit / Newsstand Magazine / Over 1 Million Circulation (Design Entire Issue)

050 ✻ MARTHA STEWART LIVING
Creative Director: Eric Pike / *Art Directors:* James Dunlinson, Joele Cuyler / *Designers:* Mary Jane Callister, Matthew Axe, Cybele Grandjean, Amber Blakesley,
Abdai, Stephen Johnson, Cameron King / *Photo Editors:* Heloise Goodman, Andrea Bakacs / *Photographers:* William Abranowicz, Gentl + Hyers, Lisa Hubbard,
David Meredith, Maria Robledo, Dana Gallagher, Jeff Mermelstein, Victoria Pearson, Sang An, Jose Picayo, Con Poulso, Anna Williams / *Style Director:*
Ayesha Patel / *Editor-In-Chief:* Margaret Roach / *Publisher:* Martha Stewart Living Omnimedia / *Issues:* May 2005, October 2005, November 2005 /
Category: Design Magazine of the Year

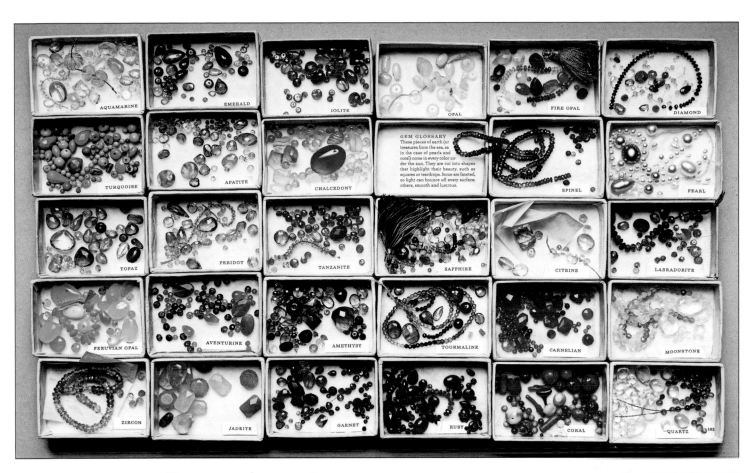

GEM GLOSSARY
These pieces of earth (or treasures from the sea, as in the case of pearls and coral) come in every color under the sun. They are cut into shapes that highlight their beauty, such as squares or teardrops. Some are faceted, so light can bounce off every surface; others, smooth and lustrous.

Menu: PERFECT ROAST TURKEY · CHESTNUT STUFFING · GRAVY · TARRAGON GREEN BEANS · BRUSSELS SPROUTS WITH LEMON AND WALNUTS · TWICE-BAKED SWEET POTATOES · CRANBERRY-ORANGE SAUCE · MASHED POTATOES · CLASSIC PUMPKIN PIE · OLD-FASHIONED APPLE PIE

Thanksgiving 101

IN MOST FAMILIES, THERE'S NO DIVERGING FROM THE CLASSIC MENU: TURKEY AND ALL THE TRIMMINGS. And thank goodness. With many of the beloved foods gracing the table just once a year, replacing them with newfangled creations would surely disappoint. Indeed, the biggest crowd-pleasers are often the standards that have been emerging from the family kitchen for generations.

Embracing the idea of household favorites, we asked our food editors which dishes they cherish most, and let their answers inspire the quintessential Thanksgiving meal. Our menu is meant to be adaptable: Prepare it entirely or choose individual recipes, weaving them into your customary spread.

All of the dishes you no doubt know, but perhaps never made quite so assuredly. As any cook will admit, getting every Thanksgiving dish to the table at once is an exercise in master planning: knowing which elements can be prepared days before the first guest arrives and which can be finished on the stove while the bird roasts in the oven. Following a schedule (ours is on page 155) is a tried-and-true method for managing the feast.

Our recipes, too, rely on time-honored techniques. Brined to retain moisture, then basted with butter and wine while roasting, the turkey, the meal's centerpiece, is golden and juicy. Then there are those trimmings. For intense depth of flavor, the gravy is made from roasted giblets and a golden-brown roux. The stuffing. (continued on page 155)

A FEAST UNFOLDS *Thanksgiving dinner is rich in tradition and still capable of inspiring wonder. The sentiment can go to place settings, too. OPPOSITE: An ear of dried corn is steamed until the husks are pliable; warm husks are curled back to expose the kernels. A guest's name is written with a calligraphy nib dipped in gouache (for the how-to, see page 99).*

PHOTOGRAPHS BY MARIA ROBLEDO · TEXT BY MELISSA CLARK

181

REAL SIMPLE

| life made easier |

50 gifts under $50:
one-of-a-kind finds to make everyone happy

The best ways to treat colds and flu

Make any beauty treatment last longer

The no-hassle wrapping solution

INSIDE
pull-out guide to
3 EASY HOLIDAY PARTIES

051 ✳ REAL SIMPLE
Creative Director: Vanessa Holden / *Art Directors:* Eva Spring, Ellene Wundrock / *Designers:* Philip Ficks, Erin Whelan, Tracy Walsh, Grace Koo, Nia Lawrence /
Illustrators: Matthew Sporzynski, Leigh Wells, MK Mabry, Greg Clarke, Jason Lee / *Photo Editors:* Naomi Nista, Lauren Epstein, Susan Phear, Annemarie Castro,
Daisy Cajas / *Photographers:* Sang An, Monica Buck, Susie Cushner, John Dolan, Kana Okada, Bill Phelps, Ellen Silverman, Amy Neunsinger, Anonis Achilleas,
Anna Williams / *Publisher:* Time Inc. / *Issues:* September 2005, November 2005, December 2005-January 2006 / *Category:* Design Magazine of the Year

STIR CRAZY

A single pan and a simple cooking method are all that separate you from countless quick, healthy, sizzling meals

Stir-frying is more than a technique—it's a weeknight strategy. It's an approach to dinner that's simple, fast, healthy, and endlessly variable when you mix and match meat, vegetables, and sauces. All you have to do is follow three easy steps: Chop the ingredients, make the sauce, and bring everything together in a pan. (And you don't even need to own a wok—any large skillet will do.)

TEXT AND RECIPES BY **NINA SIMOND** PHOTOGRAPHS BY **ANNA WILLIAMS** PROP STYLING BY **MICHELE MICHAEL**

266

Slow Down

Taking life at a more leisurely pace can improve your memory, your health, and your creativity. Take a deep breath—and learn the benefits of exiting the fast lane.

Sure, it would be nice to loll in bed for a few extra minutes in the morning. To linger over coffee after lunch. To enjoy a relaxed dinner, then amble around the neighborhood. But who has time? With work and family demands, most people barely have a second to slow down, let alone come to a full stop.

Maybe now is the moment to put on the brakes. More and more, researchers and psychologists, backed by a growing body of evidence, say that the accelerating pace of society is hurting our health. In fact, it may be taking years off our lives. "We pay an enormous price in both health and happiness for living in a sped-up world," says psychiatrist Jeffrey Brantley, director of the Mindfulness-Based Stress Reduction Program at the Duke Center for Integrative Medicine, in Durham, North Carolina.

Finding time to think, daydream, or simply watch the world go by, the experts say, is important for a healthy mind and body. "A balanced life is one that has room for

WRITTEN BY **PETER JARET**
PHOTOGRAPHS BY **SUSIE CUSHNER**

286 287

+ Merit / Newsstand Magazine / 500,000 to 1 Million Circulation (Design Spread-Single Page)

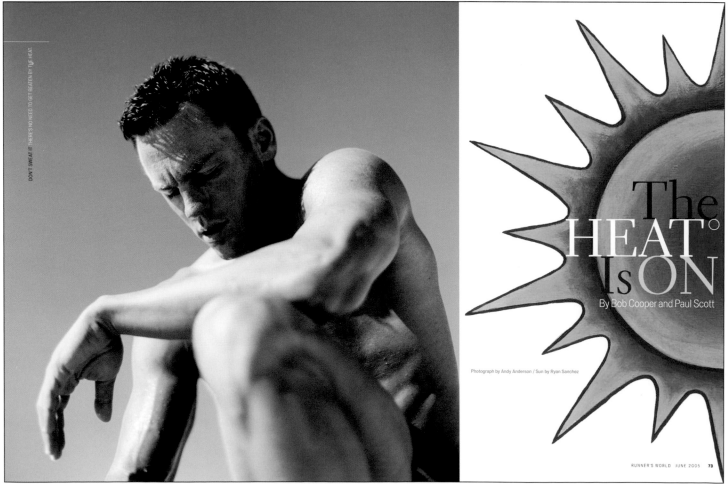

+ Merit / Newsstand Magazine / 500,000 to 1 Million Circulation (Design Spread-Single Page)

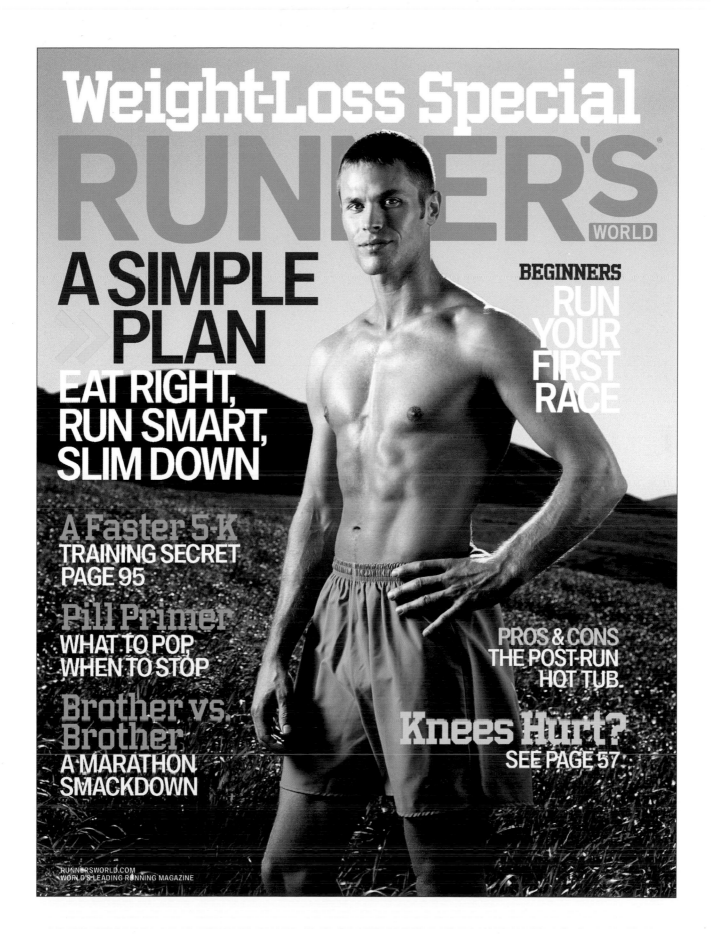

Weight-Loss Special

RUNNER'S
WORLD

A SIMPLE ›› PLAN

EAT RIGHT, RUN SMART, SLIM DOWN

BEGINNERS
RUN YOUR FIRST RACE

A Faster 5-K
TRAINING SECRET
PAGE 95

Pill Primer
WHAT TO POP
WHEN TO STOP

Brother vs. Brother
A MARATHON SMACKDOWN

PROS & CONS
THE POST-RUN
HOT TUB.

Knees Hurt?
SEE PAGE 57

RUNNERSWORLD.COM
WORLD'S LEADING RUNNING MAGAZINE

052 ✳ RUNNER'S WORLD
Design Director: Robert Festino / *Designers:* Robert Festino, Eric Paul, Erin Ploskonka, Michael Cundari / *Illustrator:* Joe Ciardiello /
Photo Editors: Don Kinsella, Michele Ervin / *Photographers:* Andy Anderson, Patrik Giardino, Dave Nagel, Jay Baker, Dylan Coutler,
Mark Weiss, Jens Morrtensen / *Publisher:* Rodale / *Issues:* April 2005, June 2005, August 2005 / *Category:* Design Magazine of the Year

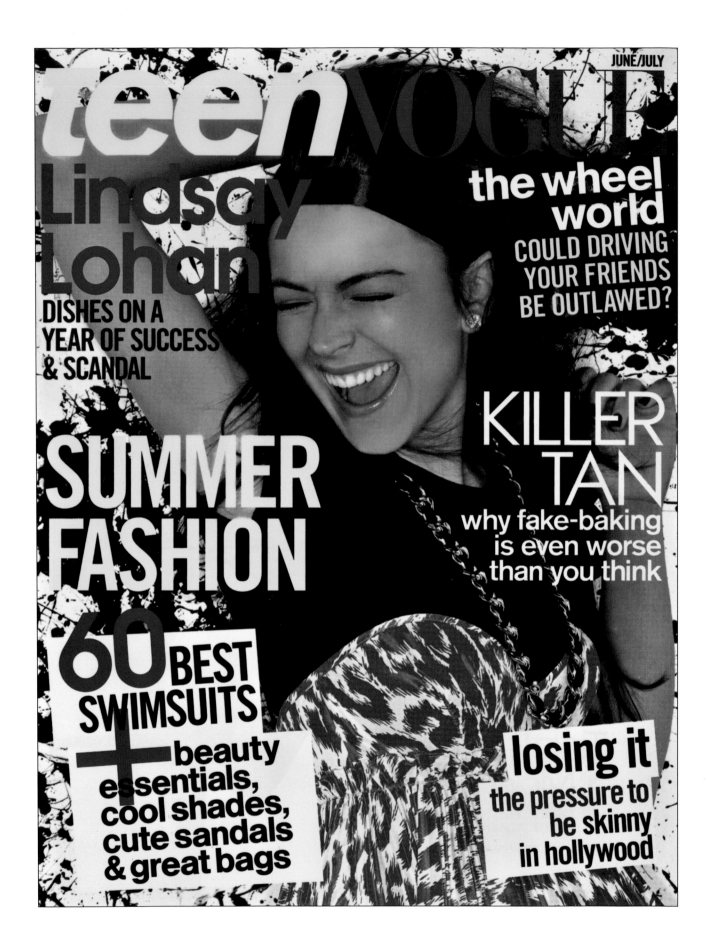

JUNE/JULY

*teen*VOGUE

Lindsay Lohan

DISHES ON A
YEAR OF SUCCESS
& SCANDAL

the wheel
world
COULD DRIVING
YOUR FRIENDS
BE OUTLAWED?

SUMMER
FASHION

KILLER
TAN
why fake-baking
is even worse
than you think

60 BEST
SWIMSUITS
+beauty
essentials,
cool shades,
cute sandals
& great bags

losing it
the pressure to
be skinny
in hollywood

053 ✳ *TEEN VOGUE*
Creative Director: Lina Kutsovskaya / *Art Director:* Kathleen McGowan / *Designers:* Jason Engdahl, Holly Stevenson, Maggie Boroujerdi /
Photo Editors: Lucy Lee, Jillian Johnson, Ashley Galloway / *Photographers:* Patrick Demarchelier, Mario Testino, Frederike Helwig, Nick Haymes,
Raymond Meier, Thomas Schenk, Michael Baumgartner, Ben Hassett, Daniel Gabbay / *Publisher:* Condé Nast Publications Inc. /
Issues: June-July 2005, August 2005, September 2005 / *Category:* Design Magazine of the Year

TRIPLE PLAY
FROM LEFT, AGNES WEARS
A CK CHOICE CALVIN KLEIN
STRIPED TUBE TOP, ABOUT
$48. CORDULLA WEARS A
LACOSTE BIKINI, ABOUT
$125. SALLY WEARS A ROXY
TRIANGLE TOP, ABOUT
$40. GIRLPROPS.COM
NECKLACE. DETAILS, SEE IN
THIS ISSUE.
FASHION EDITOR:
HAVANA LAFFITTE.

summer land

Channel the
bathing beauties
of decades past
in retro, girly suits
and cover-ups.
Photographed by
Nick Haymes.

160 WWW.TEENVOGUE.COM JUNE/JULY 2005

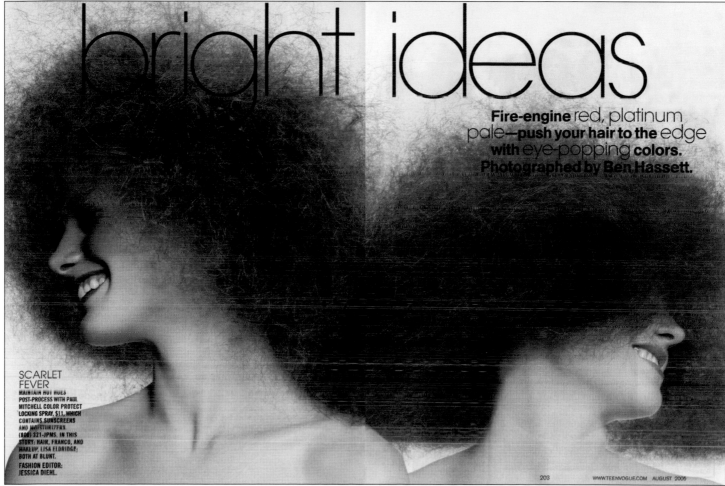

bright ideas

Fire-engine red, platinum
pale—push your hair to the edge
with eye-popping colors.
Photographed by Ben Hassett.

SCARLET
FEVER
MAINTAIN HOT HUES
POST-PROCESS WITH PAUL
MITCHELL COLOR PROTECT
LOCKING SPRAY, $11, WHICH
CONTAINS SUNSCREENS
AND MOISTURIZERS.
(800) 321-JPMS. IN THIS
STORY: HAIR, FRANCO, AND
MAKEUP, LISA ELDRIDGE;
BOTH AT BLUNT.
FASHION EDITOR:
JESSICA DIEHL.

203 WWW.TEENVOGUE.COM AUGUST 2005

MERIT

NEWSSTAND

MAGAZINE

OVER 1 MILLION

CIRCULATION

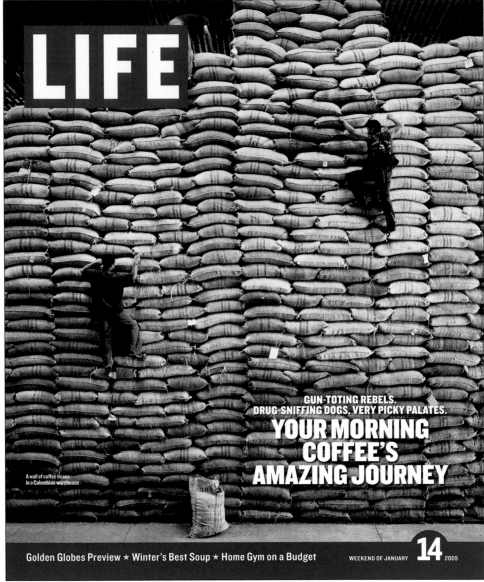

054 + Merit / Newsstand Magazine (Photography Cover)

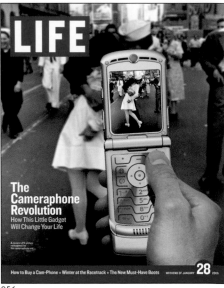

055

056

054 ✷ LIFE
Creative Director: Richard Baker / *Art Director:* Bess Wong / *Designers:* Marina Drukman, Jarred Ford / *Director of Photography:* George Pitts / *Photo Editors:* Crary Pullen, Tracy Doyle Bales, Caroline Smith / *Publisher:* Time Inc. / *Issue:* January 14, 2005 / *Category:* Design Cover

055 ✷ LIFE
Creative Director: Richard Baker / *Art Director:* Bess Wong / *Designers:* Marina Drukman, Jarred Ford / *Director of Photography:* George Pitts / *Photo Editors:* Crary Pullen, Tracy Doyle Bales, Caroline Smith / *Publisher:* Time Inc. / *Issue:* September 30, 2005 / *Category:* Design Cover

056 ✷ LIFE
Creative Director: Richard Baker / *Art Director:* Bess Wong / *Designers:* Marina Drukman, Jarred Ford / *Director of Photography:* George Pitts / *Photo Editors:* Crary Pullen, Tracy Doyle Bales, Caroline Smith / *Publisher:* Time Inc. / *Issue:* January 28, 2005 / *Category:* Design Cover

057 ✷ GOURMET
Creative Director: Richard Ferretti / *Art Director:* Erika Oliveira / *Photo Editor:* Amy Koblenzer / *Photographer:* Martyn Thompson / *Publisher:* Condé Nast Publications, Inc. / *Issue:* May 2005 / *Category:* Design Cover

058 ✷ GOURMET
Creative Director: Richard Ferretti / *Photo Editor:* Amy Koblenzer / *Photographer:* John Midgley / *Publisher:* Condé Nast Publications, Inc. / *Issue:* October 2005 / *Category:* Design Cover

059 ✷ CHICAGO TRIBUNE MAGAZINE
Art Directors: Joseph Darrow, David Syrek / *Illustrator:* John Hersey / *Publisher:* Chicago Tribune Company / *Issue:* December 4, 2005 / *Category:* Design Cover

060 ✷ ENTERTAINMENT WEEKLY
Design Director: Geraldine Hessler / *Designer:* Geraldine Hessler / *Director of Photography:* Fiona McDonagh / *Publisher:* Time Inc. / *Issue:* December 23, 2005 / *Category:* Design Cover

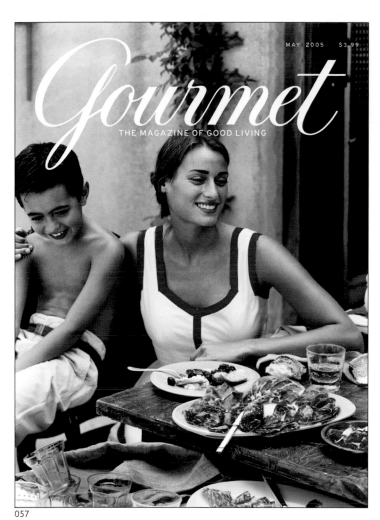

057

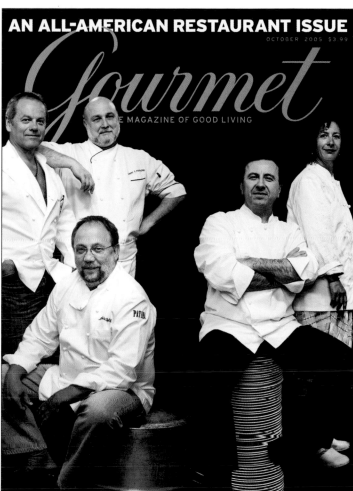

058

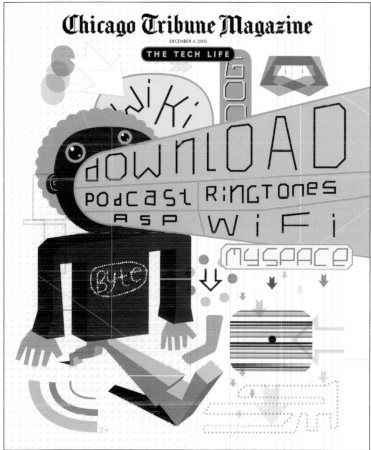

059

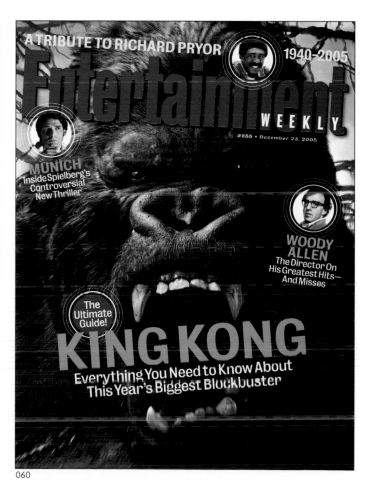

060

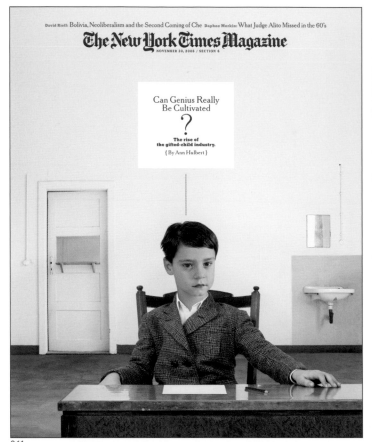

061

062

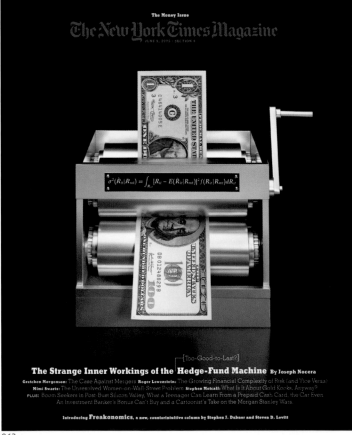

063

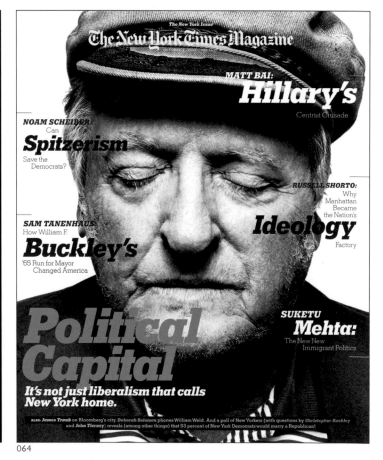

064

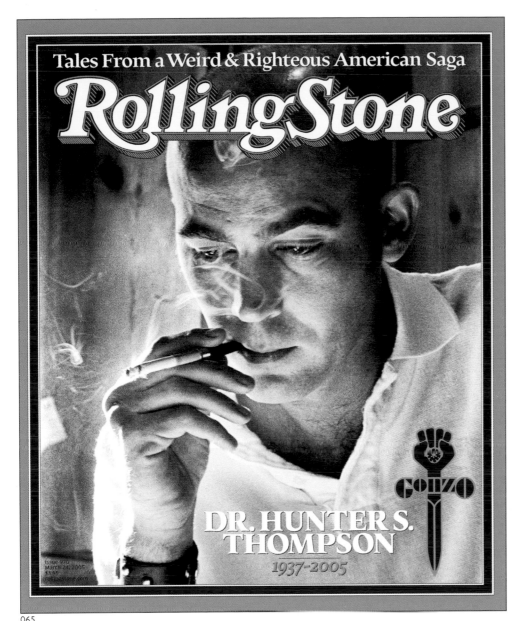

065

066

067

061 ✴ THE NEW YORK TIMES MAGAZINE
Creative Director: Janet Froelich / *Art Director:* Arem Duplessis / *Designer:* Nancy Harris Rouemy / *Photo Editor:* Kathy Ryan / *Photographer:* Loretta Lux / *Publisher:* The New York Times / *Issue:* November 20, 2005 / *Category:* Design Cover

062 ✴ THE NEW YORK TIMES MAGAZINE
Creative Director: Janet Froelich / *Art Director:* Arem Duplessis / *Designer:* Nancy Harris Rouemy / *Publisher:* The New York Times / *Issue:* January 2, 2005 / *Category:* Design Cover

063 ✴ THE NEW YORK TIMES MAGAZINE
Creative Director: Janet Froelich / *Art Director:* Arem Duplessis / *Designer:* Catherine Gilmore-Barnes / *Photo Editor:* Kathy Ryan / *Photographer:* Bela Borsodi / *Publisher:* The New York Times / *Issue:* June 5, 2005 / *Category:* Design Cover

064 ✴ THE NEW YORK TIMES MAGAZINE
Creative Director: Janet Froelich / *Art Director:* Arem Duplessis / *Designer:* Jeff Glendenning / *Photo Editor:* Kathy Ryan / *Photographer:* Platon / *Publisher:* The New York Times / *Issue:* October 2, 2005 / *Category:* Design Cover

065 ✴ ROLLING STONE
Art Director: Amid Capeci / *Designer:* Amid Capeci / *Photo Editor:* Jodi Peckman / *Photographer:* David Hiser / *Publisher:* Wenner Media / *Issue:* March 24, 2005 / *Category:* Design Cover

066 ✴ SPORTS ILLUSTRATED
Creative Director: Steve Hoffman / *Art Director:* Chris Hercik / *Director of Photography:* Steve Fine / *Photographer:* Stephen Wilkes / *Inset Photo:* Damian Strohmeyer / *Publisher:* Time Inc. / *Issue:* March 28, 2005 / *Category:* Design Cover

067 ✴ SPORTS ILLUSTRATED
Creative Director: Steve Hoffman / *Art Director:* Chris Hercik / *Director of Photography:* Steve Fine / *Photographer:* Chuck Solomon / *Publisher:* Time Inc. / *Issue:* May 30, 2005 / *Category:* Design Cover

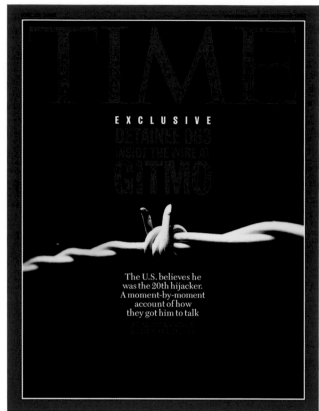

068

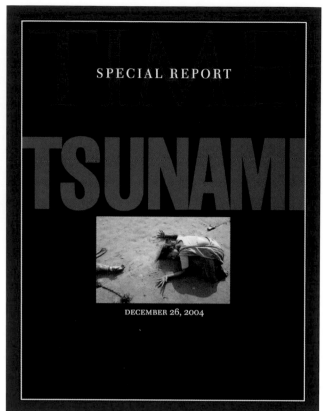

069

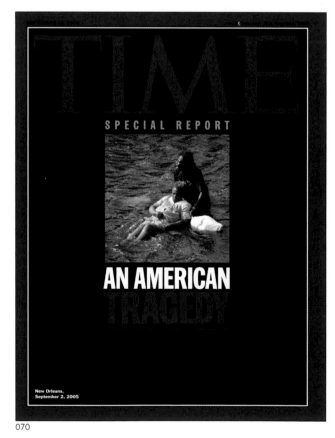

070

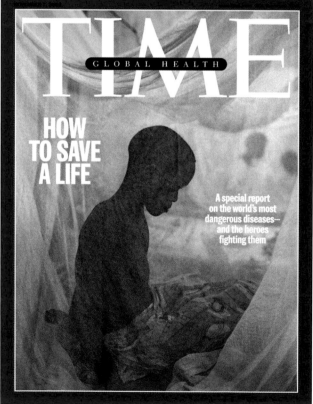

071

068 ✳ TIME
Art Director: Arthur Hochstein / *Director of Photography:* Michele Stephenson /
Photo Editor: MaryAnne Golon / *Photographer:* David Moore / *Publisher:* Time Inc. /
Issue: June 20, 2005 / *Category:* Design Cover

069 ✳ TIME
Design Director: Arthur Hochstein / *Art Director:* Cynthia A. Hoffman / *Director of
Photography:* Michele Stephenson / *Photo Editor:* MaryAnne Golon / *Associate Picture
Editor:* Alice Gabriner / *Photographer:* Arko Datta (Reuters) / *Publisher:* Time Inc. /
Issue: January 10, 2005 / *Category:* Design Cover

070 ✳ TIME
Art Director: Arthur Hochstein / *Director of Photography:* Michele Stephenson /
Photo Editor: MaryAnne Golon / *Photographer:* Kathleen Flynn / *Publisher:* Time Inc. /
Issue: September 12, 2005 / *Category:* Design Cover

071 ✳ TIME
Art Director: Arthur Hochstein / *Director of Photography:* Michele Stephenson /
Photo Editor: MaryAnne Golon / *Photographer:* James Nachtwey / *Publisher:* Time Inc. /
Issue: November 7, 2005 / *Category:* Design Cover

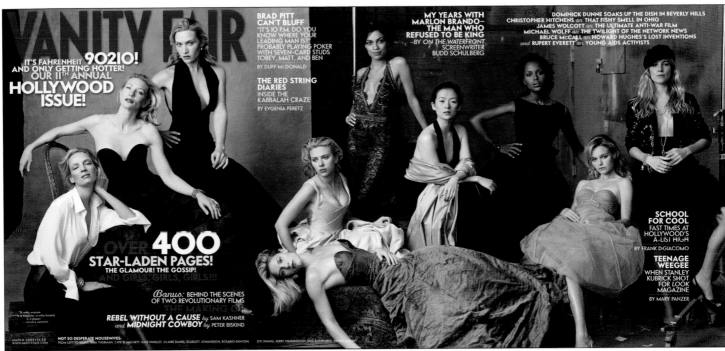

072 + Merit / Newsstand Magazine (Photography Cover)

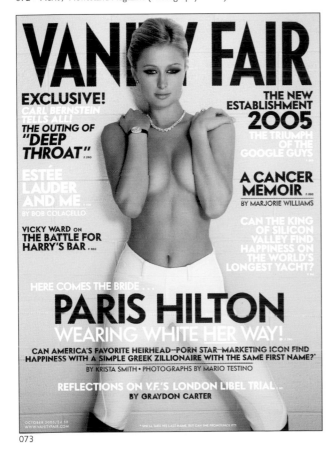

073

071

072 ✳ VANITY FAIR

Design Director: David Harris / Art Director: Julie Weiss / Designer: Chris Mueller / Director of Photography: Susan White / Photo Editors: Lisa Berman, Kathryn MacLeod / Photographer: Annie Leibovitz / Publisher: Condé Nast Publications Inc. / Issue: March 2005 / Category: Design Cover

073 ✳ VANITY FAIR

Design Director: David Harris / Art Director: Julie Weiss / Designer: Chris Mueller / Director of Photography: Susan White / Photo Editors: Lisa Berman, SunHee Grinnell / Photographer: Mario Testino / Publisher: Condé Nast Publications Inc. / Issue: October 2005 / Category: Design Cover

074 ✳ USA WEEKEND

Creative Director: Casey Shaw / Design Director: Leon Lawrence III / Designer: Leon Lawrence III / Illustrator: Saundra Gerling / Photo Editor: David Baratz / Publisher: Gannett Co. / Issue: November 6, 2005 / Category: Design Cover

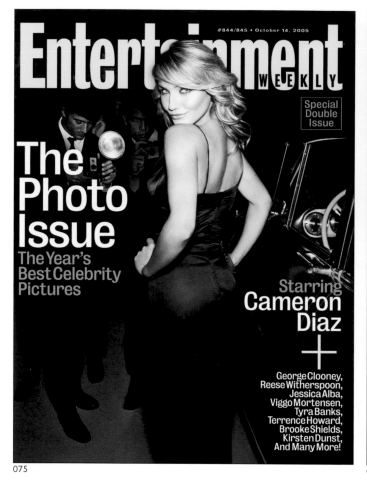

075

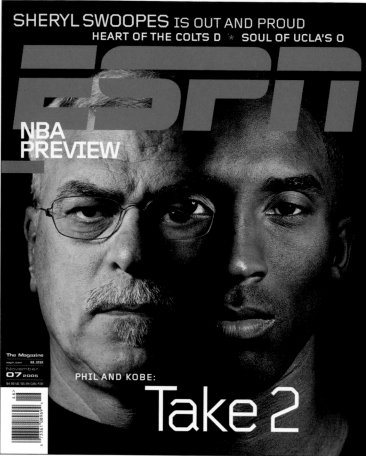

076

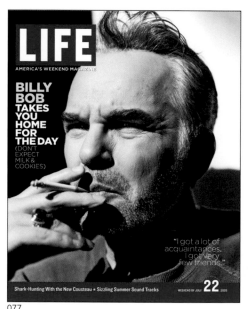

077

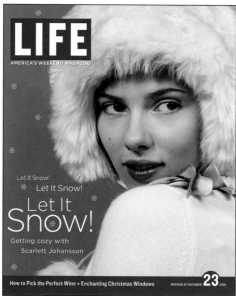

078

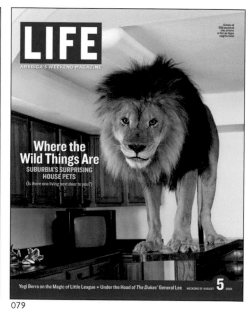

079

075 ✳ ENTERTAINMENT WEEKLY
Design Director: Geraldine Hessler / *Director of Photography:* Fiona McDonagh / *Photographer:*
James White / *Publisher:* Time Inc. / *Issue:* October 14, 2005 / *Category:* Photography Cover

076 ✳ ESPN THE MAGAZINE
Design Director: Siung Tjia / *Director of Photography:* Catriona NiAolain / *Photographer:*
Jeff Riedel / *Publisher:* ESPN, Inc. / *Issue:* November 7, 2005 / *Category:* Photography Cover

077 ✳ LIFE
Creative Director: Richard Baker / *Art Director:* Bess Wong / *Designers:* Marina Drukman, Jarred
Ford / *Director of Photography:* George Pitts / *Photo Editors:* Crary Pullen, Tracy Doyle Bales,
Caroline Smith / *Photographer:* Livia Corona / *Publisher:* Time Inc. / *Issue:* January 14, 2005 /
Category: Photography Cover

078 ✳ LIFE
Creative Director: Richard Baker / *Art Director:* Bess Wong / *Designers:* Marina Drukman, Jarred
Ford / *Director of Photography:* George Pitts / *Photo Editors:* Crary Pullen, Tracy Doyle Bales,
Caroline Smith / *Photographer:* Alexei Hay / *Publisher:* Time Inc. / *Issue:* July 22, 2005 /
Category: Photography Cover

079 ✳ LIFE
Creative Director: Richard Baker / *Art Director:* Bess Wong / *Designers:* Marina Drukman, Jarred
Ford / *Director of Photography:* George Pitts / *Photo Editors:* Crary Pullen, Tracy Doyle Bales,
Caroline Smith / *Photographer:* Koto Bolofo / *Publisher:* Time Inc. / *Issue:* December 23, 2005 /
Category: Photography Cover

080

081

082

083

080 ✳ MARTHA STEWART LIVING
Creative Director: Eric Pike / *Art Directors:* James Dunlinson, Joele Cuyler / *Photo Editors:* Heloise Goodman, Andrea Bakacs / *Photographer:* Lisa Hubbard / *Stylist:* Tanya Graff / *Garden Editor:* Tony Bielaczyc / *Publisher:* Martha Stewart Living Omnimedia / *Issue:* March 2005 / *Category:* Photography Cover

081 ✳ NATIONAL GEOGRAPHIC
Design Director: Connie Phelps / *Art Director:* Robert Gray / *Photo Editor:* Elizabeth Krist / *Photographer:* Cary Wolinsky / *Publisher:* National Geographic Society / *Issue:* May 2005 / *Category:* Photography Cover

082 ✳ REAL SIMPLE
Creative Director: Vanessa Holden / *Designer:* Vanessa Holden / *Photo Editor:* Naomi Nista / *Photographer:* Ellen Silverman / *Publisher:* Time Inc. / *Issue:* August 2005 / *Category:* Photography Cover

083 ✳ REAL SIMPLE
Creative Director: Vanessa Holden / *Designer:* Vanessa Holden / *Photo Editor:* Naomi Nista / *Photographer:* Sang An / *Publisher:* Time Inc. / *Issue:* March 2005 / *Category:* Photography Cover

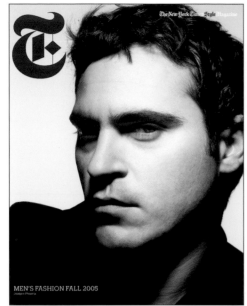

084

085

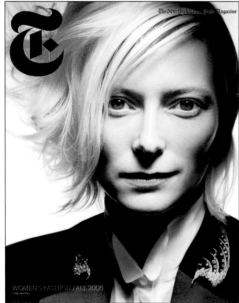

086

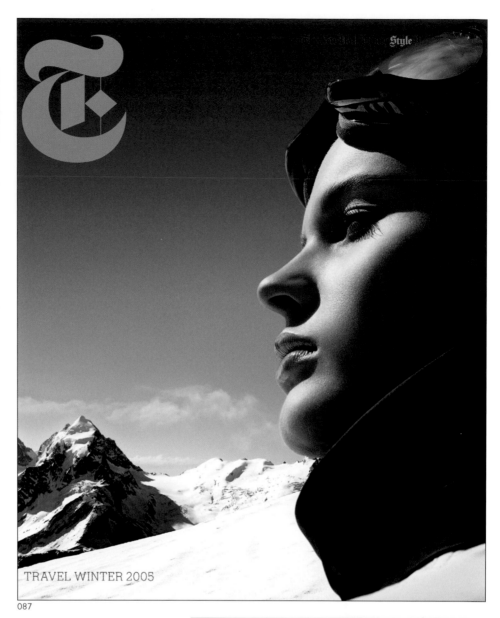

087

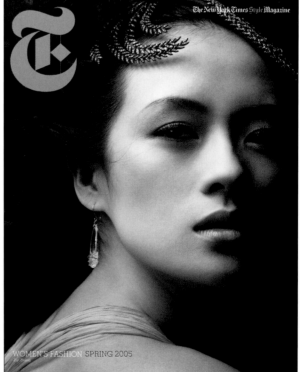

088

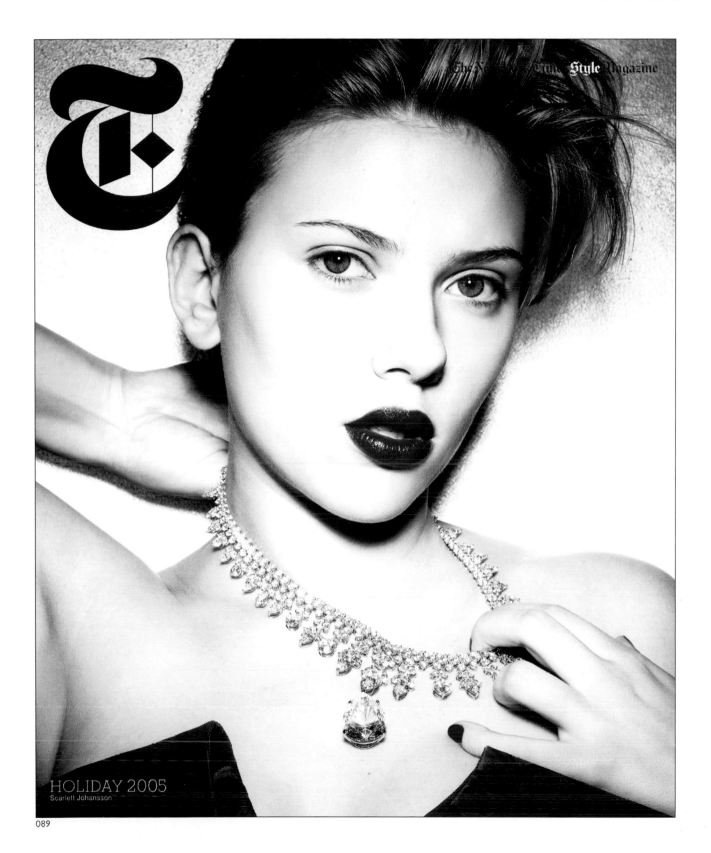

089

084 ✳ T: THE NEW YORK TIMES STYLE MAGAZINE
Creative Director: Janet Froelich / *Art Director:* David Sebbah / *Designers:* Janet Froelich, David Sebbah / *Photo Editors:* Kathy Ryan, Judith Puckett-Rinella / *Photographer:* Raymond Meier / *Publisher:* The New York Times / *Issue:* September 10, 2005 / *Category:* Photography Cover

085 ✳ T: THE NEW YORK TIMES STYLE MAGAZINE
Creative Director: Janet Froelich / *Art Director:* David Sebbah / *Designers:* Janet Froelich, David Sebbah / *Photo Editor:* Kathy Ryan / *Photographer:* Raymond Meier / *Publisher:* The New York Times / *Issue:* September 25, 2005 / *Category:* Photography Cover

086 ✳ T: THE NEW YORK TIMES STYLE MAGAZINE
Creative Director: Janet Froelich / *Art Director:* David Sebbah / *Designers:* Janet Froelich, David Sebbah / *Photo Editors:* Kathy Ryan, Judith Puckett-Rinella / *Photographer:* Raymond Meier / *Publisher:* The New York Times / *Issue:* November 20, 2005 / *Category:* Photography Cover

087 ✳ T: THE NEW YORK TIMES STYLE MAGAZINE
Creative Director: Janet Froelich / *Art Director:* David Sebbah / *Designers:* Janet Froelich, David Sebbah / *Photo Editors:* Kathy Ryan, Judith Puckett-Rinella / *Photographer:* Raymond Meier / *Publisher:* The New York Times / *Issue:* August 28, 2005 / *Category:* Photography Cover

088 ✳ T: THE NEW YORK TIMES STYLE MAGAZINE
Creative Director: Janet Froelich / *Art Director:* David Sebbah / *Designers:* Janet Froelich, David Sebbah / *Photo Editors:* Kathy Ryan, Scott Hall / *Photographer:* Raymond Meier / *Publisher:* The New York Times / *Issue:* February 20, 2005 / *Category:* Photography Cover

089 ✳ T: THE NEW YORK TIMES STYLE MAGAZINE
Creative Director: Janet Froelich / *Art Director:* David Sebbah / *Designers:* Janet Froelich, David Sebbah / *Photo Editors:* Kathy Ryan, Judith Puckett-Rinella / *Photographer:* Raymond Meier / *Publisher:* The New York Times / *Issue:* December 4, 2005 / *Category:* Photography Cover

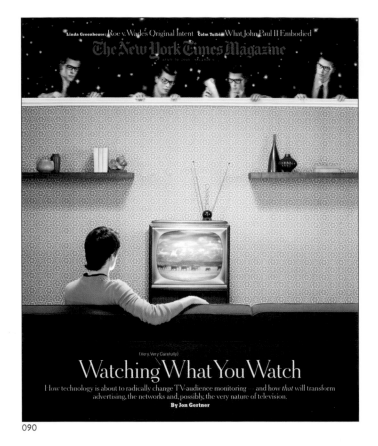

090

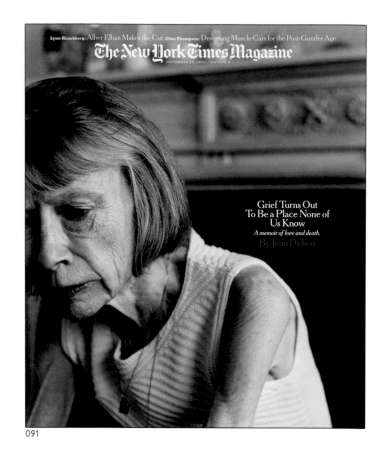

091

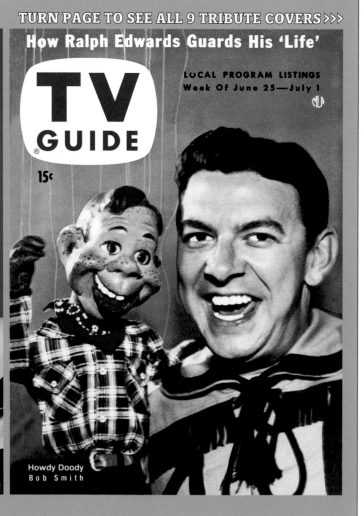

092

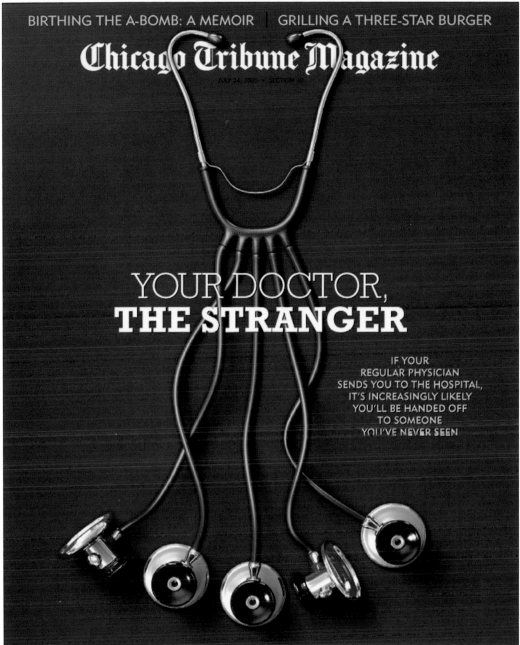

BIRTHING THE A-BOMB: A MEMOIR | GRILLING A THREE-STAR BURGER

Chicago Tribune Magazine

JULY 24, 2005 • SECTION 10

YOUR DOCTOR, THE STRANGER

IF YOUR
REGULAR PHYSICIAN
SENDS YOU TO THE HOSPITAL,
IT'S INCREASINGLY LIKELY
YOU'LL BE HANDED OFF
TO SOMEONE
YOU'VE NEVER SEEN

093

LAUREL AND HARDY FANS UNITE | THE PERSONAL WATERMELON

Chicago Tribune Magazine

JULY 10, 2005 • SECTION 10

WHEN
JOBS
GO SOUTH

OR EAST, WEST AND
NORTH. A LOOK AT HOW
DISPLACED WORKERS
IN GALESBURG AND
CHICAGO ARE COPING
WITH GLOBALIZATION

094

090 ✳ THE NEW YORK TIMES MAGAZINE
Creative Director: Janet Froelich / *Art Director:* Arem Duplessis / *Designer:* Jeff
Glendenning / *Photo Editors:* Kathy Ryan, Joanna Milter / *Photographer:* Zachary Scott /
Publisher: The New York Times / *Issue:* April 10, 2005 / *Category:* Photography Cover

091 ✳ THE NEW YORK TIMES MAGAZINE
Creative Director: Janet Froelich / *Art Director:* Arem Duplessis /
Designer: Kristina DiMatteo / *Photo Editors:* Kathy Ryan, Joanna Milter / *Photographer:*
Eugene Richards / *Publisher:* The New York Times / *Issue:* September 25, 2005 /
Category: Photography Cover

092 ✳ TV GUIDE
Creative Director: John Walker / *Director of Photography:* Donna Bender / *Deputy Photo
Editor:* Nancy Schwartz / *Photographers:* Andy Ryan, Patrik Giardino / *Fashion Editor:*
Cannon-Oliver Piro / *Set & Prop Styling:* Michael Bednark / *Custom Designed Wardrobe:*
Izquierodo Studios, Ltd. / *Publisher:* TV Guide Magazine Group, Inc. / *Issue:* October 16,
2005 / *Category:* Photography Cover

093 ✳ CHICAGO TRIBUNE MAGAZINE
Art Directors: Joseph Darrow, David Syrek / *Illustrator:* Joe Zeff / *Publisher:* Chicago
Tribune Company / *Issue:* July 24, 2005 / *Category:* Illustration Cover

094 ✳ CHICAGO TRIBUNE MAGAZINE
Art Directors: Joseph Darrow, David Syrek / *Illustrator:* David Plunkett / *Publisher:*
Chicago Tribune Company / *Issue:* July 10, 2005 / *Category:* Illustration Cover

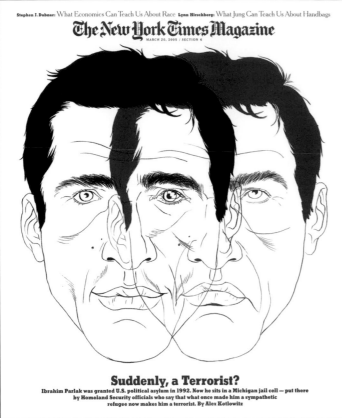

095

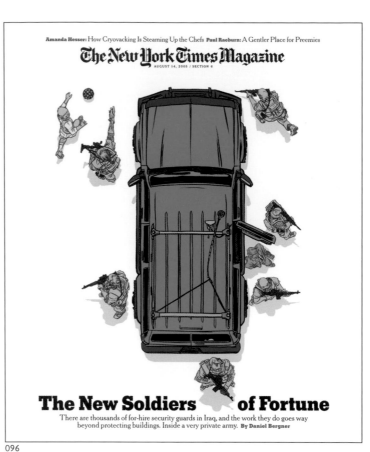

096

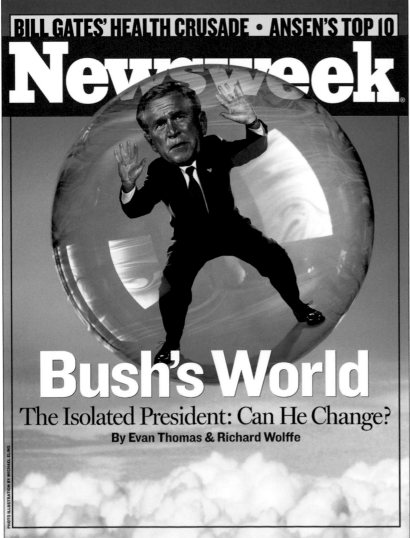

097

095 ✳ THE NEW YORK TIMES MAGAZINE
Creative Director: Janet Froelich / *Art Director:* Arem Duplessis / *Designer:*
Kristina DiMatteo / *Illustrator:* Tomer Hanuka / *Publisher:* The New York Times /
Issue: March 20, 2005 / *Category:* Illustration Cover

096 ✳ THE NEW YORK TIMES MAGAZINE
Creative Director: Janet Froelich / *Art Director:* Arem Duplessis / *Designer:* Arem
Duplessis / *Illustrator:* Nathan Fox / *Publisher:* The New York Times / *Issue:*
August 14, 2005 / *Category:* Illustration Cover

097 ✳ NEWSWEEK
Creative Director: Lynn Staley / *Art Director:* Bruce Ramsay / *Designer:* Bruce
Ramsay / *Director of Photography:* Simon Barnett / *Photo Editor:* Simon Barnett /
Photo Illustration: Michael Elins (for Newsweek) / *Publisher:* The Washington
Post Co. / *Issue:* December 19, 2005 / *Category:* Illustration Cover

098 ✳ THE NEW YORKER
Design Director: Françoise Mouly / *Illustrator:* Anita Kunz / *Publisher:* Condé
Nast Publications Inc. / *Issue:* May 9, 2005 / *Category:* Illustration Cover

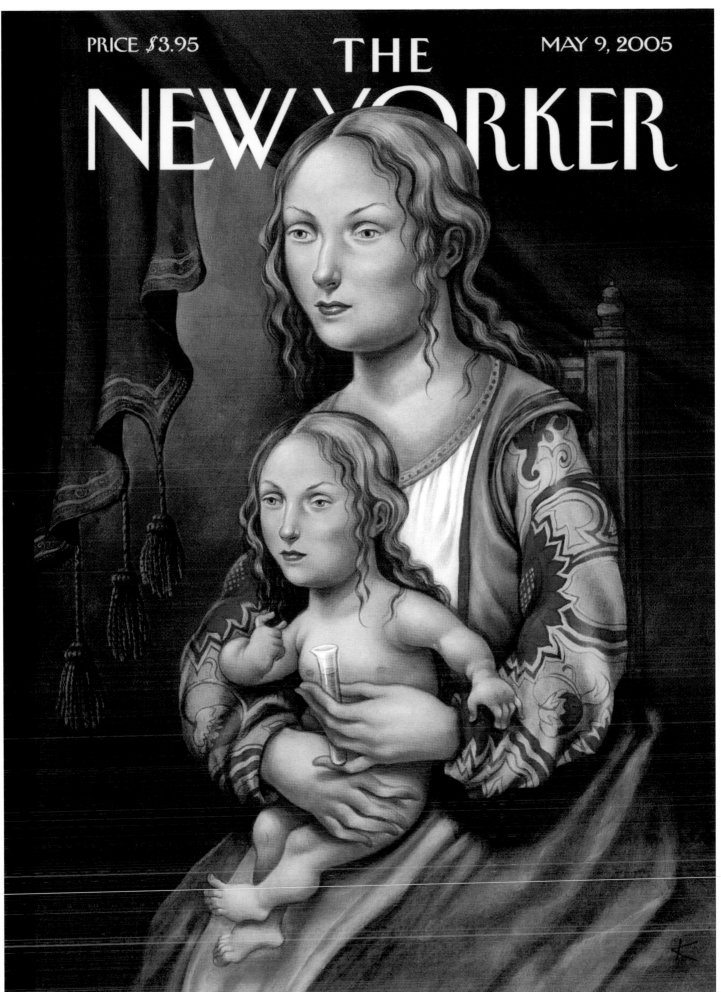

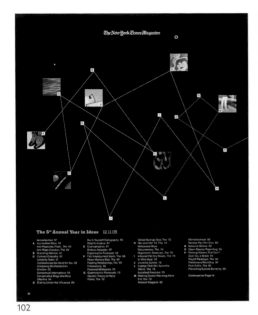

102

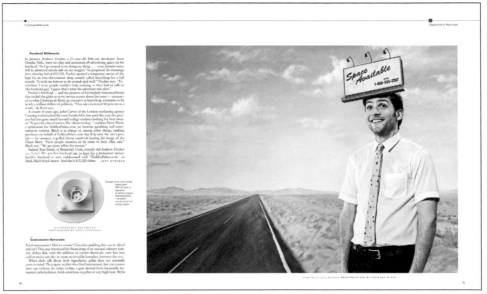

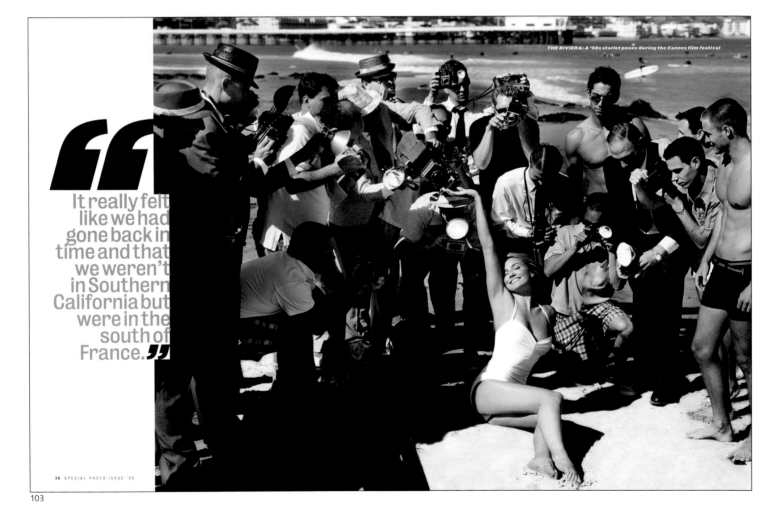

103

102 ✺ THE NEW YORK TIMES MAGAZINE
Creative Director: Janet Froelich / *Art Director:* Arem Duplessis / *Designers:* Kristina DiMatteo, Jeff Glendenning, Nancy Harris Rouemy, Cathy Gilmore-Barnes, Gail Bichler / *Photo Editor:* Kathy Ryan / *Publisher:* The New York Times / *Issue:* December 11, 2005 / *Category:* Design Entire Issue

103 ✺ ENTERTAINMENT WEEKLY
Design Director: Geraldine Hessler / *Designers:* Theresa Griggs, Jennie Chang / *Director of Photography:* Fiona McDonagh / *Photo Editors:* Audrey Landreth, Michael Kochman, Michele Romero, Richard Maltz, Freyda Tavin, Suzanne Regan, Carrie Levitt, Kristine Chin, Samantha Xu / *Photographers:* James White, Gavin Bond, Martin Schoeller, Jeff Riedel, Larry Fink, Mark Peterson, Alessandra Petlin / *Publisher:* Time Inc. / *Issue:* October 14, 2005 / *Category:* Photography Entire Issue

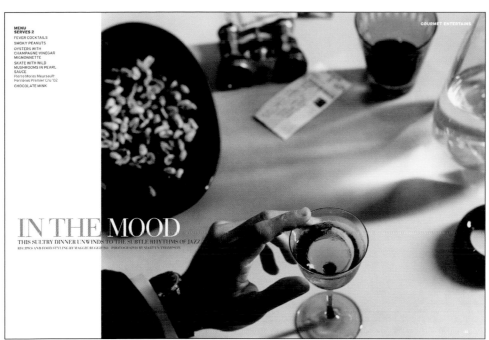

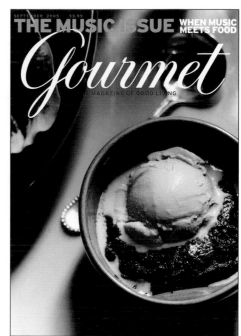

104

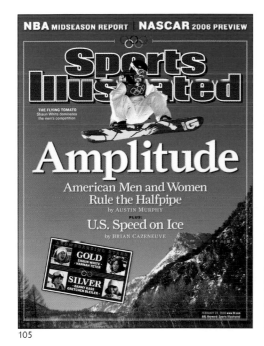

105

104 ✳ GOURMET
Creative Director: Richard Ferretti / *Art Director:* Erika Oliveira / *Photo Editor:* Amy Koblenzer / *Publisher:* Condé Nast Publications, Inc. /
Issue: September 2005 / *Category:* Photography Entire Issue

105 ✳ SPORTS ILLUSTRATED
Creative Director: Steve Hoffman / *Art Directors:* Chris Hercik, Ed Truscio, Steve Charny, Eric Marquard / *Illustrator:* John Cuneo /
Director of Photography: Steve Fine / *Photographers:* Al Tielemans, Michael O'Neill, Simon Bruty, Gary Fitzgerald, Ric Feld (AP), David N. Berkwtz /
Publisher: Time Inc. / *Issue:* December 12, 2005 / *Category:* Design Redesign

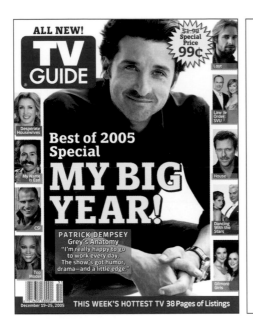

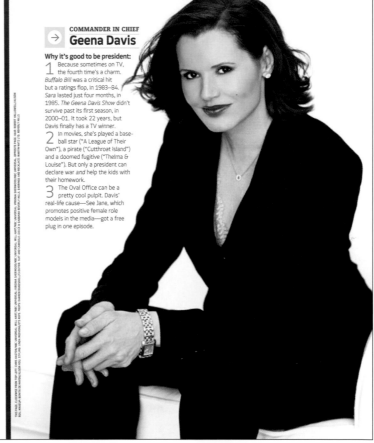

106 ✱ TV GUIDE
Creative Director: John Walker / *Art Directors:* Steve W. Thomas, Gloria Pantell, Jackie Jordan / *Designers:* Heather Parke, Sara Osten, Jessica Spector, Jill McNally, Melanie Franz, Brian Filone, Scott Wooledge / *Director of Photography:* Donna Bender / *Publisher:* TV Guide Magazine Group, Inc. / *Category:* Design Redesign

107 ✱ GOURMET
Creative Director: Richard Ferretti / *Art Director:* Flavia Schepmans / *Designer:* Flavia Schepmans / *Photographer:* Romulo Yanes / *Publisher:* Condé Nast Publications, Inc. / *Issue:* June 2005 / *Category:* Design Contents & Departments

108 ✱ GOURMET
Creative Director: Richard Ferretti / *Art Director:* Flavia Schepmans / *Designer:* Flavia Schepmans / *Photo Editor:* Amy Koblenzer / *Photographer:* Romulo Yanes / *Publisher:* Condé Nast Publications, Inc. / *Issue:* June 2005 / *Category:* Design Contents & Departments

109 ✱ GOURMET
Creative Director: Richard Ferretti / *Art Director:* Flavia Schepmans / *Designer:* Flavia Schepmans / *Photo Editor:* Amy Koblenzer / *Photographer:* Romulo Yanes / *Publisher:* Condé Nast Publications, Inc. / *Issue:* January 2005 / *Category:* Design Contents & Departments

110 ✱ GOURMET
Creative Director: Richard Ferretti / *Art Director:* Kevin DeMaria / *Designer:* Kevin DeMaria / *Photo Editor:* Amy Koblenzer / *Photographer:* Romulo Yanes / *Publisher:* Condé Nast Publications, Inc. / *Issue:* October 2005 / *Category:* Design Contents & Departments

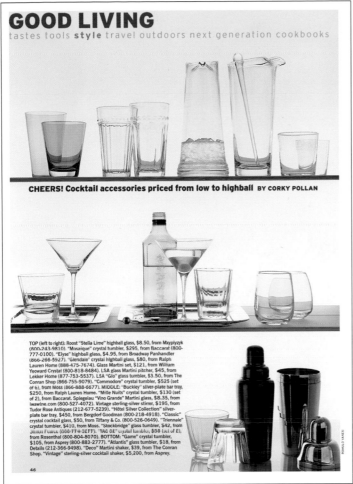

GOOD LIVING
tastes tools **style** travel outdoors next generation cookbooks

CHEERS! Cocktail accessories priced from low to highball BY CORKY POLLAN

TOP (left to right): Roost "Stella Lime" highball glass, $8.50, from Mxyplyzyk (800-243-9810). "Mosaique" crystal tumbler, $295, from Baccarat (800-777-0100). "Elyse" highball glass, $4.95, from Broadway Panhandler (866-266-5927). "Glendale" crystal highball glass, $80, from Ralph Lauren Home (888-475-7674). Glass Martini set, $121, from William Yeoward Crystal (800-818-8484). LSA glass Martini pitcher, $45, from Lekker Home (877-753-5537). LSA "Glo" glass tumbler, $3.50, from The Conran Shop (866-755-9079). "Commodore" crystal tumbler, $525 (set of 6), from Moss (866-888-6677). MIDDLE: "Buckley" silver-plate bar tray, $250, from Ralph Lauren Home. "Mille Nuits" crystal tumbler, $130 (set of 2), from Baccarat. Spiegelau "Vino Grande" Martini glass, $8.35, from iwawine.com (800-527-4072). Vintage sterling-silver stirrer, $195, from Tudor Rose Antiques (212-677-5239). "Hôtel Silver Collection" silver-plate bar tray, $450, from Bergdorf Goodman (800-218-4918). "Classic" crystal cocktail glass, $50, from Tiffany & Co. (800-526-0649). "Triennale" crystal tumbler, $410, from Moss. "Stockbridge" glass tumbler, $42, from Simon Pearce (800-774-5277). "TAC 02" crystal tumbler, $38 (set of 2), from Rosenthal (800-804-8070). BOTTOM: "Game" crystal tumbler, $105, from Asprey (800-883-2777). "Atlantis" glass tumbler, $18, from Details (212-366-9498). "Deco" Martini shaker, $39, from The Conran Shop. "Vintage" sterling-silver cocktail shaker, $5,200, from Asprey.

46

107

DRINKS
syrah riesling **tequila** viognier **bourbon** wheat beer

Mellow yellow: With its heady aroma and tangy flavor, passion fruit shines in these supersummery caipirinhas.

SQUEEZED, THEN STIRRED Generally, I'm a contrarian, and trendiness in fruit really raises my hackles. I'm thus almost embarrassed to confess my passion for fruit juices high in anthocyanins (plant pigments that impart a reddish-purple color and cherry-berry flavor), which have been relentlessly promoted for their therapeutic antioxidant properties. I just like them because they taste good.

Since anthocyanins can be chemically unstable, however, most previously available pomegranate juices tended to taste musty. That's why POM Wonderful juice, sweet-tart and winy, with a pleasing tannic tinge, is such a godsend. The makers of the juice figured out how to extract and store it—note that the juice is sold in the refrigerated section of supermarkets—so that it doesn't develop those off flavors. ❯

JUNE 2005 GOURMET 53

108

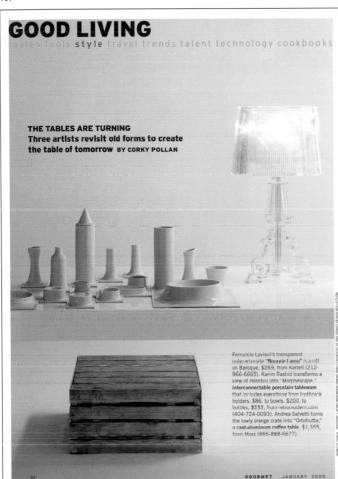

GOOD LIVING
tastes tools **style** travel trends talent technology cookbooks

THE TABLES ARE TURNING
Three artists revisit old forms to create the table of tomorrow BY CORKY POLLAN

Ferruccio Laviani's transparent polycarbonate "Bourgie Lamp" is a riff on Baroque, $269, from Kartell (212-966-6665). Karim Rashid transforms a view of Istanbul into "Morphescape," interconnectable porcelain tableware that includes everything from toothpick holders, $86, to bowls, $200, to bottles, $232, from rebumodern.com (404-724-0093). Andrea Salvetti turns the lowly orange crate into "Ortofrutta," a cast-aluminum coffee table, $1,955, from Moss (866-888-6677).

57 GOURMET JANUARY 2005

109

DRINKS
brut rosé zinfandel amontillado merlot chardonnay

THE COLD STANDARD It's possible to find spirits of almost unimaginable rarity on the top shelves of bars around the country. A dram of Bowmore 40 Year Old single-malt Scotch, for example, can be had—if you're willing to plunk down nearly $700—at Mews Tavern, in Wakefield, Rhode Island, and a glass of Hardy Private Collection 1802 Cognac is a mere $625 at Alizé, in Las Vegas. Something nearly as rare, however, will be provided at no extra charge when you order a drink at Lewers Lounge, in the Halekulani, on Oahu, or at the recently opened Pegu Club, in New York City: perfect ice. The discovery of fire—or, more accurately, the ability to create and manage fire—gets all the attention in anthropology texts, but ice might be an object of even greater obsession, particularly during the last two millennia, and particularly among America's best bartenders. ❯

58 GOURMET OCTOBER 2005

110

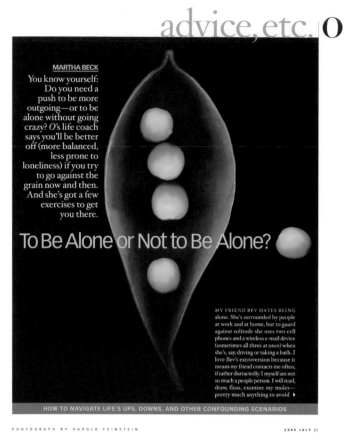

111

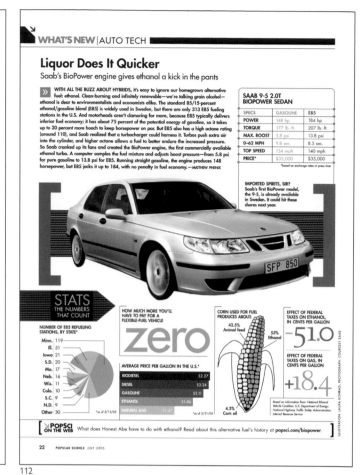

112

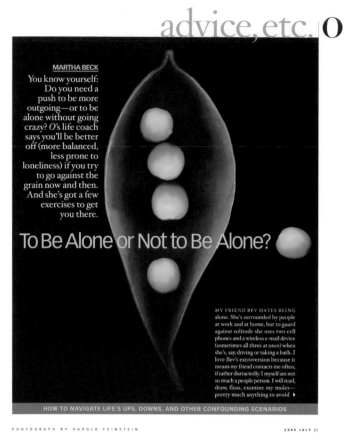

113

111 ✳ O, THE OPRAH MAGAZINE
Design Director: Carla Frank / *Art Director:* Kristin Fitzpatrick / *Designer:* Randall Leers / *Photo Editors:* Kim Gougenheim, Hadas Dembo / *Photographer:* Harold Feinstein / *Publisher:* The Hearst Corporation-Magazines Division / *Issue:* July 2005 / *Category:* Design Contents & Departments

112 ✳ POPULAR SCIENCE
Art Director: Nathalie Kirsheh / *Deputy Art Director:* Christopher Chew / *Designer:* Laura Konrad / *Illustrator:* Laura Konrad / *Photo Editor:* Kristine LaManna / *Publisher:* Time4 Media / *Issue:* July 2005 / *Category:* Design Contents & Departments

113 ✳ T: THE NEW YORK TIMES STYLE MAGAZINE
Creative Director: Janet Froelich / *Art Director:* David Sebbah / *Designers:* David Sebbah, Claudia de Almeida / *Publisher:* The New York Times / *Issue:* November 6, 2005 / *Category:* Design Contents & Departments

114 ✳ ENTERTAINMENT WEEKLY
Design Director: Geraldine Hessler / *Designer:* Theresa Griggs / *Director of Photography:* Fiona McDonagh / *Photo Editor:* Richard Maltz / *Photographer:* Larry Fink / *Publisher:* Time Inc. / *Issue:* October 14, 2005 / *Category:* Photography Contents & Departments

115 ✳ GOLF DIGEST
Design Director: Edward Mann / *Art Director:* Tim Oliver / *Designers:* Lauren Nadler, Edward Mann / *Photo Editor:* Matthew M. Ginella / *Photographer:* Adrian Mueller / *Publisher:* Condé Nast Publications Inc. / *Issue:* August 2005 / *Category:* Photography Contents & Departments

116 ✳ O, THE OPRAH MAGAZINE
Design Director: Carla Frank / *Art Director:* Lee Berresford / *Designer:* Kelly Chilton / *Photo Editor:* Laurie Kratochvil / *Photographer:* Albert Watson / *Publisher:* The Hearst Corporation-Magazines Division / *Issue:* November 2005 / *Category:* Photography Contents & Departments

117 ✳ SELF
Creative Director: Cynthia H. Searight / *Art Director:* Petra Kobayashi / *Designer:* Shira Gordon / *Photo Editor:* Kristen Mulvihill / *Photographer:* Bill Diodato / *Publisher:* Condé Nast Publications Inc. / *Issue:* August 2005 / *Category:* Photography Contents & Departments

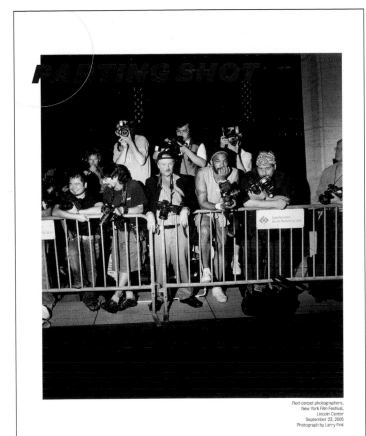

PARTING SHOT

Red-carpet photographers,
New York Film Festival,
Lincoln Center
September 23, 2005
Photograph by Larry Fink

162 SPECIAL PHOTO ISSUE '05

114

Edited by Mike Stachura

THE LATEST GEAR TO HELP YOU PLAY BETTER

Equipment

Borne in the USA

How many golf clubs are actually made in America? The answer might be as misunderstood as the real meaning of Bruce Springsteen's "Born in the USA." Although many clubs are assembled here, they're not made here, which is why Chinese exports of golf clubs to the U.S. have increased 2.1 million *percent* since 1989. Nevertheless, you can still find American-made clubs, like these (*left to right*): **PING** G2 HL hybrids. The company casts its own irons—such as this wide-sole, undercut cavity hybrid—in Phoenix and makes most of its putters there, too ($110 steel, four lofts, pinggolf.com). **SCOTTY CAMERON by TITLEIST** American Classic III. An update of the venerable Bulls Eye, the milled-head steel head features copper-tungsten heel-and-toe inserts ($179, titleist.com). **GAUGE DESIGN** GA01A ETBW. This version of the GAA stainless-steel series is custom-milled in California with a nickel finish and tungsten weights in the heel and toe ($325, gaugedesigngolf.com). **LOUISVILLE GOLF** Thumper. Handmade in the company's Louisville plant, the 285 cubic-centimeter persimmon head has a sloped crown to lower the center of gravity and a hard cycolac face insert ($350 steel, louisvillegolf.com).

IMAGE INSPIRED BY THE LEGENDARY COPYRIGHTED PHOTOGRAPH BY ANNIE LEIBOVITZ FOR THE BRUCE SPRINGSTEEN ALBUM AND USED BY PERMISSION. GOLF DIGEST PHOTO BY ADRIAN MUELLER. AUGUST 2005 GolfDigest.com **215**

115

connections O

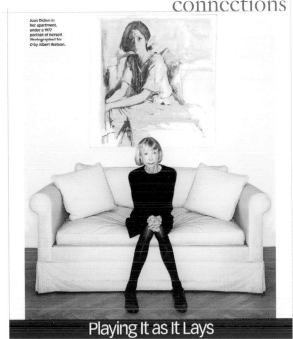

Joan Didion in
her apartment,
under a 1977
portrait of herself.
Photographed for
O by Albert Watson.

Playing It as It Lays

When her husband collapsed of a sudden heart attack,
Joan Didion discovered a grief she describes as "a form of psychosis."
On the eve of publication of her stunning new memoir... ▶

2005 NOVEMBER 102

116

fitness gear to get

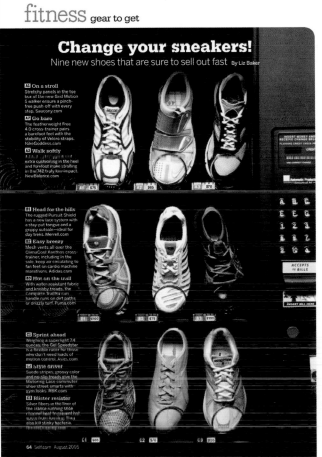

Change your sneakers!
Nine new shoes that are sure to sell out fast By Liz Baker

A1 On a stroll
Stretchy panels in the toe box of the new Grid Motion 5 walker ensure a pinch-free push-off with every step. Saucony.com

A2 Go bare
The featherweight Free 4.0 cross-trainer pairs a barefoot feel with the stability of Velcro straps. NikeGoddess.com

A3 Walk softly
Added support and extra cushioning in the heel and forefoot make strolling in the 742 truly low-impact. NewBalance.com

B1 Head for the hills
The rugged Pursuit Shield has a new lace system with a stay-put tongue and a grippy outsole—ideal for day treks. Merrell.com

B2 Easy breezy
Mesh vents all over the ClimaCool Xanthos cross-trainer, including in the sole, keep air circulating to fan feet on cardio machine marathons. Adidas.com

B3 Hot on the trail
With water-resistant fabric and knobby treads, the Complete Trailfox can handle runs on dirt paths or drizzly turf. Puma.com

C1 Sprint ahead
Weighing a superlight 7.4 ounces, the Gel Speedstar is a flexible racer for those who don't need loads of motion control. Asics.com

C2 Style driver
Suede stripes, groovy color and no-slip treads give the Motoring Lace commuter shoe street smarts with gym looks. RBK.com

C3 Blister resister
Silver fibers in the liner of the Trance running shoe channel heat to prevent hot spots from rubbing. They also kill stinky bacteria.

64 Self.com August 2005

117

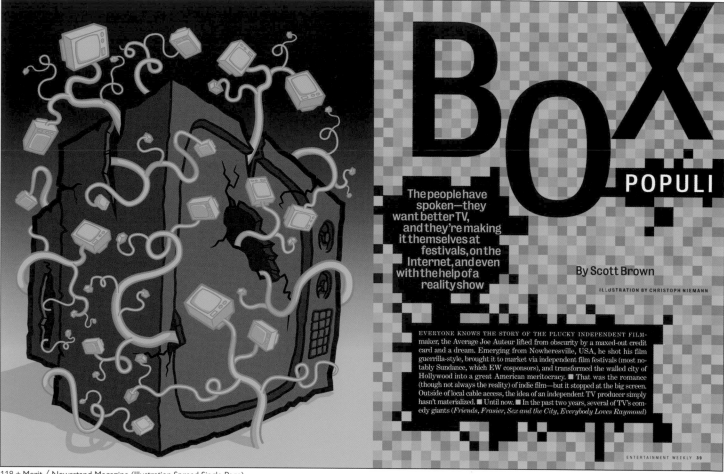

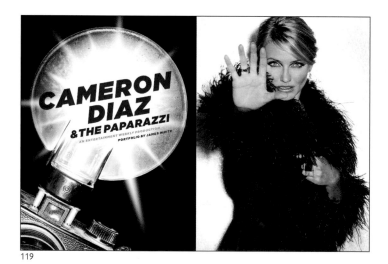

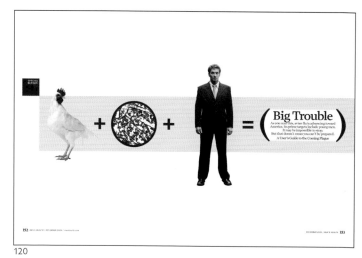

118 + Merit / Newsstand Magazine (Illustration Spread-Single Page)

119

120

118 ✳ ENTERTAINMENT WEEKLY
Design Director: Geraldine Hessler / *Director of Photography:* Fiona McDonagh / *Publisher:* Time Inc. / *Issue:* July 29, 2005 /
Category: Design Spread-Single Page

119 ✳ ENTERTAINMENT WEEKLY
Design Director: Geraldine Hessler / *Designer:* Theresa Griggs / *Director of Photography:* Fiona McDonagh / *Photographer:* James White /
Publisher: Time Inc. / *Issue:* October 14, 2005 / *Category:* Design Spread-Single Page

120 ✳ MEN'S HEALTH
Design Director: George Karabotsos / *Art Director:* Vikki Nestico / *Director of Photography:* Marianne Butler / *Publisher:* Rodale Inc. /
Issue: November 2005 / *Category:* Design Spread-Single Page

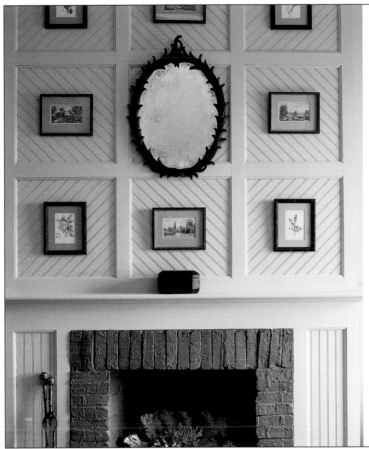

BEAD BOARD DÉCOR
GET INTO THE *groove* WITH THIS EASY-TO-INSTALL *wood paneling.*

For a detail so subtle, these slim, vertical panels of wood can make a lasting impression. Those who grew up with bead board naturally feel drawn to it, recalling lakeside houses from childhood, long hallways at New England inns, family meals in the dining rooms of 1920s bungalows. Incorporating the paneling into a home, then, is often about recapturing that casual, summery, cottage style. But here's a delightful surprise: The unpretentious simplicity of bead board works in a variety of settings — in cottages and bungalows, yes, but also in more elegant spaces. It can serve as a decorative accent or it can define a room. The difference is all in how it's used. ~ Bead board is an attractive, tongue-and groove-style wall covering with a humble history. It is named for the "bead" (or narrow channel) that runs down the center and one edge of each plank, creating the appearance of narrower slats when the boards are joined together and installed. Before the nineteenth century, it was used only for informal rooms, at least in better homes: Kitchens, pantries, bathrooms, and family bedrooms — (the covering of the lower part of a wall decorated by a chair rail or molding), it gradually gained popular appeal. By the early twentieth century, it was incorporated into North American cottage style, as well. Not only was it the relaxed, country wall covering of choice,

bead board even found its way onto ceilings, cabinetry, and porches. ~ Cost-effectiveness and ease of use are still the primary reasons incentives to give it a try in your home. You can capitalize bead board is so popular, and they are two great on the versatile material's classic appeal by using it for more than just walls. We employed it in less expected ways for larger jobs, such as building encasements for a mantel and a bathtub; we also incorporated it into small do-it-yourself projects that can be finished in a weekend A mirror frame of bead board, for instance, lends style and nostalgia to a room, and requires little time or expense to construct. Bead board panels also can be turned into a new table top for a flea market find or into a top for a Nantucket style

basket. You can stick with the more conventional whites and wood finishes or try, as we did, rich, unexpected hues of paint in some spots for an updated look. You'll find plenty of inspiration on the following pages. ~ Look for bead board in oak, pine, or even MDF (medium-density fiberboard) at home-improvement stores and lumberyards. It can be purchased in planks or sheets (for details, see "Buying Bead Board" on page 140), and in all forms it is relatively inexpensive. Expect to pay approximately $30 per sheet or 48 cents per linear foot, depending upon the project. Whether you're planning to redecorate on a large scale or simply want to incorporate bead board into the details of your home, you're sure to elicit fond memories — and create new associations — for many who pass through your doors.

PHOTOGRAPHS BY **BILL BATTEN** TEXT BY **BETHANY LYTTLE**

121

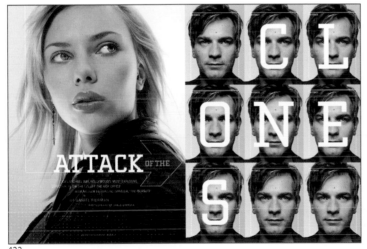

122

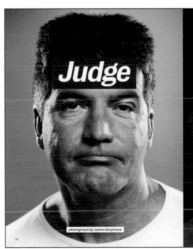
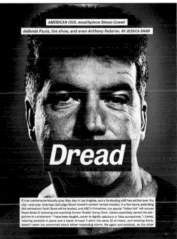

123

121 ✳ MARTHA STEWART LIVING
Creative Director: Eric Pike / *Art Directors:* James Dunlinson, Joele Cuyler / *Designers:* Eric Pike, Amber Blakesley / *Photo Editors:* Heloise Goodman, Andrea Bakacs /
Photographer: Bill Batten / *Home Editors:* Melanio Gomez, Anthony Santelli / *Publisher:* Martha Stewart Living Omnimedia / *Issue:* June 2005 / *Category:* Design Spread-Single Page

122 ✳ ENTERTAINMENT WEEKLY
Design Director: Geraldine Hessler / *Designer:* Brian Anstey / *Director of Photography:* Fiona McDonagh / *Photo Editor:* Michele Romero / *Photographer:* James Dimmock /
Publisher: Time Inc. / *Issue:* July 22, 2005 / *Category:* Design Spread-Single Page

123 ✳ ENTERTAINMENT WEEKLY
Design Director: Geraldine Hessler / *Designer:* Brian Anstey / *Director of Photography:* Fiona McDonagh / *Photo Editor:* Carrie Levitt / *Photographer:* Justin Stephens /
Publisher: Time Inc. / *Issue:* May 20, 2005 / *Category:* Design Spread-Single Page

The Empathist

How did Peter Sarsgaard learn to play the
role of a Marine sharpshooter? The way he learns every role: by deftly inhabiting
the mind-set of the unfamiliar.

By Lynn Hirschberg

PHOTOGRAPHS BY COLLIER SCHORR

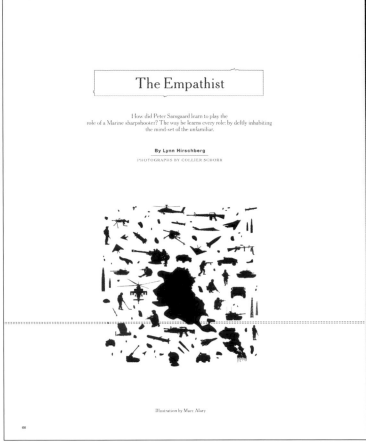

Illustration by Marc Alary

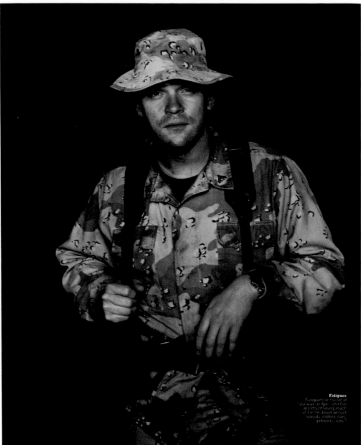

124

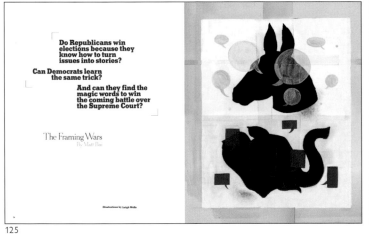

**Do Republicans win
elections because they
know how to turn
issues into stories?**

**Can Democrats learn
the same trick?**

**And can they find the
magic words to win
the coming battle over
the Supreme Court?**

The Framing Wars
By Matt Bai

Illustrations by Leigh Wells

125

Who Are
Americans
To Think That
Freedom
Is Theirs
To Spread?

By Michael Ignatieff

126

124 ✷ THE NEW YORK TIMES MAGAZINE
Creative Director: Janet Froelich / *Art Director:* Arem Duplessis / *Designer:* Arem Duplessis / *Illustrator:* Marc Alary / *Photo Editor:* Kathy Ryan /
Photographer: Collier Schorr / *Publisher:* The New York Times / *Issue:* November 13, 2005 / *Category:* Design Spread-Single Page

125 ✷ THE NEW YORK TIMES MAGAZINE
Creative Director: Janet Froelich / *Art Director:* Arem Duplessis / *Designer:* Kristina DiMatteo / *Illustrator:* Leigh Wells /
Publisher: The New York Times / *Issue:* July 17, 2005 / *Category:* Design Spread-Single Page

126 ✷ THE NEW YORK TIMES MAGAZINE
Creative Director: Janet Froelich / *Art Director:* Arem Duplessis / *Designer:* Kristina DiMatteo / *Illustrator:* Christoph Niemann /
Publisher: The New York Times / *Issue:* June 26, 2005 / *Category:* Design Spread-Single Page

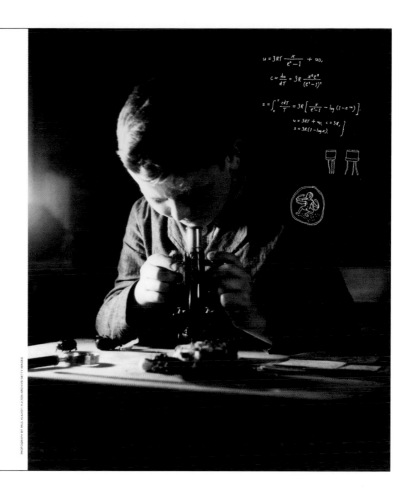

The Pro digy Puz zle

Once neglected, America's smartest children have become the beneficiaries of a well-organized effort to recognize their gifts and develop their talents. But do we know how to identify the child whose brilliance might change the world? And do we really want to?

By Ann Hulbert

Photomontages by Roderick Mills

$$u = 3RT \frac{x}{e^x - 1} + u_0,$$

$$c = \frac{du}{dT} = 3R \frac{x^2 e^x}{(e^x - 1)^2}$$

$$s = \int_0^T \frac{c \, dT}{T} = 3R \left[\frac{x}{e^x - 1} - \ln(1 - e^{-x}) \right].$$

127

128

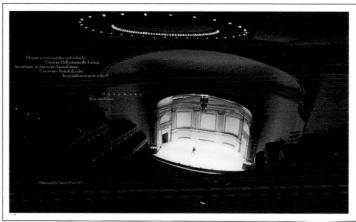

129

127 ✳ THE NEW YORK TIMES MAGAZINE
Creative Director: Janet Froelich / *Art Director:* Arem Duplessis / *Designer:* Nancy Harris Rouemy / *Illustrator:* Roderick Mills / *Photo Editor:* Kathy Ryan / *Publisher:* The New York Times / *Issue:* November 20, 2005 / *Category:* Design Spread-Single Page

128 ✳ THE NEW YORK TIMES MAGAZINE
Creative Director: Janet Froelich / *Art Director:* Arem Duplessis / *Designer:* Kristina DiMatteo / *Photo Editor:* Kathy Ryan / *Photographer:* Jerry L. Thompson / *Publisher:* The New York Times / *Issue:* October 30, 2005 / *Category:* Design Spread-Single Page

129 ✳ THE NEW YORK TIMES MAGAZINE
Creative Director: Janet Froelich / *Art Director:* Arem Duplessis / *Designer:* Kristina DiMatteo / *Photo Editor:* Kathy Ryan / *Photographer:* Antonin Kratochvil / *Publisher:* The New York Times / *Issue:* June 19, 2005 / *Category:* Design Spread-Single Page

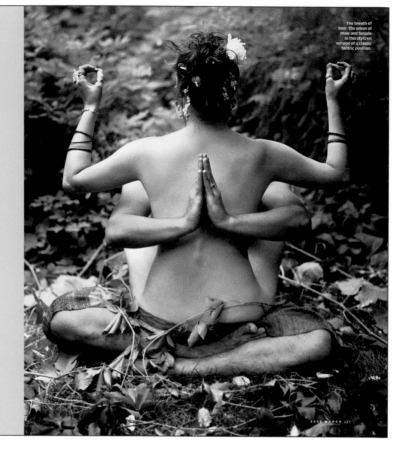

tantric sex

You've read about it. You've wondered about it. Hours and hours of kissing. Soul-melding eye contact. Transcendental sex.... Hey, I'll have what they're having! But what's involved? And what does a weekend workshop in the Poconos have to do with the real thing? **AIMEE LEE BALL** comes back with a firsthand report.

The breath of love: The union of male and female in this stylized version of a classic tantric position.

130

131

132

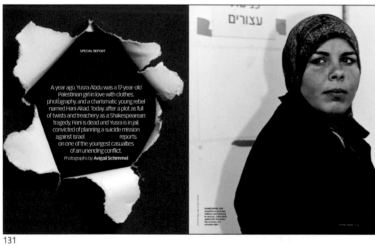

STIR CRAZY

A single pan and a simple cooking method are all that separate you from countless quick, healthy, sizzling meals

133

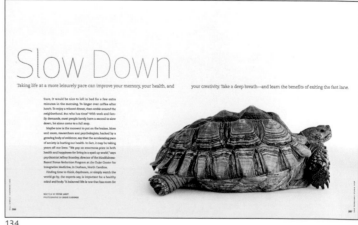

Slow Down

Taking life at a more leisurely pace can improve your memory, your health, and your creativity. Take a deep breath—and learn the benefits of exiting the fast lane.

134

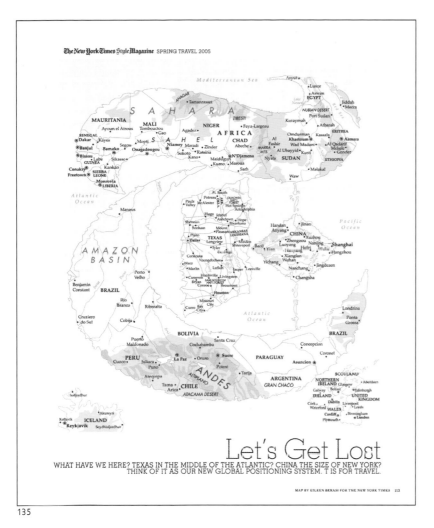

135

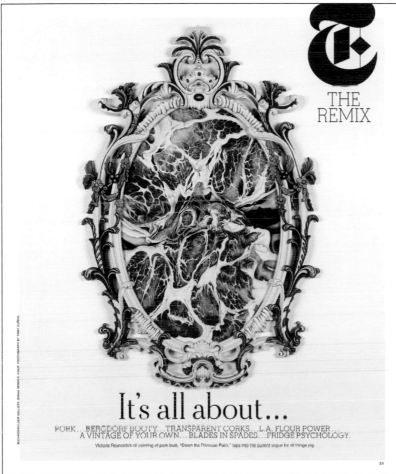

136

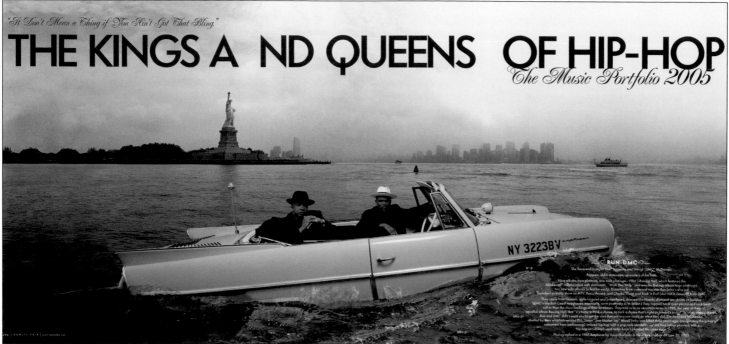

137 + Merit / Newsstand Magazine (Photography Story)

138

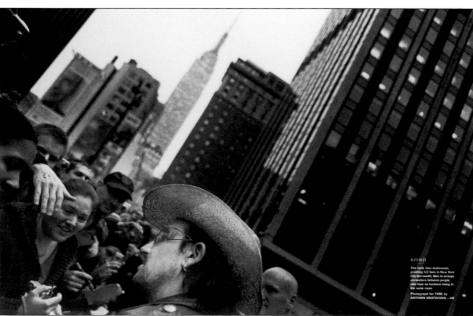

139

137 ✷ VANITY FAIR
Design Director: David Harris / *Art Director:* Julie Weiss /
Designer: Chris Mueller / *Director of Photography:* Susan
White / *Photo Editors:* Lisa Berman, Ron Beinner /
Photographer: Jonas Karlsson / *Publisher:* Condé Nast
Publications Inc. / *Issue:* November 2005 / *Category:* Design
Spread-Single Page

138 ✷ T: THE NEW YORK TIMES STYLE MAGAZINE
Creative Director: Janet Froelich / *Art Director:* David Sebbah /
Designer: David Sebbah / *Photo Editors:* Kathy Ryan, Scott
Hall / *Photographer:* Stefan Ruiz / *Publisher:* The New York
Times / *Issue:* March 20, 2005 / *Category:* Design Spread-
Single Page

139 ✷ TIME
Design Director: Arthur Hochstein / *Art Director:* D.W. Pine /
Director of Photography: Michele Stephenson / *Photo Editor:*
MaryAnne Golon / *Photographer:* Antonin Kratochvil (VII) /
Publisher: Time Inc. / *Issue:* December 26, 2005 / *Category:*
Design Spread-Single Page

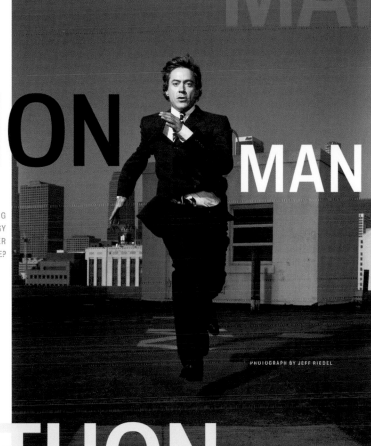

BY CHRIS NASHAWATY

MARATHON
MAN

AFTER A LIFE SPENT TRYING TO OUTRUN THE DEMONS OF DRUG ADDICTION, **ROBERT DOWNEY JR.** IS CHANNELING HIS ENERGY TOWARD A SLATE OF NEW FILMS, INCLUDING THE COMEDY THRILLER **KISS KISS, BANG BANG.** HE'S ON TRACK. CAN HE GO THE DISTANCE?

"IT'S SICK HOW GOOD I LOOK AT MY AGE," HE SAYS WITH A SMILE. "I LOOK AT SOME OF MY PEERS WHO MAYBE didn't throw down as many hard-ass rubber-to-the-road miles as I did, and I look *fantastic!*" • Robert Downey Jr. is lucky. • It may sound odd, since we're talking about a guy whose every misstep—every arrest, perp walk, detox, and blackout in a neighbor's kid's bedroom—was chronicled in the press back in the late '90s. But it's true. As true as the fact that he's sitting here right now. • Which, in itself, is a testament to his dumb luck. Because after all of the hazy, half-remembered coke-fueled nights, and the too-too-early mornings desperately trying to score more, Robert Downey Jr. should be dead. He knows it every time he looks in the mirror and sees the fantastic-looking irony of it all staring back at him. • The baddest bad boy of them all is 40 years old now, and he doesn't have a scratch on his body. It's remarkable. There are some grooves that bracket his mouth when he smiles that mischievous smile. But really, with everything he's been through, his face should look as beat-up as the Acropolis by now. • Sitting at a trendy poolside hotel bar in downtown Los Angeles, Downey is 20

PHOTOGRAPH BY JEFF RIEDEL

26 OCTOBER 28, 2005

140

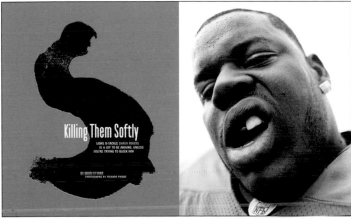

111

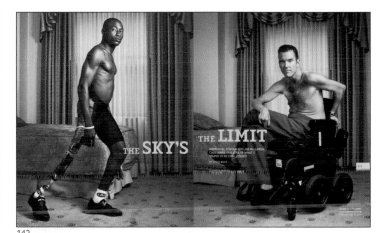

142

143

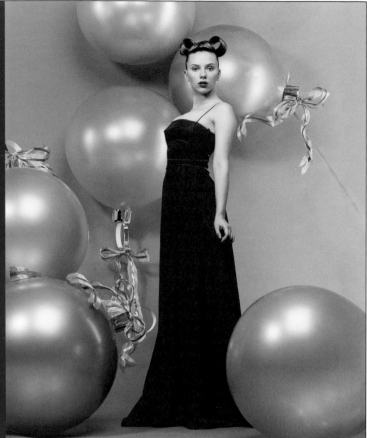

BY BRANTLEY BARDIN ✳ PHOTOGRAPHS BY KOTO BOLOFO

Scarlett fever
Flirty, funny, fabulous, feisty, festive

Scarlett Johansson, unwrapped

144

THIS MAN IS NOT A SOLDIER.

But he plays one on the weekend.

While most of us wake up on Saturday ready to watch football or hit the mall . . .

. . . he and hundreds of men and women like him slip on their camos, load up their fake weapons, and re-create battles they've seen on CNN.

By Chris O'Connell • Photographs by Alec Soth

145

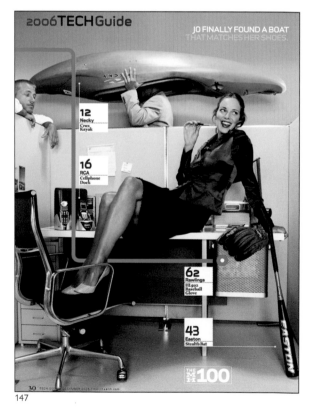

2006 TECH Guide

JO FINALLY FOUND A BOAT THAT MATCHES HER SHOES.

12 Necky Crux Kayak

16 RCA Cellphone Dock

62 Rawlings HI.692 Baseball Glove

43 Easton Stealth Bat

100

147

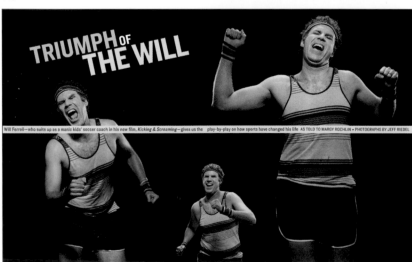

TRIUMPH OF THE WILL

Will Ferrell—who suits up as a manic kids' soccer coach in his new film, *Kicking & Screaming*—gives us the play-by-play on how sports have changed his life AS TOLD TO MARGY ROCHLIN • PHOTOGRAPHS BY JEFF RIEDEL

146

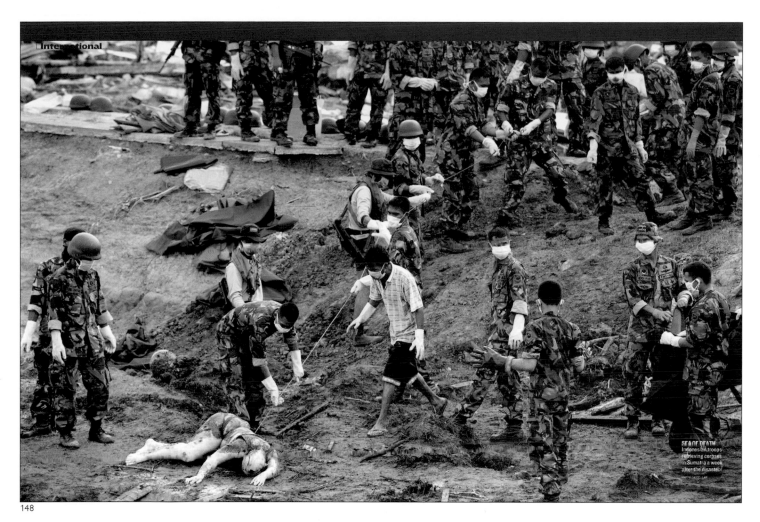

148

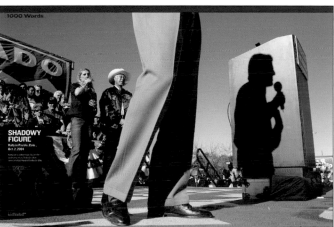

149

150

144 ✳ LIFE
Creative Director: Richard Baker / *Art Director:* Bess Wong / *Designers:* Marina Drukman, Jarred Ford / *Director of Photography:* George Pitts / *Photo Editors:* Crary Pullen, Tracy Doyle Bales, Caroline Smith / *Photographer:* Koto Bolofo / *Publisher:* Time Inc. / *Issue:* December 23, 2005 / *Category:* Photography Spread-Single Page

145 ✳ LIFE
Creative Director: Richard Baker / *Art Director:* Bess Wong / *Designers:* Marina Drukman, Jarred Ford / *Director of Photography:* George Pitts / *Photo Editors:* Crary Pullen, Tracy Doyle Bales, Caroline Smith / *Photographer:* Alec Soth / *Publisher:* Time Inc. / *Issue:* December 9, 2005 / *Category:* Photography Spread-Single Page

146 ✳ LIFE
Creative Director: Richard Baker / *Art Director:* Bess Wong / *Designers:* Marina Drukman, Jarred Ford / *Director of Photography:* George Pitts / *Photo Editors:* Crary Pullen, Tracy Doyle Bales, Caroline Smith / *Photographer:* Jeff Riedel / *Publisher:* Time Inc. / *Issue:* May 13, 2005 / *Category:* Photography Spread-Single Page

147 ✳ MEN'S HEALTH
Design Director: George Karabotsos / *Art Director:* John Dixon / *Director of Photography:* Marianne Butler / *Photographer:* Ramona Rosales / *Publisher:* Rodale Inc. / *Issue:* December 2005 / *Category:* Photography Spread-Single Page

148 ✳ NEWSWEEK
Creative Director: Richard Baker / *Art Director:* Bess Wong / *Designers:* Marina Drukman, Jarred Ford / *Director of Photography:* George Pitts / *Photo Editors:* Crary Pullen, Tracy Doyle Bales, Caroline Smith / *Photographer:* Jeff Riedel / *Publisher:* Time Inc. / *Issue:* May 13, 2005 / *Category:* Photography Spread-Single Page

149 ✳ NEWSWEEK
Creative Director: Lynn Staley / *Art Director:* Alex Ha / *Director of Photography:* Simon Barnett / *Photo Editor:* Michelle Molloy / *Photographer:* Khue Bui (for Newsweek) / *Publisher:* The Washington Post Co. / *Issue:* January 3, 2005 / *Category:* Photography Spread-Single Page

150 ✳ THE NEW YORK TIMES MAGAZINE
Creative Director: Janet Froelich / *Art Director:* Arem Duplessis / *Designer:* Guillermo Nagore / *Photo Editors:* Kathy Ryan, Cavan Farrell / *Photographer:* Tom Schierlitz / *Publisher:* The New York Times / *Issue:* June 12, 2005 / *Category:* Photography Spread-Single Page

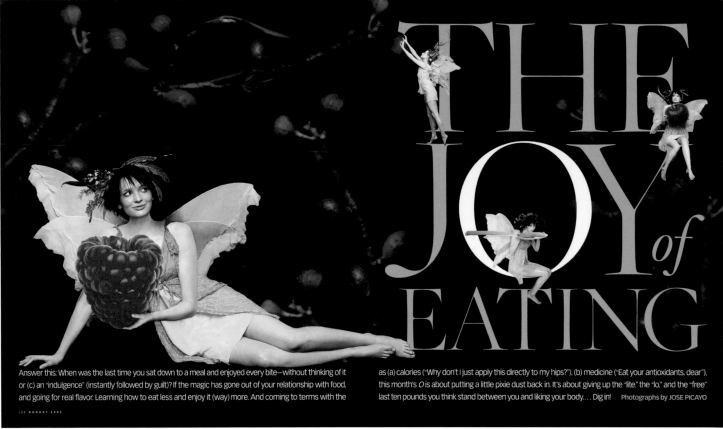

Answer this: When was the last time you sat down to a meal and enjoyed every bite—without thinking of it or (c) an "indulgence" (instantly followed by guilt)? If the magic has gone out of your relationship with food, and going for real flavor. Learning how to eat less and enjoy it (way) more. And coming to terms with the as (a) calories ("Why don't I just apply this directly to my hips?"), (b) medicine ("Eat your antioxidants, dear"), this month's *O* is about putting a little pixie dust back in. It's about giving up the "lite," the "lo," and the "free" last ten pounds you think stand between you and liking your body…. Dig in! Photographs by JOSE PICAYO

151

Nora Ephron:
On Maintenance
She knows time marches on; she just doesn't want it marching on her. How far will one woman go to keep up appearances? Only her colorist, dentist, trainer, Restylane doctor, a Russian woman on the Upper West Side— and now you— know for sure.

152

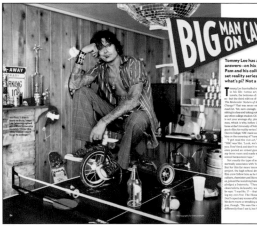

BIG MAN ON CAMPUS

Tommy Lee has all the answers—on his past, Pam and his college-set reality series. But what's pi? Not a clue

153

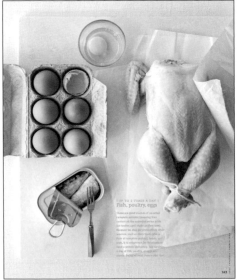

154

151 ✳ O, THE OPRAH MAGAZINE
Design Director: Carla Frank / *Art Director:* Kristin Fitzpatrick / *Designer:* Randall Leers / *Photo Editors:* Hadas Dembo, Kim Gougenheim / *Photographer:* Jose Picayo / *Publisher:* The Hearst Corporation-Magazines Division / *Issue:* August 2005 / *Category:* Photography Spread-Single Page

152 ✳ O, THE OPRAH MAGAZINE
Design Director: Carla Frank / *Art Director:* Lee Berresford / *Photo Editors:* Laurie Kratochvil, Christina Stephens / *Photographer:* Bob Hiemstra / *Publisher:* The Hearst Corporation-Magazines Division / *Issue:* October 2005 / *Category:* Photography Spread-Single Page

153 ✳ PEOPLE
Creative Director: Rina Migliaccio / *Designer:* Will McDermott / *Director of Photography:* Chris Dougherty / *Photo Editor:* Lindsay Tyler / *Photographer:* Emily Shur / *Publisher:* Time Inc. / *Issue:* August 15, 2005 / *Category:* Photography Spread-Single Page

154 ✳ REAL SIMPLE
Creative Director: Vanessa Holden / *Photo Editor:* Lauren Epstein / *Photographer:* Sang An / *Publisher:* Time Inc. / *Issue:* February 2005 / *Category:* Photography Spread-Single Page

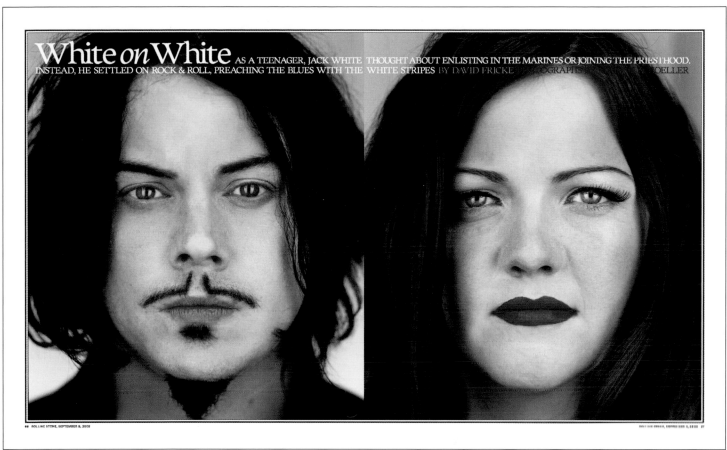

155

156

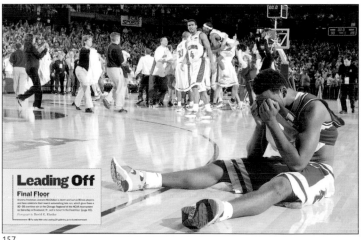

157

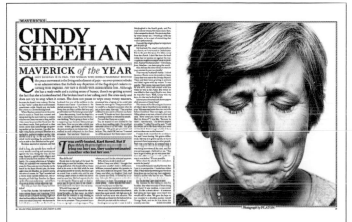

158

155 ✳ ROLLING STONE
Art Director: Amid Capeci / *Designer:* Mathew Cooley / *Photo Editors:* Jodi Peckman,
Deborah Dragon / *Photographer:* Martin Schoeller / *Publisher:* Wenner Media / *Issue:*
September 8, 2005 / *Category:* Photography Spread-Single Page

156 ✳ SPORTS ILLUSTRATED
Creative Director: Steve Hoffman / *Director of Photography:* Steve Fine / *Photo Editor:*
Jimmy Colton / *Photographer:* Bill Frakes / *Publisher:* Time Inc. / *Issue:* January 17, 2005 /
Category: Photography Spread-Single Page

157 ✳ SPORTS ILLUSTRATED
Creative Director: Steve Hoffman / *Director of Photography:* Steve Fine / *Photo Editor:*
Jimmy Colton / *Photographer:* David E. Klutho / *Publisher:* Time Inc. / *Issue:* April 4, 2005 /
Category: Photography Spread-Single Page

158 ✳ ROLLING STONE
Art Director: Amid Capeci / *Designer:* Mathew Cooley / *Director of Photography:* Jodi Peckman /
Photographer: Platon / *Publisher:* Wenner Media / *Issue:* December 29, 2005 / *Category:*
Photography Spread-Single Page

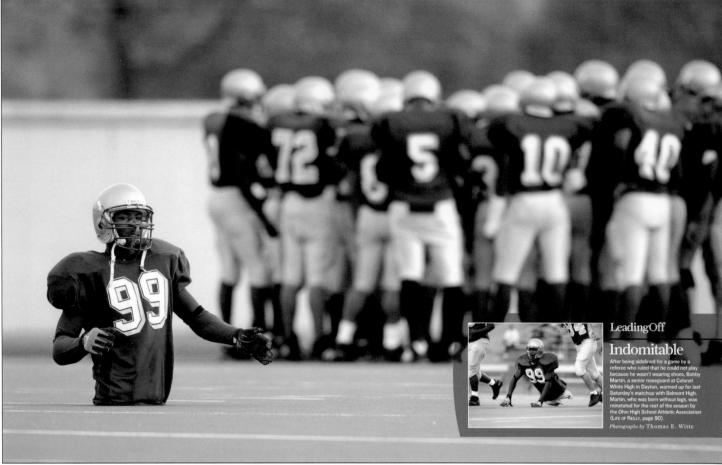

159

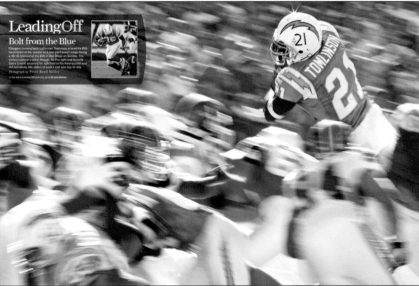

160

159 ✳ SPORTS ILLUSTRATED
Creative Director: Steve Hoffman / *Director of Photography:* Steve Fine /
Photo Editor: Jimmy Colton / *Photographer:* Thomas E. Witte /
Publisher: Time Inc. / *Issue:* October 3, 2005 / *Category:* Photography
Spread-Single Page

160 ✳ SPORTS ILLUSTRATED
Creative Director: Steve Hoffman / *Director of Photography:* Steve Fine /
Photo Editor: Jimmy Colton / *Photographer:* Peter Read Miller /
Publisher: Time Inc. / *Issue:* November 28, 2005 / *Category:*
Photography Spread-Single Page

161 ✳ VANITY FAIR
Design Director: David Harris / *Art Director:* Julie Weiss / *Designer:*
Julie Weiss / *Director of Photography:* Susan White / *Photo Editors:*
Lisa Berman, Kathryn MacLeod / *Photographer:* Annie Leibovitz /
Publisher: Condé Nast Publications Inc. / *Issue:* June 2005 /
Category: Photography Spread-Single Page

162 ✳ VANITY FAIR
Design Director: David Harris / *Art Director:* Julie Weiss / *Designer:*
Lee Ruelle / *Director of Photography:* Susan White / *Photo Editors:* Lisa
Berman, Richard Villani / *Photographer:* Norman Jean Roy / *Publisher:*
Condé Nast Publications Inc. / *Issue:* June 2005 /
Category: Photography Spread-Single Page

163 ✳ VANITY FAIR
Design Director: David Harris / *Art Director:* Julie Weiss / *Designer:*
Scott-Lee Cash / *Director of Photography:* Susan White / *Photo Editors:*
Lisa Berman, Rosanna Sguera / *Photographer:* Paolo Pellegrin /
Publisher: Condé Nast Publications Inc. / *Issue:* February 2005 /
Category: Photography Spread-Single Page

164 ✳ VANITY FAIR
Design Director: David Harris / *Art Director:* Julie Weiss / *Designer:*
Julie Weiss / *Director of Photography:* Susan White / *Photo Editors:*
Lisa Berman, Ron Beinner / *Photographer:* Patrick Demarchelier /
Publisher: Condé Nast Publications Inc. / *Issue:* January 2005 /
Category: Photography Spread-Single Page

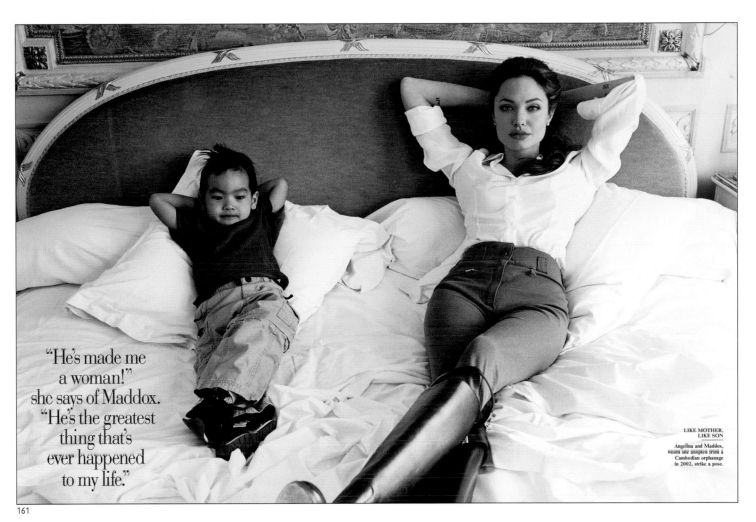

"He's made me a woman!" she says of Maddox. "He's the greatest thing that's ever happened to my life."

LIKE MOTHER, LIKE SON

Angelina and Maddox, whom she adopted from a Cambodian orphanage in 2002, strike a pose.

161

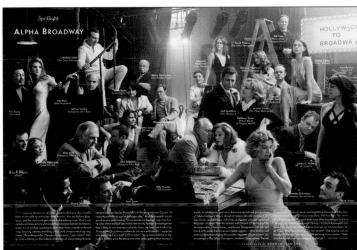

162

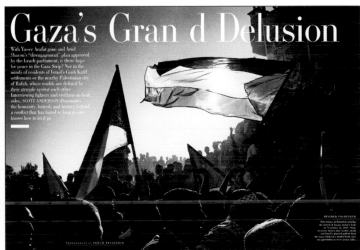

Gaza's Grand Delusion

163 + Merit / Newsstand Magazine (Photography Story)

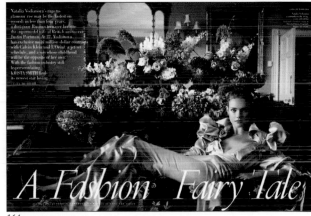

A Fashion Fairy Tale

164

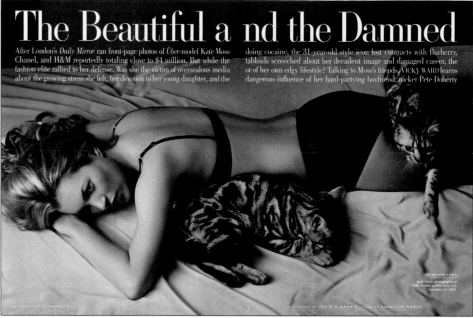

The Beautiful a nd the Damned

After London's *Daily Mirror* ran front-page photos of *Über*-model Kate Moss Chanel, and H&M reportedly totaling close to $4 million. But while the fashion elite rallied to her defense. Was she the victim of overzealous media about the growing stress she felt, her devotion to her young daughter, and the doing cocaine, the 31-year-old style icon lost contracts with Burberry, tabloids screeched about her decadent image and damaged career, the or of her own edgy lifestyle? Talking to Moss's friends, VICKY WARD learns dangerous influence of her hard-partying boyfriend, rocker Pete Doherty

165 + Merit / Newsstand Magazine (Photography Story)

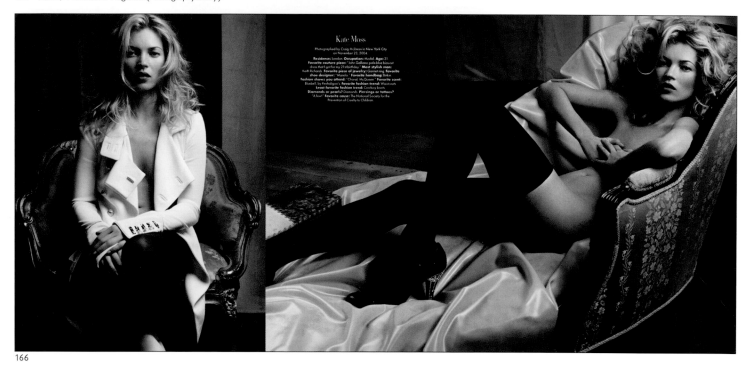

166

165 ✳ VANITY FAIR
Design Director: David Harris / *Art Director:* Julie Weiss / *Designer:* Julie Weiss /
Director of Photography: Susan White / *Photo Editors:* Lisa Berman, Ron Beinner /
Photographer: Craig McDean / *Publisher:* Condé Nast Publications Inc. / *Issue:* April 2005 /
Category: Photography Spread-Single Page

166 ✳ VANITY FAIR
Design Director: David Harris / *Art Director:* Julie Weiss / *Designer:* Julie Weiss /
Director of Photography: Susan White / *Photo Editors:* Lisa Berman, Ron Beinner /
Photographer: Craig McDean / *Publisher:* Condé Nast Publications Inc. / *Issue:* December 2005 /
Category: Photography Spread-Single Page

167 ✳ VANITY FAIR
Design Director: David Harris / *Art Director:* Julie Weiss / *Designer:* Chris Mueller /
Director of Photography: Susan White / *Photo Editors:* Lisa Berman, Kathryn MacLeod /
Photographer: Annie Leibovitz / *Publisher:* Condé Nast Publications Inc. /
Issue: January 2005 / *Category:* Photography Spread-Single Page

168 ✳ VANITY FAIR
Design Director: David Harris / *Art Director:* Julie Weiss / *Designer:* Chris Mueller /
Director of Photography: Susan White / *Photo Editors:* Lisa Berman, Sarah Czeladnicki /
Photographer: Mark Seliger / *Publisher:* Condé Nast Publications Inc. / *Issue:* November 2005 /
Category: Photography Spread-Single Page

169 ✳ VANITY FAIR
Design Director: David Harris / *Art Director:* Julie Weiss / *Designer:* Lee Ruelle /
Director of Photography: Susan White / *Photo Editors:* Lisa Berman, Kathryn MacLeod /
Photographer: Annie Leibovitz / *Publisher:* Condé Nast Publications Inc. / *Issue:* March 2005 /
Category: Photography Spread-Single Page

170 ✳ VANITY FAIR
Design Director: David Harris / *Art Director:* Julie Weiss / *Designer:* Chris Mueller /
Director of Photography: Susan White / *Photo Editors:* Lisa Berman, Kathryn MacLeod /
Photographer: Annie Leibovitz / *Publisher:* Condé Nast Publications Inc. /
Issue: January 2005 / *Category:* Photography Spread-Single Page

171 ✳ VANITY FAIR
Design Director: David Harris / *Art Director:* Julie Weiss / *Designer:* Lee Ruelle /
Director of Photography: Susan White / *Photo Editors:* Lisa Berman, Kathryn MacLeod /
Photographer: Annie Leibovitz / *Publisher:* Condé Nast Publications Inc. /
Issue: March 2005 / *Category:* Photography Spread-Single Page

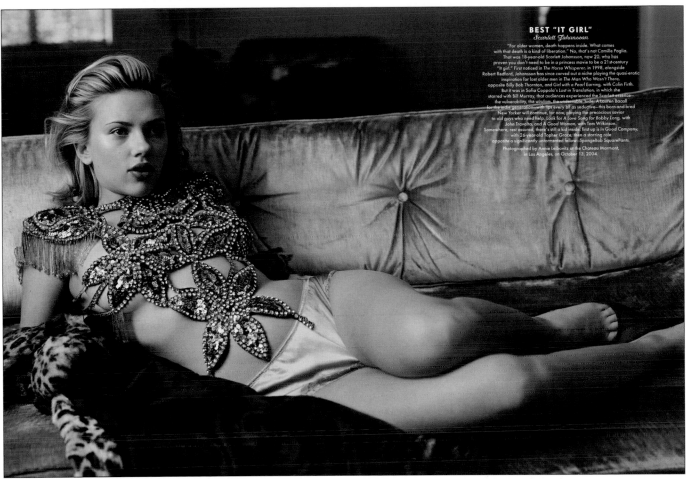

BEST "IT GIRL"
Scarlett Johansson

"For older women, death happens inside. What comes with that death is a kind of liberation." No, that's not Camille Paglia. That was 18-year-old Scarlett Johansson, now 20, who has proven you don't need to be in a princess movie to be a 21st-century "It girl." First noticed in *The Horse Whisperer*, in 1998, alongside Robert Redford, Johansson has since carved out a niche playing the quasi-erotic inspiration for lost older men in *The Man Who Wasn't There*, opposite Billy Bob Thornton, and *Girl with a Pearl Earring*, with Colin Firth. But it was in Sofia Coppola's *Lost in Translation*, in which she starred with Bill Murray, that audiences experienced the Scarlett essence—the vulnerability, the wisdom, the undeniable *Jude*; A Lauren Bacall for the indie generation—with lips every bit as seductive—this born-and-bred New Yorker will continue, for now, playing the precocious savior to old guys who need help. Look for *A Love Song for Bobby Long*, with John Travolta, and *A Good Woman*, with Tom Wilkinson. Somewhere, rest assured, there's still a kid inside; first up is *In Good Company*, with 26-year-old Topher Grace; then a starring role opposite a significantly untormented fellow—SpongeBob SquarePants.

Photographed by Annie Leibovitz at the Chateau Marmont, in Los Angeles, on October 13, 2004.

167 + Merit / Newsstand Magazine (Photography Story)

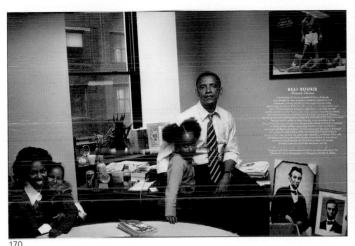

168

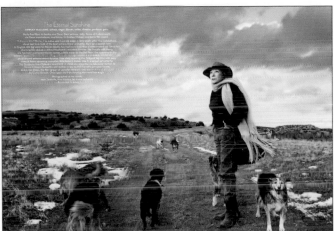

169

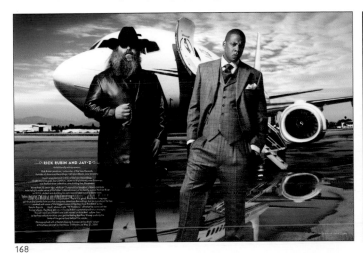

170

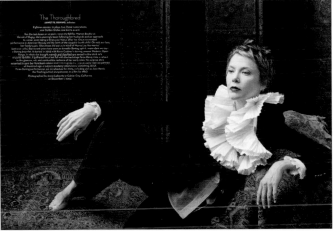

171

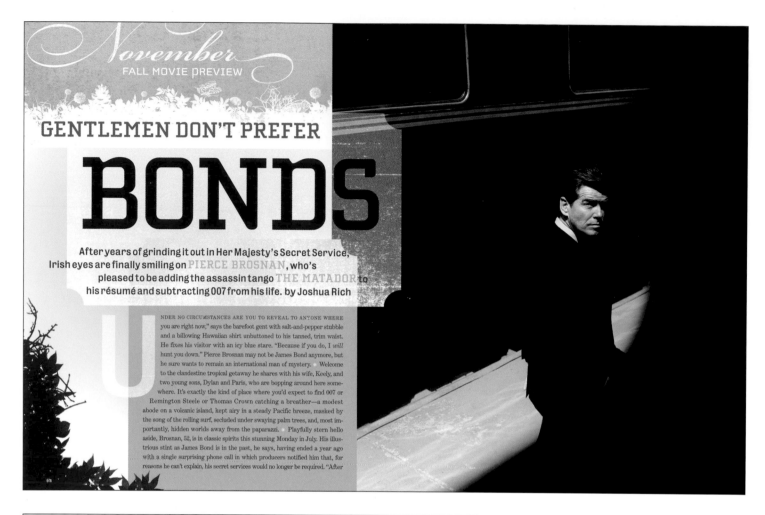

November
FALL MOVIE PREVIEW

GENTLEMEN DON'T PREFER
BONDS

After years of grinding it out in Her Majesty's Secret Service, Irish eyes are finally smiling on PIERCE BROSNAN, who's pleased to be adding the assassin tango THE MATADOR to his résumé and subtracting 007 from his life. by Joshua Rich

NDER NO CIRCUMSTANCES ARE YOU TO REVEAL TO ANYONE WHERE you are right now," says the barefoot gent with salt-and-pepper stubble and a billowing Hawaiian shirt unbuttoned to his tanned, trim waist. He fixes his visitor with an icy blue stare. "Because if you do, I *will* hunt you down." Pierce Brosnan may not be James Bond anymore, but he sure wants to remain an international man of mystery. ✳ Welcome to the clandestine tropical getaway he shares with his wife, Keely, and two young sons, Dylan and Paris, who are bopping around here somewhere. It's exactly the kind of place where you'd expect to find 007 or Remington Steele or Thomas Crown catching a breather—a modest abode on a volcanic island, kept airy in a steady Pacific breeze, masked by the song of the rolling surf, secluded under swaying palm trees, and, most importantly, hidden worlds away from the paparazzi. ✳ Playfully stern hello aside, Brosnan, 52, is in classic spirits this stunning Monday in July. His illustrious stint as James Bond is in the past, he says, having ended a year ago with a single surprising phone call in which producers notified him that, for reasons he can't explain, his secret services would no longer be required. "After

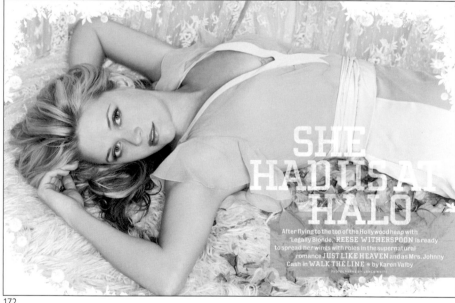

SHE HAD US AT HALO

After flying to the top of the Hollywood heap with 'Legally Blonde,' REESE WITHERSPOON is ready to spread her wings with roles in the supernatural romance JUST LIKE HEAVEN and as Mrs. Johnny Cash in WALK THE LINE ✳ by Karen Valby
PHOTOGRAPHED BY JAMIE WHITE

172

172 ✳ ENTERTAINMENT WEEKLY
Design Director: Geraldine Hessler / *Designer:* Brian Anstey / *Director of Photography:* Fiona McDonagh / *Photo Editor:* Richard Maltz / *Publisher:* Time Inc. / *Issue:* August 19, 2005 / *Category:* Design Story

173 ✳ THE NEW YORK TIMES MAGAZINE
Creative Director: Janet Froelich / *Art Director:* Arem Duplessis / *Designer:* Nancy Harris Rouemy / *Photo Editor:* Kathy Ryan / *Photographer:* Peggy Sirota / *Fashion Editor:* Elizabeth Stewart / *Publisher:* The New York Times / *Issue:* November 20, 2005 / *Category:* Design Story

174 ✳ GOURMET
Creative Director: Richard Ferretti / *Art Director:* Erika Oliveira / *Designers:* Richard Ferretti, Erika Oliveira / *Photo Editor:* Amy Koblenzer / *Photographer:* Martyn Thompson / *Publisher:* Condé Nast Publications, Inc. / *Issue:* May 2005 / *Category:* Design Story

175 ✳ FIELD & STREAM
Art Director: Robert Perino / *Designer:* Robert Perino / *Illustrator:* Jameson Simpson / *Publisher:* Time4 Media / *Issue:* September 2005 / *Category:* Design Story

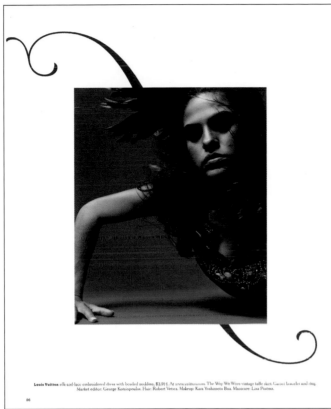

Louis Vuitton silk-and-lace embroidered dress with beaded neckline, $3,914. At www.vuitton.com The Way We Wore vintage taffle skirt. Garnet bracelet and ring. Market editor: George Kotsiopoulos. Hair: Robert Vetica. Makeup: Kara Yoshimoto Bua. Manicure: Lisa Postma.

173

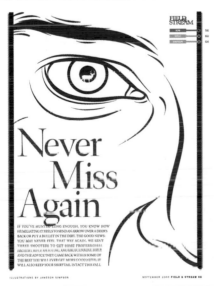
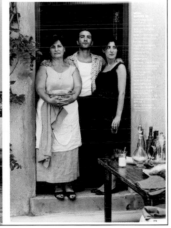

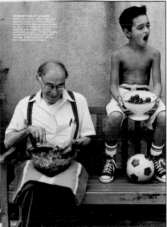

LA DOLCE VIA

From an apartment in old Siracusa to an alfresco feast on the street of New Years, the keys to a Sicilian meal are fresh ingredients and family. Recipes by Gina Marie Miraglia Eriquez. Photographs by Martyn Thompson.

174

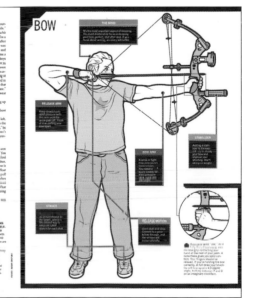

Never Miss Again

IF YOU'VE HUNTED LONG ENOUGH, YOU KNOW HOW HUMILIATING IT FEELS TO SEND AN ARROW OVER A DEER'S BACK OR PUT A BULLET IN THE DIRT. THE GOOD NEWS: YOU MAY NEVER FEEL THAT WAY AGAIN. WE SENT THREE SHOOTERS TO GET SOME PROFESSIONAL ARCHERY, RIFLE OR FLY-FISHING HELP AND THE ADVICE THEY CAME BACK WITH IS SOME OF THE BEST YOU'LL EVER GET. MORE GOOD NEWS: IT WILL ALSO KEEP YOUR SHIRTTAIL INTACT THIS FALL.

Don't Aim

THERE'S NO TRICK TO PUTTING AN ARROW EXACTLY WHERE YOU WANT IT TO GO. AS A MATTER OF FACT, IT'S WHAT YOU SHOULDN'T DO THAT COUNTS THE MOST BY BILL HEAVEY

TEST YOURSELF

CREDENTIALS

BOW

175 + Merit / Newsstand Magazine (Illustration Spread-Single Page)

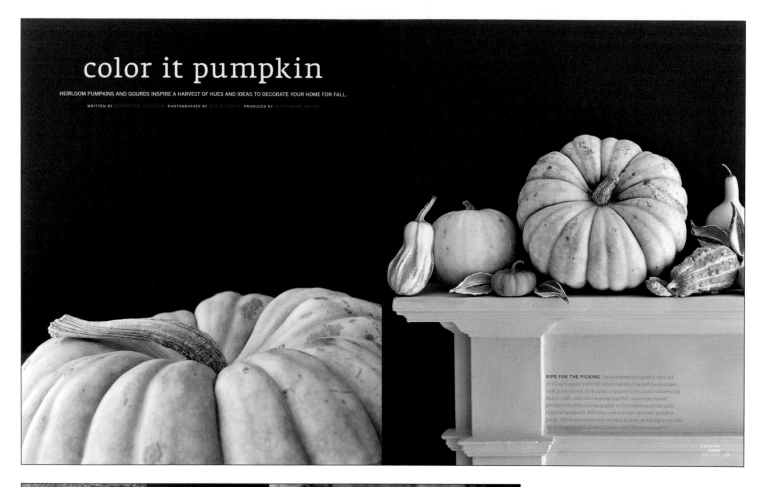

color it pumpkin

HEIRLOOM PUMPKINS AND GOURDS INSPIRE A HARVEST OF HUES AND IDEAS TO DECORATE YOUR HOME FOR FALL.

WRITTEN BY JENNIFER ESZFELD PHOTOGRAPHED BY REED DAVIS PRODUCED BY MATTHEW MEAD

176 + Merit / Newsstand Magazine (Photography Cover)

176 ✳ COUNTRY HOME
Creative Director: Mary Emmerling / *Design Director:* Matthew Mead / *Art Director:* Susan L. Uedelhofen / *Designer:* Mary Beth Majewski /
Image Quality Director: Carolyn Helmrichs / *Photographer:* Reed Davis / *Publisher:* Meredith Corp. / *Issue:* October 2005 / *Category:* Design Story

177 ✳ THE NEW YORK TIMES MAGAZINE
Creative Director: Janet Froelich / *Art Director:* Arem Duplessis / *Designers:* Arem Duplessis, Jeff Glendenning /
Photo Editor: Kathy Ryan / *Photographer:* Dan Winters / *Publisher:* The New York Times / *Issue:* April 3, 2005 /
Category: Design Story

トーキョー・スプリング！Tokyo Spring!

ケジュール

THE MURAKAMI METHOD

Inspired by comic books, cartoon heroes and monster movies, as well as by traditional painted screens, Japan's answer to Andy Warhol has constructed his own theory about what an artist is — along with a sprawling high-low, commercial-artistic enterprise. And his products are very much for export.

By Arthur Lubow

AT THE MORI ARTS CENTER, which is perched atop a skyscraper in the glittering Roppongi Hills development in Tokyo, I recently visited a museum show, "Universal Symbol of the Brand," that displayed (to quote its catalog) "the fascinating development of the history and endeavors of Louis Vuitton, the brand that is not only incredibly popular in Japan but also beloved throughout the world." A sequence of galleries exhibiting luggage and handbags proceeded to a large advertising photograph of the actress Uma Thurman and smaller shots of

runway models, all wearing Vuitton fashions. What drew me to the show, however, were two bags in the variation of the Vuitton pattern that the Japanese contemporary artist Takashi Murakami developed with the company in 2003. The brightly colored Murakami line has been phenomenally successful, with sales reported to be in the vicinity of $300 million. Murakami's handbags were presented along with two small painted screens painted in the same patterns that appear on the bags.

The handbags in the museum exhibition were hardly Mura-

Takashi Murakami at Kaikai Kiki, his factory in Tokyo.
Photographs by Dan Winters

48

トーキョー・スプリング！Tokyo Spring!

der of four preadolescent girls. "When Miyazaki's room was revealed to the public, the mass media announced that it was otaku space," Murakami once told an interviewer. "However, it was just like my room. Actually, my mother was very surprised to see his room and said: 'His room is like yours. Are you O.K.?' Of course, I was O.K. In fact, all of my friends' rooms were similar to his, too." Murakami added that Miyazaki was only "different from us" because he "videotaped dead bodies of little girls he killed."

When the administrators of the Japan Society in New York asked Murakami if he would like to curate an exhibition in their gallery, he resolved to undertake an exploration of the origins of otaku culture, a subject that, he said, is sketchily understood even in Japan. In many of the classic manga and anime stories, the plot revolves around a bomb or radiation device that devastates Tokyo. "I thought, Why does otaku culture so many times have an explosion that looks like an atomic bomb?" he told me, as we sat at the counter of an elegant sushi bar in Tokyo. "I was trying to find out why otaku people are always repeating the same scene and why I was so interested in it myself." And there was a related ques-

by the standards of modern civilization," the Japanese people were "like a boy of 12." The remark ignited headlines across Japan, with furious resentment superseding the tributes that had hailed MacArthur's departure. For a show on otaku culture that would demonstrate how Japanese artists responded to their nation's wartime suffering and postwar subordination, Murakami realized that the title "Little Boy" was perfect. As he told me this story, he sugarcoated the underlying anger and bitterness, as he does so often both in his conversation and his art, with a joke. "Little Boy and Fat Man — now both things are true exactly of the Japanese people," he said, patting his potbelly and ordering an extra helping of sushi.

AT THE BEGINNING of his career, Murakami appeared to be content with the lot of most successful contemporary artists: to create work that is admired by critics and desired by wealthy collectors but leaves the general public baffled or hostile. He was constructing conceptual pieces similar to the art being made in the West. Among them very works, which began attracting attention in the early 90's, was "Polyrhythm", a seven-

tion from the art scene," he told me. "But I hate that reaction. It looks like political art, but I am just joking."

In 1994, with a fellowship from the Manhattan-based Asian Cultural Council, Murakami came to live in New York. During that year he started to re-emphasize his Japaneseness. Upon returning home he began to create objects that looked as if they were applying for admittance to the otaku world even as he also tried to cast an unfamiliar critical spotlight on this insular subculture.

For two years, Murakami researched the concept and execution of "Miss Ko²" (pronounced "ko-ko"), the sculpture that would eventually fascinate Western collectors and set a record at Christie's New York. Collaborating with the designers at Kaiyodo, the pre-eminent manufacturer of figures in Japan, he designed a high-breasted, stiletto-heeled, vapidly smiling blonde in a skimpy waitress uniform. Made of fiberglass, "Miss Ko" is six feet tall, commanding attention as in an art gallery but evoking anxious displeasure among otaku, who like their figures small and submissive.

Murakami provoked the otaku again in 1997 with his next figure, which

ant. "Once Mr. Murakami asked me why my characters cannot be the object of affection. I said: 'When you see Miss Ko², can you masturbate to her? If not, it can't be.' He said, 'No, I couldn't do that.'"

In 1999, at an otaku festival, Murakami released "Second Mission Project Ko²," a three-piece sculptural installation that depicts a favorite otaku theme — a young woman morphing into an airplane. Triumphantly, it was praised by both art critics and otaku. In hindsight, however, their work was a coda. Murakami's sculptures of sexually charged figures, difficult for viewers and expensive for fabricators, form a discrete chapter in his artistic career and his infatuation with otaku. Although this work may be the most interesting he has yet produced, he was dissatisfied. He wanted his characters to be objects of affection. He was a pop artist who longed to be popular.

IF YOU WERE to draw a map of Japanese popular culture (a map like one from the Magellan era, grossly oversimplified but still useful), you might say that male-oriented otaku culture lies at one pole and that the female

"Sea Breeze" This huge piece is made of steel plates that open to reveal, like figures in a shrine, a ring of floodlights.

1992

1991

• **"Randoseru Project"** The skin of endangered or exotic species transformed into the not-so-everyday book bag.

• **"Polyrhythm"** A seven-foot-tall slab of yellow resin literally crawling with U.S. Army soldiers.

1996

• **"727"** The brush and painting technique of this early DOB (the "D" and "B" are ears, the "O" the face) allude to traditional Japanese forms.

• **"And Then, and Then and Then and Then and Then (Blue)"** Although Murakami was making Macy's-parade-like DOB balloons at the time, this is a painting that only looks like a balloon.

"Milk" Inspired by the forms in Edo painting and one of Murakami's favorite animators.

1998

1997

• **"Miss Ko²"** Neither small nor submissive, this figure displeased the otaku.

1999

• **"DOB in the Strange Forest (Red DOB)"** In this room-size sculpture, in which mushrooms look like trees, DOB has morphed from fierce to lovable.

"Kaikai With Moss" The only things "cuter" than the factory mascot are the flowers.

2000

2003

• **"Eye Need You"** The classic Louis Vuitton bag got a face- and culture-lift by Murakami.

tion that intrigued him: "Why do Japanese people hate otaku culture?" He concluded that otaku raised "a mirror" to a reality that the larger culture preferred to ignore. Like many other Japanese intellectuals of his generation, he deplores both his country's militarist past and what he sees as its acquiescent present. "Otaku culture is handicapped reality," Murakami said. "We have to realize we are handicapped, and we don't want to realize it. We know the U.S. is our father. We thought we were children, but we are handicapped people. We need help."

The crystallizing moment for Murakami arrived when he came up with a name for the show. In October, Alexandra Munroe, director of the Japan Society Gallery, was pressing him for an exhibition title and offered a suggestion. "She gave us 'Japanese Pop Culture Explosion,' a really long title," he recalled. "I hate that." Many Americans know that the atomic bombs that dropped on Hiroshima and Nagasaki were nicknamed, respectively, "Little Boy" and "Fat Man." But few remember the testimony that Gen. Douglas MacArthur gave to a Senate committee in 1951 upon completing a tour of more than five years as Supreme Commander of the Allied powers in Japan. MacArthur stated that at the time of the war, when "measured

foot-high slab of yellow resin, minimalist in form, on which many toy United States infantry soldiers climb. Another colossal piece, which he titled "Sea Breeze" after a men's fragrance, was fabricated of steel plates that open automatically to reveal, like figures in a shrine, a ring of high-intensity floodlights. Probably his most talked-about youthful work was the 1991 "Randoseru Project." For it, he collected hides of endangered or exotic species — whale, hippopotamus, cobra and so on — and had them brightly dyed and fabricated into the distinctive book bags, called randoseru, that Japanese schoolchildren have carried on their backs over the last century. Koyama, his Tokyo dealer, who has known Murakami since their university days, recalls that the project began with Murakami's desire to construct an object out of whale skin at a time when Japan, controversially, refused to join an international ban on commercial whaling. Someone suggested the shape of the randoseru. Behind its cuteness, the bag has bellicose overtones: it was adopted by the Japanese in the late 19th century as a Western military model. Murakami has kept an impish distance from the elaborate commentary the work inspired from critics. "'Randoseru,' my early work, got a really good reac-

he titled "Hiropon," after a popular recreational drug in postwar Japan. His idea was that the erotic pretty-girl figures known as bishojo were addictive for the otaku who collected them. Once again he made his figure big (seven feet high), but this time she was anything but vapid. Inspired by a magazine cover he had seen while attending a comic-book otaku gathering, of a bare-breasted woman with a nipple shaped like a penis, he designed a nude (although, in keeping with otaku preferences, one lacking genitalia or pubic hair) who is squeezing from her gargantuan breasts and oversize nipples a stream of milk that swirls behind her like a jump rope. The following year he created a male companion piece, "My Lonesome Cowboy," of a masturbating naked man whose ejaculation floats lasso-style in front of him. Both "Hiropon" and "My Lonesome Cowboy" have the big eyes and grins that are found on popular children's anime and manga characters like Astro Boy (the Japanese name is Mighty Atom) and Sailor Moon. While otaku people generally ignored the "Cowboy" figure, they loathed "Hiropon." "Hiropon' is like a satire, and these figures are the object of affection for otaku people," said Masahiko Asano, an otaku expert whom Murakami has enlisted as a consult-

domain of kawaii (cuteness) is situated at the other. In the mid-90's, Murakami sets sail from otaku toward kawaii. Even while he was investigating otaku model figures, he was already researching kawaii cartoon characters. Such characters, of course, had been a mainstay of Pop Art in the United States since the early 60's. Warhol used images of Mickey Mouse. Lichtenstein raided the funny pages. Murakami, however, did something else. He created his own characters.

His first, Mr. DOB, got his name from an abbreviation of a nonsensical phrase that alluded to many things — a popular television entertainer, a sexual innuendo, the indigenous Ainu people and who knows what else. The phrase also translates, more or less, as "Why? Why?" Since this could serve as Murakami's motto, it was a good choice for a character who became his alter ego. Initially, the DOB character resembled Mickey, but over time he evolved, first turning toothy and fierce, then becoming terribly cute — kawaii. In 1994, Mr. DOB had an ironic content," said the critic Midori Matsui. "It became something different later on — almost like Murakami's own house brand. He was always interested in competing with popular art on a real popular level. The things he did up to 'S.M.P. Ko²' were

"RANDOSERU" ASO; "POLYRHYTHM" TAKASHI MURAKAMI/KAIKAI KIKI COMPANY/SHINGAWA CONTEMPORARY ART, TOKYO; "SEA BREEZE" TAKASHI KURAKAMI/KAIKAI KIKI; "727" TAKASHI MURAKAMI/KAIKAI KIKI/TOKYO KEPPES GALLERY; "AND THEN" ... "MILK" ... "DOB" TAKASHI MURAKAMI/KAIKAI KIKI; "MISS KO²" TAKASHI MURAKAMI/KAIKAI KIKI/MARIANNE BOESKY GALLERY; "KAIKAI" TAKASHI MURAKAMI/KAIKAI KIKI/GALERIE EMMANUEL PERROTIN; "EYE" LOUIS VUITTON

54

THE EMPIRE STRIKES BACK

IMPERIAL VENICE MIGHT BE DEAD, BUT THE REPUBLIC OF THE INNER LIFE FORGES AHEAD. HERBERT MUSCHAMP REFLECTS.

Photographs by MASSIMO VITALI

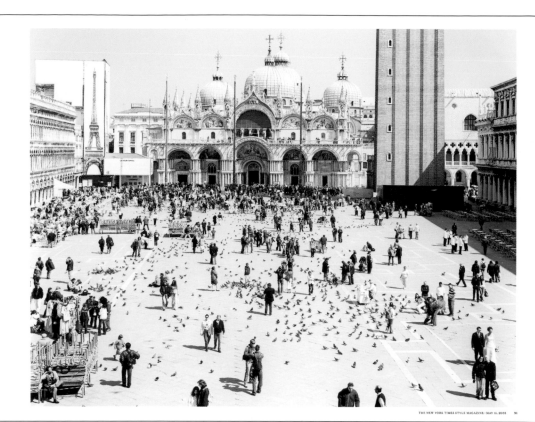

I spy for dead empires.
It's my way of coping with the imperial ambitions of the living. I spy for Venice, Vienna, Istanbul: any imperial city that has lost its global reach.

May I recruit you? We'll dress like American tourists, sip drinks on the terrace of the Gritti Palace and wave to passing groups of fellow agents disguised as Germans, Britons and Japanese. We'll wink knowingly at Russian impostors and counterfeit Swiss. No one will be the wiser, except possibly ourselves.

The dead imperial city is a global place unto itself, an international state of mind built and operated by the curious and doubtful: it is the republic of the inner life. Let others struggle to become a superpower. We prefer the underpower, in superunderwear. Our undercover mission is to form alliances and pacts with the poets and dreamers who have preceded us. We work for them.

Of all the great imperial cities, Venice is the most intact. Its enduring integrity is as scandalous as the fact of its existence. A swamp is not supposed to produce a

St. Mark's place: embracing the cliché of the Venetian tourist at Piazza San Marco.

THE NEW YORK TIMES STYLE MAGAZINE · MAY 15, 2005 91

178

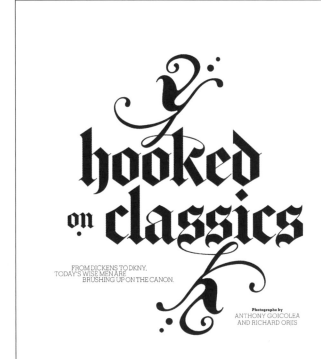

FROM DICKENS TO DKNY, TODAY'S WISE MEN ARE BRUSHING UP ON THE CANON.

Photographs by ANTHONY GOICOLEA AND RICHARD ORJIS

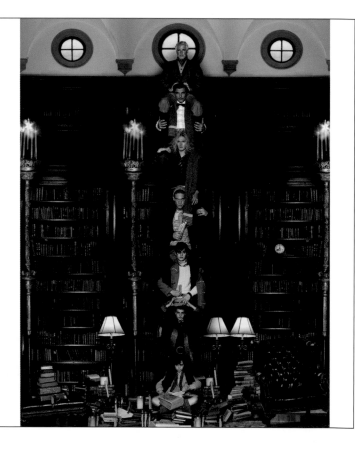

Opposite, from top: Tommy Hilfiger, Gucci, Burberry Prorsum, Marc by Marc Jacobs, Ralph Lauren, DKNY and Tommy Hilfiger Children's clothing. Fashion editor: Jay Massacret.

179

178 ✷ T: THE NEW YORK TIMES STYLE MAGAZINE
Creative Director: Janet Froelich / *Art Director:* David Sebbah / *Designer:* Janet Froelich / *Photo Editor:* Kathy Ryan / *Photographer:* Massimo Vitali / *Publisher:* The New York Times / *Issue:* May 15, 2005 / *Category:* Design Story

179 ✷ T: THE NEW YORK TIMES STYLE MAGAZINE
Creative Director: Janet Froelich / *Art Director:* David Sebbah / *Designer:* Janet Froelich / *Photo Editors:* Kathy Ryan, Judith Puckett-Rinella / *Photographer:* Raymond Meier / *Publisher:* The New York Times / *Issue:* August 28, 2005 / *Category:* Design Story

180 ✷ T: THE NEW YORK TIMES STYLE MAGAZINE
Creative Director: Janet Froelich / *Art Director:* David Sebbah / *Designer:* Christopher Martinez / *Photographers:* Anthony Goicolea, Richard Orjis / *Publisher:* The New York Times / *Issue:* December 4, 2005 / *Category:* Design Story

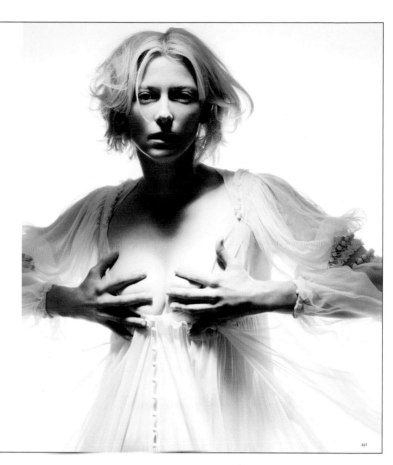

White Mischief

ONE MINUTE, SHE'S THE ARCHANGEL
GABRIEL, AND THE NEXT, MARILYN MANSON.
TILDA SWINTON,
AS LYNN HIRSCHBERG DISCOVERS, IS A
WOMAN OF EXTREMES.
Photographs by Raymond Meier

One of Tilda Swinton's ancestors on her very posh, very military Scottish family tree was painted by John Singer Sargent, and it is easy to imagine Swinton, with her alabaster skin, otherworldly green eyes and regal 5-foot-11 bearing, captured in oils. "I do look like all those old paintings," Swinton joked over a midsummer lunch of raw oysters at the Mercer hotel. "But I'm afraid my temperament does not conform. At all."

She said this, as she said nearly everything, with a mix of direct authority and engaged enthusiasm that was both immediately ingratiating and commanding. Swinton, who is 44, was wearing no trace of makeup, a print sundress and flip-flops, and her hair, which is naturally red, was dyed white-blond. "I love the roots," she said, as she tilted her scalp forward for inspection. "That's the best part of being this blond."

Her unique looks, her ease with herself and her voracious interest in the more esoteric worlds of cinema and style have made Swinton a kind of goddess of the avant-garde. In her movies, she has continually transformed herself — changing class, nationalities, gender. For "Orlando," perhaps her most famous film, she played multiple incarnations of the title character, including a man. In "Thumbsucker," opening in theaters on Sept. 16, she is utterly convincing as a suburban American mom. The director Jim Jarmusch cast her as an ex-girlfriend of Bill Murray's in the recent "Broken Flowers," in which she is terrifying, her face half-obscured by a foreboding curtain of long brown hair. For "The Chronicles of Narnia: The Lion, the Witch and the Wardrobe," a big-budget movie that is due out from Disney at the end of the year, Swinton

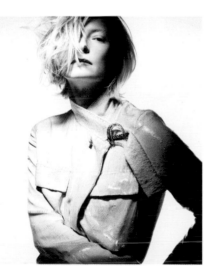

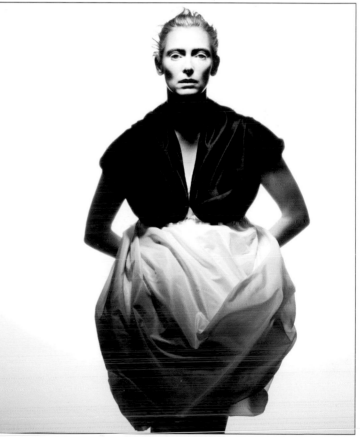

Half 'n' half HAIDER ACKERMANN JACKET, PRICE ON REQUEST, CALL 011 33 1 42 03 91 00. FRED LEIGHTON PIN. BEAUTY NOTE: SWINTON WEARS LANCÔME ISHEER PEACH ORGANZA BLUSH AND L'OTEZ LAUDER MELON LIPSTICK. OPPOSITE: ZERO MARIA CORNEJO DRESS, PRICE ON REQUEST, AIKU SUDERO, $360, AT ZERO, 225 MOTT STREET. PREVIOUS PAGE: YVES SAINT LAURENT GOWN, $12,205, AT YVES SAINT LAURENT BOUTIQUES. THE MAKEUP ARTIST CHRISTIAN MCCOLLUGH USED M.A.C. WHITE FROST EYE SHADOW ON SWINTON.

FASHION EDITOR: TINA LAAKKONEN.

embodies the White Witch. "The studio couldn't understand that someone evil would not have black hair," she said. "They told me, 'She has to be beautiful.' I said: 'The witch will be beautiful; the key is no makeup. After all, she's the White Witch; her face should be bare.' And I think, eventually, they saw my point. She's very scary. I'm fully at peace with the idea that children who see this film will be backing away from me for the rest of my life."

Swinton's own children, 7-year-old twins named Xavier and Honor, will probably not see the movie. They live on a farm in northern Scotland with their father, the writer John Byrne. "As much as I enjoyed playing the White Witch," she said, "it made me realize, as I have before, that I am just not an industrial actor. What is important to me is to find myself around other curious people and to feel involved. That's much easier when you get outside the industry of movies. I'm less interested in just playing a character. I'm more interested in the larger films. Derek

Jarman taught me that it's all about the frame; acting is simply smoke and mirrors. He changed my life by showing me what was possible; he was the first person I ever met that lived as an artist." Until his death in 1994, Jarman was an experimental filmmaker fascinated by two topics that often intersected in his movies: the history of England and homosexuality. He worked with fellow travelers who shot, edited, dressed (Sandy Powell, the Oscar-winning costume designer, started out with Jarman) and acted in his imaginative and transgressive films. Swinton met Jarman after graduating from Cambridge. She went to school to study writing, but began acting, and he immediately recognized her talent. From 1986 to 1994, she starred in eight of his films. "He was a person who found a way to make movies without any studio," she says. "Through him, I saw that I could live in a pre-industrial way."

Swinton's upbringing was the direct opposite: she grew up in privilege. Her family lived in a castle in Scotland that it had owned since the ninth

NEW YORK STATES OF MIND

OUR MAGAZINE POLL REVEALS WHAT THE CITY THINKS ABOUT THE REAL ISSUES: DATING REPUBLICANS, BILL CLINTON'S FUTURE AND THE GIANT INFLATABLE GIULIANI.

○ ━━━━━━ 🖊 POLL ○ ━━━━━━
○ ━━━━━━ ○ ━━━━━━ ○ ━━━━━━
○ ━━━━━━ ○ ━━━━━━ ○ ━━━━━━

By
JOHN TIERNEY
AND CHRISTOPHER BUCKLEY

Photographs by
LISA KERESZI

AFTER POLLING MORE THAN 1,000 New Yorkers, we can confidently report that they love their city and feel quite good about themselves. Self-esteem is not a problem. The poll's respondents think a soaring hawk would be a better city mascot than a rat or a pigeon or neurotic polar bear. Four out of five believe that if you can make it here, you really can make it anywhere.

Overall, though, New Yorkers are not so sure about their politicians. The news is relatively good for Michael Bloomberg. For starters, New Yorkers would rather have him than Rudy Giuliani as their mayor today. And asked whether Bloomberg is truly a Republican at heart, a plurality of Republicans say yes, while a plurality of Democrats suspect that he is still secretly one of them — a rare political win-win. Hillary Clinton fares pretty well, too; a majority say that they would support her for president in 2008. More than a third wouldn't mind seeing her husband back in the Oval Office, either, although another quarter would most like to see him as secretary general of the United Nations or as mayor of New York.

Their affection for the former president may have something to do with his entertainment value. When asked to predict whose husband would produce the most embarrassing headlines during the coming Senate campaigns of Hillary

Clinton and Jeanine Pirro, 43 percent of the respondents picked Albert Pirro, but 33 percent said Bill Clinton.

Giuliani doesn't do nearly as well as Hillary in a prospective presidential race. About half would not support him for president in 2008, and only 38 percent would. Of course, that puts him far ahead of the governor — only 21 percent of New Yorkers would go for Pataki as president in 2008. And perhaps the best news of all for Rudy: if the Macy's Thanksgiving Day Parade featured a balloon of one modern mayor, he would win handily.

New Yorkers admire ambition in themselves (they rated it their best quality), but they are wary of some ambitious pols. When asked to choose the primary effect of Attorney General Eliot Spitzer's measures against businesses, 27 percent said he had protected the public, but 41 percent said he had mainly driven businesses out of state or obtained publicity for himself.

The respondents said New Yorkers' worst quality is impatience, which was manifest in their attitude toward rebuilding

LEVERAGE
An assortment of voting booths found in Manhattan and Brooklyn on Primary Day, Sept. 13.

John Tierney is a columnist for The New York Times. Christopher Buckley is the author, most recently, of "Florence of Arabia."

76

SPITZERISM:

IS A PROSECUTOR'S ZEAL WHAT THE DEMOCRATS NEED?

○ ━━━━━━ ○ ━━━━━━ ○ ━━━━━━
○ ━━━━━━ 🖊 SPITZER, ○ ━━━━━━
 Eliot
○ ━━━━━━ ○ ━━━━━━ ○ ━━━━━━

By
NOAM SCHEIBER

Photograph by
PLATON

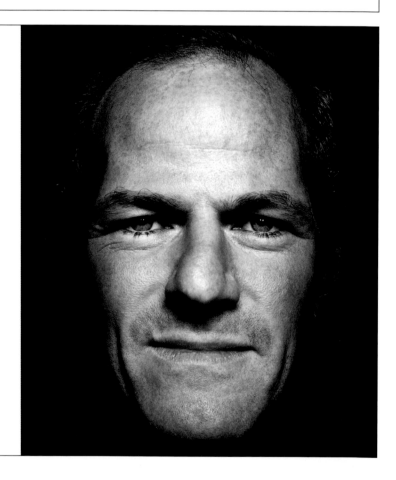

IF RECENT HISTORY IS ANY GUIDE, Eliot Spitzer's chances of becoming governor of New York next year are greatly enhanced by the presence of the words "attorney general" on his résumé. Since 2002, Democrats nationwide have won 18 open seats for governor or senator. Six of the winners had served either as state attorney general or United States attorney. Two others were prosecutors before entering politics. Not even mayors or congressmen were as well represented.

Prosecutors are in a natural position to project toughness, which helps Democratic candidates counter the soft-on-crime reputation that their party, rightly or not, bears. Moreover, middle-class white voters tend to desert Democrats when they seem beholden to organized groups like teachers' unions or trial lawyers. These same voters tend to equate prosecutorial experience with independence from special interests, according to Celinda Lake, a pollster for Gov. Janet Napolitano of Arizona. Lake says this helps explain how Napolitano, a former U.S. attorney and Democratic attorney general, fared unusually well among white men en route to winning the governor's mansion in 2002.

To see that Spitzer could benefit from a similar dynamic next year, you need only consider the polling data. The Democrats' perceived lack of toughness is one reason they typically fare significantly better among women than men. But perceptions of Spitzer, the archetypal enforcer, differ starkly from those of other New York Democrats, even popular ones like Senators Hillary Rodham Clinton and Charles E. Schumer. All three politicians have approval ratings in the neighborhood of 60 percent among the state's voters. But where Schumer and Clinton poll anywhere from 2 to 30 points better among women than among men, Spitzer routinely posts a 4- to 14-point gap in the other direction.

Spitzer, of course, isn't simply the beneficiary of this prosecutorial model; he helped create it. The attention surrounding his investigations of Wall Street revealed a popular hunger for taking on corporate fraud. Perhaps

78

181 ✳ THE NEW YORK TIMES MAGAZINE
Creative Director: Janet Froelich / *Art Director:* Arem Duplessis / *Designer:* Jeff Glendenning / *Photo Editor:* Kathy Ryan /
Publisher: The New York Times / *Issue:* October 2, 2005 / *Category:* Design Story

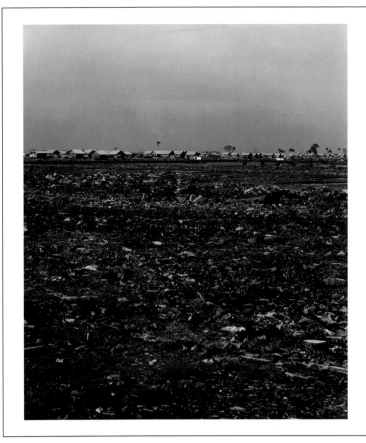

The New York Times Magazine / NOVEMBER 27, 2005

JALOE WAS ON
HIS BOAT. MAISARA WAS
MAKING BREAKFAST.
HAIKAL WAS
SLEEPING LATE.
ROMI HAD JUST
BOUGHT SOME RICE
WITH COCONUT MILK.
FARIDAH WAS
WALKING HOME.
DR. SRI
WAS FINISHING HER
SHIFT IN THE
EMERGENCY ROOM.

THIS IS THE STORY OF WHAT HAPPENED NEXT—TO THEM AND THEIR WORLD.

The Day the Sea Came
By Barry Bearak

Photographs by Taryn Simon

Remains of the day, nearly a year later: Rubble and decay where homes once stood in Banda Aceh.
In the distance, barracks built by charitable organizations.

ILLUSTRATIONS BY MARC ALARY

47

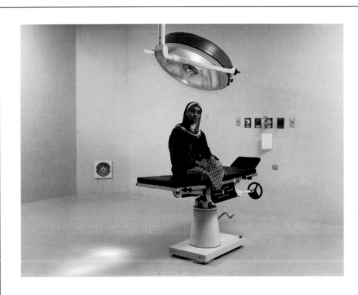

the doctor

SRI

In an operating room at the general hospital. She survived because of a change
in scheduling and was then besieged by patients.

62 PHOTOGRAPHS BY TARYN SIMON FOR THE NEW YORK TIMES.

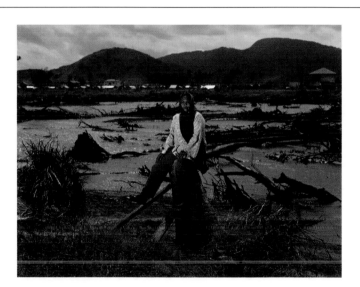

the shopkeeper

FARIDAH

Her home once stood on this spot. She was taken in by an elderly stranger and
then continued to look for her missing loved ones.

182 ✳ THE NEW YORK TIMES MAGAZINE
Creative Director: Janet Froelich / *Art Director:* Arem Duplessis / *Designer:* Jeff Glendenning / *Photo Editor:* Kathy Ryan /
Photographer: Taryn Simon / *Publisher:* The New York Times / *Issue:* November 27, 2005 / *Category:* Design Story

Happy as we would be to use this page of text to discuss some of the fascinating issues raised by the subject of celebrity photography— the complicity of the spectator as a participant in the voyeuristic gaze of the lens, the complicity of the celebrity herself, the notion of whether a glimpse of said celebrity caught unawares and then frozen in time is somehow more "real" than a posed photo shoot, the fact that these days, even the faux-incognito look of pulled-back-hair-baseball-cap-and-workout-clothes-on-the-way-from-the-gym is as carefully styled and calibrated as any appearance on the red carpet—it is our duty as journalists to put all that aside for now and begin this story by asking: What are you doing here? Seriously. What are you doing here? Our photographer, James White, has taken more than a dozen pages of pictures of Cameron Diaz, one of the most beautiful women in Hollywood. On the last of those pages, you can see her in a very flimsy bathing suit, the upper portion of which remains attached to her only by an act of wavering willpower. And you're *reading*? Please. Go ahead. Flip forward and look at the pictures. We'll wait.

No, really. We'll be right here. Go.

You're back? Good. We hope our mirrors-within-mirrors joke gets a smile out of you: a celebrity who has been famously dogged by paparazzi agreeing to collaborate with a non-paparazzo photographer in re-creating that long-lens, slightly blank-faced, "I'm just trying to have a vacation and be naked at the same time" look that has launched a thousand tabloids. We've all looked at those pictures, in the checkout aisle, on the Internet: the middle-aged leading man cavorting in the surf, a surprisingly frail, human amalgam of blob and paunch and uncertain hairline. The gorgeous young actress on the hotel balcony suddenly looking a little less sculpted than we'd imagined. The young, thought-to-be-Apollonian heartthrob on the nude beach peeling down and, to paraphrase David Niven, showing the whole world his shortcomings. They're pictures that shouldn't be taken. They're pictures that we wouldn't want taken of us. They're pictures that we can't resist because they seem to capture larger-than-life people at moments when they're simply life-size (and occa-

by Mark Harris

sionally even smaller), and that somehow decodes them for us.

"It felt really creepy," James White says about his experience taking those long-lens pictures of Diaz, probably the most challenging part of a two-day shoot that pays tribute in many different forms to the complex relationship between celebrity and shooter. We sympathize: No reputable photographer wants to walk in the shoes of what White calls "bad elements in the profession." And Diaz, who is nothing if not an extraordinarily good sport, also takes pains to point out the distinction between "paparazzo" and "photographer." "Those guys who you see on the red carpet are all credentialed photographers, and I feel really bad for them, because they're the guys they always show in those paparazzi things on E!, and they're totally nice and respectable. It's very different than the guys who track and stalk people all day long. *Those guys* are paparazzi." It's a distinction worth remembering—something to think about the next time you see Diaz walk the red carpet, an occasion that's likely to coincide with this week's opening of her new movie *In Her Shoes*, the Curtis Hanson-helmed comedy-drama about the struggle between two sisters. In the movie, Diaz plays the "pretty" sister, a young woman who is both misjudged because of her sexual allure (yeah, we know, boo-hoo, right?) and not above using it to get what—and who—she wants.

Take some time to daydream about some of the other pictures in White and Diaz's portfolio: Diaz in the car on the next page, for instance, seemingly caught just seconds before she arrives somewhere to be flash-frozen in a haze of exploding lights. Is she having a private moment, or does she know that she'll look even more beautiful if she acts like she doesn't know she's being photographed? Or the beach shot where she seems to be inviting all of that press attention, an homage to an old image from Cannes that reminds us there's nothing so new about the contemporary celebrity's dilemma, something to think about next time you see, say, Whitney Houston dressed in ostentatious celebrity mufti (head scarf, shades, *and* a visor) imploring photographers to stop taking her picture *while* she is being followed by her husband's reality-show cameras. The desire to be famous versus the desire to be private can be very...complicated. And entertaining. We hope these pictures capture that.

> **❝I was just the model for the story. This was like playing a character, or playing a moment, which I really enjoyed.❞**

34

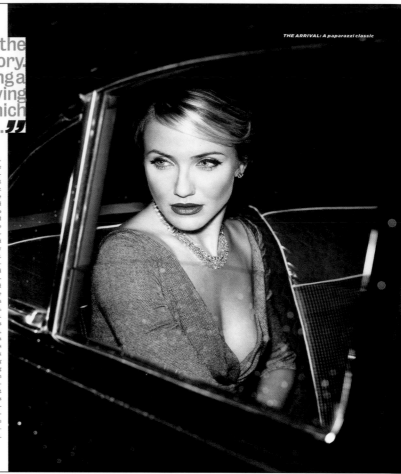
THE ARRIVAL: A paparazzi classic

183

the simple life

"TIS THE GIFT TO BE SIMPLE, 'TIS THE GIFT TO BE FREE..." SAYS AN OLD SHAKER HYMN—A PHILOSOPHY EMBRACED BY THE OWNERS OF THIS SERENE AND SPARE NEW ENGLAND RETREAT. STORY PROSE, IN NEW ENGLAND

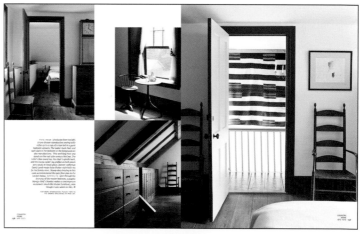

184

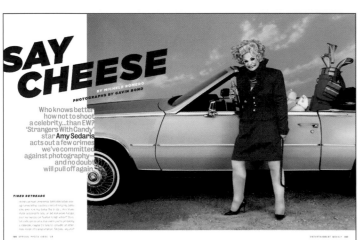

SAY CHEESE

BY MICHELE SONES
PHOTOGRAPHS BY GAVIN BOND

Who knows better how not to shoot a celebrity...than EW? 'Strangers With Candy' star **Amy Sedaris** acts out a few crimes we've committed against photography—and no doubt will pull off again

TIRED RETREADS

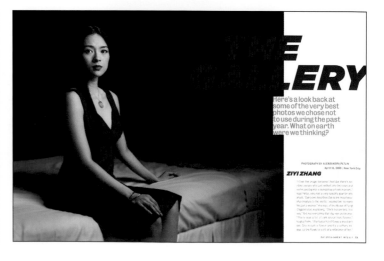

...E GALLERY

Here's a look back at some of the very best photos we chose not to use during the past year. What on earth were we thinking?

PHOTOGRAPHY BY ALEKSANDRA PETLIN
April 16, 2005 • New York City

ZIYI ZHANG

185

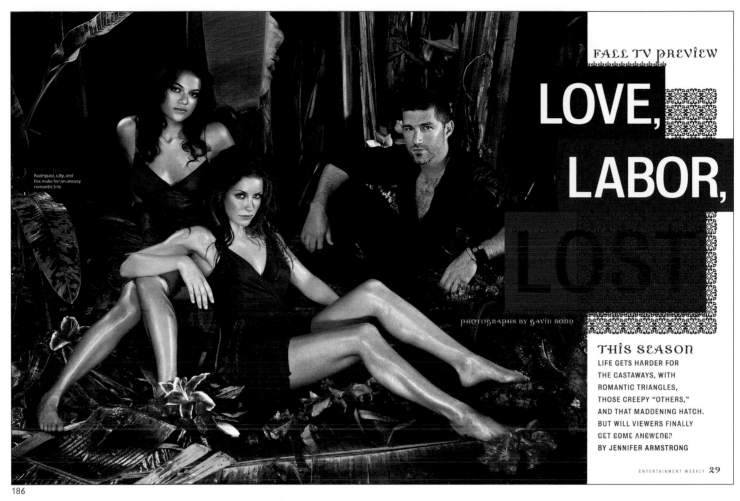

186

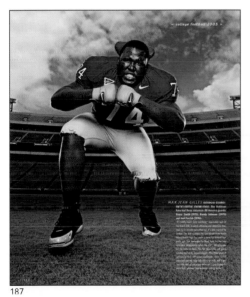
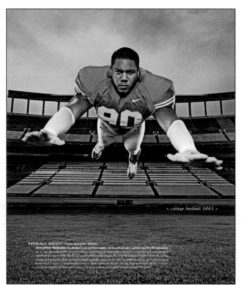
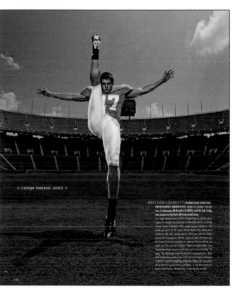

187

183 ✳ ENTERTAINMENT WEEKLY
Design Director: Geraldine Hessler / *Designer:* Theresa Griggs / *Director of Photography:* Fiona McDonagh / *Photographer:* James White / *Publisher:* Time Inc. / *Issue:* October 14, 2005 / *Category:* Photography Story

184 ✳ COUNTRY HOME
Creative Director: Mary Emmerling / *Design Director:* Tricia Foley / *Art Director:* Susan L. Uedelhofen / *Designer:* Karla Knipper / *Image Quality Director:* Carolyn Helmrichs / *Photographer:* Jeff McNamara / *Publisher:* Meredith Corp. / *Issue:* May 2005 / *Category:* Photography Story

185 ✳ ENTERTAINMENT WEEKLY
Design Director: Geraldine Hessler / *Designer:* Theresa Griggs / *Director of Photography:* Fiona McDonagh / *Photo Editor:* Michele Romero / *Photographer:* Gavin Bond / *Publisher:* Time Inc. / *Issue:* October 14, 2005 / *Category:* Photography Story

186 ✳ ENTERTAINMENT WEEKLY
Design Director: Geraldine Hessler / *Designer:* Theresa Griggs / *Director of Photography:* Fiona McDonagh / *Photo Editors:* Audrey Landreth, Suzanne Regan / *Photographer:* Gavin Bond / *Publisher:* Time Inc. / *Issue:* September 9, 2005 / *Category:* Photography Story

187 ✳ ESPN THE MAGAZINE
Design Director: Siung Tjia / *Director of Photography:* Catriona NiAolain / *Photo Editors:* Jim Surber, Andrea Buman, Joe Rodriquez / *Photographer:* Vincent Soyez / *Publisher:* ESPN, Inc. / *Issue:* August 29, 2005 / *Category:* Photography Story

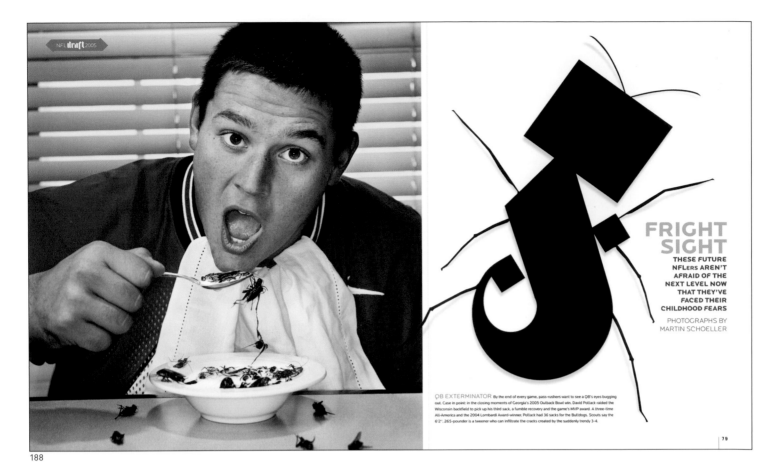

FRIGHT
SIGHT

THESE FUTURE
NFLers AREN'T
AFRAID OF THE
NEXT LEVEL NOW
THAT THEY'VE
FACED THEIR
CHILDHOOD FEARS

PHOTOGRAPHS BY
MARTIN SCHOELLER

QB EXTERMINATOR By the end of every game, pass-rushers want to see a QB's eyes bugging out. Case in point: in the closing moments of Georgia's 2005 Outback Bowl win, David Pollack raided the Wisconsin backfield to pick up his third sack, a fumble recovery and the game's MVP award. A three-time All-America and the 2004 Lombardi Award-winner, Pollack had 36 sacks for the Bulldogs. Scouts say the 6'2", 265-pounder is a tweener who can infiltrate the cracks created by the suddenly trendy 3-4.

188

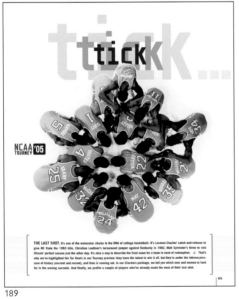

THE LAST SHOT. It's one of the molecular chains in the DNA of college basketball. It's Lorenzo Charles' catch-and-release to give NC State the 1983 title, Christian Laettner's turnaround jumper against Kentucky in 1992, Matt Sylvester's three to ruin Illinois' perfect season just the other day. It's also a way to describe the final exam for a team in need of redemption. ✳ That's why we've highlighted the Tar Heels in our Tourney preview: they have the talent to win it all, but they're under the intense pressure of history (ancient and recent), and time is running out. In our Clockers package, we tell you which men and women to look for in the waning seconds. And finally, we profile a couple of players who've already made the most of their last shot.

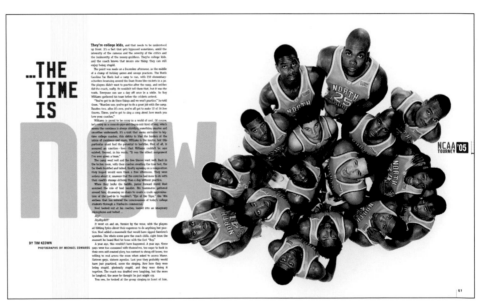

...THE
TIME
IS
NOW

BY TIM KEOWN
PHOTOGRAPHS BY MICHAEL EDWARDS

They're college kids, and that needs to be understood up front. It's a fact that gets bypassed sometimes, amid the intensity of the cameras and the severity of the critics and the insincerity of the money-grubbers. They're college kids, and the coach knows that means one thing: they can still enjoy being stupid.

The point was made on a December afternoon, in the middle of a clump of holiday games and intense practices. The North Carolina Tar Heels had a camp to run, with 350 elementary-schoolers bouncing around the front-three-line crickets in a jar. The players didn't want to practice after the camp, and neither did the coach, really. He wouldn't tell them that, but it was the truth. Everyone can use a day off once in a while. So Roy Williams gathered his team before the crickets arrived.

"You've got to do these things and we won't practice," he told them. "Besides you, you've got to do a great job with the camp. Besides you, after it's over, you're all get to make 12 of 16 free throws. Three, you've got to sing a song about how much you love your coaches."

Williams is proud to be camp in a world of cool. Of course he's camp in a console-pipe-and-bayou-salt kind of way, which meets the corniness is always chiseling something smarter and smoother underneath. It's a trait that seems exclusive to big-time college coaches, this ability to blur the borders of the union of corniness and smarts. Williams is the master, but this particular stunt had the potential to backfire. First of all, it assumed an exaction—love—that Williams couldn't be sure existed. Second, in his words, "It was the oldest arrangement I've ever given a team."

The camp went well and the free throws went well. Back in the locker room, with their coaches awaiting the first half, the Tar Heels huddled and talked, finally agreeing on a composition they hoped would save them a free afternoon. They were serious about it, unaware that the exercise had more to do with their coach's strange alchemy than a day without practice.

When they broke the huddle, junior forward David Noel assumed the role of lead vocalist. His teammates gathered around him, drumming on chairs to create a crude approximation of the need to be Raitten's "Eye of the Tiger," the Tar Heels that has entered the consciousness of today's college students through a Starbucks commercial.

Noel looked out at his coaches, leaned into an imaginary microphone and belted...

AnyRayRiff?

It went on and on, Sooner by the nose, with the players all flashing lyrics about their eagerness to do anything but practice. Noel added a mouthful that would have signed Sweeten's spandex. The whole scene gave the coach chills, right from the moment he heard Noel hit those with the first "Roy."

A year ago, this wouldn't have happened. A year ago, these guys were too consumed with themselves, too eager to bask in their own self-created glory, too-content to shrug off losses, too willing to read across the maze when asked to access blame. Sixteen guys, sixteen agendas. Last year they probably would have just practiced, since the singing, how how they were being stupid, gloriously stupid, and they were doing it together. The coach was doubled over laughing, but the more he laughed, the more he thought he just might cry.

Yes you, he looked at the group singing in front of him.

189

188 ✳ ESPN THE MAGAZINE
Design Director: Siung Tjia / *Art Director:* Chris Martinez / *Director of Photography:* Catriona NiAolain / *Photo Editor:* Jim Surber /
Photographer: Martin Schoeller / *Publisher:* ESPN, Inc. / *Issue:* April 25, 2005 / *Category:* Photography Story

189 ✳ ESPN THE MAGAZINE
Design Director: Siung Tjia / *Director of Photography:* Catriona NiAolain / *Photographer:* Michael Edwards /
Publisher: ESPN, Inc. / *Category:* Photography Story

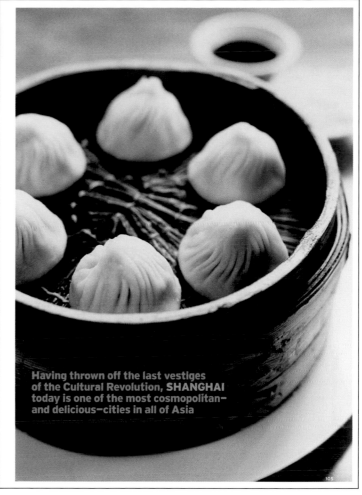

190

191

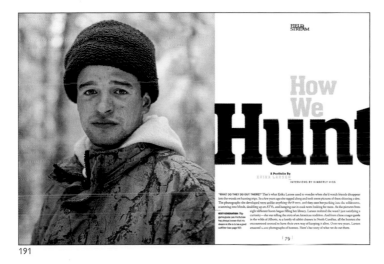

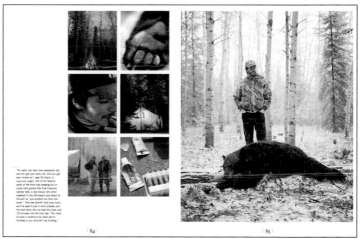

190 ✳ GOURMET
Creative Director: Richard Ferretti / *Designer:* Nanci Smith / *Photo Editor:* Amy Koblenzer / *Photographer:* Petrina Tinslay /
Publisher: Condé Nast Publications, Inc. / *Issue:* February 2005 / *Category:* Photography Story

191 ✳ FIELD & STREAM
Art Director: Robert Perino / *Designers:* Robert Perino, Sarah Garcea / *Photo Editor:* Amy Berkley / *Photographer:* Erika Larsen /
Publisher: Time4 Media / *Issue:* December 2005-January 2006 / *Category:* Photography Story

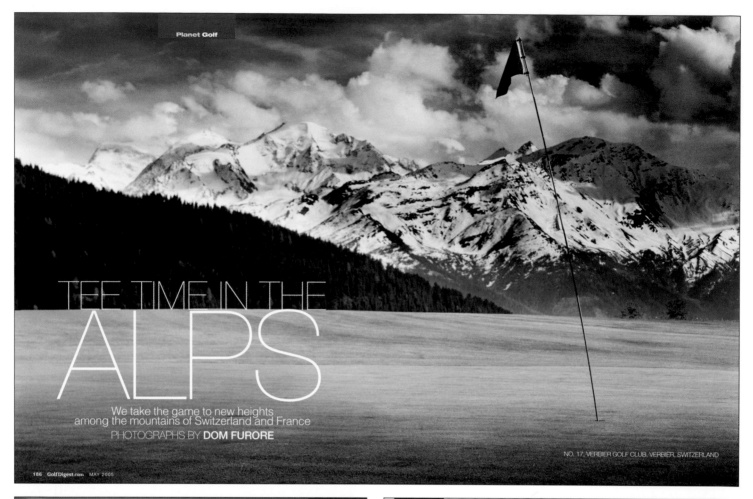

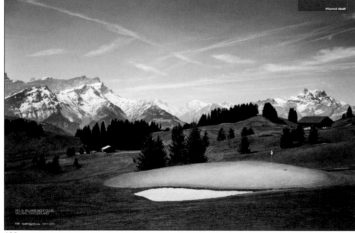

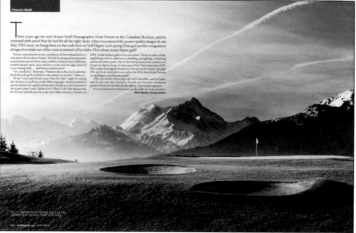

192 ✻ GOLF DIGEST
Design Director: Edward Mann / *Art Director:* Tim Oliver / *Designer:* Edward Mann / *Photo Editor:* Matthew M. Ginella /
Photographer: Dom Furore / *Publisher:* Condé Nast Publications Inc. / *Issue:* May 2005 / *Category:* Photography Story

193 ✻ LIFE
Creative Director: Richard Baker / *Art Director:* Bess Wong / *Designers:* Marina Drukman, Jarred Ford /
Director of Photography: George Pitts / *Photo Editors:* Crary Pullen, Tracy Doyle Bales, Caroline Smith /
Photographer: Marc Asnin / *Publisher:* Time Inc. / *Issue:* January 28, 2005 / *Category:* Photography Story

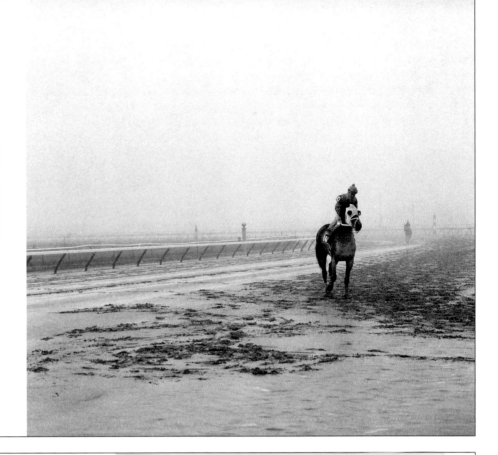

Rise and shine: A trainer's assistant gets a smooch during morning sessions (below, left), while a security guard watches the horses head in after their exercise. Right: Having run their race, the horses are turned back toward the paddock.

The Ponies in Winter

There is no off-season for the horses, trainers, or jockeys at the racetrack known as the Big A. Day after day, they perform for the same devout congregation of sports fans and gamblers, a flock whose passion is boundless.

Photographs by Marc Asnin

LIFE JANUARY 29, 2005

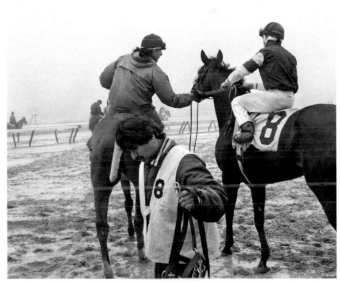

The rhythms always begin before dawn at the track, and in winter in the Northeast, where dawn arrives late and cold, those rhythms kick in well before first light. Horses are tended while the night's still black. When there's finally enough morning gray for an animal to find its way around a turn, the ponies are put through their paces. Clouds of hot breath stream from their nostrils as they're led back to the barn.

Throughout the morning, more humans arrive. Stewards. Security. Tellers. The barber, who'll do a few $8 "senior specials" today. Sam, who'll play his post-time bugle. Barbara, who'll tend her sandwich-and-bagel stand—twenty-ninth year in concessions. It's all first-name-basis at the track—Aqueduct, "the Big A," in Queens, New York—where those who work "the winter meeting" know their colleagues, and know many of the bettors, too.

The midweek crowd is one of regulars—regular attendance, regular habits, regular rhythms. The Big A, built in the '50s, can hold 75,000. On a Wednesday in winter, there are maybe 2,500. Many of them never go outside, sitting resolutely in front of TV screens in lounges that are everywhere. Most wear ball caps and jeans. Some are in tweeds and ties, dressed for the track. Some wager at the windows, some use machines; those who go to the windows never use machines, and vice versa. Ritual and superstition underlie all.

It can seem quiet at the track in winter—there is seldom any clapping, even at a race's end, and what cheering there is seems more like shouting: "Get up there. . . . Get up there!" "Get off the whale!" "Keep pushin' 'im, you're not pushin' 'im enough!" Movement, beyond that of the horses, is slow. The patrons shuffle about, they flow. No one hurries. No one waits in line for anything—to place a bet, to get chowder from Barbara—because there are no lines.

"Where's Tommy?" Barbara is asked by one of her regulars, about another of her regulars.

"Tommy died," she says. "Illness took him. He was one of the best." Tommy used to sit in his wheelchair right over there, wheel himself outside for the race, then wheel back in to get warm. A dance.

Top row: Tommy, outside for five minutes to watch a race; bettors look for an edge; a family cheering during the weekend, when crowds are bigger. Above: Jockey Ariel Smith is known for success with long shots. Left: Vinnie surveys the scene. Opposite: Horses are led to the post.

Tommy had many friends here. In the enormous expanses of the tracks the fans and gamblers are able to be left alone, or to find companionship—to build a winter family—as they choose.

Up to the grandstand, in the exact same seats they occupy just about every weekday, Chuck and Vinnie, retirees, greet each other. They don't really socialize away from the track. At the Big A, however, they've been pals for more than a dozen years. Just now, Chuck is off to place a bet, or maybe to visit his wife, who works downstairs as a teller. Vinnie,

when asked, tries to explain his passion for the track in winter. "You see friends," he says, while continuing with his midday diet of cigarettes and beef jerky. "You get to express your judgment nine times a day. To make the right decision and make money—that's golden. And fresh air! I need air. Some guys stay inside and watch. That's a sin. Look at the panorama." He gazes out upon the brown track and the buildings beyond, under a cold white-blue sky. "There's beauty here.

"I just love it, a day like today." ■

LIFE JANUARY 29, 2005　　　　JANUARY 29, 2005 LIFE

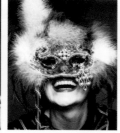
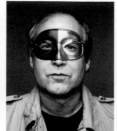

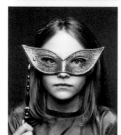

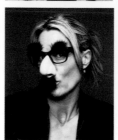

WHO'S BEHIND THE MASK?

TURN THE PAGE TO FIND OUT!

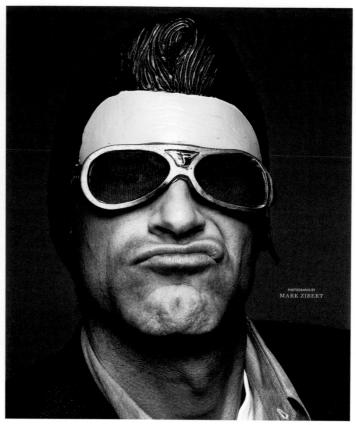

PHOTOGRAPHS BY
MARK ZIBERT

ROBERT DOWNEY JR.
Starring in *Kiss Kiss, Bang Bang*

BRENDA BLETHYN
Costarring in *Pride & Prejudice*

CHEVY CHASE
Starring in *Goose!*

DAKOTA FANNING
Starring in *Dreamer: Inspired by a True Story*

ROBIN WRIGHT PENN
Starring in *Sorry, Haters*

VAL KILMER
Starring in *Kiss Kiss, Bang Bang*

JENNIFER TILLY
Costarring in *Tideland*

WILLIAM H. MACY
Costarring in *Thank You for Smoking*

LIFE asked these famous faces
to hide behind their favorite
Halloween mask. And, yes,
after the photo shoot,
we gave them some candy.

Now that you know who's behind the mask, here's how this elaborate masquerade parade came to be: During this year's Toronto International Film Festival, LIFE invited red-carpet rovers to disguise themselves for our camera. More surprising than their choice of mask was how instantly these actors brought their alter egos to life. Our glittery kitty, Robert Downey Jr., clawed and meowed for the camera, while Aaron Eckhart tapped into his inner Elvis, snarl and all. Most interesting was the dilemma faced by former Caped Crusader Val Kilmer. He instinctively reached for a Batman hood but then thought better of it and slipped on a hockey mask instead. Final score: Maple Leafs, 1; Bruce Wayne, 0. ∎

AARON ECKHART
Starring in *Thank You for Smoking*

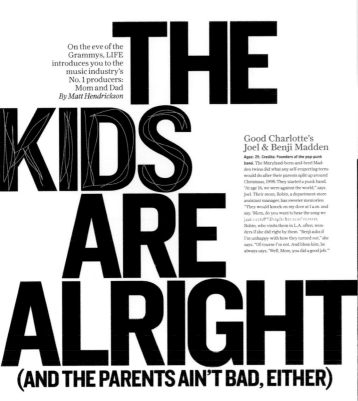

On the eve of the Grammys, LIFE introduces you to the music industry's No. 1 producers: Mom and Dad
By Matt Hendrickson

THE KIDS ARE ALRIGHT

(AND THE PARENTS AIN'T BAD, EITHER)

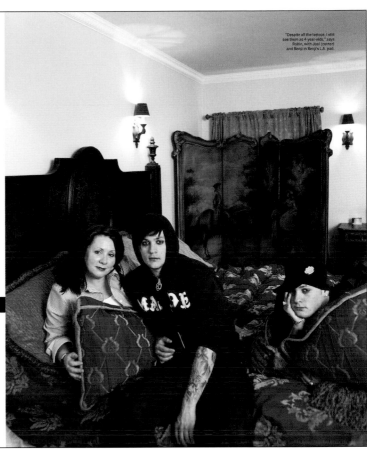

"Despite all the tattoos, I still see them as 4-year-olds," says Robin, with Joel (center) and Benji in Benji's L.A. pad.

Good Charlotte's Joel & Benji Madden

Ages: 25. **Credits:** Founders of the pop-punk band. The Maryland-born-and-bred Madden twins did what any self-respecting teens would do after their parents split up around Christmas, 1995: They started a punk band. "At age 16, we were against the world," says Joel. Their mom, Robin, a department-store assistant manager, has sweeter memories: "They would knock on my door at 1 a.m. and say, 'Mom, do you want to hear the song we just wrote?'" Despite her sons' success, Robin, who visits them in L.A. often, wonders if she did right by them. "Benji asks if I'm unhappy with how they turned out," she says. "Of course I'm not. And bless him, he always says, 'Well, Mom, you did a good job.'"

4 | LIFE FEBRUARY 11, 2005 Photograph by Joao Canziani

195

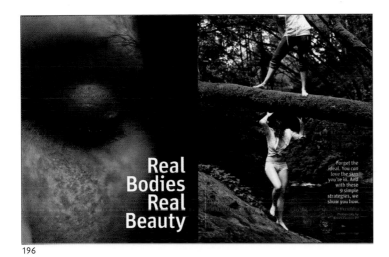

Real Bodies Real Beauty

Forget the ideal. You *can* love the skin you're in. And with these 9 simple strategies, we show you how.

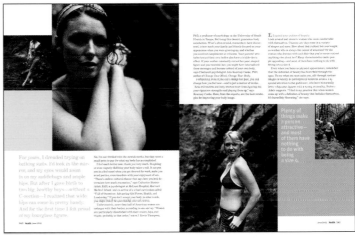

196

194 ✳ LIFE
Creative Director: Richard Baker / *Art Director:* Bess Wong / *Designers:* Marina Drukman, Jarred Ford /
Director of Photography: George Pitts / *Photo Editors:* Crary Pullen, Tracy Doyle Bales, Caroline Smith /
Photographer: Mark Zibert / *Publisher:* Time Inc. / *Issue:* October 28, 2005 / *Category:* Photography Story

195 ✳ LIFE
Creative Director: Richard Baker / *Art Director:* Bess Wong / *Designers:* Marina Drukman, Jarred Ford /
Director of Photography: George Pitts / *Photo Editors:* Crary Pullen, Tracy Doyle Bales, Caroline Smith /
Photographers: Sage Sohier, Joao Canziani / *Publisher:* Time Inc. / *Issue:* February 11, 2005 / *Category:* Photography Story

196 ✳ HEALTH
Design Director: Paul Carstensen / *Art Director:* Kevin de Miranda / *Designers:* Kevin de Miranda,
Christen Colvert, Jenn McManus / *Photo Editor:* Michelle Hauf / *Photographer:* Brown Cannon III /
Publisher: Southern Progress Corporation / *Issue:* June 2005 / *Category:* Photography Story

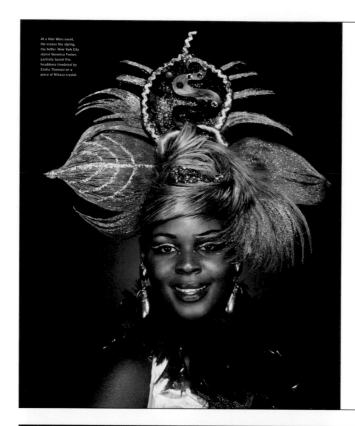

At a Hair Wars event, the crazier the styling, the better. New York City stylist Veronica Forbes partially based this headdress (modeled by Eisha Thomas) on a piece of Mikasa crystal.

I LOVE WHAT YOU'VE DONE WITH
⟡ YOUR ⟡
HAIR

There are no bad hair days at a Hair Wars contest, where stylists use vats of gel, bushels of hair extensions, and jaw-dropping ingenuity to build the world's most outrageous styles

BY MARK JACOBSON • PHOTOGRAPHS BY DAVID YELLEN

Hair is theater, hair is freedom, hair is a way of life," exclaims David Humphries. And Humphries, a man who has turned hair into a traveling follicle-centric road show/fashion extravaganza called Hair Wars, should know. On one Sunday almost every month, audiences in cities like Detroit, Miami, and New York will pack a hotel ballroom or a theater for a chance to see the world's most gravity-defying twists and twirls. Some call it a hirsute version of NASCAR.

A onetime Detroit DJ, Humphries, 48, first hit upon the idea of hair as entertainment in the early 1980s. "Hair has always been a big topic with black people," says the soft-spoken impresario. "We tend to spend a lot more time thinking about it—and spending more money on it—than other people." In the Motor City, where some salons stay open 24/7, Humphries's hair parties, then held at clubs, caught on quickly. "We said to stylists, 'Show up in your wildest dos,'" he recalls. "Hairdressers got aggressive with it. Extensions. Rainbow hues, two feet high. Snakes and flowers. Spiderwebs. Zippered beehives hiding champagne bottles. People started cheering, jumping up and down. And I knew we had something."

Now, 20 years later, Hair Wars has become a wholly choreographed catwalk-cum-hip-hop cabaret that showcases the work of dozens of the best-known hair entertainers. It has traveled coast to coast, while still remaining out of sight of the mainstream. The show features a running

APRIL 1, 2005 LIFE 11

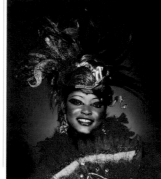

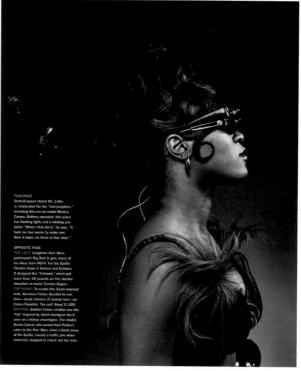

cast of hair designers (including the six-foot-four, 280-pound, 42-year-old bodybuilder Big Bad D, who sports a yard-long cable-style do of his own) and models (some shown here) but is also open to any lock-proud neophyte. "We go to a city and ask people to sign up," says Humphries. Not strictly a competition, since there are no winners chosen or cash prizes handed out, Hair Wars nevertheless generates a lot of competitive spirit. These are true weave-and-braid, tease-and-curl throw-downs, with designers entered from all over the country. The real prize, says Humphries, is the bragging rights you earn for "breaking the hair barrier."

"Creating fantasy hair is my thing," says Veronica Forbes, the proprietress of Veronica's Beautyrama, located in New York City. She joined the Hair Wars circuit when Humphries brought the show to the Apollo Theater, in Harlem, last year. Since then, Forbes, 53, has created several Hair Wars classics, including a memorial to the Twin Towers (a stately assemblage of Styrofoam, hair spray, shiny rocks, glue, and yards of red, white, and blue hair) and a Sunday-best "hat" (at right).

Forbes's motto—"If you can't grow it, Veronica will sew it"—reveals the secret behind the outlandish stylings. A copious pate is not essential to the Hair Wars experience. Little (or, sometimes, none) of the hair the audience sees is homegrown. Most is, in fact, imported from Asia, where a 14-inch piece of human hair can fetch $140. (Synthetic hair, gnarly to the touch and susceptible to melting under a blow-dryer, is eschewed at Hair Wars.) That's why an elaborate Hair Wars headdress, which often takes months to realize, can cost several thousand dollars.

Over the years, the Hair Wars productions have grown progressively more ornate—there are now skits to accompany the getups. For Humphries, however, the most important thing is to show off the work of the hair designers. "These people are true artists," he says, "as brilliant in expressing people's inner feelings as any sculptor."

12 LIFE APRIL 1, 2005

THIS PAGE
Detroit-based stylist Mr. Little is celebrated for his "hairycopters," including this one we model Monica Cooper. Battery-operated, this piece has flashing lights and a rotating propeller. "When I first did it," he says, "it took me two weeks to make one. Now it takes me three or four days."

OPPOSITE PAGE
TOP LEFT: Longtime Hair Wars participant Big Bad D gets many of his ideas from HGTV. For the Apollo Theater show in Harlem last October, D designed this "fishbowl," which put more than 58 pounds on the slender shoulders of model Terricka Rogers.
TOP RIGHT: To create this Asian-inspired look, Veronica Forbes decided to use fans—made entirely of human hair—on Clarice Pamphile. The cost? About $1,000.
BOTTOM: Another Forbes creation won this "hat" inspired by stylish headgear she'd seen on a fellow churchgoer. The model, Keisha Caesar, who walked from Forbes's salon to the Hair Wars show a block away at the Apollo, caused a traffic jam when motorists stopped to check out her hair.

197 ✳ LIFE
Creative Director: Richard Baker / *Art Director:* Bess Wong / *Designers:* Marina Drukman, Jarred Ford /
Director of Photography: George Pitts / *Photo Editors:* Crary Pullen, Tracy Doyle Bales, Caroline Smith /
Photographer: David Yellen / *Publisher:* Time Inc. / *Issue:* April 1, 2005 / *Category:* Photography Story

198 ✳ NATIONAL GEOGRAPHIC
Design Director: David Whitmore / *Art Director:* Elaine Bradley / *Photo Editor:* Kurt F. Mutchler /
Photographer: Michael Melford / *Publisher:* National Geographic Society / *Issue:* April 2005 /
Category: Photography Story

CIVIL WAR BATTLEFIELDS

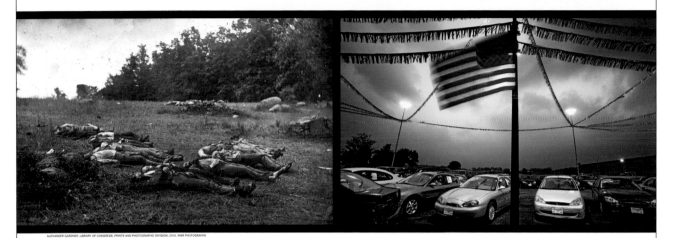

ALEXANDER GARDNER, LIBRARY OF CONGRESS, PRINTS AND PHOTOGRAPHIC DIVISION, CIVIL WAR PHOTOGRAPHS

Saving the Landscapes of America's Deadliest War

CONFEDERATE DEAD LITTERED THE BATTLEFIELD OF GETTYSBURG, where a Union victory helped turn the tide of war. Today a car lot sits within Gettysburg National Military Park. But the lot will soon be removed and the land restored to how it likely looked in 1863—one small victory in the raging fight to save the Civil War's bloodstained lands from vanishing under sprawl.

3

TRAFFIC ARTERIES FLOW THROUGH THE HEART of Manassas National Battlefield Park, site of the first major clash between North and South. Columns of commuters file slowly past Stone House, a tavern that served as a field hospital during and after the battle. On most weekday afternoons, rush-hour traffic clogs spots that thousands of soldiers crossed en route to battle. Rangers advise against trying a driving tour of the park after 2:30 p.m.

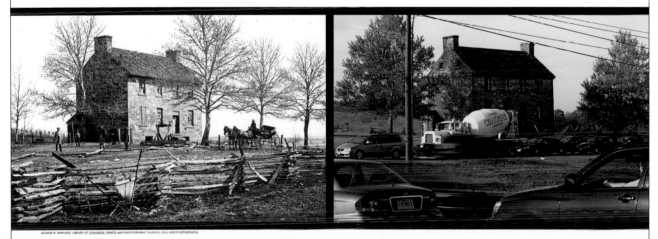

GEORGE N. BARNARD, LIBRARY OF CONGRESS, PRINTS AND PHOTOGRAPHIC DIVISION, CIVIL WAR PHOTOGRAPHS

Manassas, Virginia · July 1861 & August 1862

CASUALTIES U.S. 16,780 C.S. 10,100

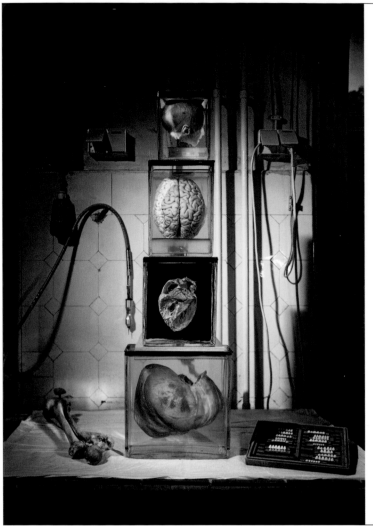

Immature and full of potential, stem cells haven't yet differentiated into the specialized cells that form body parts, like the museum specimens (left) stacked in the Berlin lab of pathologist Rudolf Virchow. He pioneered the idea, in the 1800s, that disease begins at the cellular level.

The Power to Divide

stem cells could launch a new era of medicine, curing deadly diseases with custom-made tissues and organs. But science may take a backseat to politics in deciding if—and where—that hope will be realized.

By Rick Weiss │ Photographs by Max Aguilera-Hellweg, M.D.

3

199

199 ✻ NATIONAL GEOGRAPHIC
Design Director: David Whitmore / *Art Director:* David Whitmore / *Photo Editor:* Todd James / *Photographer:* Max Aguilera-Hellweg, M.D. /
Publisher: National Geographic Society / *Issue:* July 2005 / *Category:* Photography Story

200 ✻ NATIONAL GEOGRAPHIC
Design Director: David Whitmore / *Art Director:* David Whitmore / *Photo Editor:* Bill Douthitt / *Photographer:* Lynn Johnson /
Publisher: National Geographic Society / *Issue:* September 2005 / *Category:* Photography Story

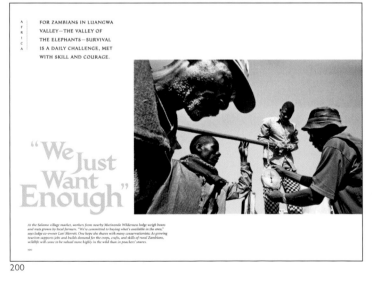

A
F
R
I
C
A

FOR ZAMBIANS IN LUANGWA VALLEY—THE VALLEY OF THE ELEPHANTS—SURVIVAL IS A DAILY CHALLENGE, MET WITH SKILL AND COURAGE.

"We Just Want Enough"

At the Salama village market, workers from nearby Mutinondo Wilderness lodge weigh beans and maize grown by local farmers. "We're committed to buying what's available in the area," says lodge co-owner Lari Merrett. One hopes she shares with many conservationists: As growing tourism supports jobs and builds demand for the crops, crafts, and skills of rural Zambians, wildlife will come to be valued more highly in the wild than in poachers' snares.

MEAT GOES TO MARKET │

Dried on the bone, raffia-tied bundles of illegal bush meat feed a brisk demand in Lusaka. Traders buy the meat from poachers and deliver it directly to regular customers in the capital city. Like shoppers in wealthy countries who pay extra for meat from free-range, organically raised animals, many urban Zambians prefer wild meat—which shows status and respect for tradition—to that of domestic livestock. Penalties for buying and selling poached game are harsh, but enforcement is difficult. Wild meat also enters the food supply legally from game ranches, licensed hunting, harvests on communal lands, and culling of problem animals.

200

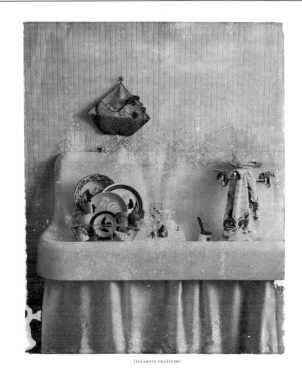

[POLAROID TRANSFER]

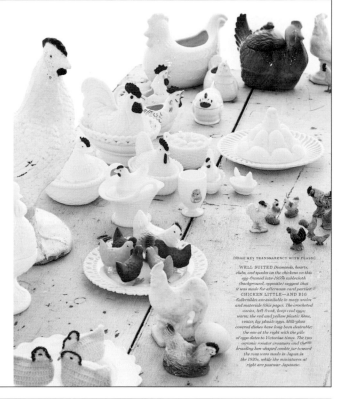

[HIGH-KEY TRANSPARENCY WITH FLASH]
WELL SUITED *Diamonds, hearts, clubs, and spades in the chickens on this egg-framed late-1950s tablecloth (background, opposite) suggest that it was made for afternoon card parties.* CHICKEN LITTLE—AND BIG *Collectibles are available in many sizes and materials (this page). The crocheted cozies, left front, keep real eggs warm; the red and yellow plastic hens, center, lay plastic eggs. Milk-glass covered dishes have long been desirable; the one at the right with the pile of eggs dates to Victorian times. The two ceramic rooster creamers and the brooding hen-shaped cookie jar toward the rear were made in Japan in the 1950s, while the miniatures at right are postwar Japanese.*

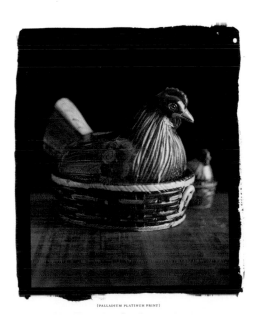

[PALLADIUM PLATINUM PRINT]

PEDIGREED POULTRY *Breeding fancy chickens became popular during the nineteenth century, and many books memorialized prize specimens. Most of these have been broken up and sold as individual plates, as in the case of the orange Buff Cochin hen (opposite, far left) from England; the rooster (center) from Britain; and the black pair (right) from Germany. The large diagram on muslin was made for students; the flash card above it taught basic addition. Also at this collector's desk are a stereopticon slide, propped atop the rooster's frame; a 1940s McCoy pitcher; and pressed-paper German candy containers.* CHICKEN TO GO *Large terra-cotta covered dishes (this page) have been made in Mexico for the tourist market for years. The thinner the clay, the older and more collectible the dish.*

[POLAROID NEGATIVE SILVER PRINT]

[TRIPLE EXPOSURE]

[CYANOTYPE]

[RING FLASH]

FINE FEATHERED FRIENDS *Building a nest egg was the goal of early-twentieth-century savers who used the cast-iron coin bank (this page, top left). The big tail of the molded-copper weather vane (top right) tells of changes in the wind. The century-old, three-foot-high bronze, from Benin in West Africa (above left), shows the rooster as a creature of noble, royal bearing. Concrete lawn hens (above right) have been made from the same molds for decades; the earliest examples have better-defined features, although these may be obscured by layers of paint.* PECKING ORDER *"Boomerang" tail feathers indicate that the dish towel at bottom right (opposite) is from the late 1950s. The printed chicken at top right is realistic, while the embroidered ones at center right are whimsical.*

124 SEE THE GUIDE FOR SOURCES | CREATED BY MATTHEW AXE, FRITZ KARCH, AND REBECCA ROBERTSON

201 ✳ MARTHA STEWART LIVING
Creative Director: Eric Pike / *Art Directors:* James Dunlinson, Joele Cuyler, / *Deputy Art Director:* Matthew Axe /
Designers: Fritz Karch, Rebecca Robertson / *Photo Editors:* Heloise Goodman, Andrea Bakacs / *Photographer:* Christopher Baker /
Publisher: Martha Stewart Living Omnimedia / *Issue:* April 2005 / *Category:* Photography Story

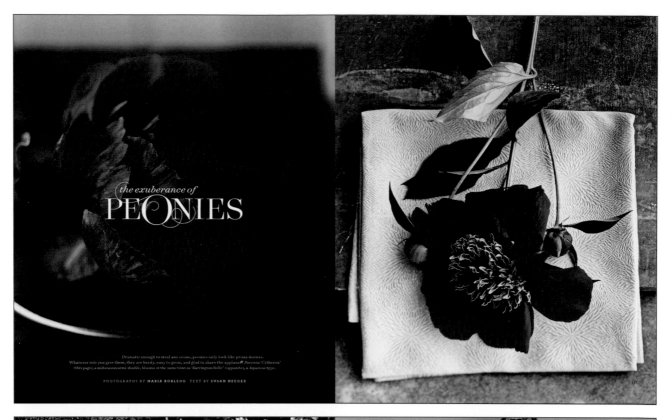

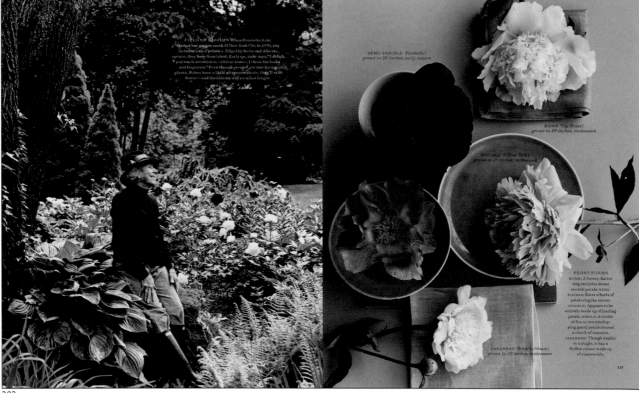

202

202 ✻ MARTHA STEWART LIVING
Creative Director: Eric Pike / *Art Directors:* James Dunlinson, Joele Cuyler / *Deputy Art Director:* Matthew Axe /
Designer: Mary Jane Callister / *Photo Editors:* Heloise Goodman, Andrea Bakacs / *Photographer:* Maria Robledo /
Stylist: Tanya Graff / *Publisher:* Martha Stewart Living Omnimedia / *Issue:* May 2005 / *Category:* Photography Story

203 ✻ NATIONAL GEOGRAPHIC
Design Director: David Whitmore / *Art Director:* Robert Gray / *Photo Editor:* Kathy Moran / *Photographer:* Joel Sartore /
Publisher: National Geographic Society / *Issue:* August 2005 / *Category:* Photography Story

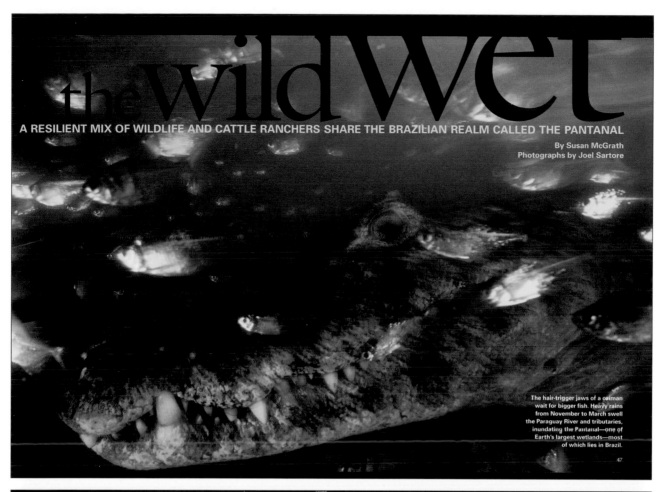

the wild wet

A RESILIENT MIX OF WILDLIFE AND CATTLE RANCHERS SHARE THE BRAZILIAN REALM CALLED THE PANTANAL

By Susan McGrath
Photographs by Joel Sartore

The hair-trigger jaws of a caiman wait for bigger fish. Heavy rains from November to March swell the Paraguay River and tributaries, inundating the Pantanal—one of Earth's largest wetlands—most of which lies in Brazil.

47

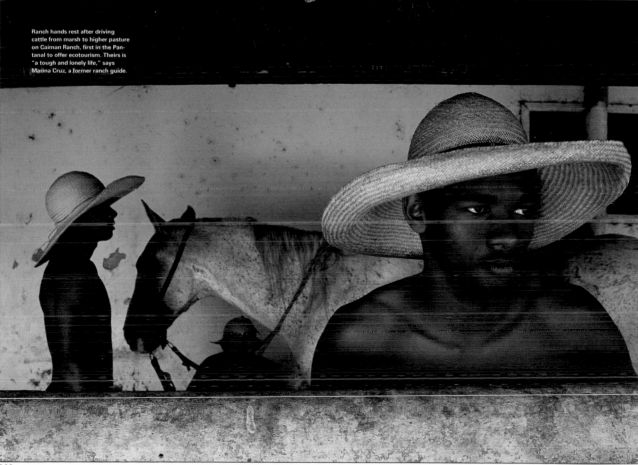

Ranch hands rest after driving cattle from marsh to higher pasture on Caiman Ranch, first in the Pantanal to offer ecotourism. Theirs is "a tough and lonely life," says Marina Cruz, a former ranch guide.

IN CENTRAL AFRICA,
WAR AND INNOCENCE
COLLIDE IN A TALE
OF PYGMIES, REBELS,
SORCERERS, AND
DREAMERS.

Who Rules the Forest?

Though blind, young Apatite Vecent (foreground) must use other senses as he endures rites of manhood alongside his peers, learning to survive in the Ituri forest.

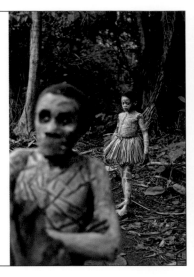

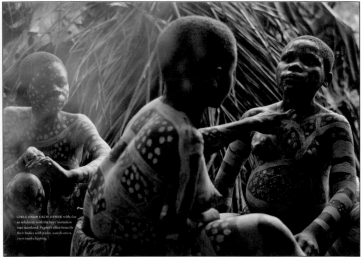

GIRLS DAUB EACH OTHER with clay in solidarity with the boys' initiation into manhood. Pygmies often beautify their bodies with paint, scarification, even tooth chipping.

204

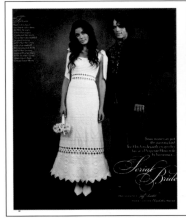

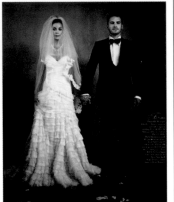

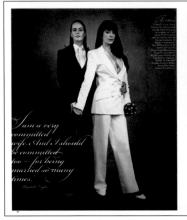

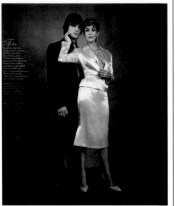

205

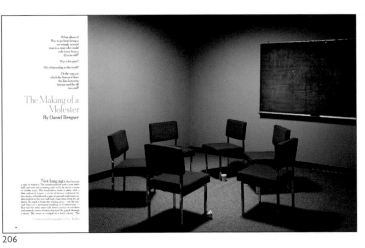

The Making of a Molester
By Daniel Bergner

206

204 ✳ NATIONAL GEOGRAPHIC
Design Director: David Whitmore / *Art Director:* David Whitmore / *Photo Editor:* Kathy Moran / *Photographer:* Randy Olson /
Publisher: National Geographic Society / *Issue:* September 2005 / *Category:* Photography Story

205 ✳ THE NEW YORK TIMES MAGAZINE
Creative Director: Janet Froelich / *Art Director:* Arem Duplessis / *Designer:* Jeff Glendenning / *Photographer:* Jeff Riedel /
Fashion Editor: Elizabeth Stewart / *Publisher:* The New York Times / *Issue:* January 16, 2005 / *Category:* Photography Story

206 ✳ THE NEW YORK TIMES MAGAZINE
Creative Director: Janet Froelich / *Art Director:* Arem Duplessis / *Designers:* Arem Duplessis, Kristina DiMatteo / *Photo Editors:* Kathy Ryan,
Joanna Milter / *Photographer:* Eric Tucker / *Publisher:* The New York Times / *Issue:* January 23, 2005 / *Category:* Photography Story

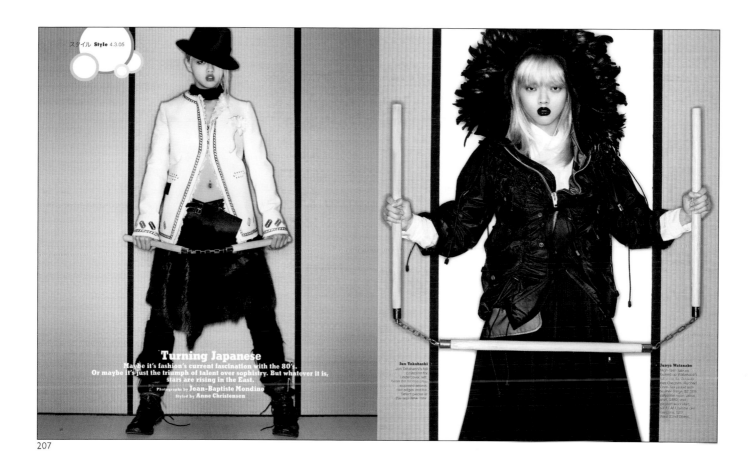

207

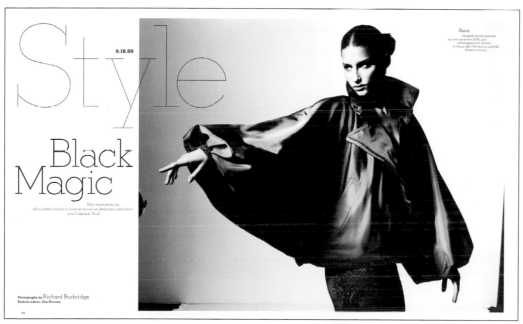

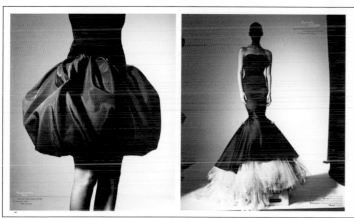

208

207 ✳ THE NEW YORK TIMES MAGAZINE
Creative Director: Janet Froelich / *Art Director:* Arem Duplessis / *Designers:* Jeff Glendenning,
Kristina DiMatteo / *Photographer:* Jean-Baptiste Mondino / *Fashion Editor:* Anne Christensen /
Publisher: The New York Times / *Issue:* April 3, 2005 / *Category:* Photography Story

208 ✳ THE NEW YORK TIMES MAGAZINE
Creative Director: Janet Froelich / *Art Director:* Arem Duplessis / *Designer:* Jeff Glendenning /
Photographer: Richard Burbridge / *Fashion Editor:* Alix Browne / *Publisher:* The New York Times /
Issue: September 18, 2005 / *Category:* Photography Story

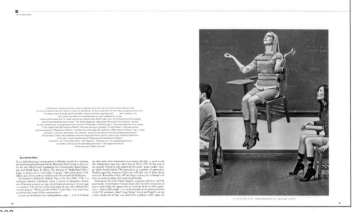

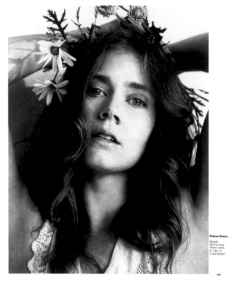

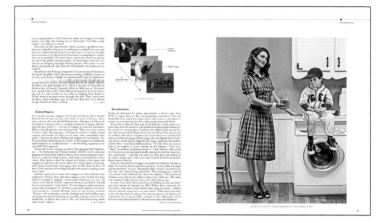

209

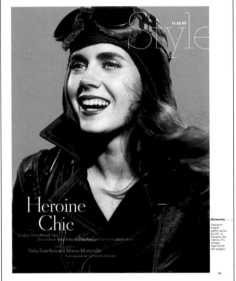

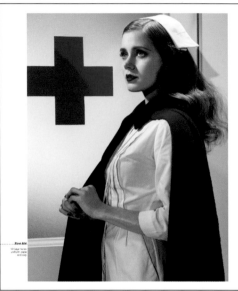

210

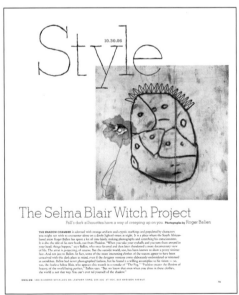

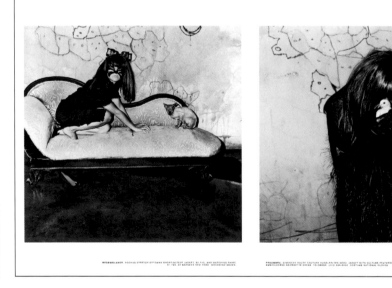

211

209 ✳ THE NEW YORK TIMES MAGAZINE
Creative Director: Janet Froelich / *Art Director:* Arem Duplessis / *Designers:* Kristina DiMatteo, Jeff Glendenning, Nancy Harris Rouemy, Cathy Gilmore-Barnes, Gail Bichler / *Photo Editors:* Kathy Ryan, Joanna Milter / *Photographer:* Zachary Scott / *Publisher:* The New York Times / *Issue:* December 11, 2005 / *Category:* Photography Story

210 ✳ THE NEW YORK TIMES MAGAZINE
Creative Director: Janet Froelich / *Art Director:* Arem Duplessis / *Designer:* Jeff Glendenning / *Photographers:* Sofia Sanchez, Mauro Mongiello / *Fashion Editor:* Elizabeth Stewart / *Publisher:* The New York Times / *Issue:* November 13, 2005 / *Category:* Photography Story

211 ✳ THE NEW YORK TIMES MAGAZINE
Creative Director: Janet Froelich / *Art Director:* Arem Duplessis / *Designer:* Jeff Glendenning / *Photo Editors:* Kathy Ryan, Kira Pollack / *Photographer:* Roger Ballen / *Publisher:* The New York Times / *Issue:* October 30, 2005 / *Category:* Photography Story

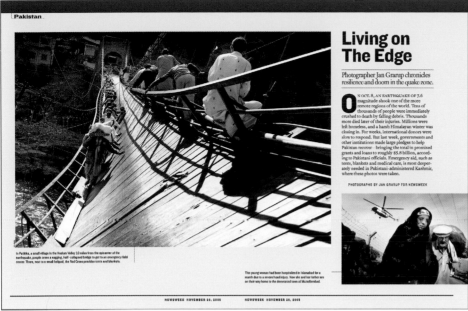

| Pakistan |

Living on The Edge

Photographer Jan Grarup chronicles resilience and doom in the quake zone.

O N OCT. 8, AN EARTHQUAKE OF 7.6 magnitude shook one of the more remote regions of the world. Tens of thousands of people were immediately crushed to death by falling debris. Thousands more died later of their injuries. Millions were left homeless, and a harsh Himalayan winter was closing in. For weeks, international donors were slow to respond. But last week, governments and other institutions made large pledges to help Pakistan recover—bringing the total in promised grants and loans to roughly $5.8 billion, according to Pakistani officials. Emergency aid, such as tents, blankets and medical care, is most desperately needed in Pakistani-administered Kashmir, where these photos were taken.

PHOTOGRAPHS BY JAN GRARUP FOR NEWSWEEK

In Patikka, a small village in the Neelum Valley 10 miles from the epicenter of the earthquake, people cross a sagging, half-collapsed bridge to get to an emergency field center. There, next to a small helipad, the Red Cross provides tents and blankets.

This young woman had been hospitalized in Islamabad for a month due to a severe head injury. Now she and her father are on their way home to the devastated town of Muzaffarabad.

212

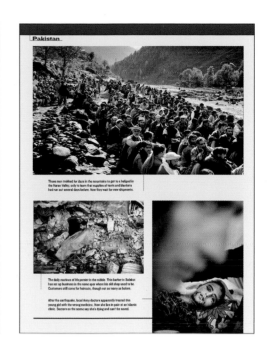

| Pakistan |

These men trekked for days in the mountains to get to a helipad in the Naran Valley, only to learn that supplies of tents and blankets had run out several days before. Now they wait for new shipments.

The daily routines of life persist in the rubble. This barber in Balakot has set up business in the same spot where his old shop used to be. Customers still come for haircuts, though not as many as before.

After the earthquake, local Army doctors apparently treated this young girl with the wrong medicine. Now she lies in pain at an Islamic clinic. Doctors on the scene say she's dying and can't be saved.

213

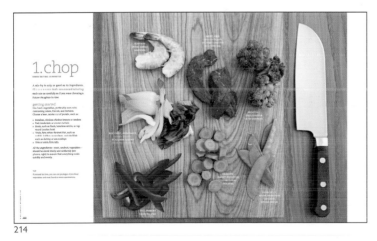

1. chop

A stir-fry is only as good as its ingredients.

2. make sauce

214

212 ✳ NEWSWEEK
Creative Director: Lynn Staley / *Art Director:* Dan Revitte / *Director of Photography:* Simon Barnett / *Photo Editor:* James Wellford / *Photographer:* Jan Grarup for Newsweek / *Publisher:* The Washington Post Co. / *Issue:* November 28, 2005 / *Category:* Photography Story

213 ✳ POPULAR SCIENCE
Art Director: Nathalie Kirsheh / *Designer:* Nathalie Kirsheh / *Photo Editor:* Kristine LaManna / *Photographer:* Hugh Kretschmer / *Deputy Art Director:* Christopher Chew / *Publisher:* Time4 Media / *Issue:* July 2005 / *Category:* Photography Story

214 ✳ REAL SIMPLE
Creative Director: Vanessa Holden / *Art Director:* Eva Spring / *Designer:* Eva Spring / *Photo Editor:* Naomi Nista / *Photographer:* Anna Williams / *Publisher:* Time Inc. / *Issue:* October 2005 / *Category:* Photography Story

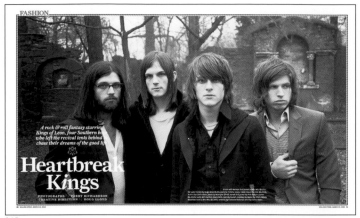

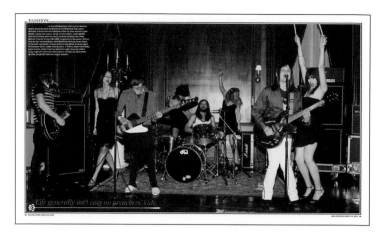

215

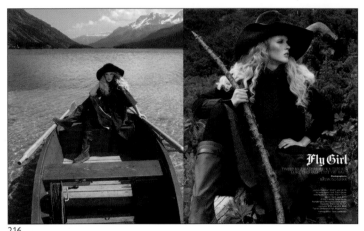

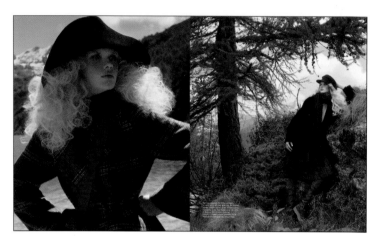

216

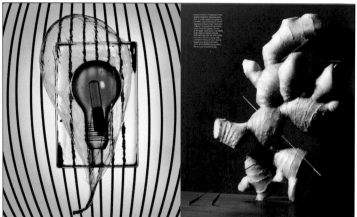

217

215 ✳ ROLLING STONE
Art Directors: Amid Capeci, Lloyd & Company / *Photo Editor:* Jodi Peckman / *Photographer:* Terry Richardson / *Publisher:* Wenner Media / *Issue:* March 10, 2005 / *Category:* Photography Story

216 ✳ T: THE NEW YORK TIMES STYLE MAGAZINE
Creative Director: Janet Froelich / *Art Director:* David Sebbah / *Designer:* Janet Froelich / *Photo Editors:* Kathy Ryan, Judith Puckett-Rinella / *Photographer:* Raymond Meier /
Publisher: The New York Times / *Issue:* September 25, 2005 / *Category:* Photography Story

217 ✳ T: THE NEW YORK TIMES STYLE MAGAZINE
Creative Director: Janet Froelich / *Art Director:* David Sebbah / *Designer:* Luise Stauss / *Photo Editors:* Kathy Ryan, Judith Puckett-Rinella / *Photographer:* Raymond Meier /
Publisher: The New York Times / *Issue:* November 6, 2005 / *Category:* Photography Story

Dark lady VIVIENNE WESTWOOD GOLD LABEL SILK TABLE BUSTIER DRESS, TO ORDER.
CALL 011 44 207 629 3757. FRED LEIGHTON RING. OPPOSITE: HUSSEIN CHALAYAN DRESS, $1,200, AT IKRAM, CHICAGO.
SWINTON ENTERED THE DARK SIDE WITH M.A.C. CARBON EYE SHADOW AND SMOLDER EYE PENCIL.

century. Her father, Maj. Gen. Sir John Swinton, was a commander of the Queen's Household Guards in London, and she and her three brothers were sent to proper boarding schools. "I have a different life than my parents," Swinton said. "But I do feel like a soldier. It's hard work getting these movies made. It took us about five years to convince people to finance 'Orlando,' and it took two years for Mike Mills to be able to direct 'Thumbsucker.' Lots of people told him he was insane. I appreciate that sense of dislocation. As a child, I felt like a changeling, at odds with the planet I arrived on. I didn't understand the world I was born into, and that feeling of dissonance colored my youth. I saw that rigidness existed, and as a result, for me, rigidness got a bad name. Looseness was far better. And I gravitated towards a different life."

While she has consistently resisted being called Jarman's muse ("He needed no muse other than himself "), she is pleased to be thought of as a fashion muse. "I met Viktor and Rolf backstage at one of their shows, and

we started cooking things up together," she said. "One collection was designed for me, and they ask me all the time what I want to wear. Once, I was gardening, and I told them that it occurred to me that I wanted some padded trousers. They made them for their next collection. Although they've yet to give me a racing-driver suit, and I've asked and asked."

Swinton is a generous, nonexclusive muse: she starred in a film by the designer Hussein Chalayan at the recent Venice Biennale and is devoted to Stefano Pilati, now at Yves Saint Laurent. "Some of the most interesting artists I know are working in fashion," she said, after ordering cheesecake for dessert. "Generally, in fashion, one's looking for what's new. Where, in film, something new takes five years to be acceptable, and then it's often not new anymore. Fashion, then, becomes like a sorbet between courses for me. It's cleansing. And then I get back to the hard work of fighting for some film that no one wants to make. That's what I mean when I say an artist's life: this is a calling, not a job." ∎

218

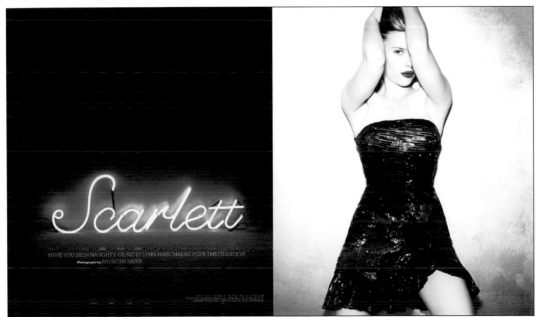

Scarlett

HAVE YOU BEEN NAUGHTY OR NICE? LYNN HIRSCHBERG POPS THE QUESTION
Photographs by RAYMOND MEIER

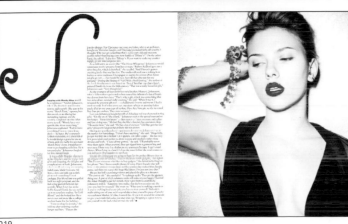

219

218 ✳ T: THE NEW YORK TIMES STYLE MAGAZINE
Creative Director: Janet Froelich / *Art Director:* David Sebbah / *Designer:* Janet Froelich /
Photo Editors: Kathy Ryan, Judith Puckett-Rinella / *Photographer:* Raymond Meier /
Publisher: The New York Times / *Issue:* August 28, 2005 / *Category:* Photography Story

219 ✳ T: THE NEW YORK TIMES STYLE MAGAZINE
Creative Director: Janet Froelich / *Art Director:* David Sebbah / *Designer:* Christopher
Martinez / *Photo Editors:* Kathy Ryan, Judith Puckett-Rinella / *Photographer:* Raymond Meier /
Publisher: The New York Times / *Issue:* December 4, 2005 / *Category:* Photography Story

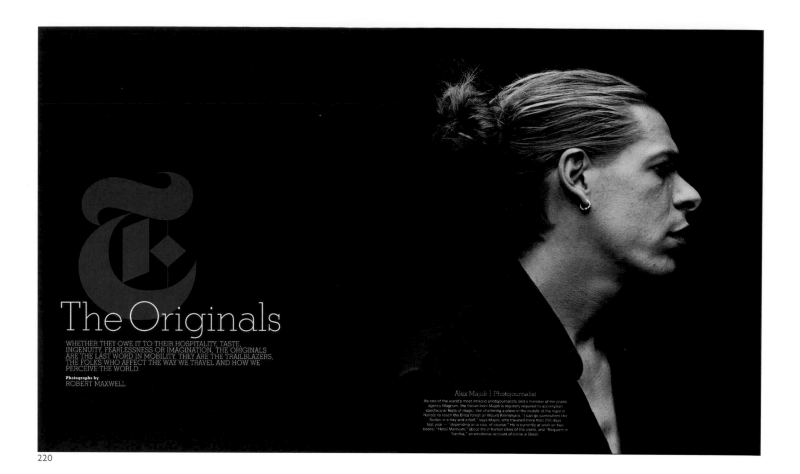

220

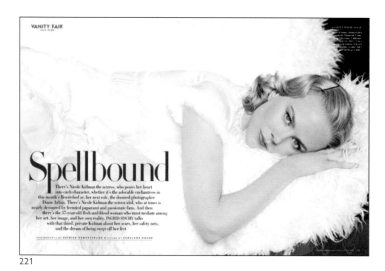

221

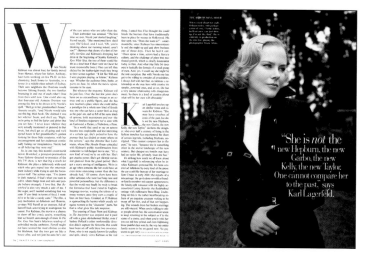

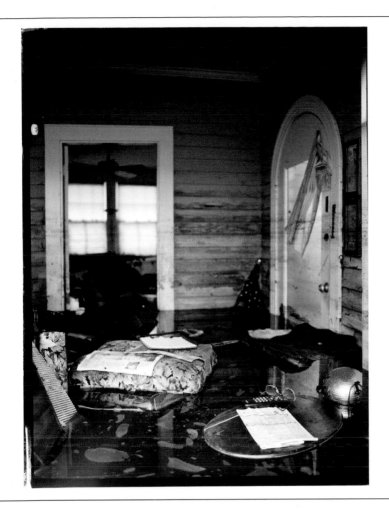

HELL
AND HIGH
WATER

American Apocalypse: New Orleans 2005

Faced with the greatest natural disaster in modern American history, Washington fumbled and failed. But the Red Cross, the doctors and nurses of Woman's Hospital, the Texas Army National Guard helicopter crews, and the ad hoc bartenders at a Bourbon Street sports bar were among the many who fought to comfort, protect, and save. Photographer JONAS KARLSSON and reporter RON BEINNER capture New Orleans' suffering and its saviors, while DAVID HALBERSTAM confronts Hurricane Katrina's most disturbing revelations

The scenes were at once familiar and unfamiliar.

Familiar because television has become expert at bringing us news of disasters—hurricanes being a particular specialty of the medium—and it does them better than it does any other kind of story. It is all about pictures, something television producers understand brilliantly, and the pictures in this instance were exceptionally powerful and compelling. The producers and television news reporters, in fact, may have become a bit too smooth, and the danger is they risk turning the real and authentic into something that appears programmed and artificial. First, there are the tragedy and the tears; then, in time, the redemption, the rejuvenation, and the gratitude. Even with Katrina the coverage sometimes seemed scripted, as if they had the story down even before the hurricane struck and needed only to find the right local characters from central casting to play their prescribed roles and the right faces in

www.vanityfair.com | VANITY FAIR | 359

Shelter from the Storm

Into the Breach

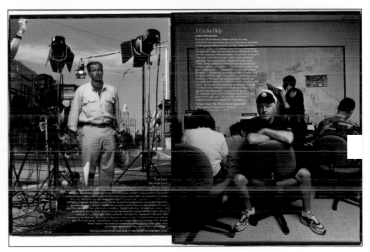

A Cry for Help

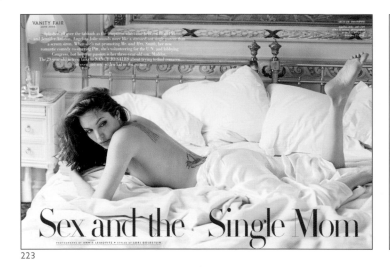

223

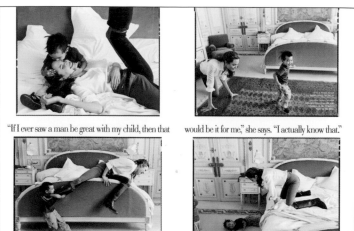

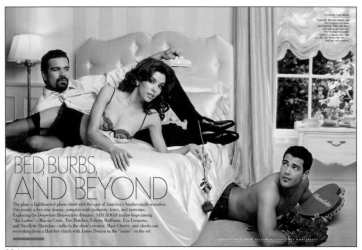

224

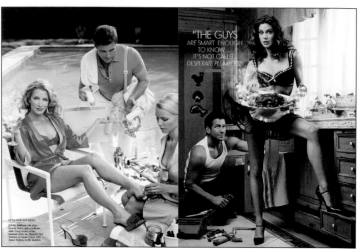

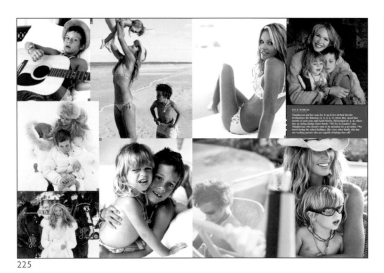

225

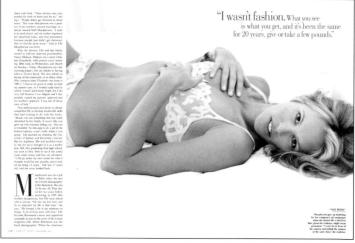

223 ✳ VANITY FAIR

Design Director: David Harris / *Art Director:* Julie Weiss / *Designer:* Julie Weiss / *Director of Photography:* Susan White / *Photo Editors:* Lisa Berman, Kathryn MacLeod / *Photographer:* Annie Leibovitz / *Publisher:* Condé Nast Publications Inc. / *Issue:* June 2005 / *Category:* Photography Story

224 ✳ VANITY FAIR

Design Director: David Harris / *Art Director:* Julie Weiss / *Designers:* Scott-Lee Cash, David Harris / *Director of Photography:* Susan White / *Photo Editors:* Lisa Berman, Richard Villani / *Photographer:* Mark Seliger / *Publisher:* Condé Nast Publications Inc. / *Issue:* May 2005 / *Category:* Photography Story

225 ✳ VANITY FAIR

Design Director: David Harris / *Art Director:* Julie Weiss / *Designer:* Adam Bookbinder / *Director of Photography:* Susan White / *Photo Editors:* Lisa Berman, Richard Villani / *Photographer:* Norman Jean Roy / *Publisher:* Condé Nast Publications Inc. / *Issue:* August 2005 / *Category:* Photography Story

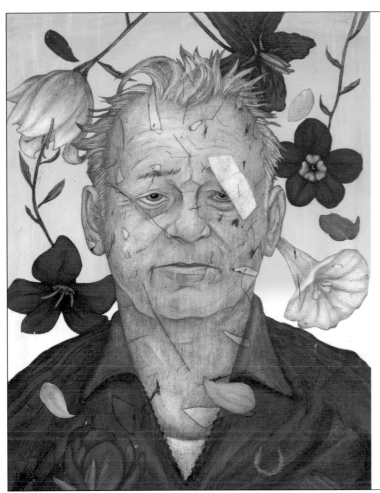

By Missy Schwartz

ILLUSTRATION BY JASON HOLLEY

Delight In August

Tired of the summer heat—the blockbuster explosions and car chases, the superheroes and clones? We feel your pain. Here are **10 alternatives** to that popcorn fare. Movies like Jim Jarmusch's 'Broken Flowers,' which follows a soul-searching **Bill** Murray on a tour of his romantic past; or 'Hustle & Flow,' which chronicles a frustrated pimp's attempt to reinvent himself as a rap star; or 'Junebug,' a Sundance fave which explores the delicate dynamics between a Southern family and its Yankee-leaning son. Plus seven other movies guaranteed to offer cool refreshment during these **D**og days.

ENTERTAINMENT WEEKLY **23**

226

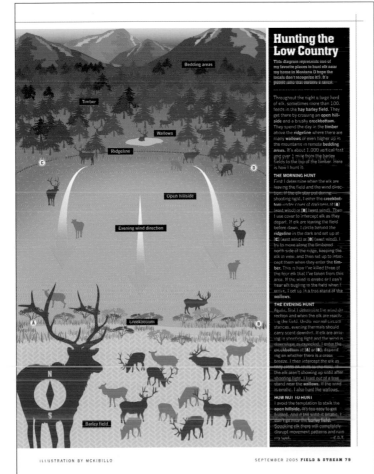

ILLUSTRATION BY MCKIBILLO SEPTEMBER 2005 **FIELD & STREAM** 79

227

226 ✳ ENTERTAINMENT WEEKLY
Design Director: Geraldine Hessler / *Designer:* Theresa Griggs / *Illustrator:* Jason Holley / *Director of Photography:* Fiona McDonagh / *Publisher:* Time Inc. / *Issue:* August 5, 2005 / *Category:* Illustration Spread-Single Page

227 ✳ FIELD & STREAM
Art Director: Robert Perino / *Designer:* Sarah Garcea / *Illustrator:* McKibillo / *Deputy Art Director:* Sarah Garcea / *Publisher:* Time4 Media / *Issue:* September 2005 / *Category:* Illustration Spread-Single Page

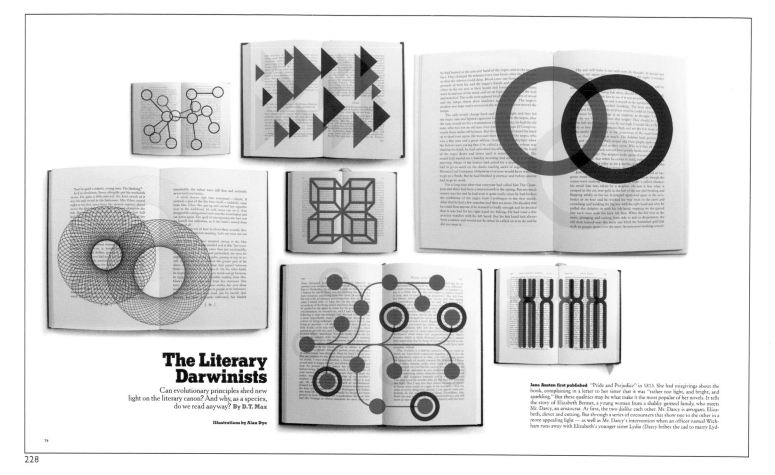

The Literary Darwinists

Can evolutionary principles shed new
light on the literary canon? And why, as a species,
do we read anyway? **By D.T. Max**

Illustrations by Alan Dye

Jane Austen first published "Pride and Prejudice" in 1813. She had misgivings about the book, complaining in a letter to her sister that it was "rather too light, and bright, and sparkling." But these qualities may be what make it the most popular of her novels. It tells the story of Elizabeth Bennet, a young woman from a shabby genteel family, who meets Mr. Darcy, an aristocrat. At first, the two dislike each other. Mr. Darcy is arrogant; Elizabeth, clever and cutting. But through a series of encounters that show one to the other in a more appealing light — as well as Mr. Darcy's intervention when an officer named Wickham runs away with Elizabeth's younger sister Lydia (Darcy bribes the cad to marry Lyd-

74

The Quality Cure?

Instead of trying to cut health-care costs or ration services, David Cutler, a Harvard
economist, wants to reward doctors for doing a better job. In the long run, he argues, patients —
and the economy — will be better off. By Roger Lowenstein

David Cutler hit what seemed to be the peak of his career at 28, when as a junior faculty member at Harvard he was whisked down to Washington to help draft a health-care bill under the tutelage of Ira Magaziner and, of course, Hillary Clinton. The project produced a dispiriting result: nothing.

Corporations, consumers, the uninsured and doctors had all been clamoring for reform, and the question of why the project failed has nagged at Cutler ever since, especially as the problems have continued to worsen. In the years since he left Washington, which was in 1994, the ranks of the uninsured have surged, from 35 million people to 45 million. There are also serious gaps in the quality of care, and there is a deep dissatisfaction with the way the system functions — in how it seems to make adversaries of patients, doctors and insurers, for instance. Arguably, Americans want health-care reform more urgently than anything else.

Yet designing a national health-care policy has become a kind of taboo. Congress provided prescription drugs for seniors, and Pres-

Illustration by Kit Hinrichs/Pentagram

46

Uncaptive Minds

What teaching a college-level class at a maximum-security correctional facility did for the inmates — and for me. By Ian Buruma

Illustration by Istvan Banyai

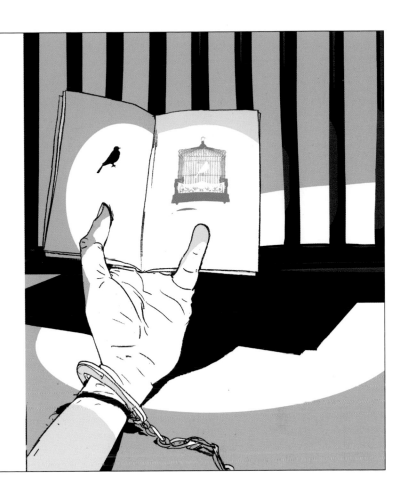

The main business of Napanoch, N.Y., is a maximum-security prison, Eastern New York Correctional Facility, also known as Happy Nap. The population of Eastern, 1,250 men, many from New York City, is about the same as that of Napanoch itself. Imposing in a hideous kind of way, the prison, built at the end of the 19th century, is modeled after a medieval fortress, with towers and turrets and a pyramid roof. The overall effect — stony pomposity framed by lush green hills — is rather Germanic.

There is nothing particularly happy about Napanoch, situated on the raffish edges of the Catskills about 70 miles north of Manhattan; its better days as an affordable resort area for New York and New Jersey Jews have long gone. There are a few motels nearby with cracked signs that read Starlite and Eldorado; a diner; a Jewish cemetery; and a "colony farm," where

230

First Person

By Ian Spiegelman

DISCOVERED SEX. I WAS 12. GREAT.

It was the mid-1980s, and I couldn't keep my hands off me. Then the AIDS movement, the Reagan administration, and Bill Cosby joined forces to keep me from getting my hands on any actual girls. Conspiracy at the highest levels.

That was when Act Up—the AIDS education/provocation group—was doing its best to convince straight, middle-class kids that we'd catch a quick death if we didn't go in wearing chain mail. The conservatives countered that there was no such disease, but if there were,

we should "Just Say No" to it. Prime-time TV, meanwhile, spread the Huxtable solution among my female classmates: Veil your budding young forms in such an ugly array of shapeless sweaters and ankle-length skirts that no one would ever suspect you of having genitals.

How could an honest kid sniff out a willing sex partner in a world so utterly full of contradiction? In the pages of a magazine, of course. And that's how I found solace in a sweet evil that would both sustain and damage me for the next 20 years.

My teenage reality was drabness, lies, slogans, and fear, but pornography beckoned with a fantastic promise. Leg Show, Penthouse, Oui—what dreams! "Come up to the penthouse and I'll show you my legs, cop!" That's a tempting proposition in any year, let alone in the '80s, when the only things mounting were the number of strip malls

The Porn Identity

When does a harmless vice turn into a destructive addiction?

and pantsuits. Sure, sure, sex mags were all make-believe. But they were honest and open in their way, easily beating out the dark descriptions society was throwing in my direction. Besides, those garter-belted goddesses who invited my gaze—and inspired my solo acts of devotion—harked back to a freer time I'd missed by just a few years.

But I did taste it, in a way. My whole idea of feminine availability had developed around a series of babysitters who supervised me on the cusp of my adolescence. They were shimmering party girls of the late '70s and early '80s who wore Daisy Dukes and platform sandals,

104 MEN'S HEALTH / APRIL 2005 / menshealth.com ILLUSTRATIONS BY GARY TAXALI

231

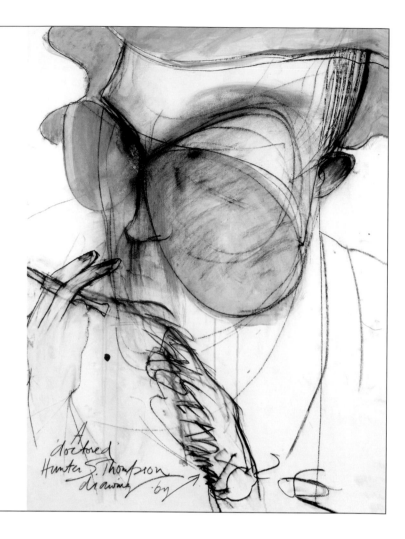

PostCards
from the Proud Highway

Dr. Hunter S. Thompson's rules for
living like a Southern gentleman.
An interrupted, pain-filled
valedictory for the
next generation

What follows is the final collaboration between Hunter Stockton Thompson and PLAYBOY, *based on a series of interviews he gave to Assistant Editor Tim Mohr last December. The two spent the better part of a week at Owl Farm analyzing a variety of subjects, from firearms to physical fitness, all of which interested Thompson deeply. "To live outside the law you must be honest," Bob Dylan wrote, but you must also possess great sensitivity to your environment and a wide range of esoteric skills and wisdom. In his 67 years on earth Thompson made himself an expert in matters great and small and loved nothing more than to expound on what he had learned. This assignment was interrupted by his death on February 20, but we could think of no better tribute to a great American writer than to present this small storehouse of vital knowledge in his own words. This is for old fans as well as those who may have come to the party only recently.* —The Editors

On *freedom* Freedom is a challenge. You decide who you are by what you do. It's like a question, like a fork in the road. An ongoing question you have to keep answering correctly. There's a touch of the high wire to it. I've never been able to walk high wires, but I get the feeling.

On *Driving* The only way to drive is at *top* speed, with a car full of whiskey. It takes commitment, especially out here with so many deer and elk around. Car lights paralyze deer. You've got to lean on the horn, brace on the wheel and stomp on the accelerator. When you hit the brakes the front of the car dips down—that will put the beast into your windshield. Now, the significant impact will still occur if you step on the gas, but you're not helpless. It'll the beast into your windshield. Now, the signifi-

ILLUSTRATIONS BY RXLPH STEADMAN

232

America's
Worst
Judges

Our Broken Gavel Award winners,
and the damage they do

BY DALE VAN ATTA

Imagine you've been the victim of a vicious crime. The perpetrator is arrested, and you finally get a trial date. So you head off to court, willing to have your attacker to see justice done. Now imagine your dismay when the judge, who you trusted to be honest and fair, turns out to be less than competent. Or worse, less than ethical. How could you ever have confidence in our court system again? When judges betray our trust, they

threaten one of the pillars of our democracy. And they deserve to be exposed. Some of the worst offenders earn a dubious distinction. We select them for our annual Broken Gavel Awards.

The conduct we reviewed potentially violates the ethical standards set by the American Bar Association and state judicial codes of conduct (see page 84). Should this year's winners be kicked off the bench? You be the judge.

233

HIPHOP2005
A SPECIAL REPORT: Did the LAPD suppress evidence that rogue cops conspired with Death Row's Suge Knight to assassinate rap star Biggie Smalls? Inside the civil trial that is threatening to bring down the most powerful institutions in Los Angeles

The Unsolved Mystery of
The No̲t̲orious
B.I.G.
The Murder. The Cover-Up. The Conspiracy.

By Randall Sullivan · Illustration by Jason Holley

234

PROUST QUESTIONNAIRE

MIKE WALLACE

In his more than 60 years on the air, Mike Wallace has interviewed almost every president of the last half-century and, at 87, continues to add to a list that includes Salvador Dalí, Yasser Arafat, and Malcolm X. As he publishes *Between You and Me: A Memoir*, the unmistakable voice of broadcast journalism speaks out about his skimpy bandage, self-absorption, and his idol, Martin Luther King Jr.

235

232 ✳ PLAYBOY MAGAZINE
Art Director: Tom Staebler / *Designer:* Scott Anderson / *Illustrator:* Ralph Steadman / *Publisher:* Playboy Enterprises International, Inc. /
Issue: May 2005 / *Category:* Illustration Spread-Single Page

233 ✳ READER'S DIGEST
Design Director: Hannu Laakso / *Art Directors:* Dean Abatemarco, Victoria Nightingale / *Designer:* Victoria Nightingale / *Illustrator:* Brian Cronin /
Publisher: Reader's Digest Association / *Client:* Reader's Digest / *Issue:* February 2005 / *Category:* Illustration Spread-Single Page

234 ✳ ROLLING STONE
Art Director: Amid Capeci / *Designer:* Matthew Cooley / *Illustrator:* Jason Holley / *Publisher:* Wenner Media / *Issue:* December 15, 2005 /
Category: Illustration Spread-Single Page

235 ✳ VANITY FAIR
Design Director: David Harris / *Art Director:* Julie Weiss / *Designer:* Adam Bookbinder / *Illustrator:* Bruce McCall / *Director of Photography:* Susan White /
Photo Editor: Lisa Berman / *Publisher:* Condé Nast Publications Inc. / *Issue:* March 2005 / *Category:* Illustration Story

236

SEVEN DEADLY DISASTERS

In the wake of December's
Indonesian tsunami, what does mother
nature have in store for us next?

By
William Speed Weed

Richard Alley is a geologist at Penn State University. In his office he has a graph that shows the earth's climatic history for the past 100,000 years. The graph reveals that for the first 92,000 of those the global thermometer roller coastered in and out of ice ages and hot spells. The turmoil leveled off about 8,000 years ago into a period of anomalous calm, one that's still with us. "The chart goes *hning-boing-boing-boing-hmmmm*," says Alley. "We live in the *hmmmm*." And because human civilization coincides with, and perhaps results from, this remarkable period of calm, most of us are blissfully unaware of the fire and ice that nature can throw at us. "We think it's always going to be *hmmmm*," says Alley, "but it's not."

As it happens, during the past 8,000 years humanity has also generally been spared the grand-scale natural cataclysms to which the earth is heir: the mega-volcanoes, the perfect earthquakes, the species-extinguishing meteors. Last December, when mother earth cracked her back and launched an Indian Ocean tsunami that killed nearly 100 times more people than died in the 9/11 attacks, the world was shocked. Such disasters seemed passé, the types of things that could now be found only in history books and at Hollywood pitch meetings. But we should have known better: Though cataclysmic from a human perspective, the earthquake-tsunami combo is a geological cheeseburger and Coke. Calamities, scientists tell us, happen all the time. Here are seven that could hit tomorrow. Of course, odds are none of them will, but if any of us are around in 75,000 years we'll most certainly have seen them all.

ILLUSTRATION BY YUKO SHIMIZU

VILLA VOLARE

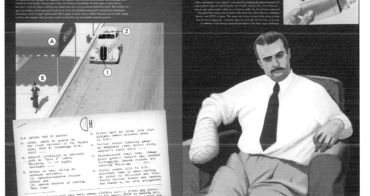

THE PERFUME SENSOR

THE GERM-FREE MONEY CLIP

237

236 ✳ PLAYBOY MAGAZINE
Art Director: Tom Staebler / *Designer:* Rob Wilson / *Illustrator:* Yuko Shimizu / *Publisher:* Playboy Enterprises International, Inc. /
Issue: July 2005 / *Category:* Illustration Spread-Single Page

237 ✳ VANITY FAIR
Design Director: David Harris / *Art Director:* Julie Weiss / *Designer:* Adam Bookbinder / *Illustrator:* Bruce McCall /
Director of Photography: Susan White / *Photo Editor:* Lisa Berman / *Publisher:* Condé Nast Publications Inc. /
Issue: March 2005 / *Category:* Illustration Story

Watching TV Makes You Smarter

Forget what your mother told you:
today's prime-time shows are giving you a
cognitive workout.

By Steven Johnson

Illustrations by Christoph Niemann

238

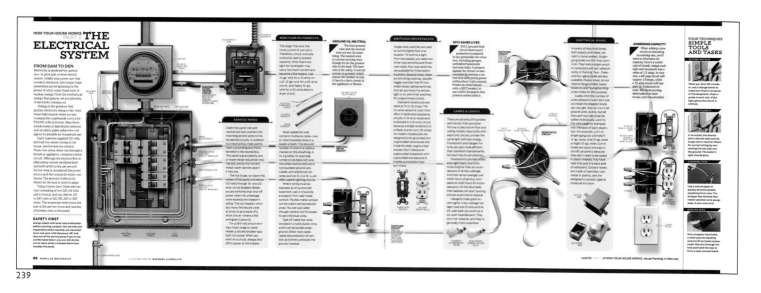

239

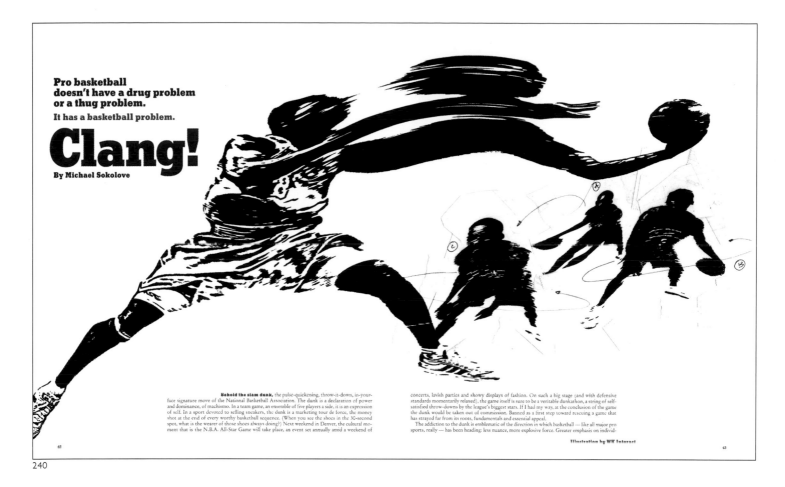

Pro basketball
doesn't have a drug problem
or a thug problem.

It has a basketball problem.

Clang!

By Michael Sokolove

Behold the slam dunk, the pulse-quickening, throw-it-down, in-your-face signature move of the National Basketball Association. The dunk is a declaration of power and dominance, of machismo. In a team game, an ensemble of five players a side, it is an expression of self. In a sport devoted to selling sneakers, the dunk is a marketing tour de force, the money shot at the end of every worthy basketball sequence. (When you see the shoes in the 30-second spot, what is the wearer of those shoes always doing?) Next weekend in Denver, the cultural moment that is the N.B.A. All-Star Game will take place, an event set annually amid a weekend of concerts, lavish parties and showy displays of fashion. On such a big stage (and with defensive standards momentarily relaxed), the game itself is sure to be a veritable dunkathon, a string of self-satisfied throw-downs by the league's biggest stars. If I had my way, at the conclusion of the game the dunk would be taken out of commission. Banned as a first step toward rescuing a game that has strayed far from its roots, fundamentals and essential appeal.

The addiction to the dunk is emblematic of the direction in which basketball — like all major pro sports, really — has been heading: less nuance, more explosive force. Greater emphasis on individ-

Illustration by WK Interact

62

63

240

THE FUTURE OF
BRAIN POWER

Leaps in our understanding
of brain chemistry
could usher in a new age of
biologically enhanced humans

WILL DRUGS MAKE US SMARTER AND HAPPIER?

June 6, 2025, 7:30 a.m. *The alarm is going off, and I feel great. Thanks to Reposinex, I've had a full four hours of deep, restorative sleep. My head hit the pillow, and boom! I was right into slow-wave delta sleep. In the car, driving to work, I sip an Achieve latte. I love these things—they sensitize my dopamine receptors, shift my MAO levels, and send my noradrenaline levels soaring. I have no jitters, and my concentration is tack-sharp. Driving used to freak me out, actually. I was involved in a bad accident a few years back. Good thing the doctor prescribed that trauma blunter. I still remember the accident; it just doesn't bug me anymore. I'm no longer one of those Human 1.0s—I'm a human with complete control of his brain chemistry.*

June 6, 2005, 7:30 p.m. Ramez Naam has a queen and a six face-up on the green felt of the blackjack table. The dealer shows a six. The obviously correct strategy is for Naam to stay, but this is his first time gambling at a casino, and nothing is obvious to him. Naam is 32, with dark hair and a neatly trimmed goatee. He peers uncertainly at his hand through blue-rimmed glasses, then taps the table with his fingertips. The dealer flips a card: a jack. Naam is out. He's blown through his $40 stack of chips in less than 10 minutes.

Designing software for Microsoft is Naam's job; envisioning the future—one in which biotechnology would allow us to shatter natural evolutionary limits—is his calling. A senior member of futurist think tanks such as the Acceleration Studies Foundation and the Foresight Institute, he speaks regularly at technology trade shows and is the author of the provocative new book *More Than Human: Embracing the Promise of Biological Enhancement.* Like most overachievers, Naam doesn't like to lose. In blackjack and in life, of course, many factors are beyond our control—we can't choose what we're dealt, from the card deck or the genetic one—and Naam argues that we should change the restrictive rules of the biological game. He asks: What if you could pop a pill to make you remember more, think faster, or become happier or higher-achieving? What if there were

BY JAMES VLAHOS | ILLUSTRATIONS BY McKIBILLO

POPULAR SCIENCE SEPTEMBER 2005 65

241

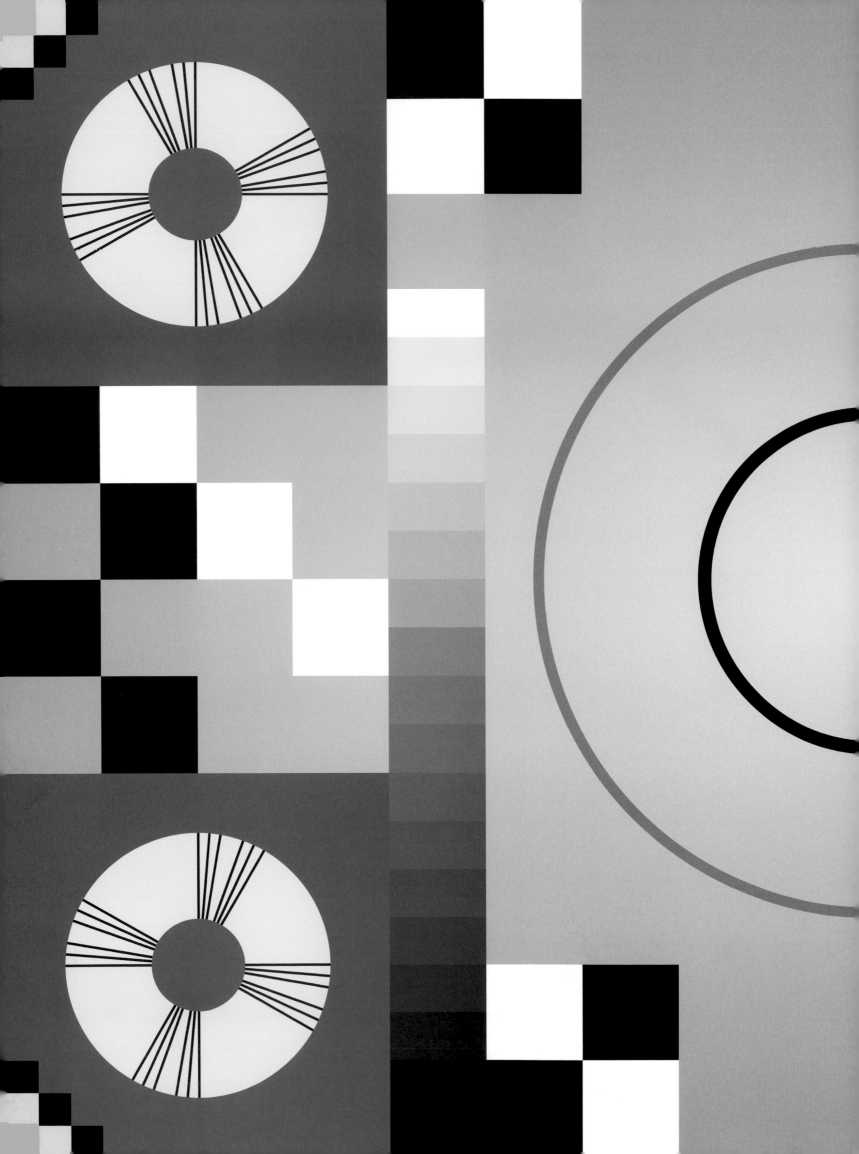

MERIT

NEWSSTAND

MAGAZINE

500,000 TO 1 MILLION

CIRCULATION

242

243

244

242 ✻ BUSINESS WEEK
Art Director: Malcolm Frouman / *Designer:* Malcolm Frouman / *Director of Photography:*
Larry Lippman / *Photo Editor:* Sarah Morse / *Publisher:* The McGraw-Hill Companies /
Issue: July 4, 2005 / *Category:* Design Cover

243 ✻ CONDÉ NAST TRAVELER
Design Director: Robert Best / *Art Director:* Kerry Robertson / *Designer:* Robert Best /
Photo Editors: Kathleen Klech, Esin Ili Goknar / *Photographer:* Lisa Limer / *Publisher:*
Condé Nast Publications, Inc. / *Issue:* May 2005 / *Category:* Design Cover

244 ✻ WIRED
Design Director: Federico Gutierrez-Schott / *Designer:* Federico Gutierrez-Schott /
Illustrator: Kenn Brown / *Director of Photography:* Brenna Britton / *Publisher:* Condé Nast
Publications, Inc. / *Issue:* December 2005 / *Category:* Design Cover

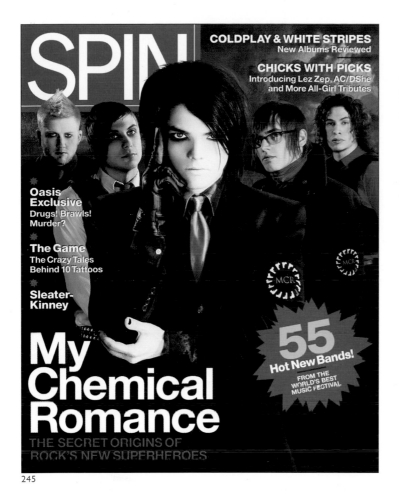

245

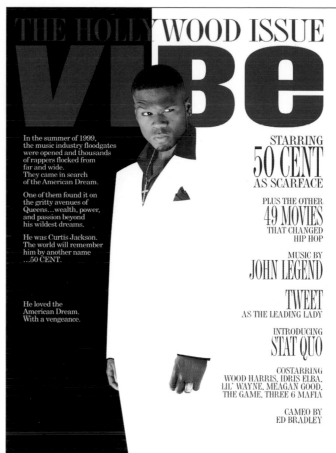

246 + Merit / Newsstand Magazine (Photography Cover)

247

248

249

245 ✳ SPIN
Design Director: Kory Kennedy / *Art Director:* Devin Pedzwater / *Designer:* Liz Macfarlane /
Director of Photography: Kathleen Kemp / *Photo Editors:* Jennifer Santana, Bethany Mezick /
Photographer: Phil Mucci / *Publisher:* Spin Media / *Issue:* June 2005 / *Category:* Design Cover

246 ✳ VIBE
Design Director: Florian Bachleda / *Photo Editor:* Liane Radel / *Photographer:* Albert Watson /
Publisher: Vibe-Spin Ventures LLC / *Issue:* April 2005 / *Category:* Design Cover

247 ✳ PREMIERE
Art Director: Dirk Barnett / *Designer:* Dirk Barnett / *Director of Photography:* David Carthas / *Publisher:*
Hachette Filipacchi Media U.S. / *Issue:* May 2005 / *Category:* Design Cover

248 ✳ WIRED
Design Director: Federico Gutierrez-Schott / *Designer:* Federico Gutierrez-Schott /
Illustrator: Jamie Hewlett / *Director of Photography:* Brenna Britton /
Publisher: Condé Nast Publications, Inc. / *Issue:* July 2005 / *Category:* Design Cover

249 ✳ MORE
Creative Director: Maxine Davidowitz / *Designer:* Maxine Davidowitz /
Photo Editor: Hazel Hammond / *Photographer:* Antoine Verglas /
Publisher: Meredith Corporation / *Issue:* May 2005 / *Category:* Design Cover

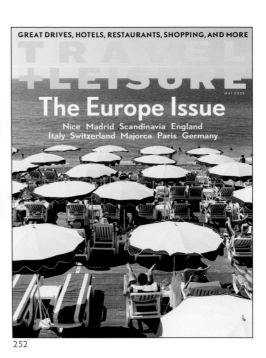

250

251 + Merit / Newsstand Magazine (Design Entire Issue)

252

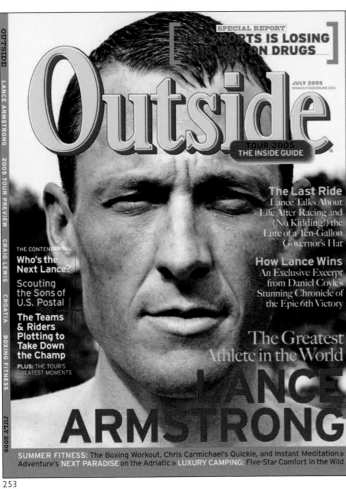

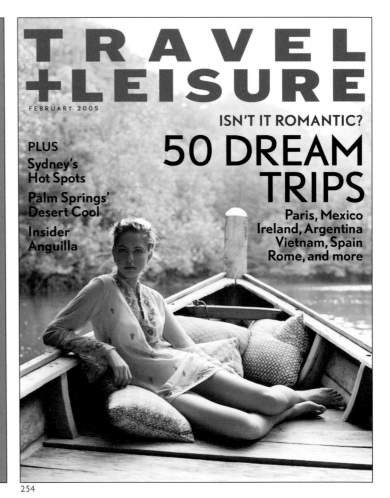

253

254

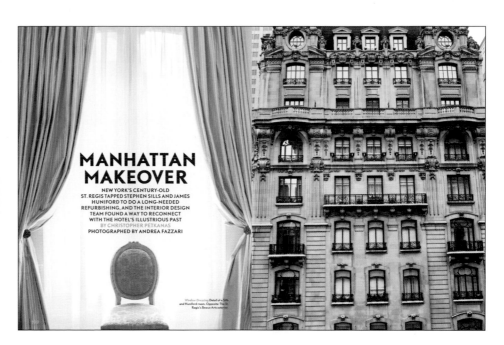

255 + Merit / Newsstand Magazine (Design Entire Issue)

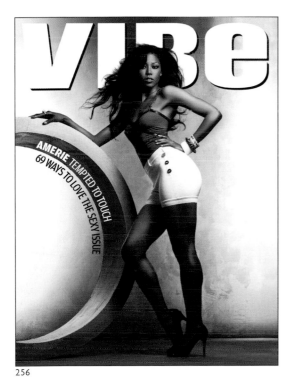

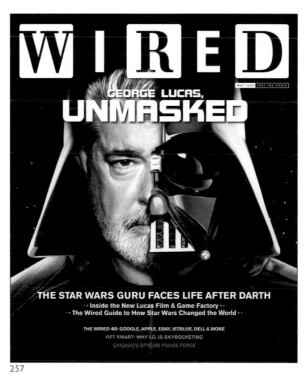

256

257

250 ✳ FORTUNE
Design Director: Robert Newman / *Photo Editors:* Greg Pond, Alix Colow /
Photographers: Robert Maxwell, Greg Pond / *Publisher:* Time Inc. /
Issue: November 14, 2005 / *Category:* Photography Cover

251 ✳ GQ
Design Director: Fred Woodward / *Designers:* Fred Woodward, Ken DeLago / *Director of
Photography:* Dora Somosi / *Photographer:* Peggy Sirota / *Creative Director:* Jim Moore /
Fashion Director: Madeline Weeks / *Publisher:* Condé Nast Publications Inc. /
Issue: December 2005 / *Category:* Photography Cover

252 ✳ TRAVEL + LEISURE
Design Director: Emily Crawford / *Designer:* Emily Crawford / *Photo Editor:* Katie Dunn /
Photographer: Andrea Fazzari / *Publisher:* American Express Publishing Co. /
Issue: May 2005 / *Category:* Photography Cover

253 ✳ OUTSIDE
Creative Director: Hannah McCaughey / *Director of Photography:* Rob Haggart / *Photographer:*
Cliff Watts / *Publisher:* Mariah Media, Inc. / *Issue:* July 2005 / *Category:* Photography Cover

254 ✳ TRAVEL + LEISURE
Design Director: Emily Crawford / *Designer:* Emily Crawford / *Photo Editor:*
Katie Dunn / *Photographer:* Max Kim-Bee / *Publisher:* American Express Publishing Co. /
Issue: February 2005 / *Category:* Photography Cover

255 ✳ TRAVEL + LEISURE
Design Director: Emily Crawford / *Designer:* Emily Crawford / *Photo Editor:* Katie Dunn /
Photographer: Joanna vanMulder / *Publisher:* American Express Publishing Co. /
Issue: June 2005 / *Category:* Photography Cover

256 ✳ VIBE
Design Director: Florian Bachleda / *Photo Editor:* Liane Radel /
Photographer: Michelangelo De Batista / *Publisher:* Vibe-Spin Ventures LLC /
Issue: August 2005 / *Category:* Photography Cover

257 ✳ WIRED
Design Director: Federico Gutierrez Schott / *Director of Photography:* Brenna Britton /
Photographer: Michael Elins / *Publisher:* Condé Nast Publications, Inc. / *Issue:* May 2005 /
Category: Photography Cover

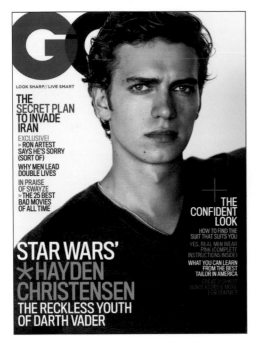

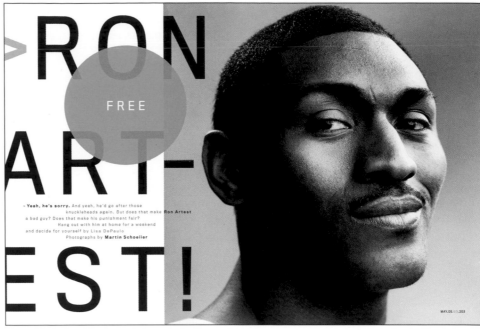

+ Merit / Newsstand Magazine (Design Spread-Single Page)

258 ✷ GQ
Design Director: Fred Woodward / *Designers:* Ken DeLago, Anton Ioukhnovets, Sarah Viñas, Thomas Alberty, Chloe Weiss /
Illustrators: Tavis Coburn, Christoph Niemann, Eboy / *Director of Photography:* Bradley Young / *Photo Editors:* Kristen Schaefer, Monica Bradley /
Photographers: Mario Testino, Martin Schoeller, Bruce Weber, Mark Seliger, Terry Richardson, Mitch Feinberg, Anders Overgaard, Lauren Greenfield,
Oliviero Toscani, Tom Schierlitz / *Creative Director:* Jim Moore / *Fashion Director:* Madeline Weeks / *Publisher:* Condé Nast Publications Inc. /
Issue: May 2005 / *Category:* Design Entire Issue

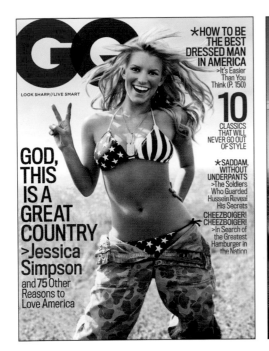

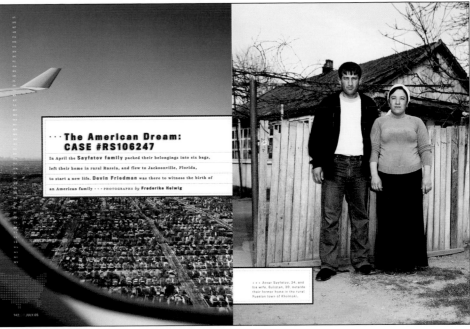

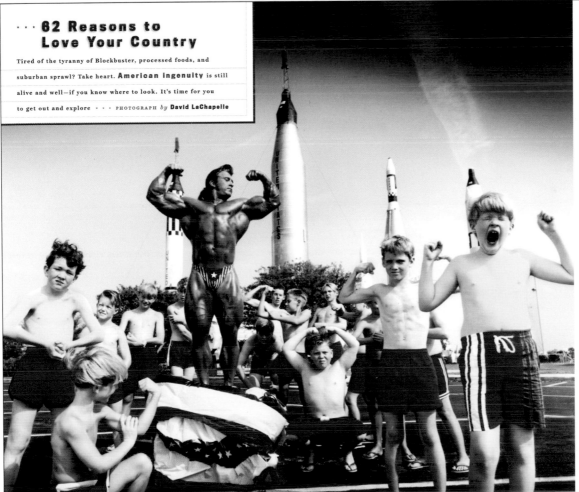

259 ✳ GQ

Design Director: Fred Woodward / *Designers:* Ken DeLago, Anton Ioukhnovets, Sarah Viñas, Thomas Alberty, Chloe Weiss / *Illustrators:* Tavis Coburn, John Ritter / *Director of Photography:* Bradley Young / *Photo Editors:* Dora Somosi, Kristen Schaefer, Monica Bradley / *Photographers:* Peggy Sirota, Kurt Markus, Bruce Weber, Frederike Helwig, Martin Schoeller, Tom Schierlitz, Jason Schmidt, Nathaniel Goldberg, Jeff Riedel / *Creative Director:* Jim Moore / *Fashion Director:* Madeline Weeks / *Publisher:* Condé Nast Publications Inc. / *Issue:* July 2005 / *Category:* Design Entire Issue

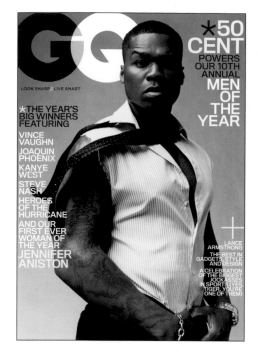

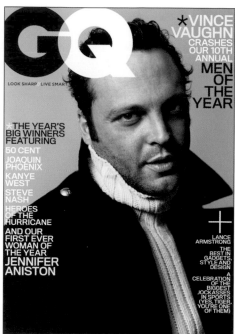

+ Merit / Newsstand Magazine (Design Story, Photography Story)

260 ✳ GQ
Design Director: Fred Woodward / *Designers:* Ken DeLago, Anton Ioukhnovets, Thomas Alberty, Michael Pangilinan, Drue Wagner /
Illustrators: Tavis Coburn, Tomer Hanuka, Jean-Philippe Delhomme, John Ueland / *Director of Photography:* Dora Somosi /
Photo Editors: Kristen Schaefer, Monica Bradley / *Photographers:* Peggy Sirota, Michael Thompson, Max Vadukal, Hedi Slimane,
Carter Smith, Martin Schoeller, Mark Seliger, Hugh Kretchmer, Tom Schierlitz / *Creative Director:* Jim Moore / *Fashion Director:*
Madeline Weeks / *Publisher:* Condé Nast Publications Inc. / *Issue:* December 2005 / *Category:* Design Entire Issue

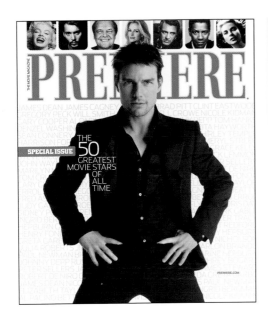

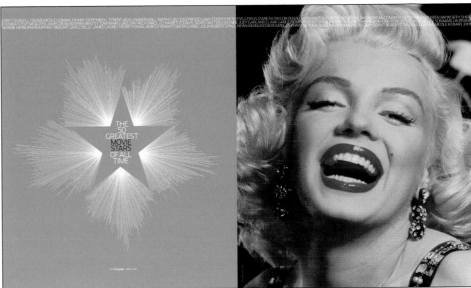

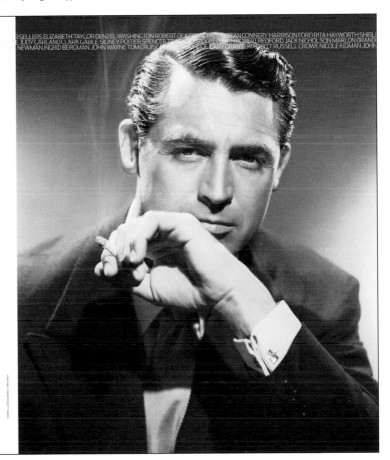

+ Merit / Newsstand Magazine (Design Story)

1904-1986 **ESSENTIAL FILMS:** *She Done Him Wrong* (1933), *The Awful Truth* (1937), *Only Angels Have Wings* (1939), *The Philadelphia Story* (1940), *Notorious* (1946), *To Catch a Thief* (1955), *North by Northwest* (1959). **OSCAR DISH:** Two nominations, for *Penny Serenade* (1941) and *None But the Lonely Heart* (1944). Grant was given an honorary award in 1970. **DO YOU HAVE TO SEE HIM RIGHT NOW?** Watch *To Catch a Thief*, not because it's his greatest film (though it's a thoroughly giddy pleasure) but because it embodies his darkness, his comedic timing, and his dazzling sex appeal.

In *Charade*, made in 1963, near the end of Cary Grant's movie career, a smitten Regina Lampert, played by Audrey Hepburn, confronts Grant's Peter Joshua.
 Lampert: Do you know what's wrong with you?
 Joshua: No, what?
 Lampert: Nothing!
 That's the way women, and men, felt about Grant from 1933, when the formerly underachieving 29-year-old played the ingenue to Mae West's sexual predator in *She Done Him Wrong*, to 1966, when he made his last film, *Walk, Don't Run* in an incredible, unequaled 33-year stretch as America's ultimate movie icon. As an action hero (*Only Angels Have Wings, Destination Tokyo*), the darkly conflicted center of Hitchcock classics (*Suspicion, Notorious, To Catch a Thief, North by Northwest*), and a supremely physical comedian (*Bringing Up Baby, My Favorite Wife, His Girl Friday, Arsenic and Old Lace*), Grant created an ideal self out of ferocious need.
 Born Archibald Leach in a poor family in Bristol, England, Grant came home one day at age ten to be told that his mother had gone to the seaside for a little rest, shortly after, he was told that she had died. (Twenty years later, he learned that she had been institutionalized and was still alive.) Grant pretty much raised himself, first as a truant and petty thief, then as part of an acrobatic troupe that eventually toured America. There, he mutated from a popular escort who looked great in a tux into a Broadway actor who looked great in a tux. Few foresaw the movie star he would become in the mid-'30s in movies like *She Done Him Wrong, Topper*, and *The Awful Truth*, which showcased both his desirability and his self-deprecating comedic personality. From *The Awful Truth* on, he was the Platonic ideal of a star—beautiful, fit, meticulously dressed and groomed, witty, and a bit melancholy. And then it turned out, in films like *Suspicion* and *Notorious*, that he could really act! Though clearly talented, Grant was most loved for the urbane persona he created for the screen and then pretty much became in real life. And in the end, we all wanted him to be Cary Grant as much as he did.

78 PREMIERE APRIL 2005

261 ✳ PREMIERE
Art Director: Dirk Barnett / *Designers:* Dirk Barnett, Christine Cucuzza, David Schlow / *Director of Photography:* Catriona NiAolain /
Photo Editors: Linda Liang, Nara Irigoyen / *Photographers:* Tony Duran, David Strick, Andrew Hetherington / *Publisher:* Hachette Filipacchi Media U.S. /
Issue: April 2005 / *Category:* Design Entire Issue

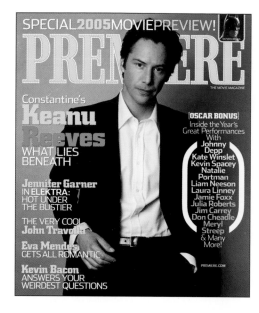

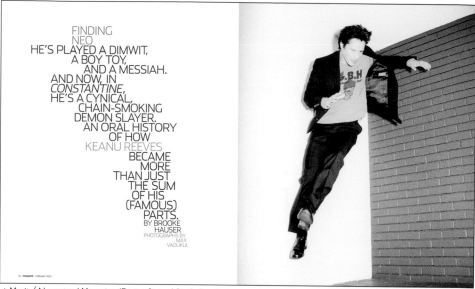

+ Merit / Newsstand Magazine (Design Spread-Single Page)

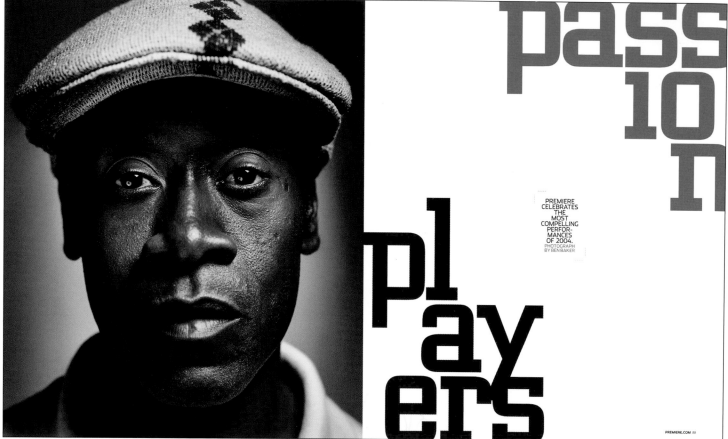

+ Merit / Newsstand Magazine (Design Spread-Single Page)

262 ✳ PREMIERE

Art Director: Dirk Barnett / *Designers:* Dirk Barnett, Christine Cucuzza, David Schlow / *Director of Photography:* Catriona NiAolain
Photo Editors: Linda Liang, Nara Irigoyen / *Photographers:* Max Vadukul, Tierney Gearon, Ben Baker, Anette Aurell, Trevor Ray Hart,
Andrew Southam / *Publisher:* Hachette Filipacchi Media U.S. / *Issue:* February 2005 / *Category:* Design Entire Issue

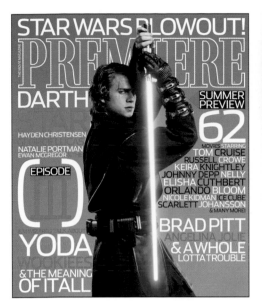

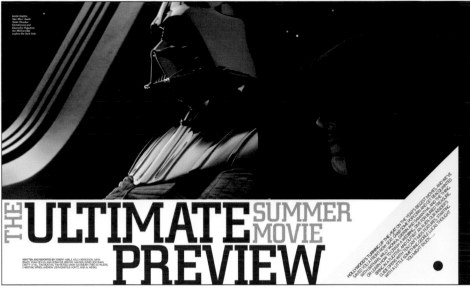

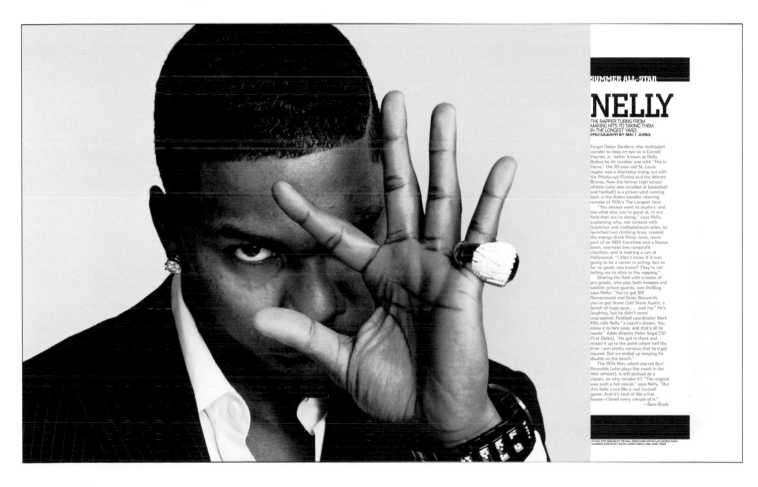

263 ✳ PREMIERE
Art Director: Dirk Barnett / *Designers:* Dirk Barnett, April Bell, David Schlow / *Director of Photography:* David Carthas /
Photo Editors: Linda Liang, Nara Ingoyen / *Photographers:* Martin Schoeller, Carlos Serrao, Bryce Duffy, Matt Jones, Sheryl Nields,
Jeff Lipsky, Meredith Jenks, David Strick / *Publisher:* Hachette Filipacchi Media U.S. / *Issue:* May 2005 / *Category:* Design Entire Issue

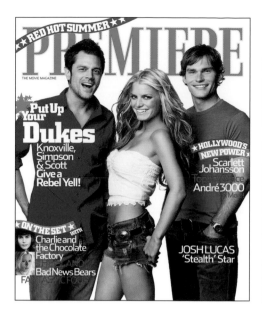

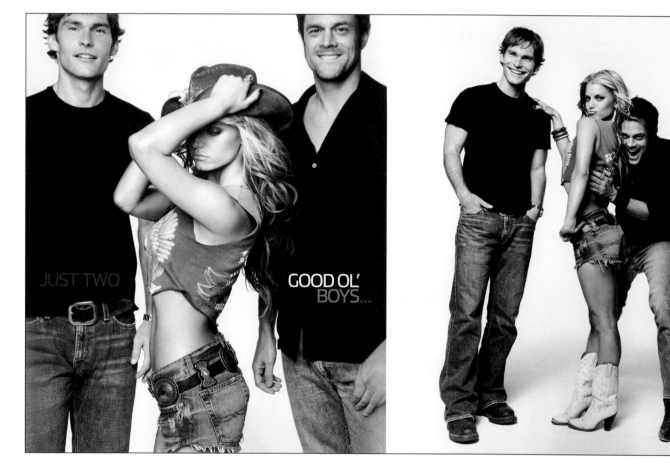

264 ✳ PREMIERE
Art Director: Dirk Barnett / *Designers:* Dirk Barnett, April Bell, David Schlow / *Director of Photography:* David Carthas /
Photo Editors: Linda Liang, Nara Irigoyen / *Photographers:* Mark Abrahams, Robert Maxwell, Jake Chessum, Bryce Duffy,
Catherine Ledner, David Strick, Ben Baker / *Publisher:* Hachette Filipacchi Media U.S. / *Issue:* July-August 2005 / *Category:* Design Entire Issue

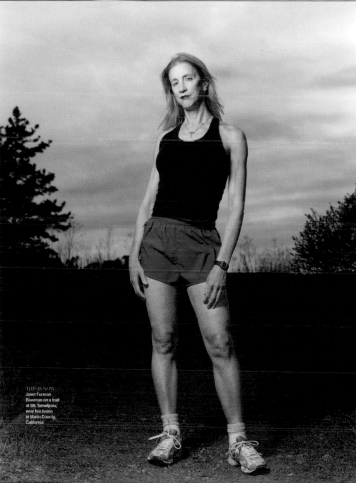

+ Merit / Newsstand Magazine (Design Spread-Single Page)

A 6 Minute Difference

by Cynthia Gorney

PHOTOGRAPH BY DAN WINTERS

EVER WONDER
HOW MUCH FASTER (OR
SLOWER) YOU'D RUN
IF YOU WERE THE
OPPOSITE SEX?
JANET FURMAN
BOWMAN MAY BE
THE ONLY RUNNER
IN AMERICA WHO KNOWS.

106 JUNE 2005 RUNNERSWORLD.COM

265 ✱ RUNNER'S WORLD
Design Director: Robert Festino / Designers: Eric Paul, Michael Cundari, Robert Festino / Illustrators: Ryan Sanchez, Thomas Fuchs, Tim Bower / Photo Editors: Don Kinsella, Michele Ervin / Photographers: Andy Anderson, Dan Winters, Kristine Larsen, Bill Diodato / Publisher: Rodale / Issue: June 2005 / Category: Design Entire Issue

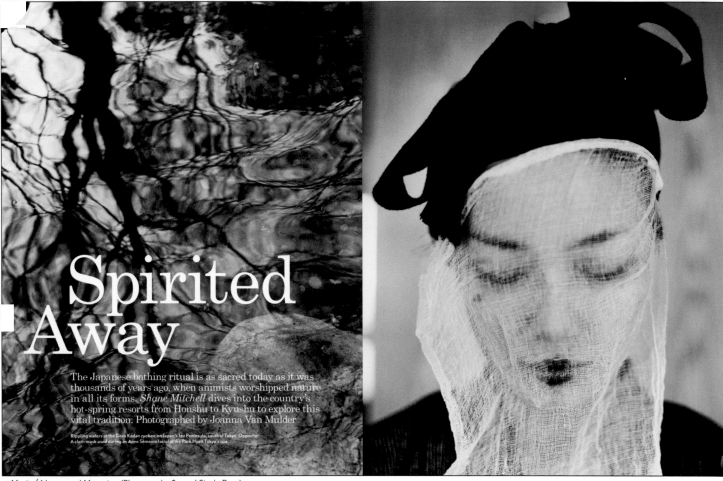

Spirited Away

The Japanese bathing ritual is as sacred today as it was thousands of years ago, when animists worshipped nature in all its forms. *Shane Mitchell* dives into the country's hot-spring resorts from Honshu to Kyushu to explore this vital tradition. Photographed by Joanna Van Mulder

Rippling waters at the Gora Kadan ryokan on Japan's Izu Peninsula, south of Tokyo. Opposite: A cloth mask used during an Anne Sémonin facial at the Park Hyatt Tokyo's spa.

+ Merit / Newsstand Magazine (Photography Spread-Single Page)

SPECIAL REPORT

update

Travel Smarter

Sleeping Around

Want to rest easier on the road? This month, T+L examines the race for better beds that is shaking up the hotel industry, and sends one intrepid reporter on a soporific test-drive to find out whether the improvements are actually making a difference to travelers. You'll also get the inside scoop on just how often all that bedding gets washed, which sleep aids really work, and everything else you need to make your next night away from home a trip to dreamland.

174 Tom Schierlitz

266 ✳ TRAVEL + LEISURE

Design Director: Emily Crawford / *Art Director:* David Heasty / *Designers:* Gillian Goodman Berenson, Sandra Garcia, Nancy Chan / *Photo Editors:* Katie Dunn, Wendy Ball, Kathryn Noble / *Publisher:* American Express Publishing Co. / *Issue:* June 2005 / *Category:* Design Entire Issue

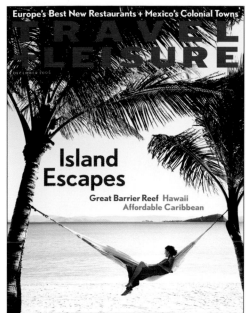

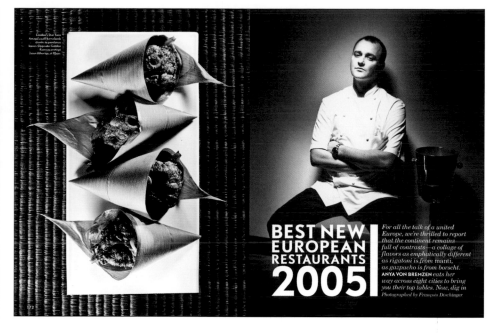

+ Merit / Newsstand Magazine (Photography Entire Issue)

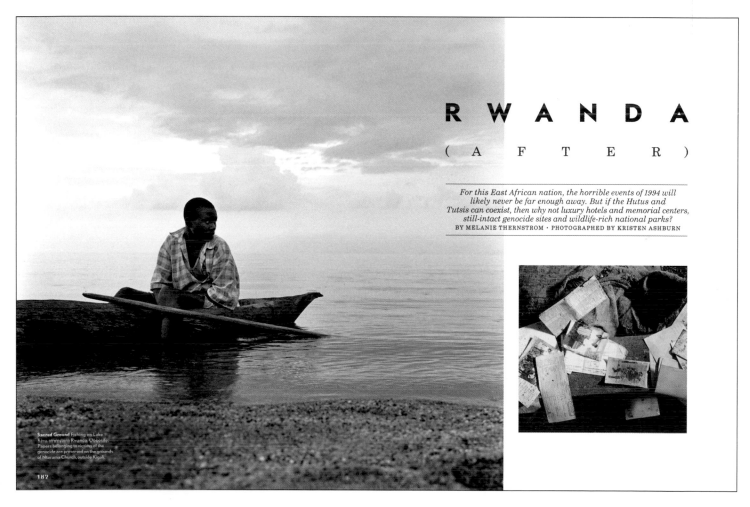

Design Director: Emily Crawford / Art Director: David Heasty / Designers: Gillian Goodman Berenson, Sandra Garcia /
Photo Editors: Katie Dunn, Wendy Ball, Whitney Lawson / Publisher: American Express Publishing Co. / Issue: December 2005 /
Category: Design Entire Issue

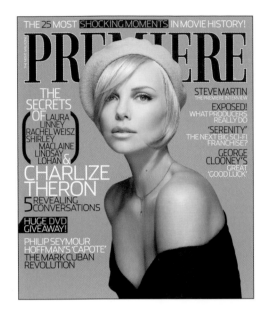

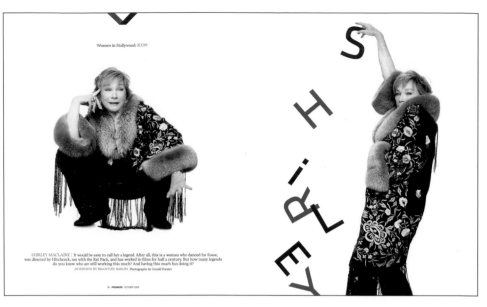

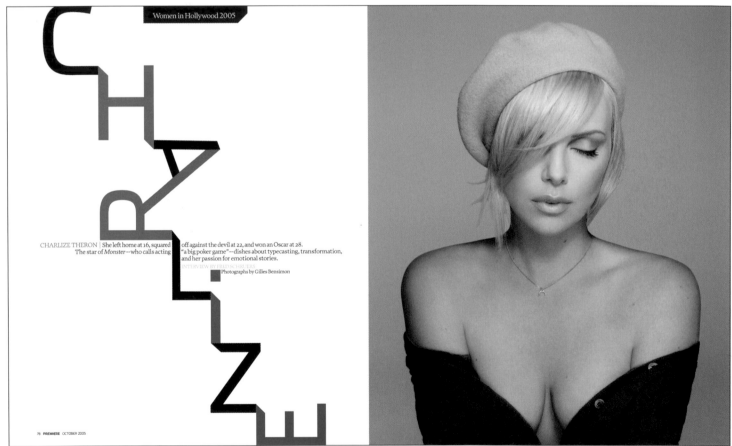

+ Merit / Newsstand Magazine (Design Story)

268 ✳ PREMIERE

Art Director: Dirk Barnett / *Designers:* Dirk Barnett, April Bell / *Director of Photography:* David Carthas /
Photo Editors: Linda Lang, Nara Irigoyen / *Photographers:* Gilles Bensimon, Chris Buck, John Midgley,
Gerald Forster, Jacqueline Bohnert, David Strick, Brent Humphreys / *Publisher:* Hachette Filipacchi
Media U.S. / *Issue:* October 2005 / *Category:* Design Redesign

269 ✳ THIS OLD HOUSE
Design Director: Amy Rosenfeld / *Art Director:* Hylah Hill /
Designers: Andrea Dunham, John Taylor, Ariama Sequo /
Photo Editors: Denise Sfraga, Leah Vinluan / *Photographers:*
Mark Hooper, Dan Winters, Plamen Petkov, Mark Weiss,
Russell Kaye, Alison Rosa, Keller + Keller / *Publisher:* Time
Inc. / *Issue:* September 2005 / *Category:* Design Redesign

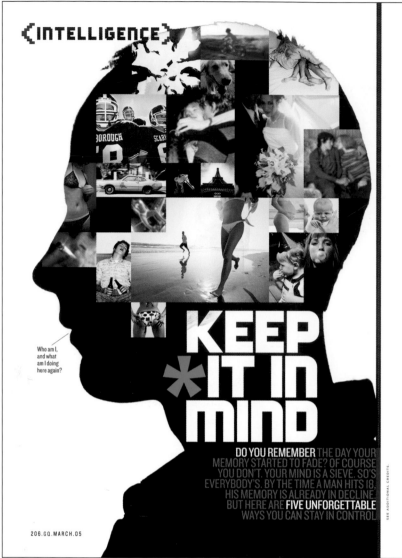

270

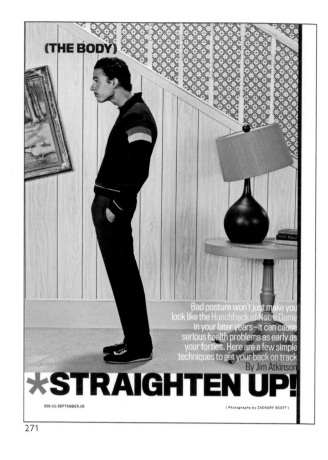

271

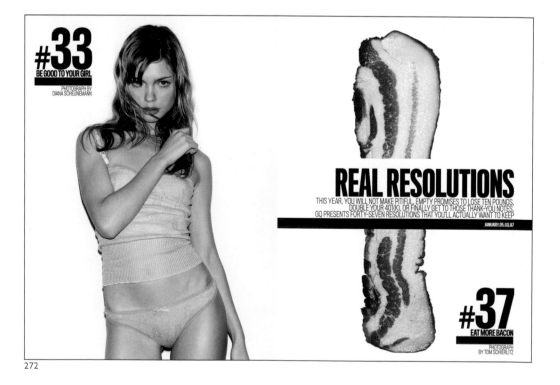

272

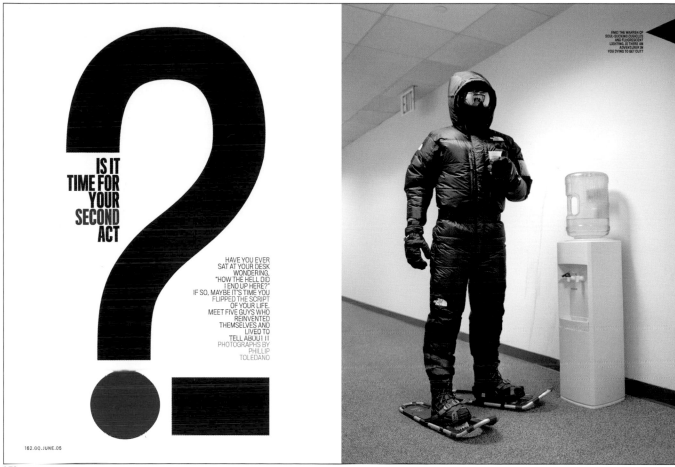

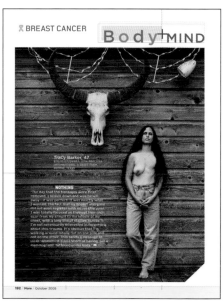

273

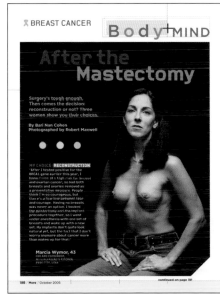

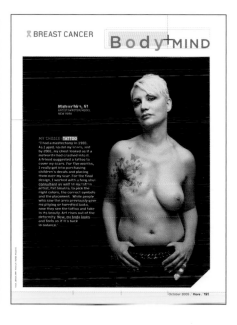

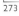

271

273 ✳ GQ
Design Director: Fred Woodward / Designer: Anton Ioukhnovets / Director of Photography: Bradley Young / Photo Editor: Dora Somosi /
Photographer: Philip Toledano / Publisher: Condé Nast Publications Inc. / Issue: June 2005 / Category: Photography Contents & Departments

274 ✳ MORE
Creative Director: Maxine Davidowitz / Art Director: Jose G. Fernandez / Designer: Sarah Goldschadt / Photo Editor: Karen Frank /
Photographer: Robert Maxwell / Publisher: Meredith Corporation / Issue: October 2005 / Category: Photography Contents & Departments

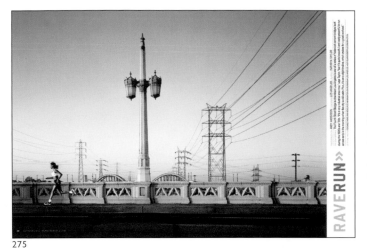

275

276

277

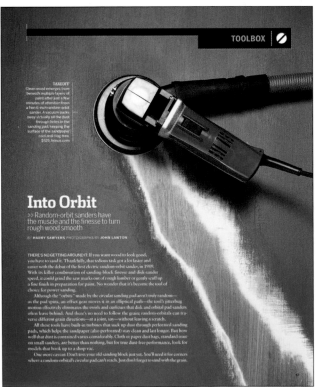

278

275 ✳ RUNNER'S WORLD
Design Director: Robert Festino / *Designers:* Eric Paul, Erin Ploskonka / *Photo Editor:* Don Kinsella / *Photographer:* Andy Anderson / *Publisher:* Rodale / *Issue:* October 2005 / *Category:* Photography Contents & Departments

276 ✳ SPIN
Design Director: Kory Kennedy / *Art Director:* Devin Pedzwater / *Designer:* Liz Macfarlane / *Director of Photography:* Kathleen Kemp / *Photo Editors:* Jennifer Santana, Bethany Mezick / *Photographer:* Lucy Hamblin / *Publisher:* Spin Media / *Issue:* December 2005 / *Category:* Photography Contents & Departments

277 ✳ TRAVEL + LEISURE
Design Director: Emily Crawford / *Designer:* Emily Crawford / *Photo Editor:* Katie Dunn / *Photographer:* Stefan Ruiz / *Publisher:* American Express Publishing Co. / *Issue:* September 2005 / *Category:* Photography Contents & Departments

278 ✳ THIS OLD HOUSE
Design Director: Amy Rosenfeld / *Designer:* John Taylor / *Photo Editor:* Denise Sfraga / *Photographer:* John Lawton / *Publisher:* Time Inc. / *Issue:* November 2005 / *Category:* Photography Contents & Departments

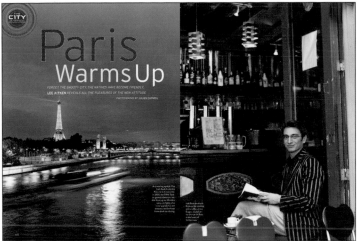

279

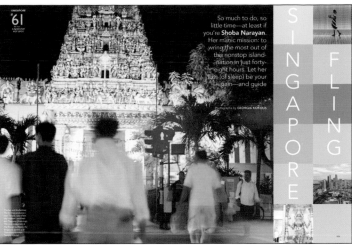

280

281

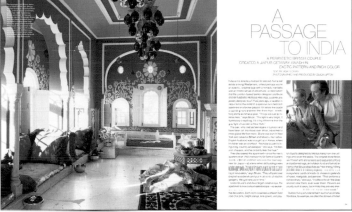

282

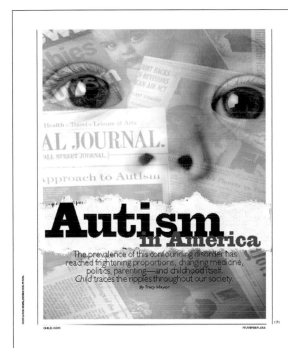

283

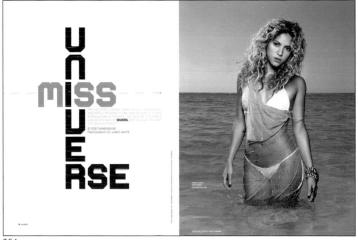

284

279 ✳ CONDÉ NAST TRAVELER
Design Director: Robert Best / *Art Director:* Kerry Robertson / *Designer:* Kerry Robertson /
Photo Editors: Kathleen Klech, Esin Ili Goknar / *Photographer:* Julien Capmeil / *Publisher:* Condé
Nast Publications, Inc. / *Issue:* May 2005 / *Category:* Design Spread-Single Page

280 ✳ CONDÉ NAST TRAVELER
Design Director: Robert Best / *Art Director:* Kerry Robertson / *Designer:* Kerry Robertson /
Photo Editors: Kathleen Klech, Esin Ili Goknar / *Photographer:* George Kokolis / *Publisher:* Condé
Nast Publications, Inc. / *Issue:* July 2005 / *Category:* Design Spread-Single Page

281 ✳ ELLE DÉCOR
Art Director: Florentino Pamintuan / *Photo Editor:* Melissa LeBoeuf / *Publisher:* Hachette Filipacchi
Media U.S. / *Issue:* February 2005 / *Category:* Design Spread-Single Page

288 ✳ ELLE DÉCOR
Art Director: Florentino Pamintuan / *Photo Editor:* Melissa LeBoeuf / *Publisher:* Hachette Filipacchi
Media U.S. / *Issue:* April 2005 / *Category:* Design Spread-Single Page

283 ✳ CHILD
Art Director: Daniel Chen / *Photo Editors:* Ulrika Thunberg, Melissa Malinowsky / *Deputy Art
Director:* Megan Henry / *Publisher:* Meredith / *Issue:* November 2005 / *Category:* Design
Spread-Single Page

284 ✳ BLENDER
Creative Director: Andy Turnbull / *Designer:* Andy Turnbull / *Photo Editor:* Tonya Martin /
Photographer: James White / *Publisher:* Dennis Publishing / *Issue:* July 2005 / *Category:* Design
Spread-Single Page

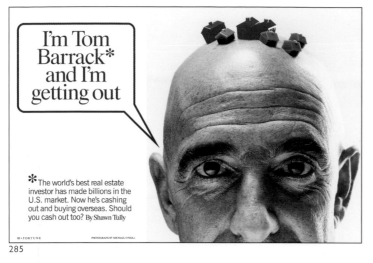

285

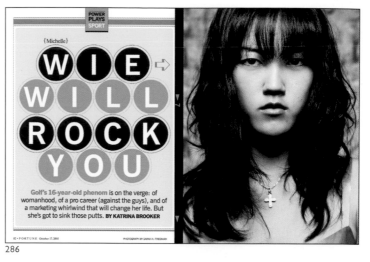

286

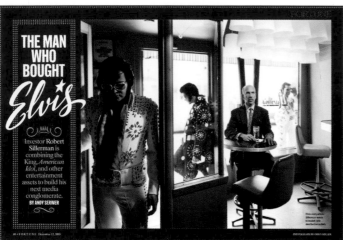

287

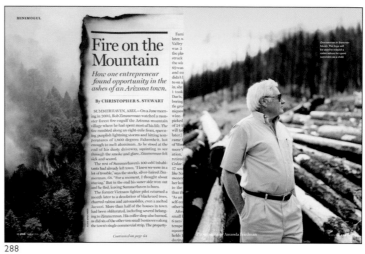

288

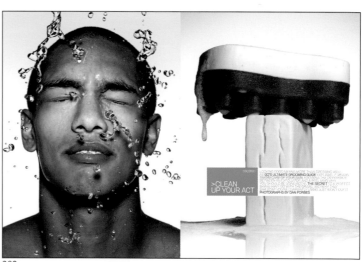

289

285 ✳ F O R T U N E
Design Director: Robert Newman / *Designer:* Tony Mikolajczyk / *Director of Photography:* Greg Pond / *Photo Editor:* Scott Thode / *Photographer:* Michael O'Neill / *Publisher:* Time Inc. / *Issue:* October 31, 2005 / *Category:* Design Spread-Single Page

286 ✳ F O R T U N E
Design Director: Robert Newman / *Designer:* Tony Mikolajczyk / *Director of Photography:* Greg Pond / *Photo Editor:* Scot Thode / *Publisher:* Time Inc. / *Issue:* October 17, 2005 / *Category:* Design Spread-Single Page

287 ✳ F O R T U N E
Design Director: Robert Newman / *Designer:* Tony Mikolajczyk / *Director of Photography:* Greg Pond / *Photo Editor:* Mia Diehl / *Photographer:* Sarah A. Friedman / *Publisher:* Time Inc. / *Issue:* December 12, 2005 / *Category:* Design Spread-Single Page

288 ✳ F S B F O R T U N E S M A L L B U S I N E S S
Art Director: Scott Davis / *Designer:* Michael Novak / *Illustrator:* Chris O'Riley / *Photo Editor:* Kathy Howe / *Photographer:* Amanda Friedman / *Publisher:* Time Inc. / *Issue:* March 2005 / *Category:* Design Spread-Single Page

289 ✳ G Q
Design Director: Fred Woodward / *Designer:* Ken DeLago / *Photo Editor:* Kristen Schaefer / *Photographer:* Dan Forbes / *Publisher:* Condé Nast Publications Inc. / *Issue:* November 2005 / *Category:* Design Spread-Single Page

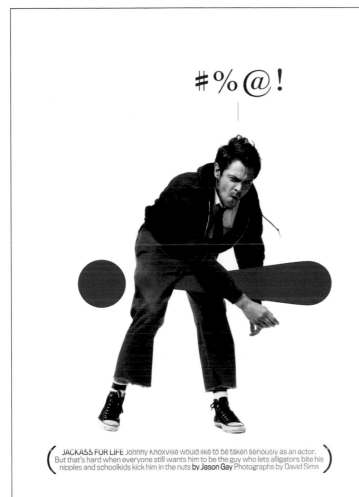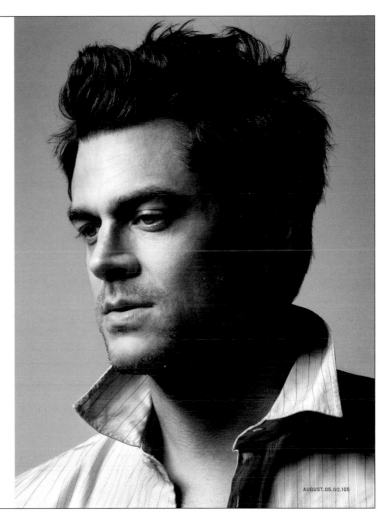

290 + Merit / Newsstand Magazine (Photography Story)

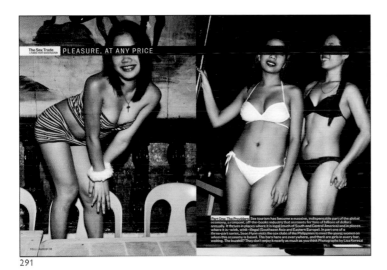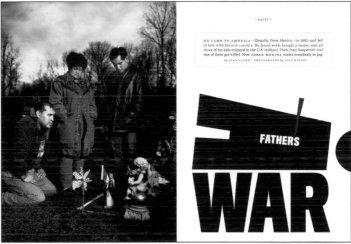

291

292 + Merit / Newsstand Magazine (Photography Spread-Single Page)

290 ✳ GQ

Design Director: Fred Woodward / *Designer:* Ken DeLago / *Director of Photography:* Bradley Young / *Photographer:* David Sims / *Creative Director:* Jim Moore / *Fashion Director:* Madeline Weeks / *Publisher:* Condé Nast Publications Inc. / *Issue:* August 2005 / *Category:* Design Spread-Single Page

291 ✳ GQ

Design Director: Fred Woodward / *Designer:* Thomas Alberty / *Director of Photography:* Bradley Young / *Photo Editor:* Dora Somosi / *Photographer:* Lisa Kereszi / *Publisher:* Condé Nast Publications Inc. / *Issue:* August 2005 / *Category:* Design Spread-Single Page

292 ✳ GQ

Design Director: Fred Woodward / *Designer:* Ken DeLago / *Director of Photography:* Bradley Young / *Photo Editor:* David Carthas / *Photographer:* Jeff Riedel / *Publisher:* Condé Nast Publications Inc. / *Issue:* February 2005 / *Category:* Design Spread-Single Page

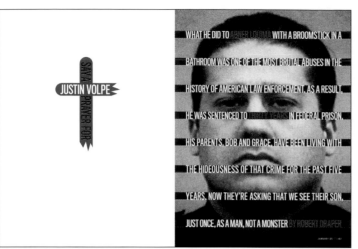

293

294

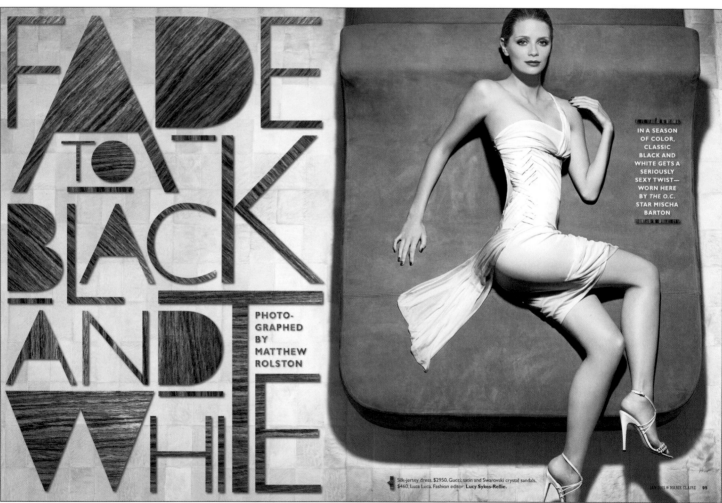

Silk-jersey dress, $2950, Gucci; satin and Swarovski crystal sandals, $460, Luca Luca. Fashion editor: **Lucy Sykes-Rellie.**

295

293 ✳ G Q
Design Director: Fred Woodward / *Designer:* Ken DeLago / *Director of Photography:* Bradley Young / *Photo Editor:* Monica Bradley /
Publisher: Condé Nast Publications Inc. / *Issue:* January 2005 / *Category:* Design Spread-Single Page

294 ✳ INC.
Creative Director: Blake Taylor / *Designer:* Lou Vega / *Illustrator:* Lou Vega / *Publisher:* Mansueto Ventures / *Issue:* September 2005 /
Category: Design Spread-Single Page

295 ✳ MARIE CLAIRE
Creative Director: Paul Martinez / *Art Director:* Jenny Leigh Thompson / *Designer:* Paul Martinez / *Director of Photography:* Dora Samosi /
Photographer: Matthew Rolston / *Fashion Editor:* Lucy Sykes-Rellie / *Publisher:* The Hearst Corporation-Magazines Division /
Issue: January 2005 / *Category:* Design Spread-Single Page

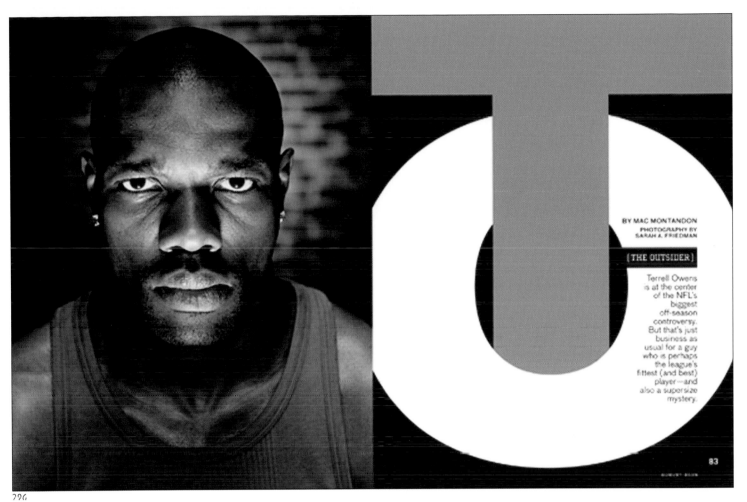

296

297

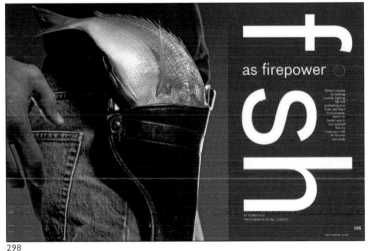

298

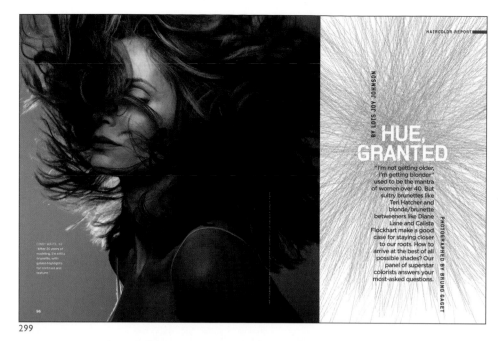

299

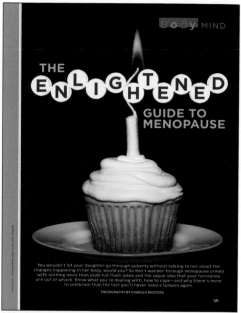

300

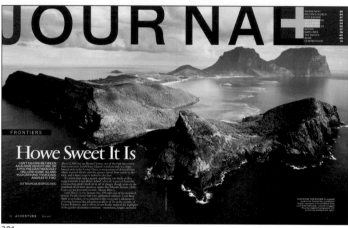

301

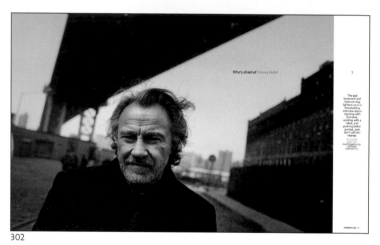

302

299 ✳ MORE
Creative Director: Maxine Davidowitz / *Art Director:* Jose G. Fernandez / *Designer:* Grace Lee / *Photo Editor:* Karen Frank / *Photographer:*
Charles Masters / *Publisher:* Meredith Corporation / *Issue:* December 2005-January 2006 / *Category:* Design Spread-Single Page

300 ✳ MORE
Creative Director: Maxine Davidowitz / *Designer:* David McKenna / *Photo Editor:* Karen Frank / *Photographer:* Bruno Gaget /
Publisher: Meredith Corporation / *Issue:* July-August 2005 / *Category:* Design Spread-Single Page

301 ✳ NATIONAL GEOGRAPHIC ADVENTURE
Design Director: Julie Curtis / *Art Director:* Jose Fernandez / *Designers:* Jose Fernandez, Isaac Gertman / *Photo Editors:* Sabine Meyer,
Caroline Hirsch / *Photographer:* R. Ian Lloyd / *Publisher:* National Geographic Society / *Issue:* May 2005 / *Category:* Design Spread-Single Page

302 ✳ PREMIERE
Art Director: Dirk Barnett / *Designer:* Dirk Barnett / *Director of Photography:* Catriona NiAolain / *Photographer:* Antonin Kratochvil /
Publisher: Hachette Filipacchi Media U.S. / *Issue:* March 2005 / *Category:* Design Spread-Single Page

303 ✳ PREMIERE
Art Director: Dirk Barnett / *Designer:* Dirk Barnett / *Photo Editors:* David Carthas, Nara Irigoyen / *Photographer:* Bryce Duffy /
Publisher: Hachette Filipacchi Media U.S. / *Issue:* May 2005 / *Category:* Design Spread-Single Page

304 ✳ PREMIERE
Art Director: Dirk Barnett / *Designer:* Dirk Barnett / *Director of Photography:* David Carthas / *Photographer:* Martin Schoeller /
Publisher: Hachette Filipacchi Media U.S. / *Issue:* May 2005 / *Category:* Design Spread-Single Page

303

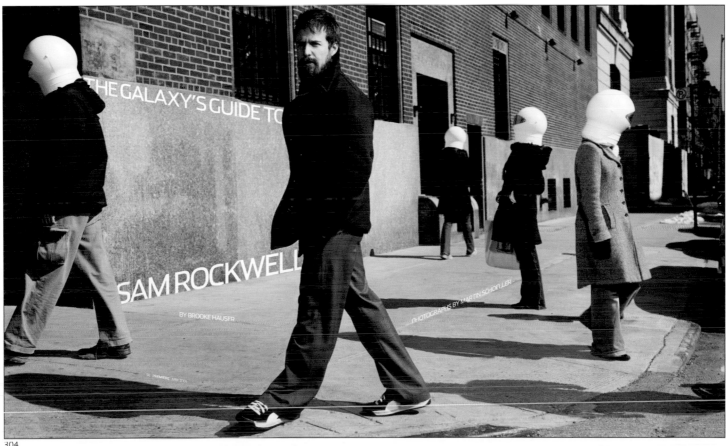

304

305

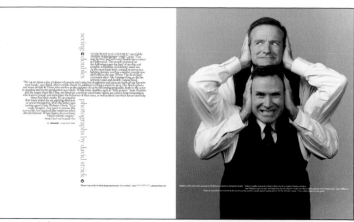

306 + Merit / Newsstand Magazine (Photography Story)

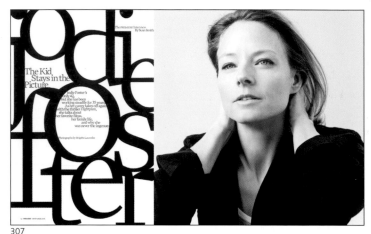

307

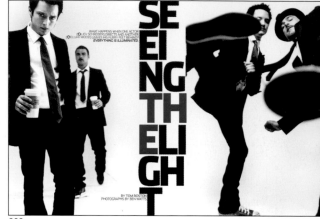

308

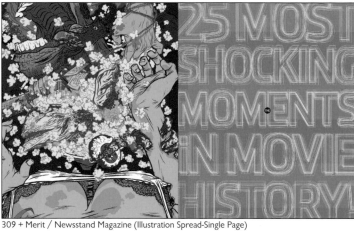

309 + Merit / Newsstand Magazine (Illustration Spread-Single Page)

310

305 ✳ PREMIERE

Art Director: Dirk Barnett / *Designer:* Dirk Barnett / *Director of Photography:* David Carthas /
Photographer: Platon / *Publisher:* Hachette Filipacchi Media U.S. / *Issue:* September 2005 /
Category: Design Spread-Single Page

306 ✳ PREMIERE

Art Director: Dirk Barnett / *Designer:* Dirk Barnett / *Photo Editor:* Catriona NiAolain /
Photographer: David Strick / *Publisher:* Hachette Filipacchi Media U.S. / *Issue:* July-August 2005 /
Category: Design Spread-Single Page

307 ✳ PREMIERE

Art Director: Dirk Barnett / *Designer:* Dirk Barnett / *Director of Photography:* David Carthas /
Photographer: Brigitte Lacombe / *Publisher:* Hachette Filipacchi Media U.S. / *Issue:* September
2005 / *Category:* Design Spread-Single Page

308 ✳ PREMIERE

Art Director: Dirk Barnett / *Designer:* Dirk Barnett / *Director of Photography:* David Carthas /
Photo Editor: Linda Liang / *Photographer:* Ben Watts / *Publisher:* Hachette Filipacchi Media U.S. /
Issue: September 2005 / *Category:* Design Spread-Single Page

309 ✳ PREMIERE

Art Director: Dirk Barnett / *Designer:* Dirk Barnett / *Illustrator:* Nathan Fox / *Publisher:* Hachette
Filipacchi Media U.S. / *Issue:* October 2005 / *Category:* Design Spread-Single Page

310 ✳ PREMIERE

Art Director: Dirk Barnett / *Designer:* Dirk Barnett / *Director of Photography:* David Carthas /
Photographer: Jeff Lipsky / *Publisher:* Hachette Filipacchi Media U.S. / *Issue:* May 2005 /
Category: Design Spread-Single Page

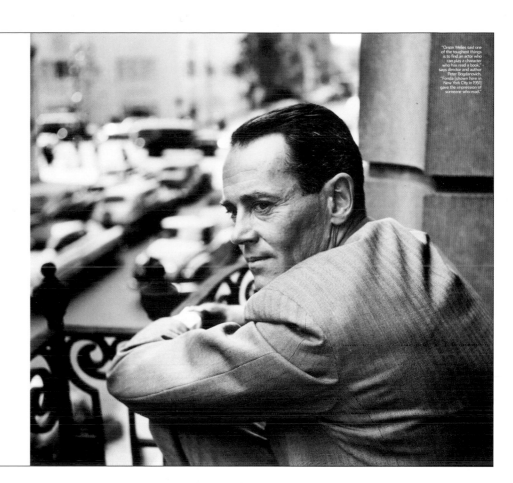

311

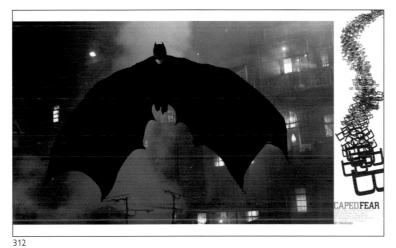

312

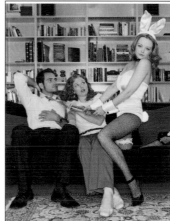

313

311 ✳ PREMIERE
Art Director: Dirk Barnett / *Designer:* Dirk Barnett / *Director of Photography:* David Carthas / *Photo Editor:* Linda Liang /
Photographer: Slim Aarons / *Publisher:* Hachette Filipacchi Media U.S. / *Issue:* June 2005 / *Category:* Design Spread-Single Page

312 ✳ PREMIERE
Art Director: Dirk Barnett / *Designer:* Dirk Barnett / *Director of Photography:* David Carthas / *Publisher:* Hachette Filipacchi Media U.S. /
Issue: June 2005 / *Category:* Design Spread-Single Page

313 ✳ PSYCHOLOGY TODAY
Creative Director: Edward Levine / *Photo Editor:* Claudia Stefezius / *Photographer:* Lynda Churilla / *Publisher:* Sussex Publishers /
Issue: October 2005 / *Category:* Design Spread-Single Page

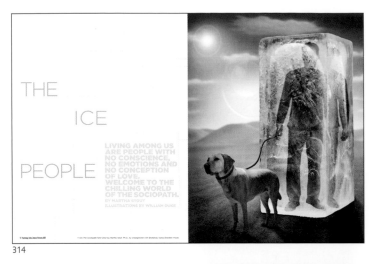

314

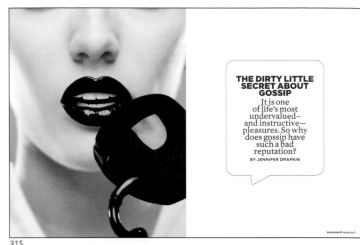

315

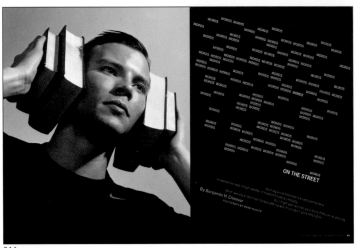

316

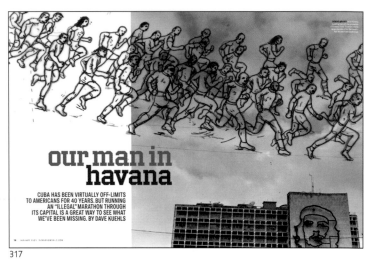

317

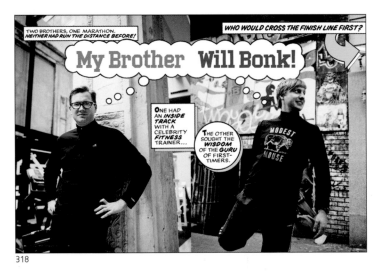

318

319

314 ✳ PSYCHOLOGY TODAY
Creative Director: Edward Levine / *Illustrator:* William Duke / *Publisher:* Sussex Publishers / *Issue:* February 2005 / *Category:* Design Spread-Single Page

315 ✳ PSYCHOLOGY TODAY
Creative Director: Edward Levine / *Photo Editor:* Claudia Stefezius / *Publisher:* Sussex Publishers / *Issue:* December 2005 / *Category:* Design Spread-Single Page

316 ✳ RUNNER'S WORLD
Design Director: Robert Festino / *Designer:* Robert Festino / *Photo Editor:* Don Kinsella / *Photographer:* Mark Hooper / *Publisher:* Rodale / *Issue:* September 2005 / *Category:* Design Spread-Single Page

317 ✳ RUNNER'S WORLD
Design Director: Robert Festino / *Designer:* Robert Festino / *Illustrator:* Jonathan Rosen / *Photo Editor:* Don Kinsella / *Photographer:* David Nicolas / *Publisher:* Rodale / *Issue:* January 2005 / *Category:* Design Spread-Single Page

318 ✳ RUNNER'S WORLD
Design Director: Robert Festino / *Designer:* Robert Festino / *Photo Editor:* Don Kinsella / *Photographer:* Joshua Paul / *Publisher:* Rodale / *Issue:* April 2005 / *Category:* Design Spread-Single Page

319 ✳ RUNNER'S WORLD
Design Director: Robert Festino / *Designer:* Robert Festino / *Photo Editor:* Don Kinsella / *Photographer:* Patrik Giardino / *Publisher:* Rodale / *Issue:* February 2005 / *Category:* Design Spread-Single Page

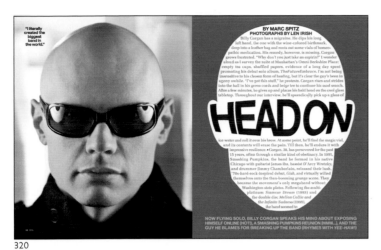

320

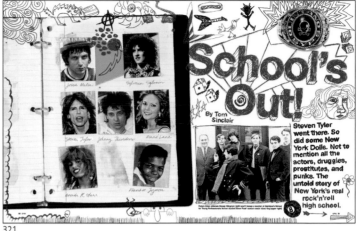

321

322

320 ✿ SPIN
Design Director: Kory Kennedy / *Art Director:* Devin Pedzwater / *Designer:* Liz Macfarlane / *Director of Photography:* Kathleen Kemp / *Photo Editors:*
Jennifer Santana, Bethany Mezick / *Photographer:* Len Irish / *Publisher:* Spin Media / *Issue:* August 2005 / *Category:* Design Spread-Single Page

321 ✿ SPIN
Design Director: Kory Kennedy / *Art Director:* Devin Pedzwater / *Designer:* Liz Macfarlane / *Director of Photography:* Kathleen Kemp / *Photo Editors:*
Jennifer Santana, Bethany Mezick / *Publisher:* Spin Media / *Issue:* September 2005 / *Category:* Design Spread-Single Page

322 ✿ SPIN
Design Director: Kory Kennedy / *Art Director:* Devin Pedzwater / *Designer:* Liz Macfarlane / *Director of Photography:* Kathleen Kemp / *Photo Editors:*
Jennifer Santana, Bethany Mezick / *Publisher:* Spin Media / *Issue:* December 2005 / *Category:* Design Spread-Single Page

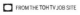
FROM THE TOH TV JOB SITE

The
Man

With

Too
Many

Plans

*The owner of TOH's new TV project house
struggled for more than a decade to find a renovation
blueprint he could live with. Here are 10 lessons
drawn from his experience to help you get the right plan
for your house, right from the start*

By MAX ALEXANDER
Photographs by RUSSELL KAYE

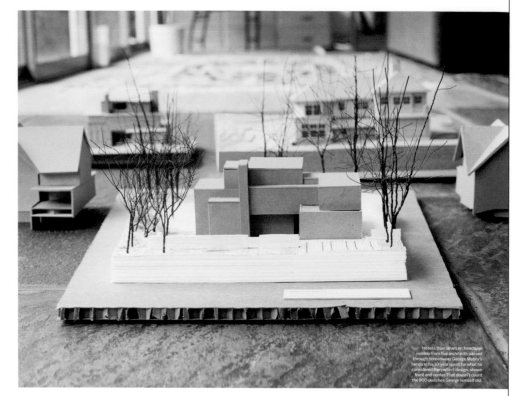

No less than seven architectural models from five architects passed through homeowner George Matny's hands in his 10-year quest for what he considered the perfect design shown front and center. That doesn't count the 900 sketches George himself did.

SEPTEMBER 2005 THIS OLD HOUSE 133

323

a warming trend
Vintage stoves have style and firepower to burn. Here's how to find one, fix it up, and fit it into your kitchen design

324

FOR REASONS POLITICAL, CULTURAL, AND GEOGRAPHIC, THIS COUNTRY REMAINS INTRIGUINGLY MYSTERIOUS. BUT ITS RICH AND LIVELY HISTORY LIVES ON IN THE RUINED PALACES OF PERSEPOLIS, IN THE GARDENS OF ESFAHAN, AND IN THE BAZAARS OF TEHRAN. PETER JON LINDBERG EXPLORES A NATION THAT'S BY TURNS HARD-LINE TRADITIONAL AND WESTERN-POP-STYLE-OBSESSED, HOME TO BOTH ASPHALT GRIT AND SNOWCAPPED MOUNTAINS—A PLACE FEW AMERICAN TRAVELERS SEE

IRAN

PHOTOGRAPHED BY CEDRIC ANGELES

325

323 ✳ THIS OLD HOUSE
Design Director: Amy Rosenfeld / *Art Director:* Hylah Hill / *Designers:* Hylah Hill, Arianna Squeo / *Photo Editor:* Denise Sfraga /
Photographer: Russell Kane / *Publisher:* Time Inc. / *Issue:* September 2005 / *Category:* Design Spread-Single Page

324 ✳ THIS OLD HOUSE
Design Director: Amy Rosenfeld / *Art Director:* Hylah Hill / *Designer:* Hylah Hill / *Photo Editor:* Denise Sfraga /
Photographer: Zubin Shroff / *Publisher:* Time Inc. / *Issue:* October 2005 / *Category:* Design Spread-Single Page

325 ✳ TRAVEL + LEISURE
Design Director: Emily Crawford / *Designer:* Sandra Garcia / *Photo Editor:* Katie Dunn / *Photographer:* Cedric Angeles /
Publisher: American Express Publishing Co. / *Issue:* July 2005 / *Category:* Design Spread-Single Page

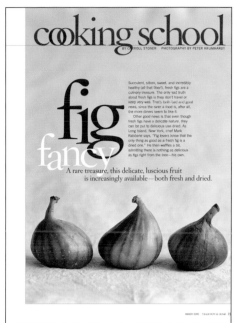

326

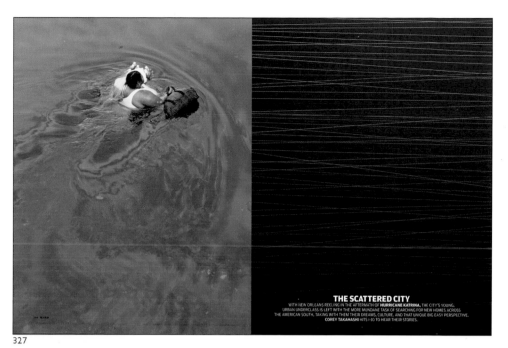

327

328

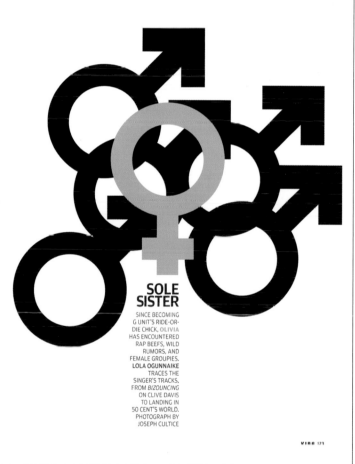

326 ✳ TRADITIONAL HOME
Art Director: Kathryn Kunz Finney / *Designer:* Wendy Johnson / *Director of Photography:* Kathryn Finney / *Photo Editor:* Jo Ann McVicker /
Photographer: Peter Krumhardt / *Publisher:* Meredith / *Issue:* March 2005 / *Category:* Design Spread-Single Page

327 ✳ VIBE
Design Director: Florian Bachleda / *Publisher:* Vibe-Spin Ventures LLC / *Issue:* December 2005 / *Category:* Design Spread Single Page

328 ✳ VIBE
Design Director: Florian Bachleda / *Designer:* Alice Alves / *Photo Editor:* Liane Radel / *Photographer:* Joseph Cultice /
Publisher: Vibe-Spin Ventures LLC / *Issue:* October 2005 / *Category:* Design Spread-Single Page

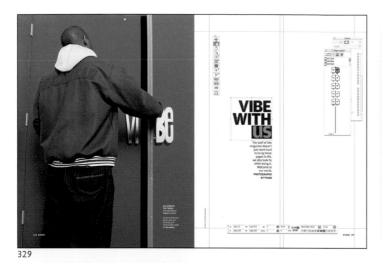

329

330

331 + Merit / Newsstand Magazine (Photography Spread-Single Page)

332

329 ✳ V I B E
Design Director: Florian Bachleda / *Designer:* Alice Alves / *Photo Editor:* Liane Radel / *Photographer:* Pham /
Publisher: Vibe-Spin Ventures LLC / *Issue:* November 2005 / *Category:* Design Spread-Single Page

330 ✳ V I B E
Design Director: Florian Bachleda / *Art Director:* Wyatt Mitchell / *Photo Editor:* Liane Radel / *Photographer:* Greg Broom /
Publisher: Vibe-Spin Ventures LLC / *Issue:* December 2005 / *Category:* Design Spread-Single Page

331 ✳ V I B E
Design Director: Florian Bachleda / *Designer:* Michael Friel / *Photo Editor:* Liane Radel / *Photographer:* Sarah Friedman /
Publisher: Vibe-Spin Ventures LLC / *Issue:* January 2005 / *Category:* Design Spread-Single Page

332 ✳ V I B E
Design Director: Florian Bachleda / *Art Director:* Wyatt Mitchell / *Photo Editor:* Liane Radel / *Photographer:* Guzman /
Publisher: Vibe-Spin Ventures LLC / *Issue:* October 2005 / *Category:* Design Spread-Single Page

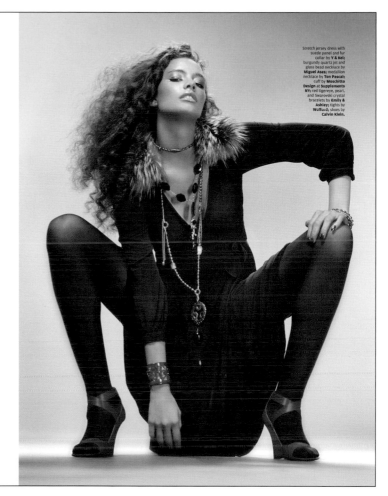

333

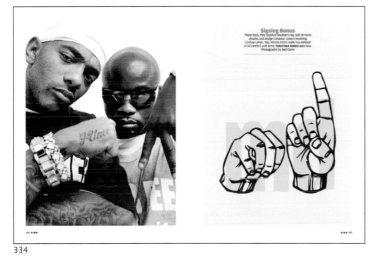

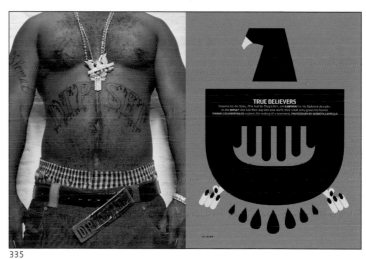

334 335

333 ✳ VIBE VIXEN
Design Director: Florian Bachleda / *Art Director:* Alice Alves / *Photo Editor:* Liane Radel / *Photographer:* Christopher Kolk /
Issue: Fall 2005 / *Category:* Design Spread-Single Page

334 ✳ VIBE
Design Director: Florian Bachleda / *Art Director:* Wyatt Mitchell / *Photo Editor:* Liane Radel / *Photographer:* Neil Gavin /
Publisher: Vibe-Spin Ventures LLC / *Issue:* December 2005 / *Category:* Design Spread-Single Page

335 ✳ VIBE
Design Director: Florian Bachleda / *Designer:* Alice Alves / *Photo Editor:* Liane Radel / *Photographer:* Kenneth Cappello /
Publisher: Vibe-Spin Ventures LLC / *Issue:* November 2005 / *Category:* Design Spread-Single Page

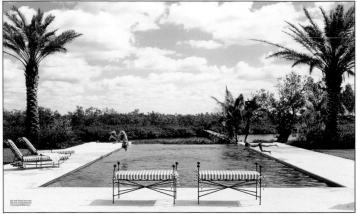

336

337

338

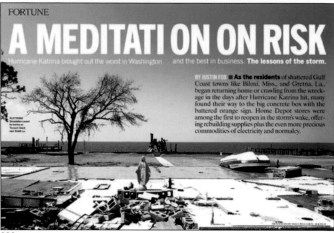

339

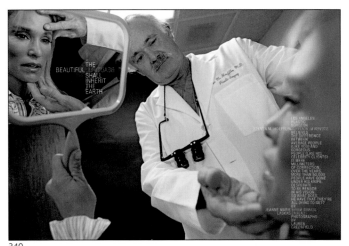

340

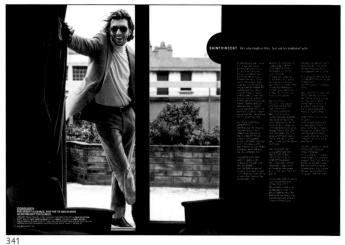

341

336 ✳ ELLE DÉCOR
Art Director: Florentino Pamintuan / *Photo Editor:* Melissa LeBoeuf / *Producer:* Anita Sarsidi /
Publisher: Hachette Filipacchi Media U.S. / *Issue:* July-August 2005 / *Category:* Photography
Spread-Single Page

337 ✳ GQ
Design Director: Fred Woodward / *Designer:* Ken DeLago / *Director of Photography:*
Dora Somosi / *Photographer:* Peggy Sirota / *Creative Director:* Jim Moore / *Fashion
Director:* Madeline Weeks / *Publisher:* Condé Nast Publications Inc. / *Issue:* December
2005 / *Category:* Photography Spread-Single Page

338 ✳ FORTUNE
Design Director: Robert Newman / *Designer:* Fran Fifield / *Photo Editors:* Greg Pond,
Nancy Jo Johnson / *Photographers:* Steve Pyke, Greg Pond / *Publisher:* Time Inc. /
Issue: October 17, 2005 / *Category:* Photography Spread-Single Page

339 ✳ FORTUNE
Design Director: Robert Newman / *Designer:* Tony Mikolajczyk / *Photo Editor:* Scott Thode /
Photographer: Paolo Pellegrin (Magnum) / *Publisher:* Time Inc. / *Issue:* October 13, 2005 /
Category: Photography Spread-Single Page

340 ✳ GQ
Design Director: Fred Woodward / *Designer:* Anton Ioukhnovets / *Director of Photography:*
Bradley Young / *Photographer:* Lauren Greenfield / *Publisher:* Condé Nast Publications Inc. /
Issue: May 2005 / *Category:* Photography Spread-Single Page

341 ✳ GQ
Design Director: Fred Woodward / *Designer:* Sarah Viñas / *Director of Photography:* Bradley
Young / *Photographer:* Nathaniel Goldberg / *Creative Director:* Jim Moore / *Fashion
Director:* Madeline Weeks / *Publisher:* Condé Nast Publications Inc. / *Issue:* August 2005 /
Category: Photography Spread-Single Page

342 ✳ GQ
Design Director: Fred Woodward / *Designer:* Ken DeLago / *Director of Photography:*
Bradley Young / *Photographer:* Kurt Markus / *Publisher:* Condé Nast Publications Inc. /
Issue: July 2005 / *Category:* Photography Spread-Single Page

343 ✳ GQ
Design Director: Fred Woodward / *Designer:* Ken DeLago / *Director of Photography:*
Bradley Young / *Photographer:* Brigitte Lacombe / *Publisher:* Condé Nast Publications Inc. /
Issue: June 2005 / *Category:* Photography Spread-Single Page

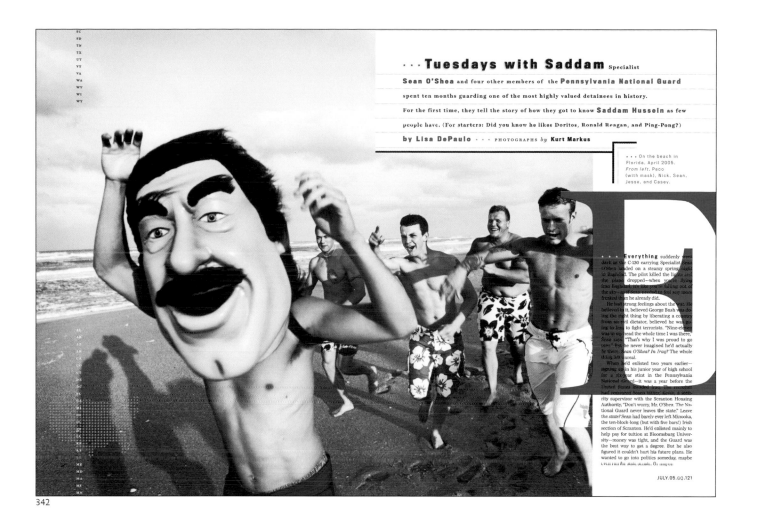

···Tuesdays with Saddam Specialist

Sean O'Shea and four other members of the **Pennsylvania National Guard** spent ten months guarding one of the most highly valued detainees in history. For the first time, they tell the story of how they got to know **Saddam Hussein** as few people have. (For starters: Did you know he likes Doritos, Ronald Reagan, and Ping-Pong?)

by Lisa DePaulo ··· PHOTOGRAPHS *by* **Kurt Markus**

··· On the beach in Florida, April 2005. *From left,* Paco (with mask), Nick, Sean, Jesse, and Casey.

342

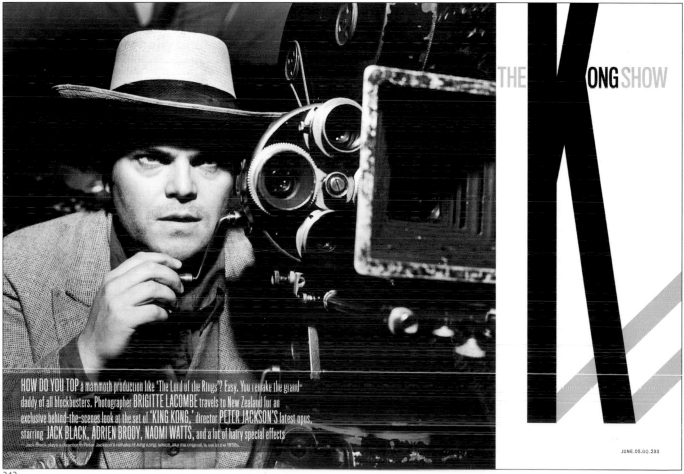

THE **K**ONG SHOW

HOW DO YOU TOP a mammoth production like 'The Lord of the Rings'? Easy. You remake the grand-daddy of all blockbusters. Photographer BRIGITTE LACOMBE travels to New Zealand for an exclusive behind-the-scenes look at the set of 'KING KONG,' director PETER JACKSON'S latest opus, starring JACK BLACK, ADRIEN BRODY, NAOMI WATTS, and a lot of hairy special effects

Jack Black plays a director in Peter Jackson's remake of King Kong, which, like the original, is set in the 1930s.

JUNE.05.GQ.233

343

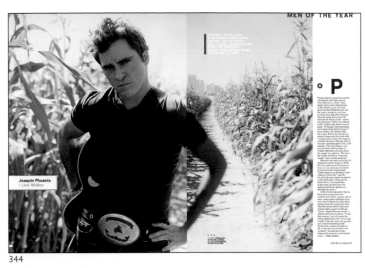

344

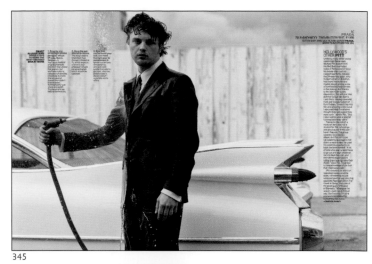

345

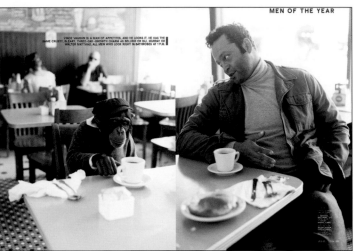

346

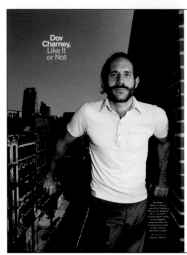
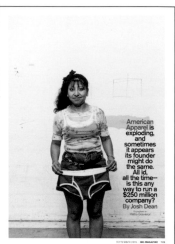

347

344 ✳ G Q
Design Director: Fred Woodward / *Designer:* Ken DeLago / *Director of Photography:* Dora Somosi /
Photographer: Peggy Sirota / *Creative Director:* Jim Moore / *Fashion Director:* Madeline Weeks / *Publisher:*
Condé Nast Publications Inc. / *Issue:* December 2005 / *Category:* Photography Spread-Single Page

345 ✳ G Q
Design Director: Fred Woodward / *Designer:* Sarah Viñas / *Director of Photography:* Bradley Young /
Photographer: Bruce Weber / *Creative Director:* Jim Moore / *Fashion Director:* Madeline Weeks / *Publisher:*
Condé Nast Publications Inc. / *Issue:* May 2005 / *Category:* Photography Spread-Single Page

346 ✳ G Q
Design Director: Fred Woodward / *Designer:* Ken DeLago / *Director of Photography:* Dora Somosi /
Photographer: Peggy Sirota / *Creative Director:* Jim Moore / *Fashion Director:* Madline Weeks / *Publisher:*
Condé Nast Publications Inc. / *Issue:* December 2005 / *Category:* Photography Spread-Single Page

347 ✳ INC.
Creative Director: Blake Taylor / *Photo Editor:* Alexandra Brez / *Photographers:* Naomi Harris, Misha
Gravenor / *Publisher:* Mansueto Ventures / *Issue:* September 2005 / *Category:* Photography Spread-Single Page

348 ✳ MARIE CLAIRE
Creative Director: Paul Martinez / *Art Director:* Jenny Leigh Thompson / *Designer:* Paul Martinez / *Director
of Photography:* Alix B. Campbell / *Associate Photo Editor:* Melanie Chambers / *Photographer:* Ami Vitale /
Publisher: The Hearst Corporation-Magazines Division / *Issue:* September 2005 /
Category: Photography Spread-Single Page

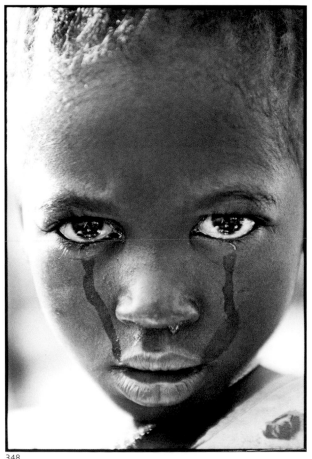

348

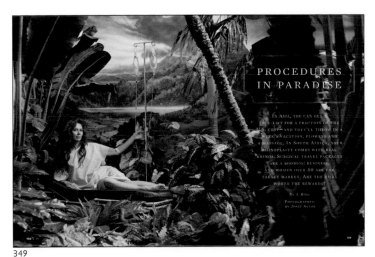

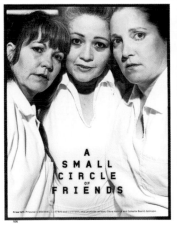

349

350

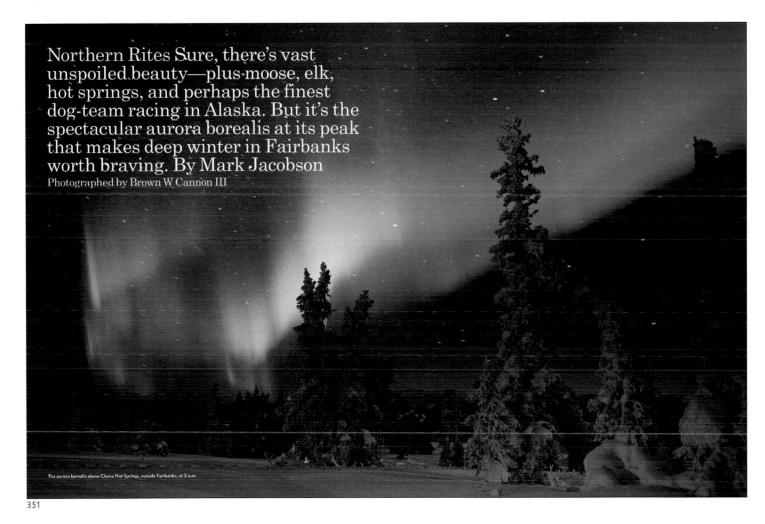

Northern Rites Sure, there's vast unspoiled beauty—plus moose, elk, hot springs, and perhaps the finest dog-team racing in Alaska. But it's the spectacular aurora borealis at its peak that makes deep winter in Fairbanks worth braving. By Mark Jacobson
Photographed by Brown W Cannon III

The aurora borealis above Chena Hot Springs, outside Fairbanks, at 2 a.m.

351

349 ✳ MORE
Creative Director: Maxine Davidowitz / *Art Director:* Jose G. Fernandez / *Designer:* Maxine Davidowitz / *Photo Editor:* Karen Frank /
Photographer: Josef Astor / *Publisher:* Meredith Corporation / *Issue:* November 2005 / *Category:* Photography Spread-Single Page

350 ✳ MORE
Creative Director: Maxine Davidowitz / *Art Director:* Jose G. Fernandez / *Designer:* Jose G. Fernandez / *Photo Editor:* Karen Frank /
Photographer: Nigel Parry / *Publisher:* Meredith Corporation / *Issue:* December 2005-January 2006 / *Category:* Photography Spread-Single Page

351 ✳ TRAVEL + LEISURE
Design Director: Emily Crawford / *Designer:* Emily Crawford / *Photo Editor:* David Cicconi / *Photographer:* Brown W Cannon III /
Publisher: American Express Publishing Co. / *Issue:* February 2005 / *Category:* Photography Spread-Single Page

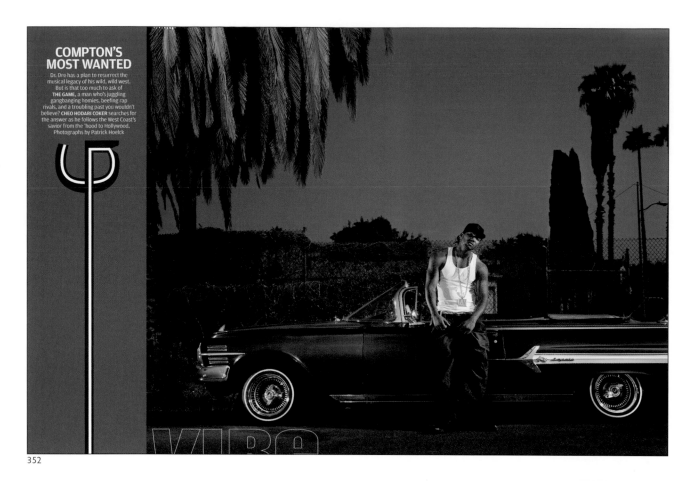

352

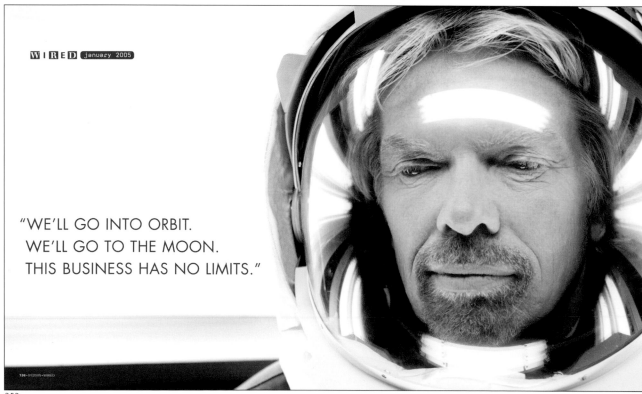

353

352 ✷ VIBE
Design Director: Florian Bachleda / *Designer:* Michael Friel / *Photo Editor:* Liane Radel / *Photographer:* Patrick Hoelck /
Publisher: Vibe-Spin Ventures LLC / *Issue:* February 2005 / *Category:* Photo Spread-Single Page

353 ✷ WIRED
Creative Director: Darrin Perry / *Design Director:* Federico Gutierrez-Schott / *Designer:* Darrin Perry / *Director of Photography:* Brenna Britton /
Photographer: Art Strieber / *Publisher:* Condé Nast Publications, Inc. / *Issue:* January 2005 / *Category:* Photo Spread-Single Page

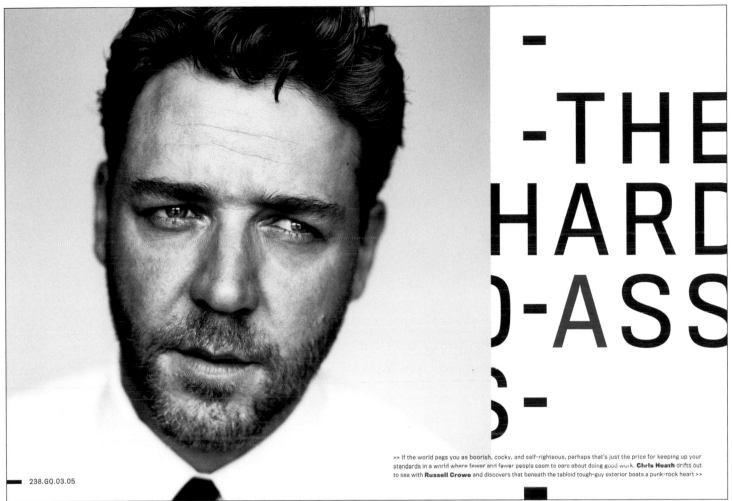

238.GQ.03.05

-THE
HARD
0-ASS
5-

>> If the world pegs you as boorish, cocky, and self-righteous, perhaps that's just the price for keeping up your standards in a world where fewer and fewer people seem to care about doing good work. **Chris Heath** drifts out to sea with **Russell Crowe** and discovers that beneath the tabloid tough-guy exterior beats a punk-rock heart >>

354 + Merit / Newsstand Magazine (Photography Story)

355

354 ✳ GQ
Design Director: Fred Woodward / *Designer:* Ken DeLago / *Director of Photography:* Bradley Young / *Photographers:* Nathaniel Goldberg, Morad Bouchakour, Terry Richardson, Laurie Bartley, Bruce Weber, Satoshi Saikusa, David Armstrong, Brigitte Lacombe, Ellen Von Unwerth / *Creative Director:* Jim Moore / *Fashion Director:* Madeline Weeks / *Publisher:* Condé Nast Publications Inc. / *Issue:* March 2005 / *Category:* Design Story

355 ✳ GQ
Design Director: Fred Woodward / *Designer:* Ken DeLago / *Director of Photography:* Dora Somosi / *Photographer:* Peggy Sirota / *Creative Director:* Jim Moore / *Fashion Director:* Madeline Weeks / *Publisher:* Condé Nast Publications Inc. / *Issue:* December 2005 / *Category:* Design Story

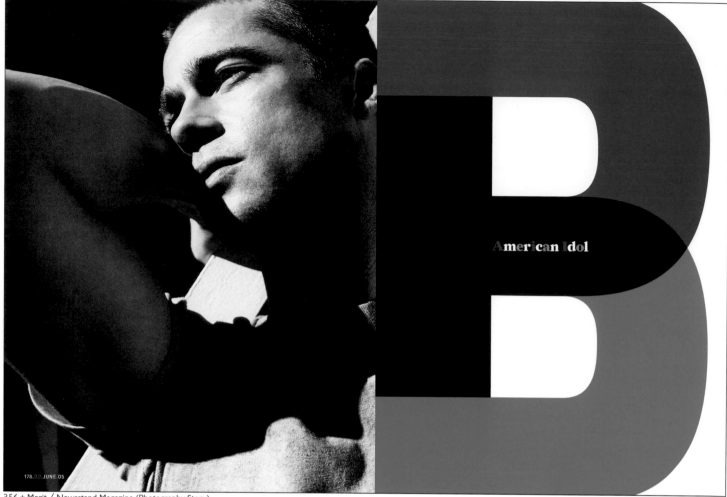

American Idol

356 + Merit / Newsstand Magazine (Photography Story)

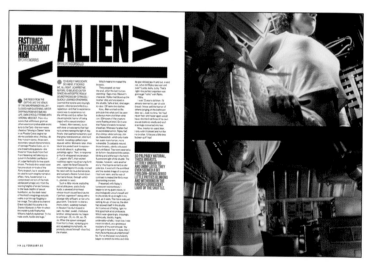

357

356 ✳ GQ
Design Director: Fred Woodward / *Designer:* Ken DeLago / *Director of Photography:* Bradley Young / *Photo Editor:* Dora Somosi /
Photographer: Mario Testino / *Creative Director:* Jim Moore / *Fashion Director:* Madeline Weeks / *Publisher:* Condé Nast Publications Inc. /
Issue: June 2005 / *Category:* Design Story

357 ✳ GQ
Design Director: Fred Woodward / *Designer:* Anton Ioukhnovets / *Director of Photography:* Bradley Young / *Photo Editor:* Monica Bradley /
Publisher: Condé Nast Publications Inc. / *Issue:* February 2005 / *Category:* Design Story

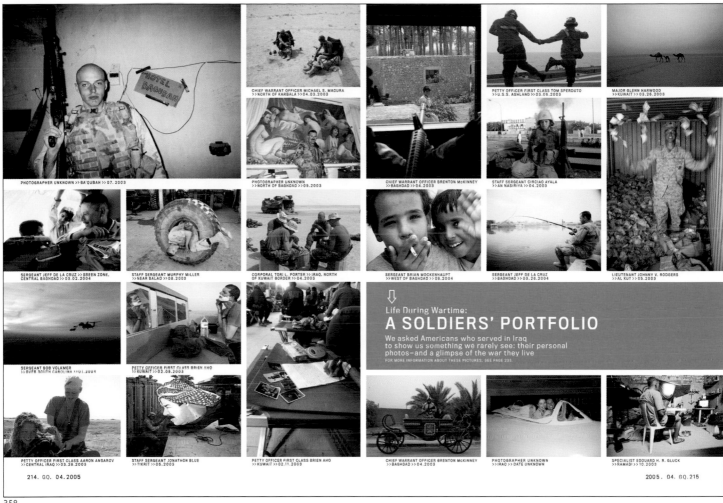

358

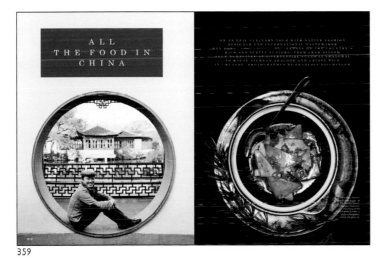

359

360

358 ✳ GQ
Design Director: Fred Woodward / *Designer:* Sarah Viñas / *Photo Editor:* Greg Pond / *Photographers:* Luis R. Agostini,
Brien Aho, Aaron Ansarov, Michael S. Madura, Tori L. Porter, Murphy Miller, Jeff de la Cruz, Bob Volkmer, Jonathan Blue,
Brenton McKinney, Edouard H. R. Gluck, Johnny V. Rogers, Brian Mockenhaupt, Tom Sperduto, Glenn Harwood,
Circiao Ayala, Crystal F. James, Adam Nuelken, Travis Howell, Kevin H. Tierney, John Wayne Paul, Bob Wiebler, Michael Pierson,
I. Philip Ludvigson, Jeffrey M. Gardner, Andrew Meyers / *Publisher:* Condé Nast Publications Inc. / *Issue:* April 2005 /
Category: Design Story

359 ✳ TRAVEL + LEISURE
Design Director: Emily Crawford / *Designer:* David Heasty / *Director of Photography:* Katie Dunn /
Photographer: François Dischinger / *Publisher:* American Express Publishing Co. / *Issue:* October 2005 / *Category:* Design Story

360 ✳ TRAVEL + LEISURE
Design Director: Emily Crawford / *Designer:* David Heasty / *Illustrator:* Peter Arkle / *Director of Photography:* David Cicconi /
Photographers: Catherine Ledner, Kai Wiechmann / *Publisher:* American Express Publishing Co. / *Issue:* March 2005 / *Category:* Design Story

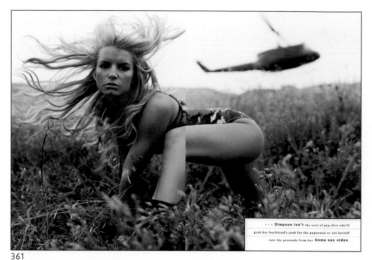

361

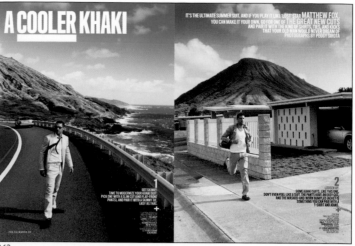

362

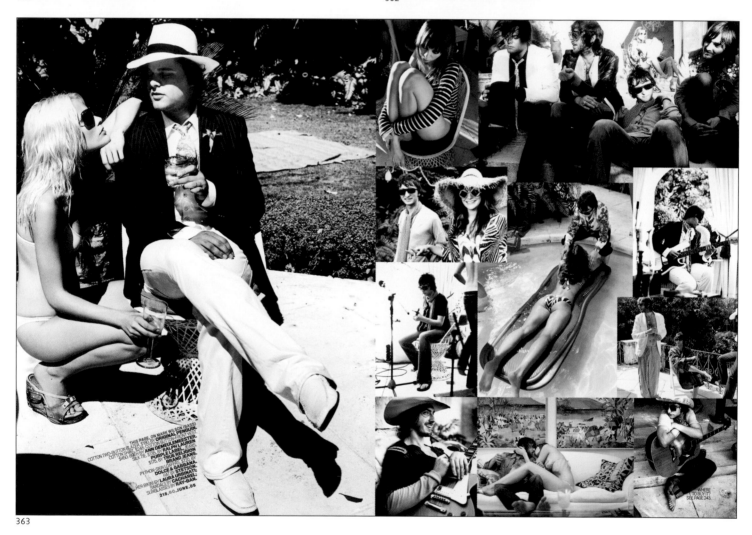

363

361 ✳ G Q
Design Director: Fred Woodward / *Designer:* Ken DeLago / *Director of Photography:* Bradley Young / *Photographer:* Peggy Sirota /
Creative Director: Jim Moore / *Fashion Director:* Madeline Weeks / *Publisher:* Condé Nast Publications Inc. / *Issue:* July 2005 / *Category:* Photo Story

362 ✳ G Q
Design Director: Fred Woodward / *Designer:* Anton Ioukhnovets / *Director of Photography:* Bradley Young / *Photographer:* Peggy Sirota /
Creative Director: Jim Moore / *Fashion Director:* Madeline Weeks / *Publisher:* Condé Nast Publications Inc. / *Issue:* March 2005 / *Category:* Photo Story

363 ✳ G Q
Design Director: Fred Woodward / *Designer:* Sarah Viñas / *Director of Photography:* Bradley Young / *Photographer:* Carter Smith /
Creative Director: Jim Moore / *Fashion Director:* Madeline Weeks / *Publisher:* Condé Nast Publications Inc. / *Issue:* June 2005 / *Category:* Photo Story

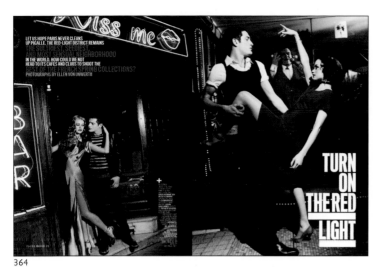

364

365

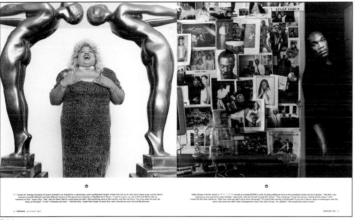

366

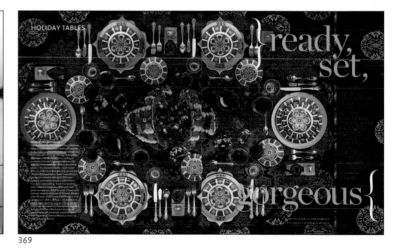

367

368

369

364 ✳ GQ
Design Director: Fred Woodward / *Designer:* Anton Ioukhnovets / *Director of Photography:* Bradley Young / *Photographer:* Ellen Von Unwerth / *Creative Director:* Jim Moore / *Fashion Director:* Madeline Weeks / *Publisher:* Condé Nast Publications Inc. / *Issue:* March 2005 / *Category:* Photo Story

365 ✳ GQ
Design Director: Fred Woodward / *Designer:* Ken DeLago / *Director of Photography:* Bradley Young / *Photo Editors:* Bradley Young, David Carthas, Kristen Schaefer / *Photographers:* Nathaniel Goldberg, Morad Bouchakour, Terry Richardson, Laurie Bartley, Bruce Weber, Satoshi Saikusa, David Armstrong, Brigitte Lacombe, Ellen Von Unwerth / *Creative Director:* Jim Moore / *Fashion Director:* Madeline Weeks / *Publisher:* Condé Nast Publications Inc. / *Issue:* March 2005 / *Category:* Photo Story

366 ✳ PREMIERE
Art Director: Dirk Barnett / *Designer:* Dirk Barnett / *Photo Editor:* Catriona Ni Aolain / *Photographer:* David Strick / *Publisher:* Hachette Filipacchi Media U.S. / *Issue:* July-August 2005 / *Category:* Photo Story

367 ✳ WIRED
Design Director: Federico Gutierrez-Schott / *Designer:* Federico Gutierrez-Schott / *Director of Photography:* Brenna Britton / *Photo Editor:* Zana Woods / *Photographer:* Livia Corona / *Publisher:* Condé Nast Publications, Inc. / *Issue:* May 2005 / *Category:* Photo Story

368 ✳ OUTSIDE
Creative Director: Hannah McCaughey / *Art Director:* Lisa Thé / *Photo Editor:* Rob Haggart / *Photographer:* Dan Winters / *Publisher:* Mariah Media, Inc. / *Issue:* January 2005 / *Category:* Photo Story

369 ✳ O AT HOME
Creative Director: Adam Glassman / *Design Director:* Robert Priest / *Art Director:* Edward Levine / *Designer:* Angela Riechers / *Photo Editor:* Kathryn Arnold Millan / *Photographer:* Bob Hiemstra / *Publisher:* The Hearst Corporation-Magazines Division / *Issue:* Winter 2005 / *Category:* Photo Story

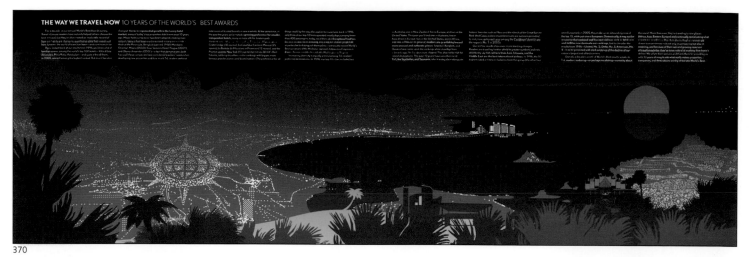

370

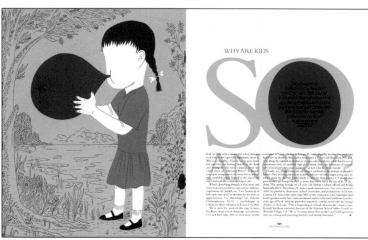

371

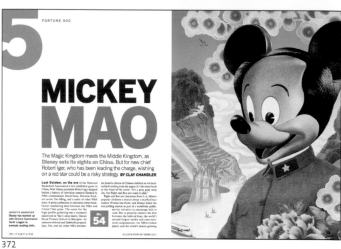

372

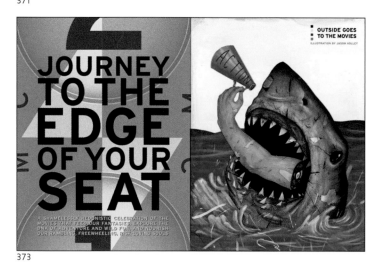

373

374

370 ✳ TRAVEL + LEISURE
Design Director: Emily Crawford / *Designer:* David Heasty / *Illustrator:* Matt Pyke (Universal Everything) / *Publisher:* American Express Publishing Co. / *Issue:* August 2005 / *Category:* Illustration Spread-Single Page

371 ✳ CHILD
Creative Director: Dan Josephs / *Art Director:* Daniel Chen / *Illustrator:* Brian Cronin / *Deputy Art Director:* Leslie Long / *Associate Art Director:* Megan Henry / *Publisher:* Meredith / *Issue:* August 2005 / *Category:* Illustration Spread-Single Page

372 ✳ FORTUNE
Design Director: Robert Newman / *Art Director:* Renee Klein / *Designer:* Linda Rubes / *Illustrator:* Eddie Guy / *Publisher:* Time Inc. / *Issue:* April 18, 2005 / *Category:* Illustration Spread-Single Page

373 ✳ OUTSIDE
Creative Director: Hannah McCaughey / *Designer:* Jana Meier / *Illustrator:* Jason Holley / *Publisher:* Mariah Media, Inc. / *Issue:* June 2005 / *Category:* Illustration Spread-Single Page

374 ✳ OUTSIDE
Creative Director: Hannah McCaughey / *Designer:* Susanne Ducker / *Illustrator:* Brian Cronin / *Publisher:* Mariah Media, Inc. / *Issue:* February 2005 / *Category:* Illustration Spread-Single Page

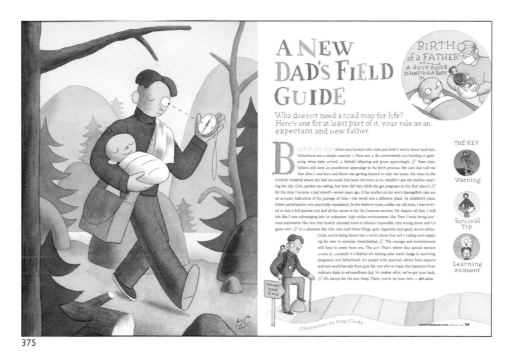

375

376

377

375 ✳ FIT PREGNANCY
Art Director: Stephanie Birdsong / *Illustrator:* Greg Clarke / *Publisher:* Weider Publications, Inc. / *Issue:* June-July 2005 / *Category:* Illustration Story

376 ✳ GQ
Design Director: Fred Woodward / *Designer:* Ken DeLago / *Illustrator:* Ken DeLago / *Publisher:* Condé Nast Publications Inc. / *Issue:* September 2005 / *Category:* Photo Illustration Story / Spread-Single Page

377 ✳ SPIN
Design Director: Kory Kennedy / *Art Director:* Devin Pedzwater / *Designer:* Liz Macfarlane / *Director of Photography:* Kathleen Kemp / *Photo Editors:* Jennifer Santana, Bethany Mezick / *Photographer:* Matthias Clamer / *Publisher:* Spin Media / *Issue:* August 2005 / *Category:* Photo Illustration Story / Spread-Single Page

MERIT

NEWSSTAND MAGAZINE

UNDER 500,000 CIRCULATION

378

379

380

381

382

378 ✳ ABSOLUTE NEW YORK
Creative Director: Michael Grossman / *Design Director:* Deanna Lowe / *Designers:* Michael Grossman, Deanna Lowe / *Director of Photography:* Catherine Talese / *Associate Photo Editor:* Hali Tara Feldman / *Photographer:* Mitchell Feinberg / *Publisher:* Absolute Publishing / *Issue:* March 2005 / *Category:* Design Cover

379 ✳ BEST LIFE
Art Director: Brandon Kavulla / *Director of Photography:* Chris Dougherty / *Photo Editor:* Nell Murray / *Photographer:* Martin Schoeller / *Publisher:* Rodale / *Issue:* July-August 2005 / *Category:* Design Cover

380 ✳ HARVARD BUSINESS REVIEW
Art Director: Karen Player / *Designer:* Kaajal S. Asher / *Photographer:* Fredrik Broden / *Publisher:* Harvard Business School Publishing / *Issue:* December 2005 / *Category:* Design Cover

381 ✳ INTERIOR DESIGN
Art Director: Claudia Marulanda / *Designer:* Claudia Marulanda / *Photographer:* Jimmy Cohrssen / *Publisher:* Reed Business Information / *Issue:* June 2005 / *Category:* Design Cover

382 ✳ LIFE & STYLE
Creative Director: Guillermo Caballero / *Design Director:* Fernanda Aguilar / *Art Director:* Julio Contreras / *Designer:* Julia Gonzalez / *Photo Editor:* Karen Migoni / *Photographer:* Pablo Morales / *Publisher:* Grupo Editorial Expansión / *Issue:* November 2005 / *Category:* Design Cover

383

384

385

386 + Merit / Newsstand Magazine (Photography Cover)

383 ✳ PRINT
Art Director: Stephanie Skirvin / *Designer:* Abbott Miller /
Studio: Pentagram / *Publisher:* F & W Publications /
Issue: November-December 2005 / *Category:* Design Cover

384 ✳ TIME OUT MEXICO DF
Creative Director: Guillermo Caballero / *Art Director:* Fernanda Aguilar /
Designer: Claudia Rosales / *Photo Editor:* Karen Migoni /
Photographer: Jean Paul Bergerault / *Publisher:* Grupo Editorial Expansión /
Issue: December 2005 / *Category:* Design Cover

385 ✳ TIME OUT NEW YORK
Art Director: Matt Guemple / *Photo Editor:* Courtenay Kendall /
Photographer: Jorge Colombo / *Publisher:* Time Out New York Partners, L.P. /
Issue: October 6-12, 2005 / *Category:* Design Cover

386 ✳ NEW YORK
Design Director: Luke Hayman / *Director of Photography:* Jody Quon /
Photographer: Michael Elins / *Publisher:* New York Magazine Holdings, LLC /
Issue: July 25, 2005 / *Category:* Design Cover

W

EXCLUSIVE

Brad & Angelina

A 60-Page Portfolio by Steven Klein

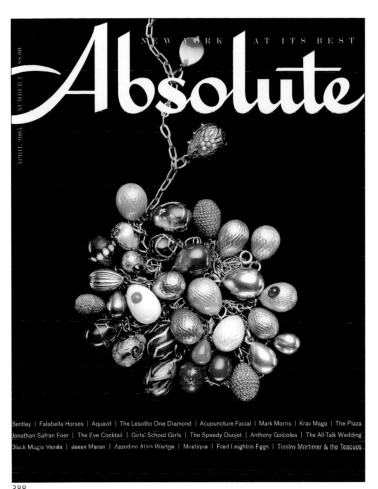

388

389 + Merit / Newsstand Magazine (Design Entire Issue)

390

391

392

387 ✳ W
Creative Director: Dennis Freedman / *Design Director:* Edward Leida / *Designer:* Edward Leida / *Photographer:* Steven Klein / *Publisher:* Fairchild Publications / *Issue:* July 2005 / *Category:* Design Cover

388 ✳ ABSOLUTE NEW YORK
Creative Director: Michael Grossman / *Design Director:* Deanna Lowe / *Designers:* Michael Grossman, Deanna Lowe / *Director of Photography:* Catherine Talese / *Associate Photo Editor:* Hali Tara Feldman / *Photographer:* Mitchell Feinberg / *Publisher:* Absolute Publishing / *Issue:* April 2005 / *Category:* Photography Cover

389 ✳ NEW YORK
Design Director: Luke Hayman / *Director of Photography:* Jody Quon / *Photo Editor:* Amy Hoppy / *Photographer:* Phillip Toledano / *Publisher:* New York Magazine Holdings, LLC / *Issue:* November 21, 2005 / *Category:* Photography Cover

390 ✳ NEW YORK
Design Director: Luke Hayman / *Director of Photography:* Jody Quon / *Photographer:* Dan Winters / *Publisher:* New York Magazine Holdings, LLC / *Issue:* December 12, 2005 / *Category:* Photography Cover

391 ✳ TIME ASIA
Art Director: Cecelia Wong / *Photo Editor:* Lisa Botos / *Photographer:* John Stanmeyer (VII) / *Publisher:* Time Inc. / *Issue:* June 6, 2005 / *Category:* Photography Cover

392 ✳ CITY MAGAZINE
Creative Director: Fabrice G. Frere / *Director of Photography:* Piera Gelardi / *Photographer:* Alexander Deutsch / *Publisher:* City Publishing LLC. / *Issue:* December 2005 / *Category:* Photography Cover

393

394

395

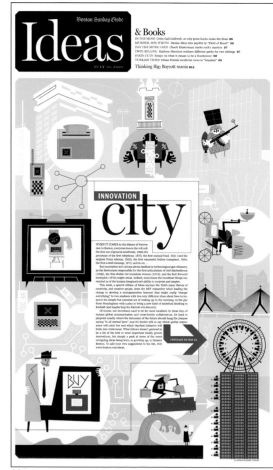

396

393 ✳ THE BOSTON GLOBE
Design Director: Dan Zedek /
Art Director: Gregory Klee / *Designer:*
Gregory Klee / *Illustrator:* Gregory Klee /
Publisher: The New York Times Co. /
Issue: August 14, 2005 / *Category:*
Design Front Page

394 ✳ THE BOSTON GLOBE
Design Director: Dan Zedek /
Art Director: Chin Wang / *Designer:*
Chin Wang / *Publisher:* The New York
Times Co. / *Issue:* June 23, 2005 /
Category: Design Front Page

395 ✳ THE BOSTON GLOBE
Design Directors: Dan Zedek, Gregory
Klee / *Art Director:* Chin Wang /
Designer: Chin Wang / *Publisher:* The
New York Times Co. / *Issue:* January 9,
2005 / *Category:* Design Front Page

396 ✳ THE BOSTON GLOBE
Design Directors: Dan Zedek, Gregory
Klee / *Art Director:* Chin Wang /
Designer: Chin Wang / *Publisher:* The
New York Times Co. / *Issue:* July 31,
2005 / *Category:* Design Front Page

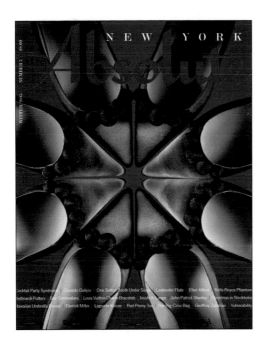

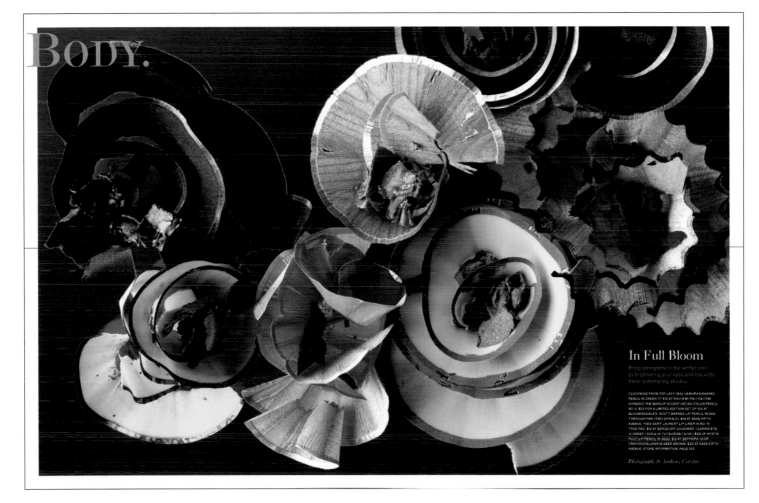

397 ✳ ABSOLUTE NEW YORK
Creative Director: Michael Grossman / *Design Director:* Deanna Lowe / *Designers:* Deanna Lowe, Jessica Erixon /
Director of Photography: Catherine Talese / *Associate Photo Editor:* Hali Tara Feldman / *Photographers:* Mitchell Feinberg,
David Slijper, Richard Barnes, Annika Huet, Ilan Rubin, Nigel Cox, Anthony Cotisfas / *Publisher:* Absolute Publishing /
Issue: Winter 2005 / *Category:* Design Entire Issue

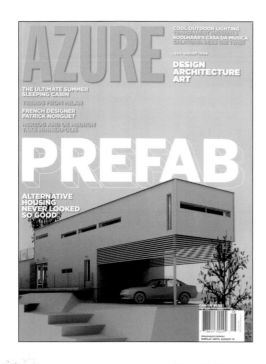

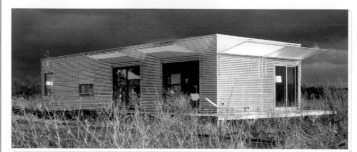

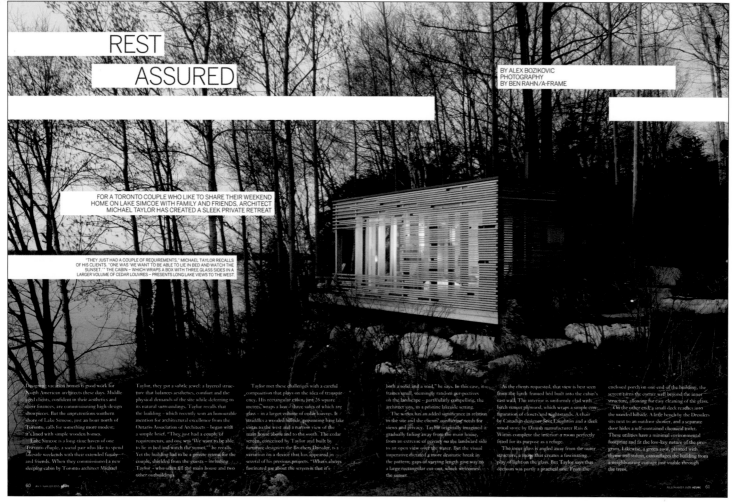

398 ✻ AZURE

Art Directors: Diti Katona, John Pylypczak / *Designers:* Andrew Cloutier, Natalie Do, Omar Morson, Jordan Poirier / *Studio:* Concrete Design
Communications Inc. / *Publisher:* Azure Publishing Inc. / *Client:* Azure / *Issue:* July-August 2005 / *Category:* Design Entire Issue

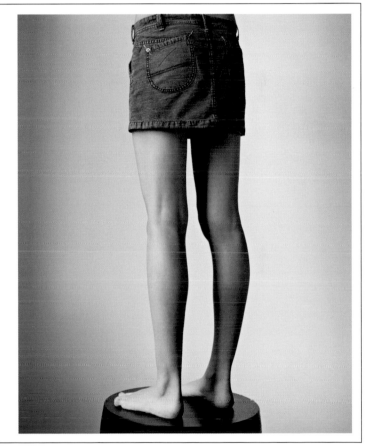

PHOTOGRAPHY BY YANGTAN STYLING BY BEVERLEY HYDE

399 ✳ CITY
Creative Director: Fabrice G. Frere / *Art Director:* Adriana Jacoud / *Director of Photography:* Piera Gelardi /
Publisher: City Publishing LLC / *Issue:* Spring 2005 / *Category:* Design Entire Issue

400 ✽ COOKIE
Design Director: Kirby Rodriguez / *Art Director:* Alex Grossman / *Designers:* Nicolette Berthelot, Karla Lima /
Photo Editor: Yolanda Edwards / *Photographers:* Jennifer Livingston, Gary Mcleod / *Publisher:* Condé Nast Publications Inc. /
Issue: December 2005-January 2006 / *Category:* Design Entire Issue

401 ✳ COUPE
Art Director: Bill Douglas / *Designer:* Bill Douglas / *Photographers:* Bill Douglas, Sacha Gatien, Eamon Mac Mahon, Edward Pond /
Studio: The Bang / *Publisher:* Coupe / *Issue:* Spring 2005 / *Category:* Design Entire Issue

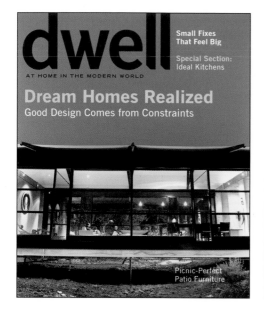

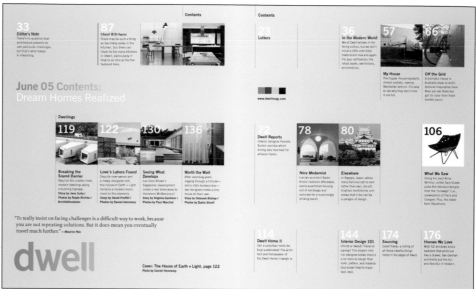

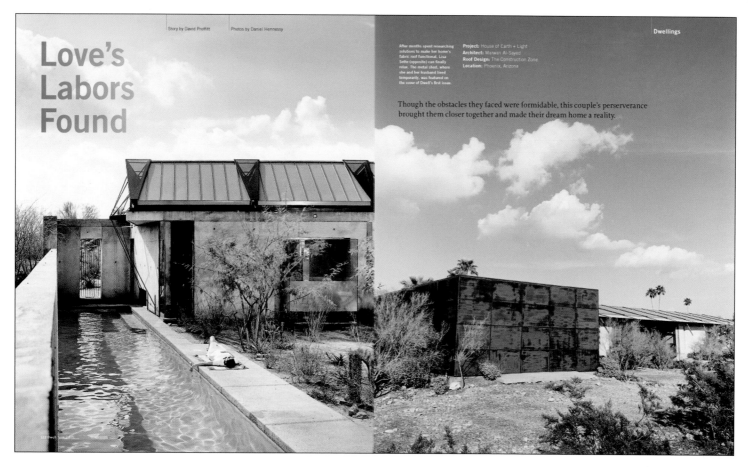

402 ✳ DWELL
Creative Director: Jeanette Hodge Abbink / *Designers:* Kyle Blue, Craig Bromley, Craig Snelgrove / *Photo Editor:* Kate Stone /
Photographers: Ralph Richter-Architekturphoto, Daniel Hennessy, Paul Warchol, Zubin Shroff, Barbel Miebach, Peter Hyatt,
Diana Koenigsberg, Andy Boone, Joe Fletcher, John H. Hall, Paul Rivera, Sarah Blee, Elizabeth Felicella, Peter Belanger, Quirin Leppert /
Asst. Photo Editor: Aya Brackett / *Publisher:* Dwell LLC / *Issue:* June 2005 / *Category:* Design Entire Issue

MAGAZINE

2005 EL RESUMEN MÁS SARCÁSTICO DE TODO UN AÑO

Juan Pablo II

Virginia Mayo
Simon Wiesenthal
"Papá" Clemente
Álvaro Cunhal
Álvaro Domecq
Gloria Lasso
El tabaco
Rey Fahd de Arabia
Anne Bancroft
Guillermo Cabrera Infante
Daniel C. Haanz
Larry Collins
Ramón Gaya

La vida
que ellos vivieron

Javier Tusell
Rafael Termes
Aenne Burda
Peter Jennings
Rosa Parks
Periodismo
Olga Ramos

Augusto Roa Bastos
George Best
Ranieri III de Mónaco
Julián Marías
Victoria de los Ángeles
Terri Schiavo
Julio Iglesias Puga
Arthur Miller
José Antonio Jáuregui
Tookie Williams

{ 22-IV-1929 21-II-2005 }

Cabrera
Infante
Militó en la literatura y el periodismo como un disidente de la dictadura cubana

por Raúl Rivero

[19-IV-1948 22-III-2005]

El "papa" Clemente
Un pontifice de panadería, prisionero de su "Vaticano" sevillano

por Antonio Fraile

{ 18-V-1920 2-IV-2005 }

Juan Pablo II

Carismático, viajero y conservador, el Papa polaco terminó de derribar los muros del comunismo

por Paloma Gómez Borrero

403 ✳ EL MUNDO

Design Director: Carmelo Caderot / *Art Director:* Rodrigo Sanchez / *Designer:* Rodrigo Sanchez / *Photo Editor:* Rodrigo Sanchez / *Publisher:* Unidad Editorial S.A. / *Issue:* December 31, 2005 / *Category:* Design Entire Issue

404 ✳ GIANT
Creative Director: Ash Gibson / *Art Director:* Todd Detwiler / *Designer:* Todd D. Gechtman / *Illustrators:* Noma Bar, Olivier Kugler, Eddie Guy / *Director of Photography:* Lisa Elin / *Photographers:* Don Flood, Jake Chessum, John Spinks, Alex Freund / *Publisher:* Vertical Media LLC / *Online Address:* www.giantmag.com / *Issue:* December 2005 / *Category:* Design Entire Issue

Neville attacks Arsenal culture of hypocrisy

Gunners cannot bear to be tackled says midfielder

Accusation that he tried to hurt Pires was 'insulting'

Dominic Fifield

Phil Neville has launched a scathing attack on Arsenal, claiming Arsène Wenger's players must "have it written in their contracts that you are not allowed to tackle them" after Robert Pires accused the England midfielder of deliberately attempting to injure him during Everton's defeat at Highbury this week.

Pires hobbled off within the opening half-hour of the Gunners' 2-0 victory on Monday after sustaining a dead leg in a challenge with Neville, who was not booked in the incident. The France international later alleged his opponent "made the tackle to catch me, and he did", though Neville yesterday insisted Arsenal's outrage had merely been an ill-conceived attempt to deflect attention from Robin van Persie's sending-off for a raised boot against FC Thun a few days earlier.

"Those comments didn't surprise me one little bit – some clubs have different agendas," said Neville. "I make a tackle, win the ball, the referee doesn't give a foul, I don't get booked and all of a sudden I'm a thug. [Five] days before, one of their players nearly takes someone's head off and they are pleading innocence. How many times over the years have we seen that from Arsène Wenger and Arsenal?

"When you play Arsenal, you know you are playing a great team with great players. Robert Pires is an absolutely fantastic

Inside »
Football's big debate
With the national game under attack for high prices and dull games we asked a panel of experts to suggest five measures to make it better. From balls that fly straighter to sin-bins for yellow cards they debate how football can bring back its fizz. Plus David Lacey's verdict.
Page 3 »

player who has put in some unbelievable performances since he has come to this country. But in English football, you have got to tackle. Sometimes when you play against these type of players, it's as if they have it in their contracts that you are not allowed to tackle them. Well, Everton's strength and my strength is tackling and it may be a more British type of game.

"You can't sit off against Arsenal and let them play because they'll kill you. My job is to tackle and over the years – apart from against Fulham this season – I've never been sent off. That suggests I'm not a dirty player so for him to say that I deliberately went out to 'do him' was, to be honest, insulting."

There is a simmering enmity between Neville and Arsenal, stemming from his performances for Manchester United against them over the last three years and, most notably, the part he played in ending the Gunners' 49-match unbeaten run at Old Trafford last season. The utility player filled in for Roy Keane and Arsenal were unhappy with the treatment handed out by the home players, Neville included, to José Antonio Reyes that day.

The Spaniard left the pitch after 70 minutes, just before United scored the first of their two goals, and later said: "In all my sporting life I have never received so many kicks as in Manchester. The referee [Mike Riley] should have stopped the violence of the Manchester United players." His testimony was a little lost in the furore over a food fight erupting in the tunnel later.

Neville denied any wrongdoing that day and received his manager David Moyes' backing after Arsenal's criticisms last week. "They were saying we deliberately went out to target Reyes in that game last season," added the £3.5m signing. "I have seen the video and I made two tackles on Reyes that day, one of which was a foul. That doesn't suggest you've gone out to continuously target someone or to me. As I say, you are not allowed to tackle, you are not allowed to touch.

"You only have to look at Arsenal's disciplinary record, which suggests that the problem lies within rather than outside the club. We have seen it over 10 years and it is not going to change now. Wenger will defend his players like David Moyes defended me. You defend your own, but sometimes it has to have a bit of realism and honesty about it."

Neville targets Europe, page 5 »

Murray minced Britain crash in Davis Cup

Great Britain's Andrew Murray screams in frustration during his straight-sets defeat by Stanislas Wawrinka in the Davis Cup. Switzerland have a 2-0 lead in the best-of-five rubber after Roger Federer's earlier win. Report, page 9 » *Anja Niedringhaus/AP*

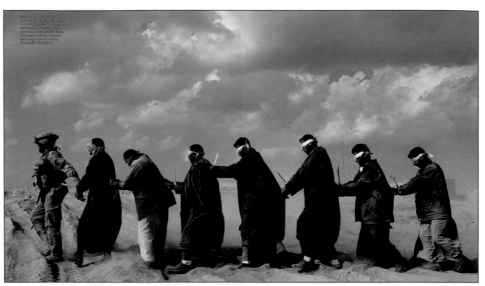

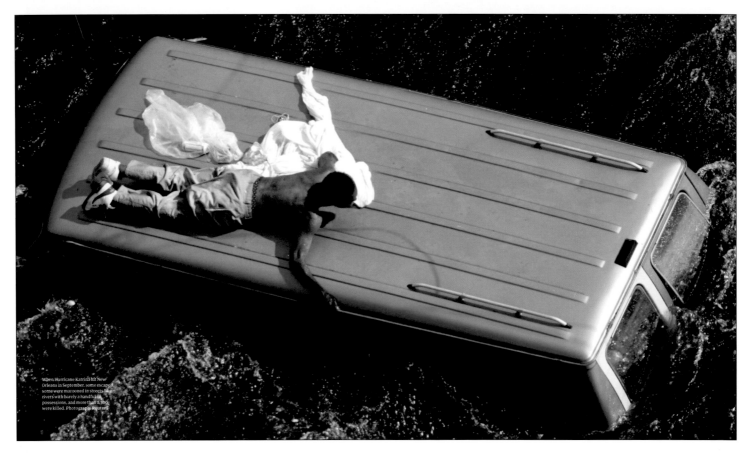

406 ✳ THE GUARDIAN

Creative Director: Mark Porter / *Art Director:* Maggie Murphy / *Designers:* Pauline Doyle, Bruno Haward / *Photo Editor:* Kate Edwards / *Publisher:* Guardian Newspapers Limited / *Issue:* December 31, 2005 / *Category:* Design Entire Issue

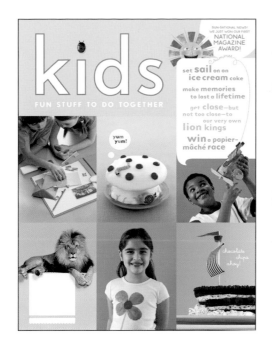

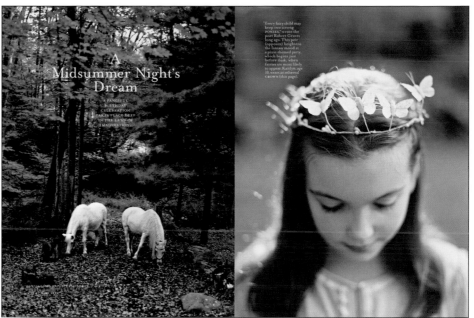

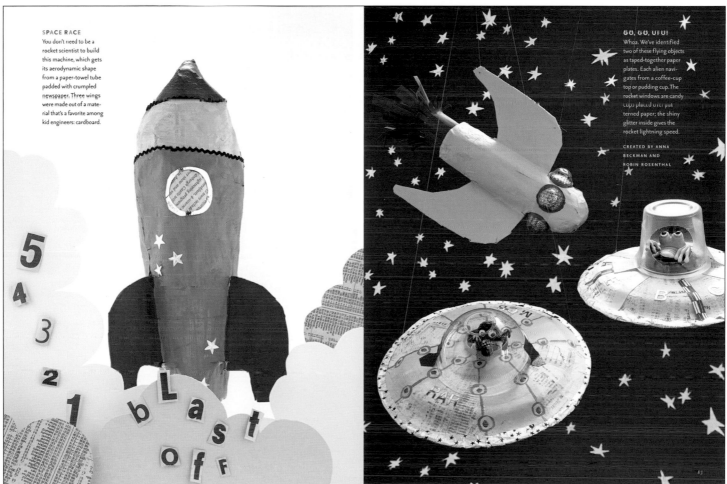

407 ✷ KIDS

Creative Director: Eric A. Pike / *Design Director:* Deb Bishop / *Art Directors:* Robin Rosenthal, Tina Chang, Jennifer Merrill /
Stylists: Anna Beckman, Charlyne Mattox, Megan Hedgpeth, Silke Stoddard, Tara Bench, Sarah Conroy / *Illustrators:* Kristen Ulve, MK Mabry /
Director of Photography: Heloise Goodman / *Photo Editors:* Rebecca Donnelly, Lina Watanabe / *Photographers:* Catherine Ledner, Anna Williams,
Frank Heckers, Tosca Radigonda, Gentl+Hyers, Kirsten Strecker / *Publisher:* Martha Stewart Living Omnimedia / *Issue:* Summer 2005 /
Category: Design Entire Issue

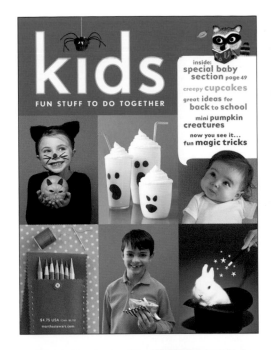

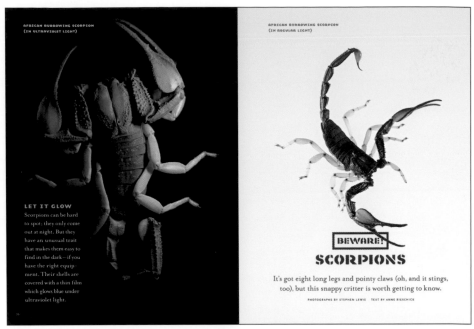

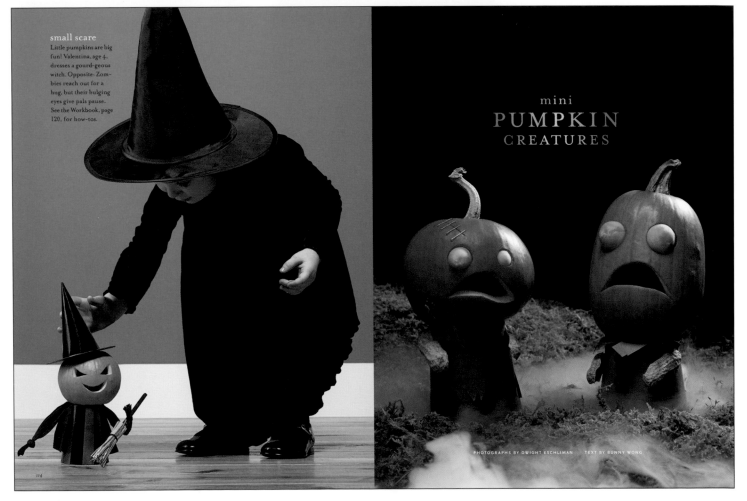

408 ✳ KIDS
Creative Director: Eric A. Pike / *Design Director:* Robin Rosenthal / *Art Directors:* Jennifer Merrill, Tina Chang / *Stylists:* Anna Beckman,
Charlyne Mattox, Sarah Conroy, Silke Stoddard, Megan Hedgpeth, Tara Bench / *Illustrators:* Kirsten Ulve, Marc Boutavant, Calef Brown /
Director of Photography: Heloise Goodman / *Photo Editors:* Rebecca Donnelly, Lina Watanabe, Mary Cahill / *Photographers:* Stephen Lewis,
Anna Williams, Sang An, Victor Schrager, Dwight Eschliman, Philip Newton / *Publisher:* Martha Stewart Living Omnimedia /
Issue: Fall 2005 / *Category:* Design Entire Issue

ARTIST

Francis McKee traces the path
of Belgian artist Francis Alÿs as he
explores the boundaries between
politics, poetry and art

'Once there was a man who …
pushed a block of ice across
a vast city until it melted and
disappeared; an artist who
sent a peacock to take his place
in an important gathering
of his peers; a man who
persuaded a small army of
workers to move an immense
sand dune armed only with
shovels; a solitary walker who
one day emerged from a shop
holding a loaded pistol…'

Issue 1/Spring 2005/**MAP**

26th Bienal de São Paolo

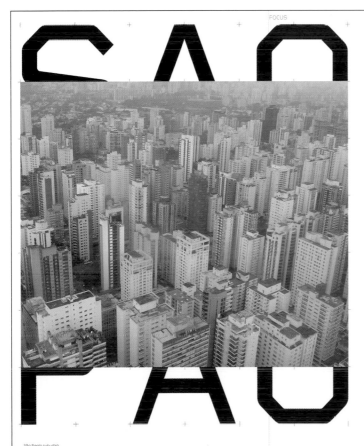

São Paolo suburbia,
near Congonhas airport
Richard Williams, 2004

Brazil has been long established in the European intellectual mind as exotic. What I had not appreciated until this visit was the extent to which Brazilians themselves cultivated their own exoticism. Nor, now in their minds, the exotic was equally a part of the metropolis as the Amazon, of modernity as much as the distant past. One example will suffice: there is a widely-held myth that some middle-class residents of São Paolo are now so terrified of their city that they no longer descend to street level, flitting from one high-rise to another by helicopter. They have, effectively, evolved into a race of aerial beings, or unconnected with ordinary Brazilians or the Tupú-Kawahib. As I left Rio to make my way to the Bienal, my friend's mother – herself a displaced Paolistano – fixed me with a look of sadness mixed with despair and said, 'May God be with you'. A latter-day Colonel Fawcett, I was going to a lost world and I was not, evidently, coming back.

Arrival in SP naturally dispelled such anthropological fears. As long as you don't look up, or to the horizon, it is just a big modern city, reassuringly busy with work and money. But it is unbelievably vast – 22 million people – and it has a peculiar cityscape all of its own. Its enormity is different from that of Manhattan, where you can always see the edge, or London, whose sprawl is on a human scale and is in any case punctuated by greenery, or even Shanghai, which has the colonial Bund, a sort of Liverpool-on-the-Huangpu. São Paolo, by contrast, seems completely undifferentiated. The entire city, from wherever you stand as far as the horizon, seems to be made of 30-storey point blocks, built in astonishing proximity to one another. The sense of endlessness is greater than in any city I know. It is both terrifying, and in purely aesthetic terms, thrilling.

So to the Bienal, which is found in the strangely picturesque Parque Ibirapuera. In many ways, it matches the city in scale. In terms of visitor numbers, a million in total, it far outstrips any other equivalent biennale, and must be one of the most visited exhibitions in the world. It is enormous: 135 artists from 62 countries. You need a couple of days to do it justice. It was also free in 2004, thanks to the sponsorship of a local bank, and its organisers spoke grandly of the democratisation of art as their principal aim. The scale and ambition of the thing is undeniably impressive, memorialised in its permanent home, Oscar Niemeyer's 1951 Pavilion. The size of the Pompidou, it is both an elegant and exuberant space, the restrained International Style of the exterior containing some spectacular ramps, as if the Illinois Institute of Technology were wrapped around the Guggenheim.

What of the show? It was, to begin with, hard not to be distracted by several things; first, the crowds of schoolchildren, often very young, who made up the majority of the audience on the days I went (I approved of this – it certainly dispelled whatever pretensions to cool the Bienal had); second, the views of the city, which even after several days were still compelling; and third, the incredible noise of many of the exhibits.

On the ground floor, the chief offender was 'Bon Voyage' by Cai Guo-Qiang. This profoundly irritating piece was a 20-foot aeroplane-meets-fish, woven from open plastic from divers and plastic with thousand sof sundry objects recently confiscated from air travellers around the world. In place of the four engines were four electric fans, going full blast, with long streamers attached. This was the source of the racket. What was the point? It made no sense to me: confused in its vision and execution, it offered up every possible

reading and none, so generalised an object as to be meaningless. On the same floor you could find a gigantic climbing frame from which was suspended a spinning VW beetle (Leo Shatzl), an upside-down boat made of mahogany (Simon Starling) and a huge bank of speakers blasting out the sounds of gunfire (Santiago Serra). Upstairs, other things clamoured for attention, not least a circumcision filmed in real time by the Bulgarian artist Nassim, projected on two gigantic screens (the ten-year-old girl sitting next to me asked me, being the only adult around, for an explanation: I was an art historian from Edinburgh, I said, and no, I didn't know what I was doing there either).

But by the second day, these circus-like installations came to seem aberrant. What most artists were portraying was a kind of intuitive anthropology, often casting their own familiar surroundings as other, and recording them through endless lists and photographs. It seemed an oddly appropriate thing to be doing in Brazil, a country which since its origins has been the object of harsh anthropological scrutiny. The Bienal was a good place to think about this systematic, sometimes cruel mode of looking: Juan Brites's photographs of Amazonian Indians clearly fell into this category, as did Edward Burtynsky's images of the Three Gorges Dam in China, and Thomas Struth's pictures of the barriadas on the outskirts of Lima. All were beautiful images, but profoundly disturbing because they aestheticised poverty or displacement for the pleasure of the viewer. In Struth's Lima image, the appearance of Stockbroker Tudor on a slum shack was grimly funny. But it wasn't clear where Struth stood in relation to his subjects, and what he (and I) were laughing at.

It was refreshing by contrast to have the European gaze turned on itself as in Veronika Zapaletalová's gloomy observations of Czech summerhouses, Krzysztof Zielinski's grim Wabrzezn street scenes, and (most clearly) Nayoya Hatakeyama's snapshots of English suburban houses. Meanwhile the always politically correct Mark Dion sent up the whole business of anthropology, with a faux-naïf reconstruction of Thomas Ende's 19th-century Austrian expedition to Brazil. Dion assembled a seven-man Austro-Brazilian team to retrace Ende's steps, each team member adopting a key role – Dion himself was Ende. The results – a range of documents and drawings, parodying Ende's originals – were displayed as literally (and metaphorically) wooden museum exhibition.

But all this anthropological reflection had a wearying cumulative effect. We are all other was the clear message, but it was unclear to what extent this differed from a bland multiculturalism of the UN. I was tired. I needed a beer. And it was in the bar over a glass of the always reliable Antártica that I saw unquestionably the best, and possibly smallest, work in the entire Bienal: Miguel Calderón's footballing fantasy. The game between the national sides of Mexico and Brazil was screened on TV monitors over the bar (where else?). It began innocuously enough, but when the underdogs opened the scoring you realised something was amiss. To the accompaniment of a wonderfully convincing commentary, Mexico then opened up a quite preposterous lead. I didn't stay until the end, but when I left, it was 24-nil. Great stuff.

Richard J Williams is an art historian and author of The Anxious City, *published by Routledge, 2004*

São Paolo Bienal 26 Sep – 19 Dec 2004

409 ✳ MAP
Creative Directors: Matt Willey, Zoe Bather / *Designers:* Matt Willey, Zoe Bather / *Studio:* Frost Design, London /
Publisher: MAP Magazine Limited / *Issue:* Spring 2005 / *Category:* Design Entire Issue

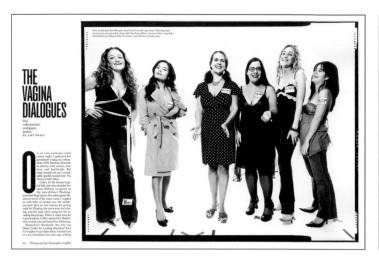

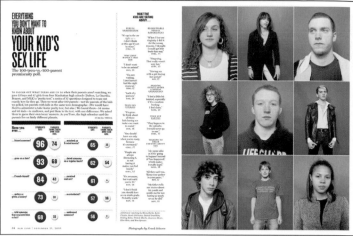

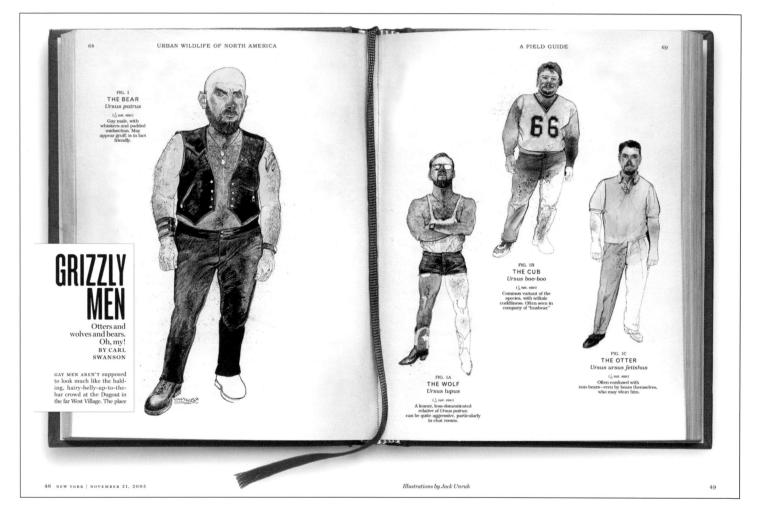

410 ✳ NEW YORK

Design Director: Luke Hayman / *Art Director:* Chris Dixon / *Designers:* Randy Minor, Kate Elazegui, Emily Anton /
Illustrators: Christopher Sleboda, Yuko Shimizu, Jack Unruh, Zohar Lazar / *Director of Photography:* Jody Quon /
Photo Editors: Amy Hoppy, Leana Alagia, Lea Golis, Lisa Corson, Justin O'Neill / *Photographers:* Phillip Tolenano,
Frank Schwere, Todd Selby, Davies + Starr, Christopher Griffith, Jake Chessum, James Wojcik, Tim Richardson /
Publisher: New York Magazine Holdings, LLC / *Issue:* November 21, 2005 / *Category:* Design Entire Issue

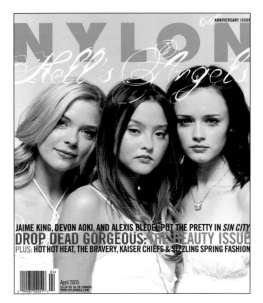

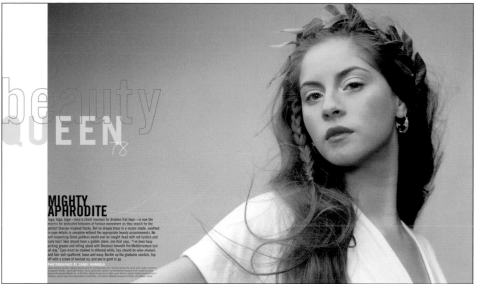

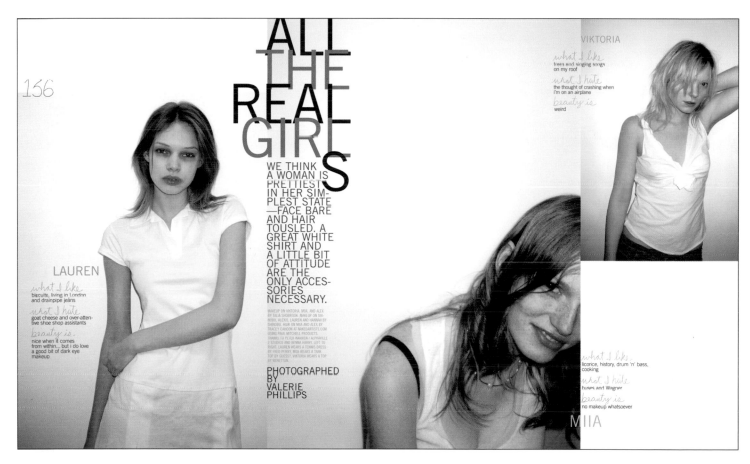

411 ✳ NYLON

Design Director: Patrick Mitchell / *Art Director:* Andrea Fella / *Designer:* Michael Pangilinan / *Illustrators:* Connie Makita,
Etsu Meusy, Jason Munn, Jodie Hayford, Mark Lazenby / *Director of Photography:* Stacey Mark / *Photographers:* Valerie Phillips,
Marvin Scott Jarrett, Blossom Berkofsky, Alan Clarke, Xavier Brunet, Kenneth Capello, David Reich / *Publisher:* Nylon LLC /
Issue: April 2005 / *Category:* Design Entire Issue

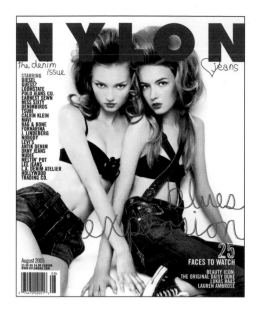

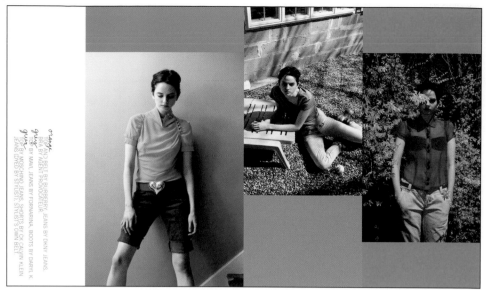

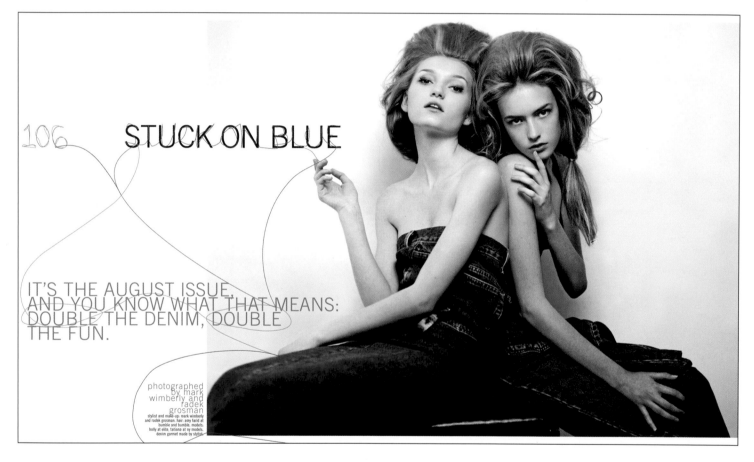

STUCK ON BLUE

106

IT'S THE AUGUST ISSUE, AND YOU KNOW WHAT THAT MEANS: DOUBLE THE DENIM, DOUBLE THE FUN.

photographed by mark wimberly and radek grosman

stylist and make-up: mark wimberly and radek grosman. hair: amy farid at bumble and bumble. models: holly at elite, tatiana at ny models. denim garmet made by stylist

412 ✳ NYLON

Design Director: Patrick Mitchell / *Art Director:* Andrea Fella / *Designer:* Michael Pangilinan / *Illustrators:* Kat Macleod, Zara Wood /
Director of Photography: Stacey Mark / *Photographers:* Mark Wimberly, Radek Grosman, Pierre Bailly, Carlin Mayer, Jordan Bennett,
Carol Cohen, Valerie Phillips, Junko Kitano / *Publisher:* Nylon LLC / *Issue:* August 2005 / *Category:* Design Entire Issue

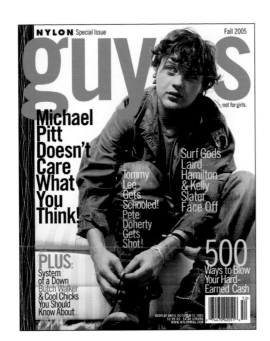

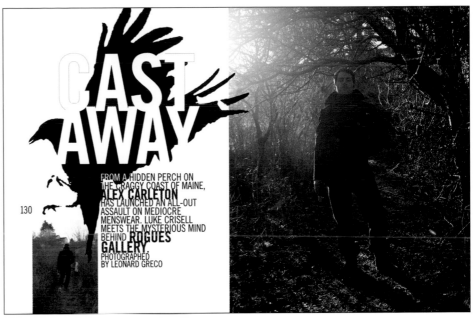

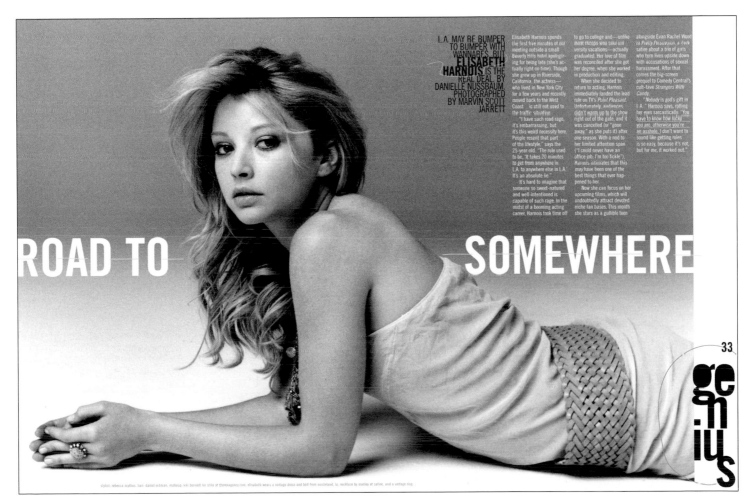

413 ✳ NYLON GUYS
Design Director: Patrick Mitchell / *Art Director:* Andrea Fella / *Designer:* Michael Pangilinan / *Illustrator:* Andrew Zbihlyj /
Director of Photography: Stacey Mark / *Photo Editor:* Heather Catania / *Photographers:* Richard Kern, Patrick O'Dell,
Leonard Greco, Leigh Ledare, Hedi Slimane, Roberta Rente, Marvin Scott Jarrett / *Publisher:* Nylon LLC /
Issue: Fall 2005 / *Category:* Design Entire Issue

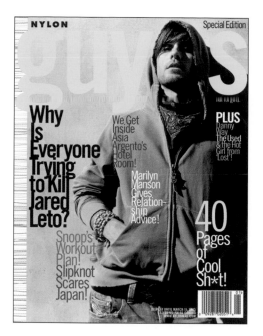

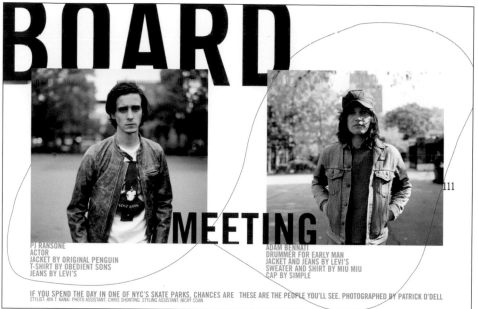

414 ✳ NYLON GUYS
Design Director: Patrick Mitchell / *Art Director:* Andrea Fella / *Designers:* Michael Pangilinan, Susannah Haesche, Katherine MacIntyre /
Director of Photography: Stacey Mark / *Photographers:* Sasha Eisenman, Joshua Wildman, Justin Hollar, Melodie Mcdaniel, Patrick O'Dell,
Junko Kitano, Xavier Brunet / *Publisher:* Nylon LLC / *Issue:* Spring 2005 / *Category:* Design Entire Issue

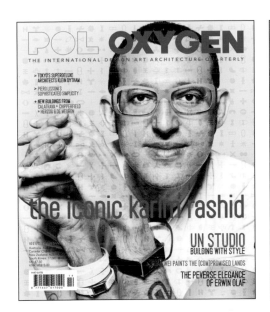

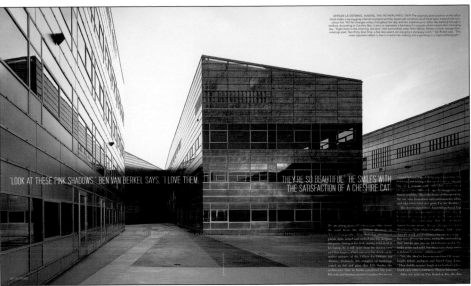

a wedding chapel that looks like an eyelid, a construction screen made of living, growing plants. klein dytham architecture has made its name with small-scale or temporary constructions, but this small firm is now hitting the big time ...

415 ✳ POL OXYGEN

Art Director: Marcus Piper / *Photographers:* Martin Mishkilnig, James Mollison, Erwin Olaf, Keetja Allard, Guy Drayton, Lukas Göbel, Gen Kay, Ingvar Kenne / *Publisher:* POL Publications / *Issue:* August 2005 / *Category:* Design Entire Issue

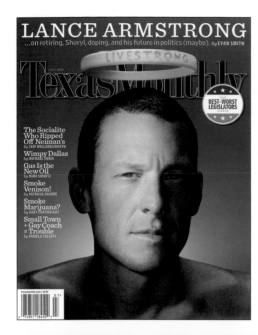

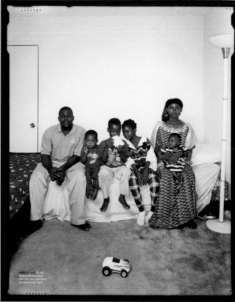

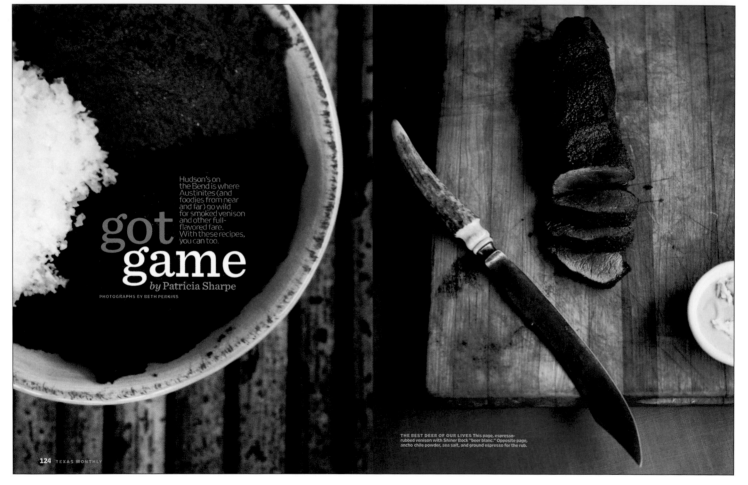

416 ✳ TEXAS MONTHLY

Creative Director: Scott Dadich / *Art Director:* TJ Tucker / *Designers:* Scott Dadich, TJ Tucker / *Illustrators:* Tim Bower, Luba Lukova, Noli Novak, Bruce McCall, Noah Woods / *Photo Editor:* Leslie Baldwin / *Photographers:* Dan Winters, O. Rufus Lovett, Beth Perkins, Peter Yang, Wyatt MacSpadden / *Publisher:* Emmis Communications Corp. / *Issue:* July 2005 / *Category:* Design Entire Issue

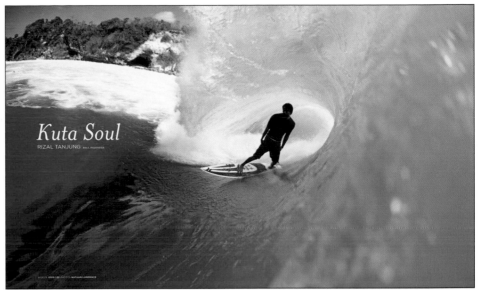

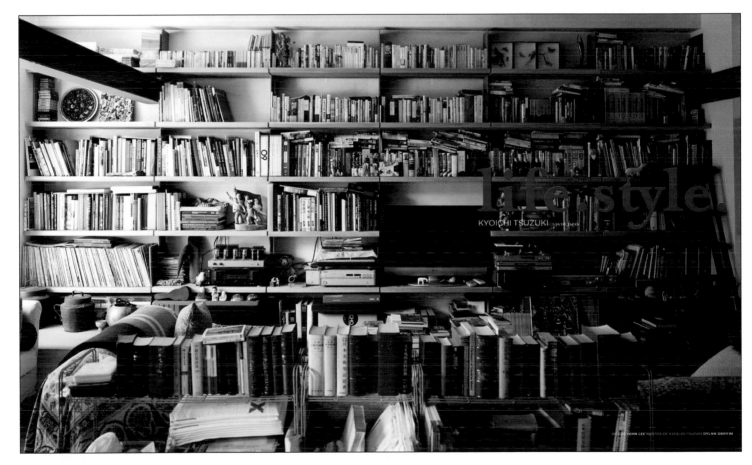

417 ✳ THEME

Creative Directors: Jiae Kim, John Lee / *Designers:* Jiae Kim, John Lee, Walton Dale / *Illustrator:* Walton Dale /
Photo Editors: Jiae Kim, John Lee / *Photographers:* Dylan Griffin, Eugene Oh, Elizabeth Young, Andrew Paynter /
Publisher: Theme Publishing, Inc. / *Issue:* Summer 2005 / *Category:* Design Entire Issue

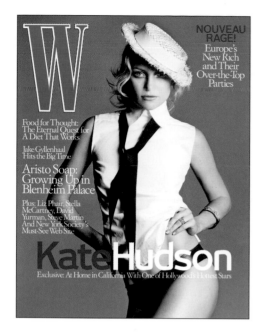

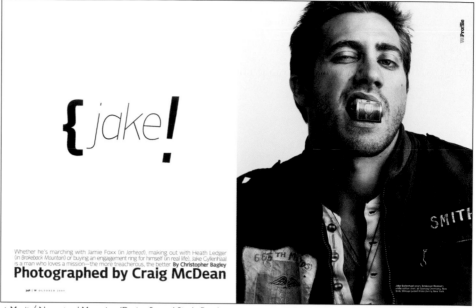

+ Merit / Newsstand Magazine (Design Spread-Single Page)

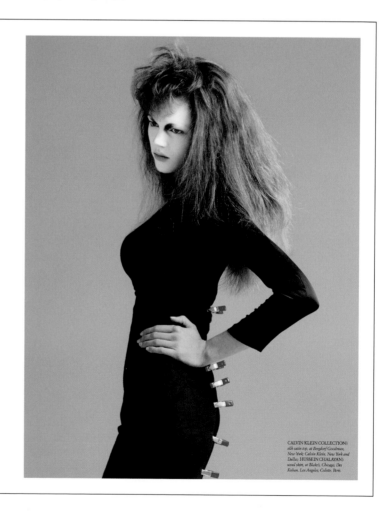

+ Merit / Newsstand Magazine (Design Spread-Single Page)

418 ✳ W

Creative Director: Dennis Freedman / *Design Director:* Edward Leida / *Art Director:* Nathalie Kirsheh / *Designers:* Nathalie Kirsheh,
Shanna Greenberg, Carmen Chan / *Photo Editor:* Nadia Vellam / *Publisher:* Fairchild Publications / *Issue:* October 2005 / *Category:* Design Entire Issue

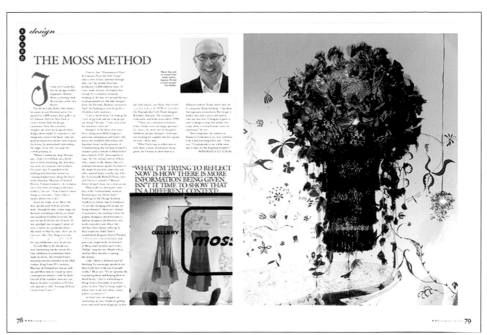

419 ✳ WWD SCOOP
Design Director: Jean Griffin / *Designers:* Orville T. Clarke, Kyoko Kobayashi, Janice Carpentier, Mandy Lee / *Illustrator:* David Horii /
Photo Editors: Jennifer Bikel, Eric Russ / *Photographers:* John Aquino, Talaya Centeno, George Chinsee, Steve Eichner, Kyle Ericksen,
Dominique Maitre, Thomas Iannaccone, Robert Mitra, David Turner, Giovanni Giannoni, Stephane Feugere, Delphine Achard, Tim Jenkins /
Publisher: Fairchild Publications / *Issue:* June 1, 2005 / *Category:* Design Entire Issue

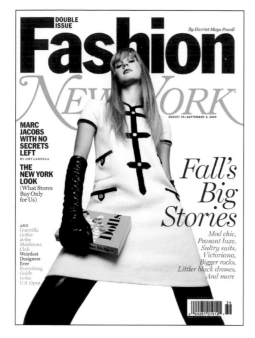

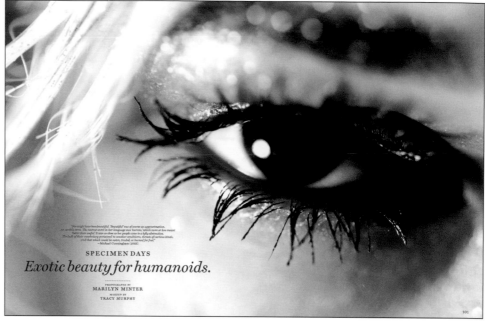

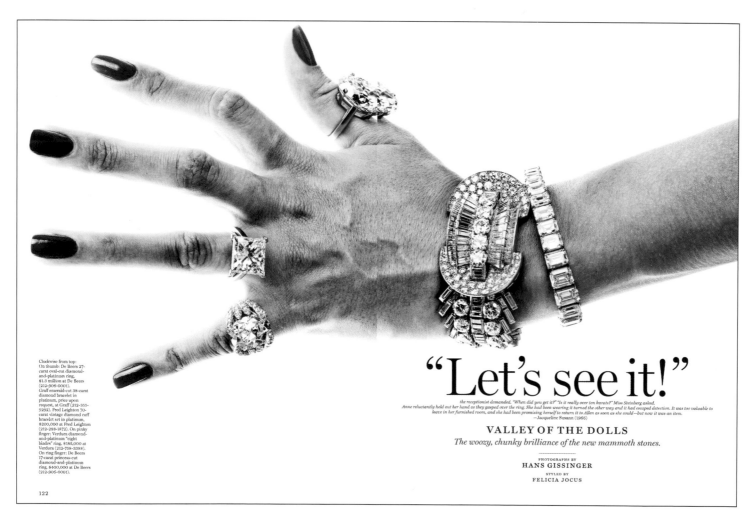

420 ✳ NEW YORK
Design Director: Luke Hayman / *Director of Photography:* Jody Quon / *Photo Editors:* Amy Hoppy, Leana Alagia, Lea Golis, Justin O'Neill / *Photographers:*
Bruce Gilden, Ryan McGinley, Joseph Maida, Thomas Dworzak, Billy Jim, Alex Majoli, Sarah Jones, Marilyn Minter, Burkhard Schittny, Hans Gissinger,
Roman Barrett, Davies + Starr, Jake Chessum / *Publisher:* New York Magazine Holdings, LLC / *Issue:* August 29, 2005 / *Category:* Photography Entire Issue

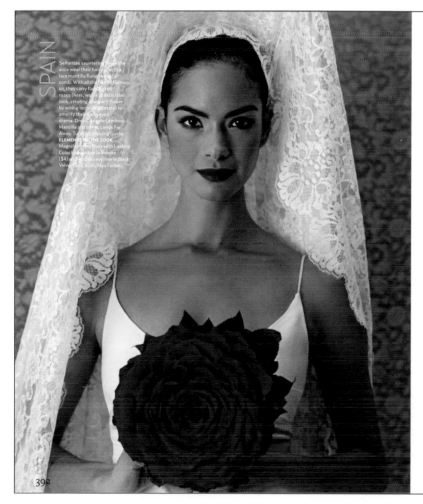

ONE LOVE

Nothing unites the world like the ritual of getting married. Celebrating with both solemnity and joy, each nation embraces this event with a look all its own. From Africa to Japan, we circled the globe and discovered a universal truth: No matter what the country's bridal style, beauty knows no boundaries.

PHOTOGRAPHS BY SUSIE CUSHNER

421 ✷ BRIDES
Design Director: Gretchen Smelter / *Art Director:* Donna Agajanian / *Designers:* Gretchen Smelter, Donna Agajanian, Ann Marie Menillo /
Illustrators: Martha Rich, Juliette Borda, Edwin Fotheringham, Maurice Vellekoop, Irene Rofheart / *Director of Photography:* Kristi Drago Price /
Photo Editor: Kristen Walsh / *Photographers:* Debra McClinton, Bruno Gaget, Susie Cushner, Alison Rosa, Peter Buckingham, Anita Calero,
Quentin Bacon, Michael Luppino, Isabel Garcia / *Issue:* May-June 2005 / *Category:* Design Redesign

422

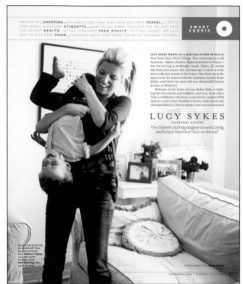

423

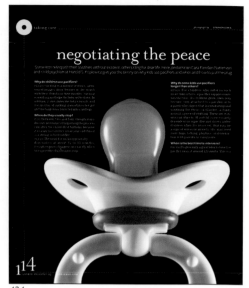

424

425

422 ✳ COOKIE
Design Director: Kirby Rodriguez / *Art Director:* Alex Grossman / *Publisher:* Condé Nast Publications Inc. / *Issue:* December 2005-January 2006 / *Category:* Design Contents & Departments

423 ✳ COOKIE
Design Director: Kirby Rodriguez / *Art Director:* Alex Grossman / *Designers:* Nicolette Berthelot, Karla Lima / *Illustrator:* Brian Rea / *Photo Editor:* Yolanda Edwards / *Photographers:* Richard Pierce, Stephen Lewis, John Huba / *Publisher:* Condé Nast Publications Inc. / *Issue:* December 2005-January 2006 / *Category:* Design Contents & Departments

424 ✳ COOKIE
Design Director: Kirby Rodriguez / *Art Director:* Alex Grossman / *Designers:* Nicolette Berthelot, Karla Lima / *Photo Editor:* Yolanda Edwards / *Publisher:* Condé Nast Publications Inc. / *Issue:* December 2005-January 2006 / *Category:* Design Contents & Departments

425 ✳ CARGO
Creative Director: Donald Robertson / *Design Director:* Peter Yates / *Designers:* Merv Garretson, Cass Spencer / *Photo Editor:* Stephanie Prepon / *Photographer:* Douglas Friedman / *Publisher:* Condé Nast Publications Inc. / *Issue:* June 2005 / *Category:* Design Contents & Departments

426

427

428

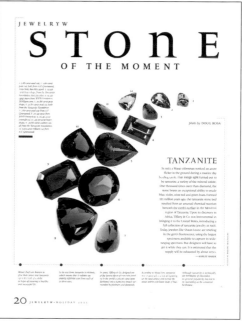

479

426 ✳ GOOD THINGS FOR ENTERTAINING
Creative Director: Eric A. Pike / *Deputy Art Director:* William Van Roden / *Art Director:* Alberto Capolino / *Photographer:* Karl Juengel / *Publisher:* Martha Stewart Omnimedia / *Issue:* July 2005 / *Category:* Design Contents & Departments

427 ✳ HAWAII SKIN DIVER
Design Director: Clifford Cheng / *Designer:* Clifford Cheng / *Photographer:* Sterling Kaya / *Studio:* Voice Design / *Publisher:* Hawaii Skin Diver Publishing / *Client:* Hawaii Skin Diver / *Issue:* Summer 2005 / *Category:* Design Contents & Departments

428 ✳ HAWAII SKIN DIVER
Design Director: Clifford Cheng / *Designer:* Clifford Cheng / *Photographer:* Sterling Kaya / *Studio:* Voice Design / *Publisher:* Hawaii Skin Diver Publishing / *Client:* Hawaii Skin Diver / *Issue:* Winter 2005 / *Category:* Design Contents & Departments

429 ✳ JEWELRY W
Creative Director: Dennis Freedman / *Design Director:* Edward Leida / *Art Director:* Nathalie Kirsheh / *Designers:* Nathalie Kirsheh, Shanna Greenberg, Carmen Chan / *Photo Editor:* Nadia Vellam / *Photographer:* Doug Rosa / *Publisher:* Fairchild Publications / *Issue:* Holiday 2005 / *Category:* Design Contents & Departments

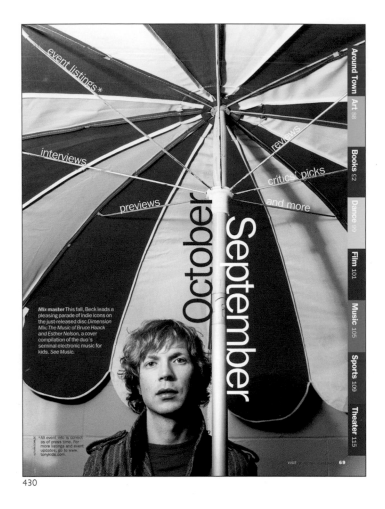

430

431

432

430 ✳ TIME OUT NEW YORK KIDS
Design Director: Ron de la Peña / *Photo Editor:* Sarina Finkelstein / *Photographer:* Autumn Dewilde / *Issue:* September-October 2005 / *Category:* Design Contents & Departments

431 ✳ JEWELRY W
Creative Director: Dennis Freedman / *Design Director:* Edward Leida / *Art Director:* Nathalie Kirsheh / *Designers:* Nathalie Kirsheh, Shanna Greenberg, Carmen Chan / *Publisher:* Fairchild Publications / *Issue:* Holiday 2005 / *Category:* Design Contents & Departments

432 ✳ W
Creative Director: Dennis Freedman / *Design Director:* Edward Leida / *Art Director:* Nathalie Kirsheh / *Designers:* Nathalie Kirsheh, Shanna Greenberg, Carmen Chan / *Illustrator:* Matt Collins / *Photo Editor:* Nadia Vellam / *Photographers:* Richard Pierce, Alia Malley, Martien Mulder, John Lawton, Eva Vermandel / *Publisher:* Fairchild Publications / *Issue:* December 2005 / *Category:* Design Contents & Departments

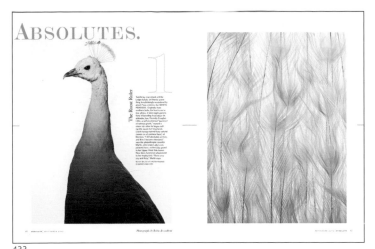

433

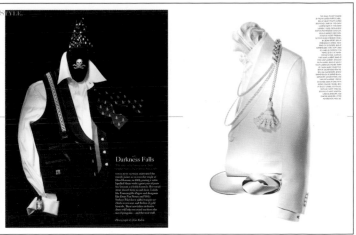

434

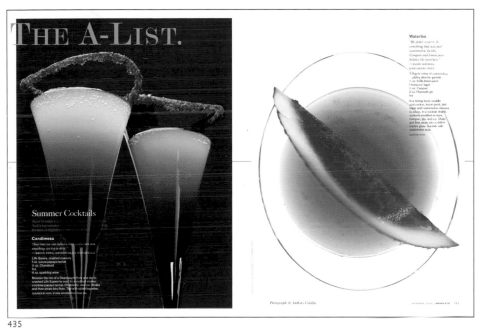

435

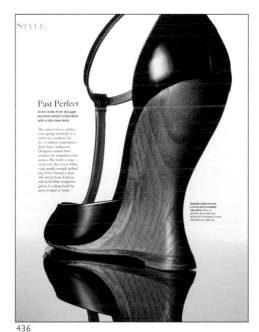

436

433 ✻ ABSOLUTE NEW YORK
Creative Director: Michael Grossman / *Design Director:* Deanna Lowe / *Designers:* Deanna Lowe, Jessica Erixon / *Director of Photography:* Catherine Talese / *Associate Photo Editor:* Hali Tara Feldman / *Photographer:* Robin Broadbent / *Publisher:* Absolute Publishing / *Issue:* September 2005 / *Category:* Photography Contents & Departments

434 ✻ ABSOLUTE NEW YORK
Creative Director: Michael Grossman / *Design Director:* Deanna Lowe / *Designers:* Deanna Lowe, Jessica Erixon / *Director of Photography:* Catherine Talese / *Associate Photo Editor:* Hali Tara Feldman / *Photographer:* Ilan Rubin / *Stylist:* Brendz Barr / *Publisher:* Absolute Publishing / *Issue:* Winter 2005 / *Category:* Photography Contents & Departments

435 ✻ ABSOLUTE NEW YORK
Creative Director: Michael Grossman / *Design Director:* Deanna Lowe / *Designer:* Jessica Erixon / *Director of Photography:* Catherine Talese / *Associate Photo Editor:* Hali Tara Feldman / *Photographer:* Anthony Cotsifas / *Food Stylist:* Liza Ternow / *Prop Stylist:* Barbara Fierros / *Publisher:* Absolute Publishing / *Issue:* Summer 2005 / *Category:* Photography Contents & Departments

436 ✻ ABSOLUTE NEW YORK
Creative Director: Michael Grossman / *Design Director:* Deanna Lowe / *Designers:* Deanna Lowe, Jessica Erixon / *Director of Photography:* Catherine Talese / *Associate Photo Editor:* Hali Tara Feldman / *Photographer:* Robin Broadbent / *Publisher:* Absolute Publishing / *Issue:* April 2005 / *Category:* Photography Contents & Departments

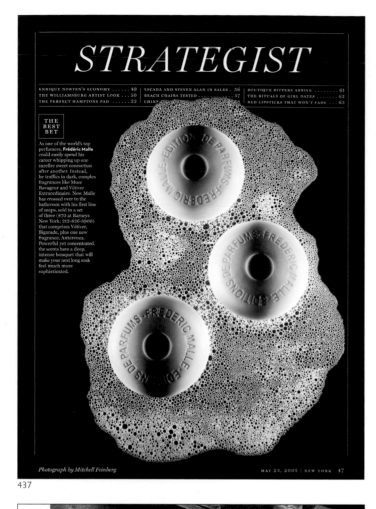

437

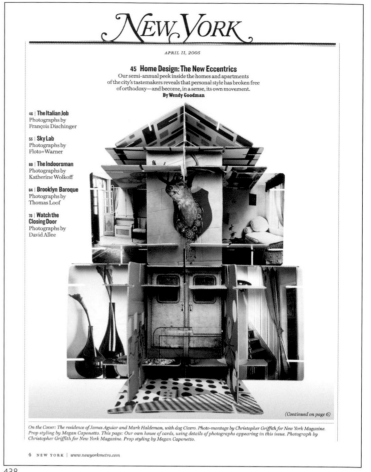

438

439

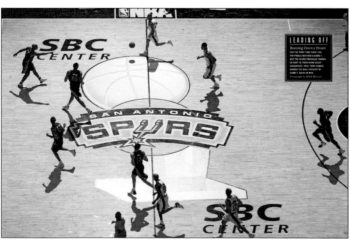

440

437 ✳ NEW YORK

Design Director: Luke Hayman / *Director of Photography:* Jody Quon / *Photo Editor:* Leana Alagia / *Photographer:* Mitchell Feinberg / *Publisher:* New York Magazine Holdings, LLC / *Issue:* May 23, 2005 / *Category:* Photography Contents & Departments

438 ✳ NEW YORK

Design Director: Luke Hayman / *Director of Photography:* Jody Quon / *Photographer:* Christopher Griffith / *Publisher:* New York Magazine Holdings, LLC / *Issue:* April 11, 2005 / *Category:* Photography Contents & Departments

439 ✳ NYLON

Art Director: Andrea Fella / *Designer:* Andrea Fella / *Director of Photography:* Stacey Mark / *Photo Editor:* Heather Catania / *Photographer:* Skye Parrott / *Publisher:* Nylon LLC / *Issue:* October 2005 / *Category:* Photography Contents & Departments

440 ✳ SPORTS ILLUSTRATED PRESENTS

Art Director: Craig Gartner / *Designer:* Karen Meneghin / *Photo Editor:* Jeff Weig / *Photographer:* John Biever / *Publisher:* Time Inc. / *Issue:* June 29, 2005 / *Category:* Photography Contents & Departments

441

442

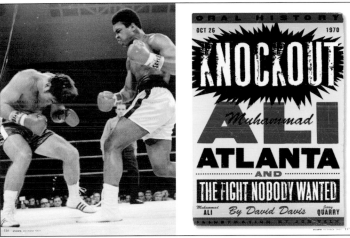

443

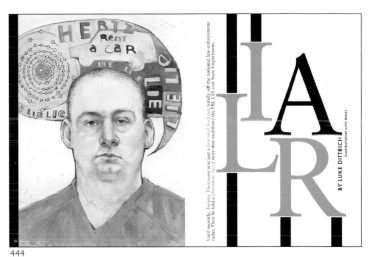

444

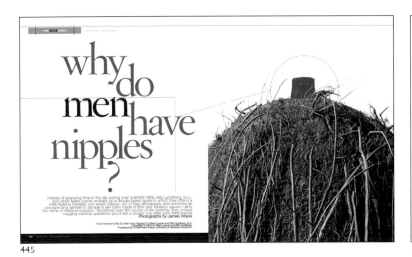

445

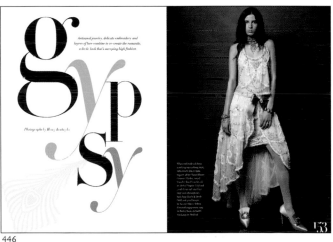

446

441 ✻ 5280
Art Director: Kevin Goodbar / *Photographer:* David Mejias / *Publisher:* 5280 Publishing, Inc. /
Issue: February-March 2005 / *Category:* Design Spread-Single Page

442 ✻ ABSOLUTE NEW YORK
Design Director: Deanna Lowe / *Designers:* Deanna Lowe, Jessica Erixon / *Director of
Photography:* Catherine Talese / *Associate Photo Editor:* Hali Tara Feldman / *Photographer:*
Mitchell Feinberg / *Publisher:* Absolute Publishing / *Issue:* Winter 2005 / *Category:* Design
Spread-Single Page

443 ✻ ATLANTA
Design Director: Susan Bogle / *Art Director:* Burgan Shealy / *Illustrator:* Jon Valk / *Publisher:*
Emmis Communications / *Issue:* October 2005 / *Category:* Design Spread-Single Page

444 ✻ ATLANTA
Design Director: Susan Bogle / *Art Director:* Marla Kaplan / *Illustrator:* Katie Ridley / *Publisher:*
Emmis Communications / *Issue:* January 2005 / *Category:* Design Spread-Single Page

445 ✻ BEST LIFE
Art Director: Brandon Kavulla / *Designer:* Brandon Kavulla / *Director of Photography:* Chris
Dougherty / *Photo Editor:* Nell Murray / *Photographer:* James Wojcik / *Publisher:* Rodale /
Issue: July-August 2005 / *Category:* Design Spread-Single Page

446 ✻ ELEGANT BRIDE
Creative Director: Lou DiLorenzo / *Art Director:* Albert Toy / *Designer:* Jessica Thomas / *Photo Editor:*
Claudia Grimaldi / *Photographer:* Henry Leutwyler / *Publisher:* Condé Nast Publications Inc. / *Issue:*
Summer 2005 / *Category:* Design Spread-Single Page

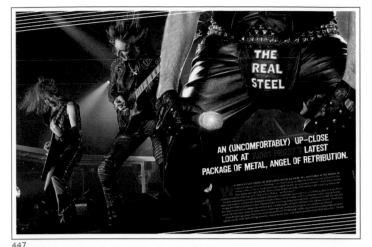

447

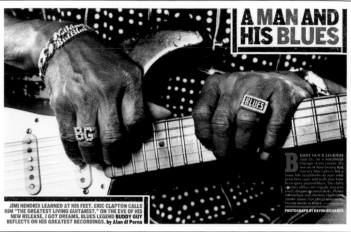

448

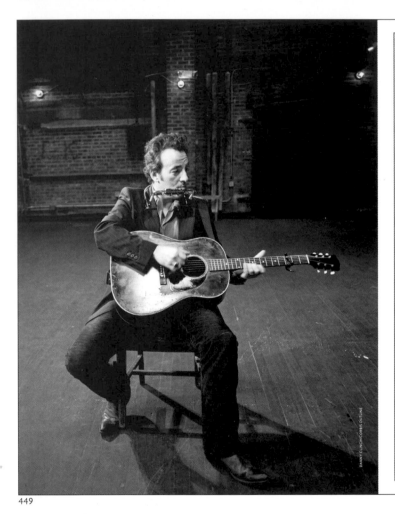

449

447 ✷ GUITAR ONE
Design Director: Andy Omel / *Art Director:* Adam Fulrath / *Designer:* Josh Bernstein / *Illustrator:* Stella Zotis / *Photo Editor:* Jimmy Hubbard /
Photographers: Jimmy Hubbard, Bruno Marzi / *Publisher:* Future US / *Issue:* July 2005 / *Category:* Design Spread-Single Page

448 ✷ GUITAR WORLD
Design Director: Andy Omel / *Designers:* Andy Omel, Julie Soltz / *Photo Editor:* Jimmy Hubbard / *Photographer:* Rayon Richards /
Publisher: Future US / *Issue:* October 2005 / *Category:* Design Spread-Single Page

449 ✷ GUITAR WORLD ACOUSTIC
Design Director: Andy Omel / *Art Director:* Eugene Wang / *Designer:* Julie Stolz / *Photo Editor:* Jimmy Hubbard / *Photographer:* Danny Clinch /
Publisher: Future US / *Issue:* August-September 2005 / *Category:* Design Spread-Single Page

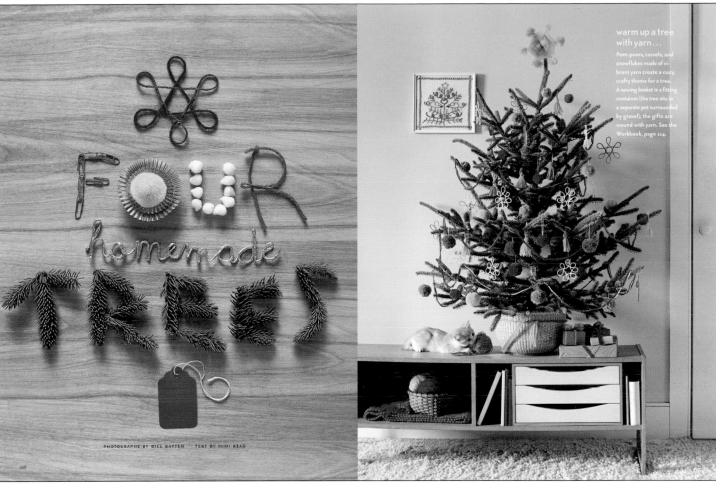

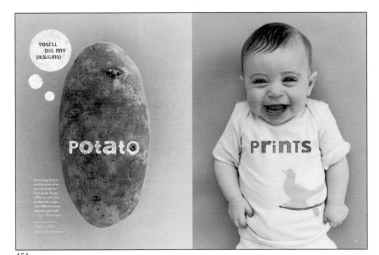

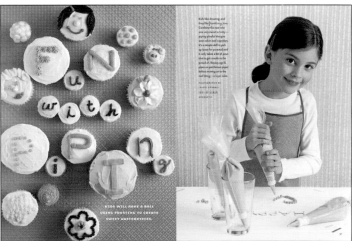

450 ✷ KIDS
Creative Director: Eric A. Pike / *Design Director:* Robin Rosenthal / *Art Director:* Jody Churchfield / *Stylists:* Anna Beckman, Anthony Santelli,
Silke Stoddard / *Director of Photography:* Heloise Goodman / *Photo Editors:* Rebecca Donnelly, Mary Cahill / *Photographers:* Bill Batten,
Karl Juengel / *Publisher:* Martha Stewart Living Omnimedia / *Issue:* Winter 2005 / *Category:* Design Spread-Single Page

451 ✷ KIDS
Creative Director: Eric A. Pike / *Design Director:* Deb Bishop / *Art Directors:* Robin Rosenthal, Jennifer Dahl / *Stylists:* Anna Beckman, Charlyne Mattox /
Director of Photography: Heloise Goodman / *Photo Editors:* Rebecca Donnelly, Lina Watanabe / *Photographer:* Frank Heckers / *Publisher:* Martha Stewart
Living Omnimedia / *Issue:* Summer 2005 / *Category:* Design Spread-Single Page

452 ✷ KIDS
Creative Director: Eric A. Pike / *Design Director:* Deb Bishop / *Art Director:* Robin Rosenthal / *Designers:* Helen Quinn, Tara Bench / *Director of Photography:*
Heloise Goodman / *Photo Editors:* Rebecca Donnelly, Lina Watanabe / *Photographer:* Laurie Frankel / *Publisher:* Martha Stewart Living Omnimedia /
Issue: Spring 2005 / *Category:* Design Spread-Single Page

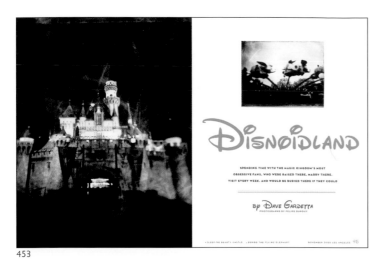

453

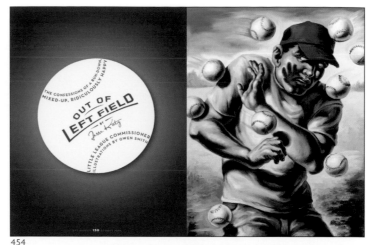

454

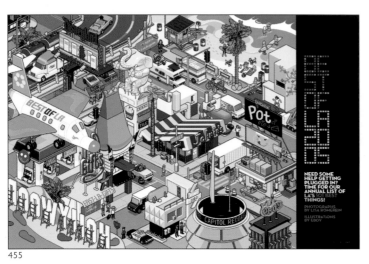

455

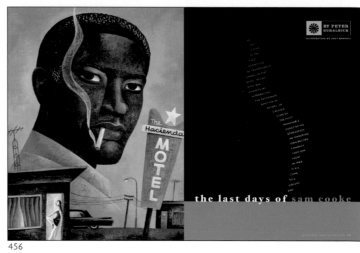

456

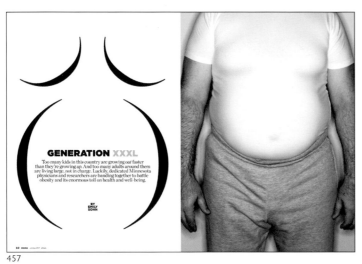

457

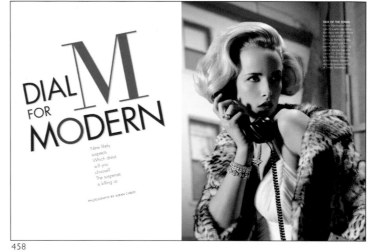

458

453 ✳ LOS ANGELES
Design Director: Joe Kimberling / *Director of Photography:* Kathleen Clark / *Photographer:* Felipe Dupouy / *Publisher:* Emmis / *Issue:* November 2005 / *Category:* Design Spread-Single Page

454 ✳ LOS ANGELES
Design Director: Joe Kimberling / *Designer:* John Valk / *Illustrator:* Owen Smith / *Publisher:* Emmis / *Issue:* October 2005 / *Category:* Design Spread-Single Page

455 ✳ LOS ANGELES
Design Director: Joe Kimberling / *Illustrator:* Eboy / *Publisher:* Emmis / *Issue:* August 2005 / *Category:* Design Spread-Single Page

456 ✳ LOS ANGELES
Design Director: Joe Kimberling / *Art Director:* Lisa M. Lewis / *Illustrator:* Jody Hewgill / *Publisher:* Emmis / *Issue:* November 2005 / *Category:* Design Spread-Single Page

457 ✳ MINNESOTA MONTHLY
Art Director: Brian Johnson / *Photographer:* Thomas Strand / *Publisher:* Greenspring Media Group / *Issue:* January 2005 / *Category:* Design Spread-Single Page

458 ✳ MODERN BRIDE
Creative Director: Lou DiLorenzo / *Art Director:* Amy Jaffe / *Designer:* Amy Jaffe / *Photo Editor:* Holly Watson / *Photographer:* Alban Christ / *Publisher:* Condé Nast Publications Inc. / *Issue:* August-September 2005 / *Category:* Design Spread-Single Page

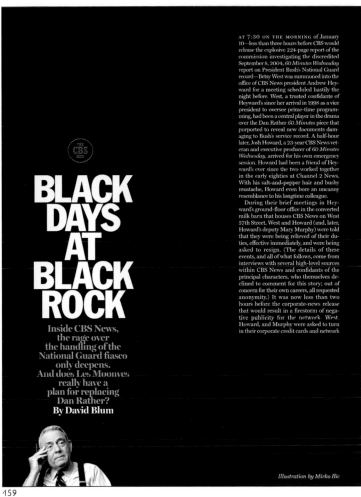

BLACK DAYS AT BLACK ROCK

Inside CBS News, the rage over the handling of the National Guard fiasco only deepens. And does Les Moonves really have a plan for replacing Dan Rather?
By David Blum

AT 7:30 ON THE MORNING of January 10—less than three hours before CBS would release the explosive 224-page report of the commission investigating the discredited September 8, 2004, *60 Minutes Wednesday* report on President Bush's National Guard record—Betsy West was summoned into the office of CBS News president Andrew Heyward for a meeting scheduled hastily the night before. West, a trusted confidante of Heyward's since her arrival in 1998 as a vice president to oversee prime-time programming, had been a central player in the drama over the Dan Rather *60 Minutes* piece that purported to reveal new documents damaging to Bush's service record. A half-hour later, Josh Howard, a 23-year CBS News veteran and executive producer of *60 Minutes Wednesday,* arrived for his own emergency session. Howard had been a friend of Heyward's ever since the two worked together in the early eighties at Channel 2 News. With his salt-and-pepper hair and bushy mustache, Howard even bore an uncanny resemblance to his longtime colleague.

During their brief meetings in Heyward's ground-floor office in the converted milk barn that houses CBS News on West 57th Street, West and Howard (and, later, Howard's deputy Mary Murphy) were told that they were being relieved of their duties, effective immediately, and were being asked to resign. (The details of these events, and all of what follows, come from interviews with several high-level sources within CBS News and confidants of the principal characters, who themselves declined to comment for this story; out of concern for their own careers, all requested anonymity.) It was now less than two hours before the corporate-news release that would result in a firestorm of negative publicity for the network. West, Howard, and Murphy were asked to turn in their corporate credit cards and network

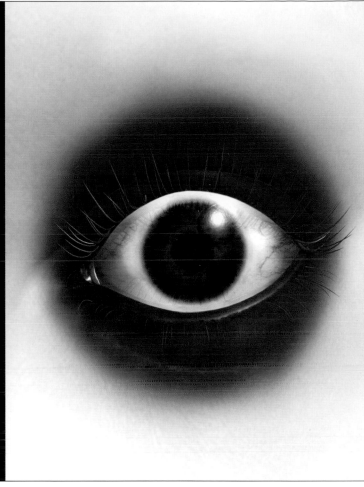

Illustration by Mirko Ilić

159

A

Empire of the Alpha Mom

Does the world need a Martha Stewart of parenting? Isabel Kallman would like to submit her résumé.
BY RANDALL PATTERSON

Photograph by Phillip Toledano

460

How Omar Minaya ensnared players like Pedro Martinez and Carlos Beltran to create a new Latin dream team. Now, can they win any games?
BY CHRIS SMITH

LOS METS

Photography by Carlos Serrao

461

159 ✳ NEW YORK
Design Director: Luke Hayman / *Art Director:* Chris Dixon / *Illustrator:* Mirko Ilić / *Director of Photography:* Jody Quon / *Publisher:* New York Magazine Holdings, LLC / *Issue:* February 7, 2005 / *Category:* Design Spread Single Page

460 ✳ NEW YORK
Design Director: Luke Hayman / *Art Director:* Chris Dixon / *Director of Photography:* Jody Quon / *Photographer:* Phillip Toledano / *Publisher:* New York Magazine Holdings, LLC / *Issue:* June 20, 2005 / *Category:* Design Spread-Single Page

461 ✳ NEW YORK
Design Director: Luke Hayman / *Art Director:* Chris Dixon / *Director of Photography:* Jody Quon / *Publisher:* New York Magazine Holdings, LLC / *Issue:* March 7, 2005 / *Category:* Design Spread-Single Page

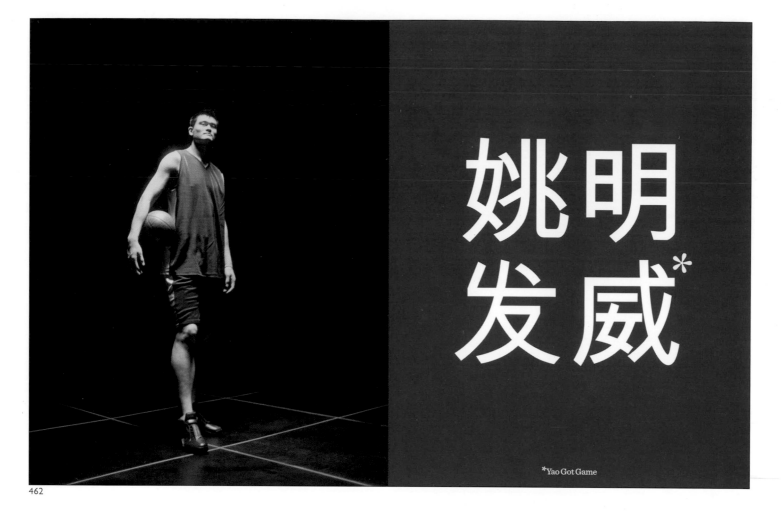

462

463

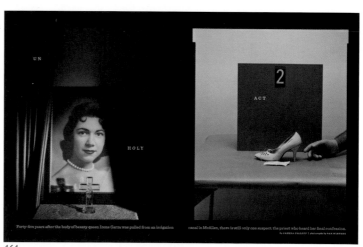

464

462 ✳ TEXAS MONTHLY
Creative Director: Scott Dadich / *Art Director:* TJ Tucker / *Designer:* Scott Dadich / *Photo Editor:* Leslie Baldwin / *Photographer:* Mark Leong /
Publisher: Emmis Communications Corp. / *Issue:* November 2005 / *Category:* Design Spread-Single Page

463 ✳ TEXAS MONTHLY
Creative Director: Scott Dadich / *Art Director:* TJ Tucker / *Designers:* TJ Tucker, Scott Dadich / *Illustrator:* Jason Lee / *Photo Editor:* Leslie Baldwin /
Photographer: Mark Hooper / *Publisher:* Emmis Communications Corp. / *Issue:* September 2005 / *Category:* Design Spread-Single Page

464 ✳ TEXAS MONTHLY
Creative Director: Scott Dadich / *Art Director:* TJ Tucker / *Designers:* Scott Dadich, TJ Tucker / *Photo Editor:* Leslie Baldwin / *Photographer:* Dan Winters /
Publisher: Emmis Communications Corp. / *Issue:* April 2005 / *Category:* Design Spread-Single Page

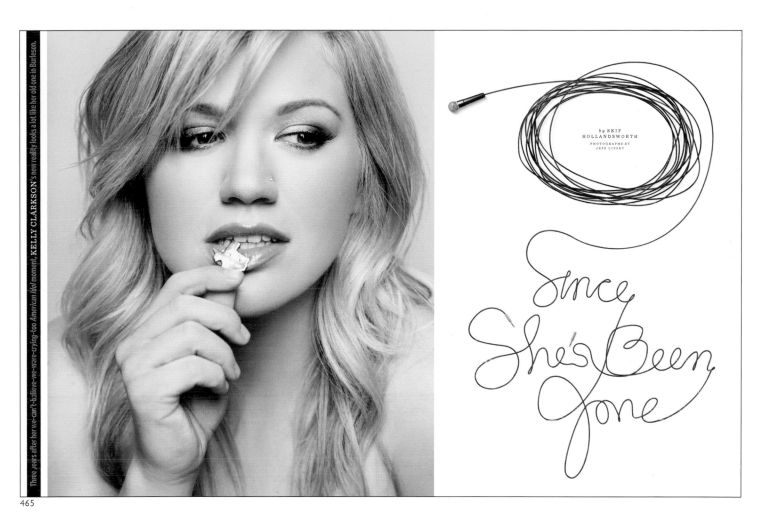

465

466

467

465 ✳ TEXAS MONTHLY
Creative Director: Scott Dadich / *Art Director:* TJ Tucker / *Designers:* Scott Dadich, TJ Tucker / *Illustrator:* Jason Lee / *Photo Editor:* Leslie Baldwin /
Photographer: Jeff Lipsky / *Publisher:* Emmis Communications Corp. / *Issue:* May 2005 / *Category:* Design Spread-Single Page

466 ✳ TEXAS MONTHLY
Creative Director: Scott Dadich / *Art Director:* TJ Tucker / *Designer:* Scott Dadich / *Photo Editor:* Leslie Baldwin / *Photographer:* Nigel Parry /
Publisher: Emmis Communications Corp. / *Issue:* April 2005 / *Category:* Design Spread-Single Page

467 ✳ TEXAS MONTHLY
Creative Director: Scott Dadich / *Art Director:* TJ Tucker / *Designer:* Scott Dadich / *Photo Editor:* Leslie Baldwin / *Publisher:* Emmis Communications Corp. /
Issue: November 2005 / *Category:* Design Spread-Single Page

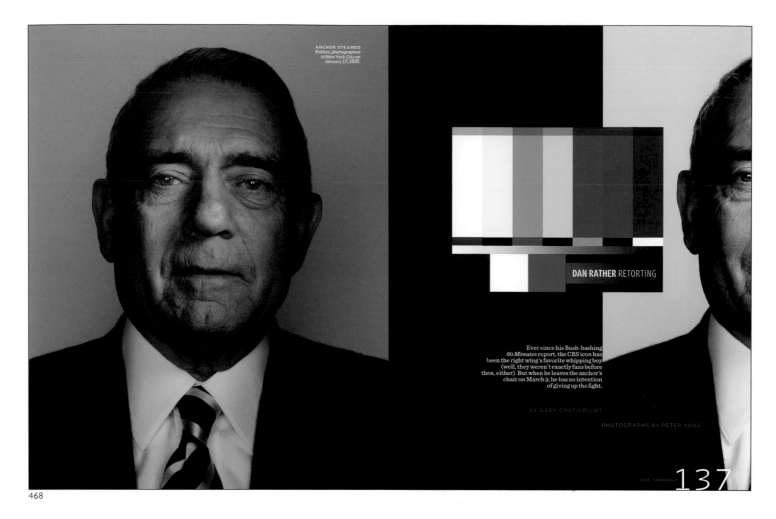

468

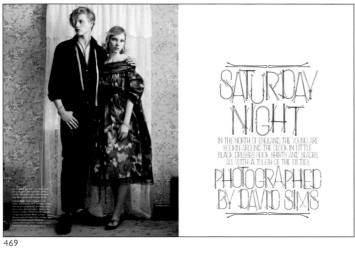

469

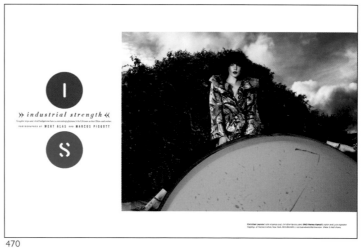

470

468 ✳ TEXAS MONTHLY
Creative Director: Scott Dadich / *Art Director:* TJ Tucker / *Designers:* Scott Dadich, TJ Tucker / *Photo Editor:* Leslie Baldwin / *Photographer:* Peter Yang / *Publisher:* Emmis Communications Corp. / *Issue:* March 2005 / *Category:* Design Spread-Single Page

469 ✳ W
Creative Director: Dennis Freedman / *Design Director:* Edward Leida / *Designers:* Edward Leida, Shanna Greenberg / *Illustrator:* Eric Pryor / *Photographer:* David Sims / *Publisher:* Fairchild Publications / *Issue:* August 2005 / *Category:* Design Spread-Single Page

470 ✳ W
Creative Director: Dennis Freedman / *Design Director:* Edward Leida / *Designers:* Edward Leida, Shanna Greenberg, Carmen Chan / *Photographers:* Mert Alas, Marcus Piggott / *Publisher:* Fairchild Publications / *Issue:* March 2005 / *Category:* Design Spread-Single Page

471 ✳ W
Creative Director: Dennis Freedman / *Design Director:* Edward Leida / *Art Director:* Kirby Rodriguez / *Designers:* Edward Leida, Shanna Greenberg / *Photographers:* Mert Alas, Marcus Piggot / *Publisher:* Fairchild Publications / *Issue:* March 2005 / *Category:* Design Spread-Single Page

472 ✳ W
Creative Director: Dennis Freedman / *Design Director:* Edward Leida / *Art Director:* Nathalie Kirsheh / *Designers:* Edward Leida, Shanna Greenberg / *Photographer:* Paolo Roversi / *Publisher:* Fairchild Publications / *Issue:* December 2005 / *Category:* Design Spread-Single Page

473 ✳ W
Creative Director: Dennis Freedman / *Design Director:* Edward Leida / *Designers:* Edward Leida, Shanna Greenberg / *Illustrator:* Kaws / *Photographer:* Steven Klein / *Publisher:* Fairchild Publications / *Issue:* May 2005 / *Category:* Design Spread-Single Page

474 ✳ WASHINGTONIAN
Art Director: Lance A. Pettiford / *Designer:* Lance A. Pettiford / *Illustrator:* Jennifer Jessee / *Issue:* May 2005 / *Category:* Design Spread-Single Page

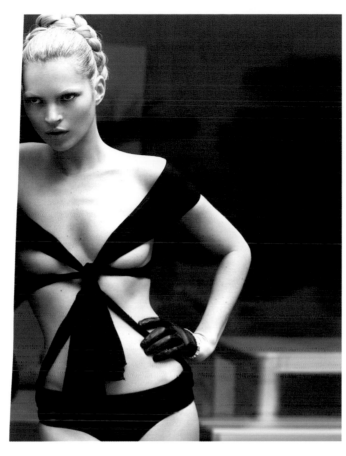

{ *glamazon* }

NEVER UNDERESTIMATE THE POWER OF A WOMAN—
ESPECIALLY ONE IN SENSUAL CLOTHES THAT
ARE CUT TO CURVE. FOR LOOKS SUCH AS
STEAMY, STRAPPY SWIMSUITS, TIGHT RUFFLED BLOUSES AND
HOURGLASS BLACK DRESSES, THE WATCHWORDS
ARE "DECADENT" AND "STYLIZED."

Photographed by
MERT ALAS AND MARCUS PIGGOTT

Gucci's black silk jersey bathing suit,
at select Gucci stores, 800.234.8224,
gucci.com. Chanel gloves.

MARCH 2003 W | **397**

471

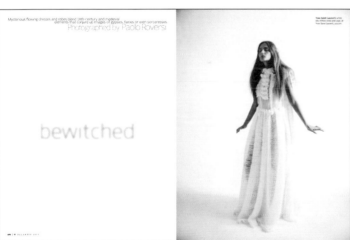

bewitched

472

GUESS
WHAT'S COMING
FOR DINNER

473

474

475

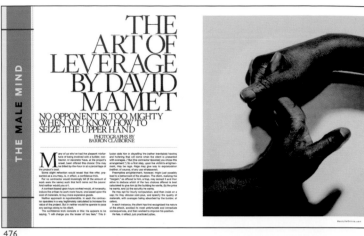

476

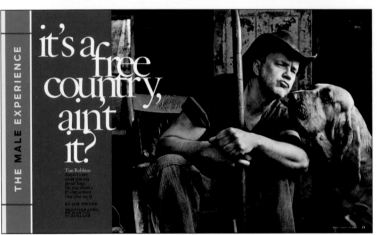

477

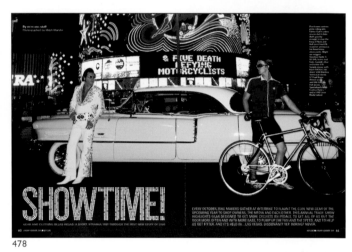

478

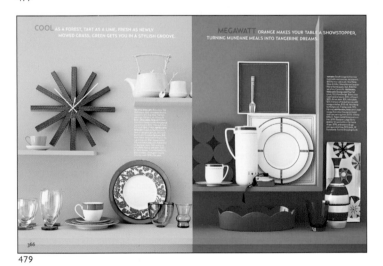

479

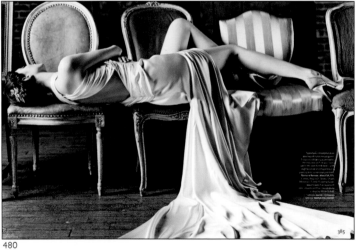

480

475 ✳ ABSOLUTE NEW YORK
Creative Director: Michael Grossman / *Design Director:* Deanna Lowe / *Designer:* Michael Grossman / *Director of Photography:* Catherine Talese / *Associate Photo Editors:* Hali Tara Feldman, Tina Chai / *Photographer:* Cedric Buchet / *Publisher:* Absolute Publishing / *Issue:* March 2005 / *Category:* Photography Spread-Single Page

476 ✳ BEST LIFE
Art Director: Brandon Kavulla / *Designer:* Brandon Kavulla / *Director of Photography:* Chris Dougherty / *Photo Editor:* Nell Murray / *Photographer:* Barron Claiborne / *Publisher:* Rodale / *Issue:* July-August 2005 / *Category:* Photography Spread-Single Page

477 ✳ BEST LIFE
Art Director: Brandon Kavulla / *Designer:* Brandon Kavulla / *Director of Photography:* Chris Dougherty / *Photographer:* Martin Schoeller / *Publisher:* Rodale / *Issue:* July-August 2005 / *Category:* Photography Spread-Single Page

478 ✳ BICYCLING
Design Director: David Speranza / *Designers:* David Speranza, Susanne Bamberger / *Director of Photography:* Stacey Emenecker / *Photographer:* Mitch Mandel / *Publisher:* Rodale, Inc. / *Issue:* January February 2005 / *Category:* Photography Spread-Single Page

479 ✳ BRIDES
Design Director: Gretchen Smelter / *Art Director:* Donna Agajanian / *Designer:* Donna Agajanian / *Photo Editor:* Kristi Drago-Price / *Photographer:* Sang An / *Issue:* July-August 2005 / *Category:* Photography Spread-Single Page

480 ✳ BRIDES
Design Director: Gretchen Smelter / *Art Director:* Donna Agajanian / *Designer:* Donna Agajanian / *Photo Editor:* Kristi Drago-Price / *Photographer:* Debra McClinton / *Issue:* May-June 2005 / *Category:* Photography Spread-Single Page

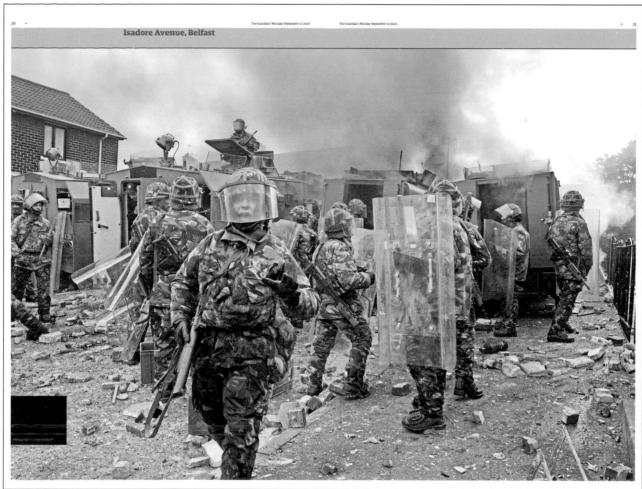

481

482

483

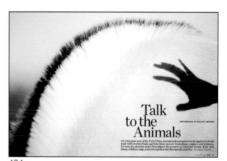

484

481 ✳ THE GUARDIAN
Creative Director: Mark Porter / *Photo Editor:* Roger Tooth / *Photographer:* Crispin Rodwell /
Publisher: Guardian Newspapers Limited / *Issue:* September 12, 2005 / *Category:* Photography
Spread-Single Page

482 ✳ THE GUARDIAN
Creative Director: Mark Porter / *Photo Editor:* Roger Tooth / *Photographer:* Sean Smith /
Publisher: Guardian Newspapers Limited / *Issue:* November 17, 2005 / *Category:* Photography
Spread-Single Page

483 ✳ BRIDES
Design Director: Gretchen Smelter / *Art Director:* Donna Agajanian / *Designer:* Ann Marie
Mennillo / *Photo Editor:* Kristi Drago-Price / *Photographer:* Gentl + Hyers / *Issue:* November-
December 2005 / *Category:* Photography Spread-Single Page

484 ✳ MINNESOTA MONTHLY
Art Director: Brian Johnson / *Photographer:* Michael Crouser / *Publisher:* Greenspring Media
Group / *Issue:* December 2005 / *Category:* Photography Spread-Single Page

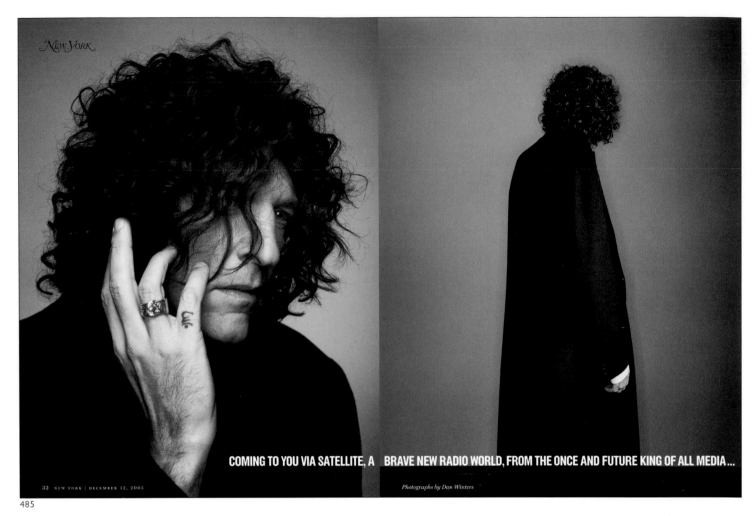

485

486

487

485 ✳ NEW YORK
Design Director: Luke Hayman / *Director of Photography:* Jody Quon / *Photo Editor:* Lea Golis / *Photographer:* Dan Winters /
Publisher: New York Magazine Holdings, LLC / *Issue:* December 12, 2005 / *Category:* Photography Spread-Single Page

486 ✳ NEW YORK
Design Director: Luke Hayman / *Director of Photography:* Jody Quon / *Photographer:* Dan Winters / *Publisher:* New York Magazine Holdings, LLC /
Issue: September 12, 2005 / *Category:* Photography Spread-Single Page

487 ✳ NEW YORK
Design Director: Luke Hayman / *Director of Photography:* Jody Quon / *Photo Editor:* Justin O'Neill / *Photographer:* Jason Schmidt /
Publisher: New York Magazine Holdings, LLC / *Issue:* May 2, 2005 / *Category:* Photography Spread-Single Page

JEAN-GEORGES IS SEEING STARS

After enduring an unexpected backlash,
the chef who revolutionized New York cuisine is fighting
his way back to perfection. BY JAY MCINERNEY

ROBUCHON'S IN THE HOUSE. Usher's also in the house, at the bar here at Jean Georges with his mom, with that unmistakable low-rider hairline, drinking a cocktail of his own invention, Chambord and ginger ale. But his host, Jean-Georges Vongerichten, I have discovered, is only vaguely and intermittently cognizant of the showbiz luminaries who bedizen his restaurants. "He's a big deal, yeah?" Jean-Georges asks me. "He's here a lot, I think." Meantime, Vongerichten is keeping an eye on Joël Robuchon, one of the last of the old-time Frog toqueheads, who retired from his eponymous Michelin three-star restaurant at 51 only to reemerge, seven years later, into a new culinary universe of multicultural menus and multinational empires that is to no small extent the creation of Franco-American prodigy Jean-Georges Vongerichten. "The guy's a legend," says Jean-Georges, who's dressed in crisp kitchen whites finished off with black Prada trousers and loafers and looks like George Clooney crossed with a Renaissance putto.

22 *Photograph by Olaf Blecker*

488

THE PORN HUNTER

There's cash in Grandma's dirty pictures. BY JENNIFER KABAT

489

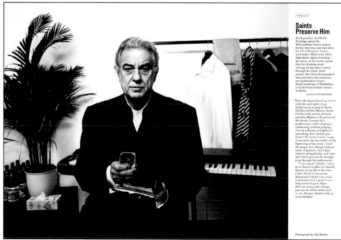

Saints Preserve Him

490

488 ✲ NEW YORK
Design Director: Luke Hayman / *Director of Photography:* Jody Quon / *Photographer:* Olaf Blecker / *Publisher:* New York Magazine Holdings, LLC /
Issue: June 27, 2005 / *Category:* Photography Spread-Single Page

489 ✲ NEW YORK
Design Director: Luke Hayman / *Director of Photography:* Jody Quon / *Photo Editor:* Amy Hoppy / *Photographer:* Phillip Toledano /
Publisher: New York Magazine Holdings, LLC / *Issue:* November 21, 2005 / *Category:* Photography Spread-Single Page

490 ✲ NEW YORK
Design Director: Luke Hayman / *Director of Photography:* Jody Quon / *Photo Editor:* Amy Hoppy / *Photographer:* Olaf Blecker /
Publisher: New York Magazine Holdings, LLC / *Issue:* September 26, 2005 / *Category:* Photography Spread-Single Page

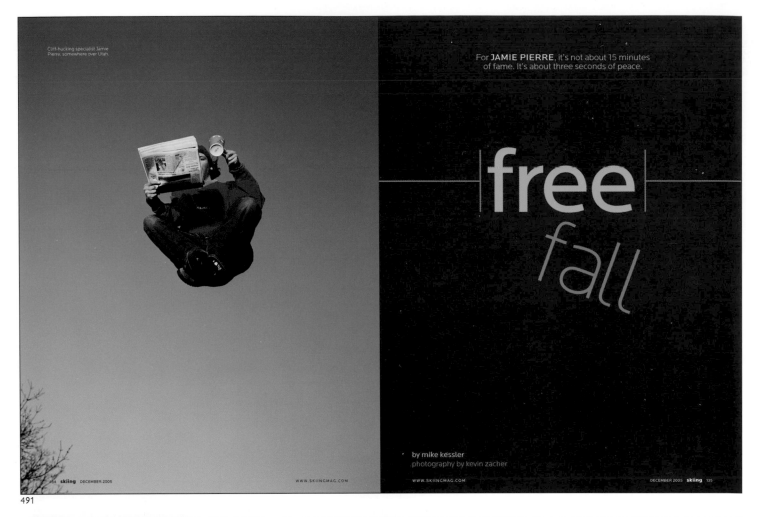

491

492

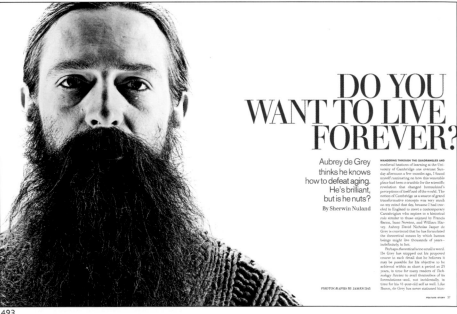

493

491 ✳ SKIING
Art Director: Dave Allen / *Deputy Art Director:* Nicole Duggan / *Photo Editor:* Julia Beck Hoggson / *Photographer:* Kevin Zacher /
Publisher: Mountain Sports Media / *Issue:* December 2005 / *Category:* Photography Spread-Single Page

492 ✳ QUIEN
Creative Director: Guillermo Caballero / *Design Director:* Paola Alonso / *Art Director:* Socorro Toxtli / *Photographer:* Erwan Fichou /
Publisher: Grupo Editorial Expansión / *Issue:* July 2005 / *Category:* Photography Spread-Single Page

493 ✳ TECHNOLOGY REVIEW
Art Director: Julia Moburg / *Designers:* Julia Moburg, George Lee, John Sheppard / *Photographer:* James Day / *Publisher:* Massachusetts
Institute of Technology / *Issue:* February 2005 / *Category:* Photography Spread-Single Page

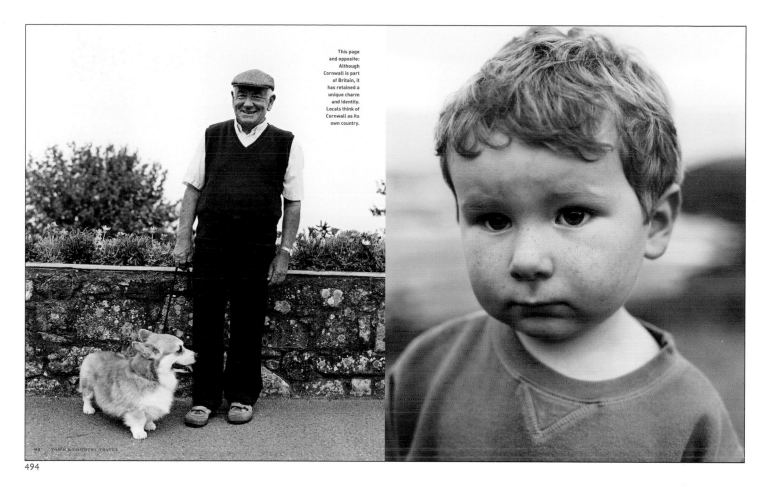

494

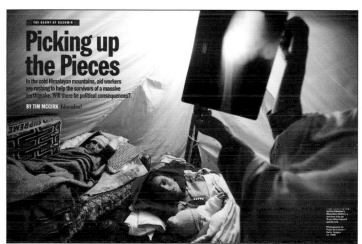

495

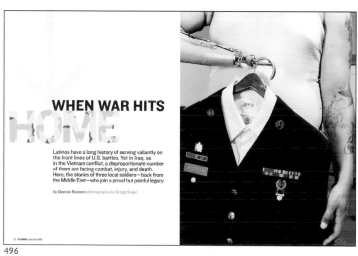

496

494 ✳ TOWN & COUNTRY TRAVEL
Creative Director: Mary Shanahan / *Art Director:* Matthew Lenning / *Photo Editor:* Mara Hoberman / *Photographer:* John Huba / *Editor:* Melissa Biggs Bradley /
Publisher: The Hearst Corporation-Magazines Division / *Issue:* Spring 2005 / *Category:* Photography Spread-Single Page

495 ✳ TIME ASIA
Art Director: Cecelia Wong / *Designer:* Yuki Endo / *Photo Editors:* Lisa Botos, Maria Wood / *Photographer:* Paula Bronstein (Getty) / *Publisher:* Time Inc. /
Issue: October 24, 2005 / *Category:* Photography Spread-Single Page

496 ✳ TU CIUDAD
Art Director: Thomas O'Quinn / *Photo Editor:* Bailey Franklin / *Photographer:* Gregg Segal / *Publisher:* Emmis Communications Corp. / *Issue:* June-July 2005 /
Category: Photography Spread-Single Page

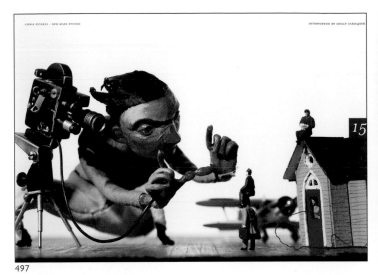

497

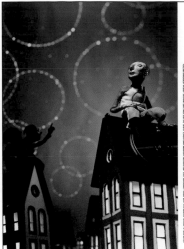

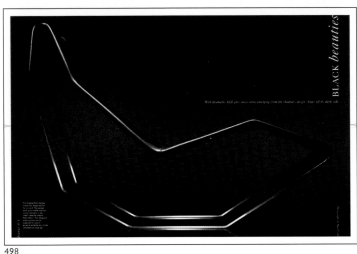

498

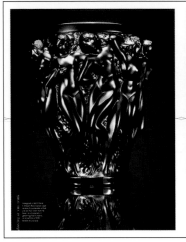

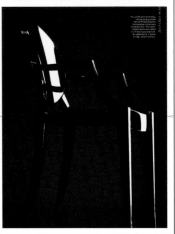

499

497 ✳ 3X3, THE MAGAZINE OF CONTEMPORARY ILLUSTRATION
Creative Director: Charles Hively / *Art Director:* Sarah Munt / *Designer:* Charles Hively / *Illustrator:*
Chris Sickels / *Photographer:* Chris Sickels / *Issue:* October 2005 / *Category:* Design Story

498 ✳ ABSOLUTE NEW YORK
Creative Director: Michael Grossman / *Design Director:* Deanna Lowe / *Designers:* Deanna Lowe,
Jessica Erixon / *Director of Photography:* Catherine Talese / *Associate Photo Editor:* Hali Tara
Feldman / *Photographer:* Dan Forbes / *Publisher:* Absolute Publishing / *Issue:* April 2005 /
Category: Design Story

499 ✳ ABSOLUTE NEW YORK
Design Director: Deanna Lowe / *Designer:* Deanna Lowe / *Illustrator:* Annika Huett / *Director of
Photography:* Catherine Talese / *Associate Photo Editor:* Hali Tara Feldman / *Publisher:* Absolute
Publishing / *Issue:* Winter 2005 / *Category:* Design Story

500 ✳ ELEGANT BRIDE
Creative Director: Lou DiLorenzo / *Art Director:* Albert Toy / *Designer:* Jessica Thomas / *Photo
Editor:* Claudia Grimaldi / *Photographer:* Cleo Sullivan / *Publisher:* Condé Nast Publications Inc. /
Issue: Fall 2005 / *Category:* Design Story

501 ✳ KIDS
Creative Director: Eric A. Pike / *Design Director:* Robin Rosenthal / *Stylists:* Jodi Levine, Megan
Hedgpeth, Tara Bench / *Director of Photography:* Heloise Goodman / *Photo Editors:* Rebecca
Donnelly, Mary Cahill, Lina Watanabe / *Photographer:* Sang An / *Publisher:* Martha Stewart
Living Omnimedia / *Issue:* Fall 2005 / *Category:* Design Story

502 ✳ LOS ANGELES
Design Director: Joe Kimberling / *Director of Photography:* Kathleen Clark / *Photographers:* Dan
Winters, Karin Catt, Ian White / *Publisher:* Emmis / *Issue:* February 2005 / *Category:* Design Story

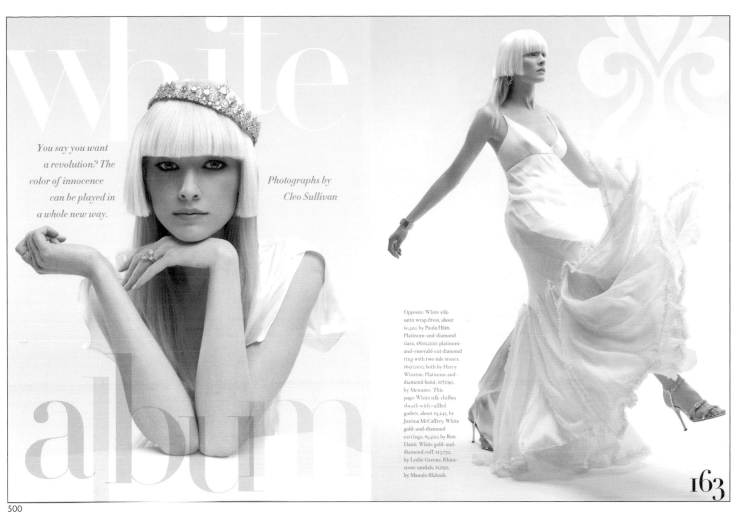

500

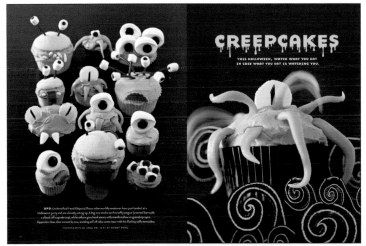

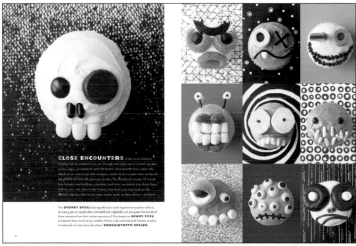

501

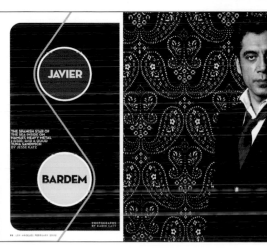

502

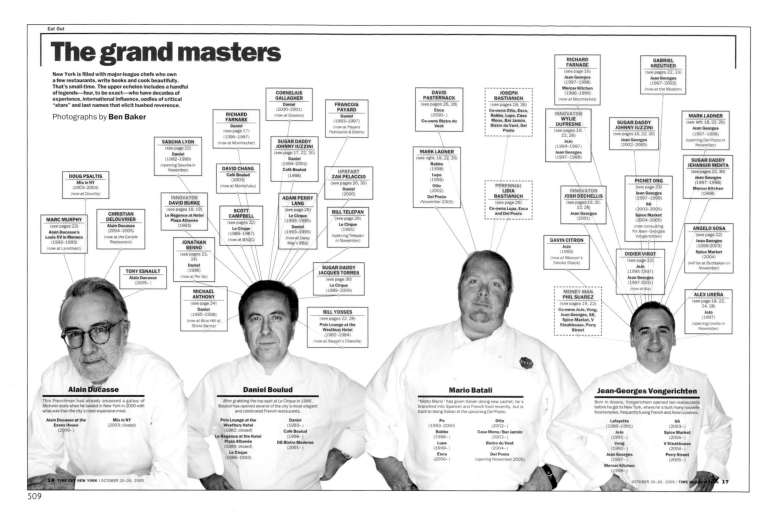

509

510

509 ✳ TIME OUT NEW YORK
Art Director: Matt Guemple / *Designer:* Jordan Hadley / *Photo Editor:* Brona Hatchette / *Photographer:* Ben Baker /
Publisher: Time Out New York Partners, L.P. / *Issue:* October 20-26, 2005 / *Category:* Design Story

510 ✳ TOWN & COUNTRY TRAVEL
Creative Director: Mary Shanahan / *Art Director:* Matthew Lenning / *Illustrator:* Yoko Murao / *Photo Editor:* Mara Hoberman /
Photographer: John Huba / *Editor:* Melissa Biggs Bradley / *Publisher:* The Hearst Corporation-Magazines Division / *Issue:* Fall 2005 /
Category: Design Story

511 ✳ VINO + GASTRONOMÍA
Creative Director: Carmelo Caderot / *Designer:* Carmelo Caderot / *Publisher:* Vino y Gastronomía Comunicación /
Issue: 2005 / *Category:* Design Story

RANKING 2005

{2005}

Por primera vez vez en sus 20 años de historia, Vino + Gastronomía ha convocado a los más reputados **críticos** de nuestro país para que voten Los 10 **mejores** platos de 2005. Una cuestión nada fácil de dirimir dado el nivel actual de nuestra gastronomía. Y aunque a la llamada no han acudido todos los que son, no cabe la menor **duda** de que sí son todos los que están. Con sus votos, a veces tan viscerales como **exigentes**, hemos elaborado una **lista** que ofrece una muestra significativa de lo que ha dado de sí la temporada en el terreno de la cocina española de autor. Ahora **juzguen** ustedes mismos. ENCUESTA / EMMA SUEIRO

EL JURADO

XAVIER AGULLÓ Crítico de Metrópoli	JOSE CARLOS CAPEL Crítico El País, Pres. Madrid Fusión
CRISTINO ALVAREZ y/o Caius Apicius Crítico Agencia Efe	CARMEN CASAS Crítica La Vanguardia
RAFAEL ANSÓN Pres. Academia Española de Gastronomía	LUIS CEPEDA Crítico La Guía del Ocio
JUAN MANUEL BELLVER Crítico El Mundo	CARLOS MARIBONA Crítico ABC
PEPE BARRENA Crítico de Metrópoli	PAZ IVISON Subdirectora Club del Gourmet
	IGNACIO MEDINA Crítico Punto Radio, Vino + Gastromía

los 10 mejores platos

{ **LAS VOTACIONES**

● **sistema de votación**
Los críticos han votado sus 10 platos del año. En la revista sólo se citan los que han obtenido dos o más votos.

● **finalistas**
Barbacoa fría de Miguel Sánchez Romera, L'Esguard, Barcelona. / Bonito con foie, cacao y manzana verde, Casa Gerardo, Asturias. / Sopa de tomate y violetas con tuétanos de verduras, moluscos y gambas de Koldo Rodero, Pamplona. / Nem de caballa, pan de maíz, cebolla y brotes germinados de grelo de Marcelo Tejedor, Casa Marcelo, Santiago de Compostela. / Jugo de vaina cruda con foie a la crema de Raifort de Martín Berasategui, Lasarte. / Ventresca de atún a la llama con yuzu y aceite de oliva de Alberto Chicote, No Do, Madrid. / Yema cremosa con guisantes de Pepe Solla, Casa Solla, Pontevedra. / Lenguado con guisantes, espardeñas y morillas de Santi Santamaría, Can Fabes, Sant Celoni. / Ventresca de bonito de Josean M. Alija, Guggenheim, Bilbao. / Tartar de sargo con huevos de semmarrilla, Playa Club, A Coruña. / Pompas de fresa de Juan Mari Arzak, San Sebastián. / Tartar de gambas rojas sobre patatas chafadas, de Marc Gascons, Els Tinars, Llagostera, Girona. / Escabeche de raya y moluscos de Manicha Bermúdez, Taberna de Rotilio, Sanxenxo. / Vieiras asadas con puré de trufas, de Toño Pérez, Atrio, Cáceres.

Lenguado FRITO A 180..CON EMBLANCO LIGADO CON MISO Y TOMATE SEMISECO		1
Tierra, TALLO, HOJA Y FLOR		2
Deshielo DOS MIL CINCO		3
Arroz CARNAROLI GELIFICADO CON ALOE VERA		4
Sepia AL PUNTO CON ALMENDRAS TIERNAS Y CACAO RALLADO		5
Patatas APLASTADAS, HUEVOS ROTOS Y CARBÓN VEGETAL CON CASEÍNA DE AJOS		6
Helado DE JAMÓN IBÉRICO CON SEMILLAS DE TOMATE, TROPEZONES DE PAN Y ACEITE		7
Velo DE GARBANZOS, LA PRINGADA DEL COCIDO Y SU CALDO		8
Niguiri DE TUÉTANO DE TERNERA		9
Atún ROJO CON MELÓN A LA PLANCHA Y CHUPITO DE MARMITAKO		10

29 VINO Y GASTRONOMÍA

{2005}

1

{ *Lenguado* FRITO A 180.. CON EMBLANCO LIGADO CON MISO Y TOMATE SEMISECO }

DANI GARCIA

{2005}

2

{ *Tierra* TALLO, HOJA Y FLOR }

JOAN ROCA

{2005}

3

{ *Deshielo* 2005 }

FERRAN ADRIA

{2005}

4

{ *Arroz* CARNAROLI GELIFICADO CON ALOE VERA }

QUIQUE DACOSTA

{2005}

5

{ *Sepia* AL PUNTO CON ALMENDRAS TIERNAS Y CACAO }

CARME RUSCALLEDA

{2005}

6

{ *Patatas* APLASTADAS, HUEVOS ROTOS Y CARBÓN VEGETAL CON CASEÍNA DE AJOS }

ANDONI LUIS ADURIZ

{2005}

7

{ *Helado* DE JAMÓN IBÉRICO CON SEMILLAS DE TOMATE, TROPEZONES DE PAN Y ACEITE DE OLIVA }

FRANCIS PANIEGO

{2005}

8

{ *Velo* DE GARBANZOS, LA PRINGADA DEL COCIDO Y SU CALDO }

PEPE RODRIGUEZ REY

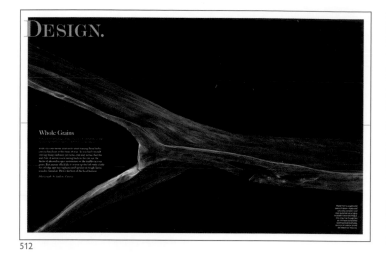

512

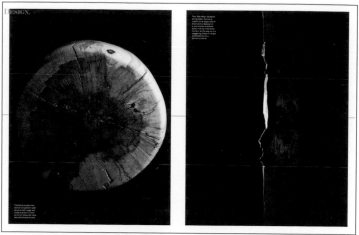

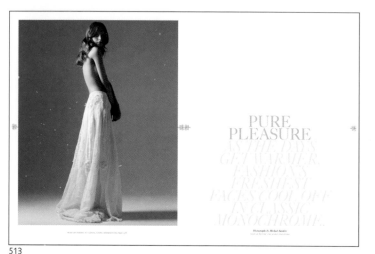

513

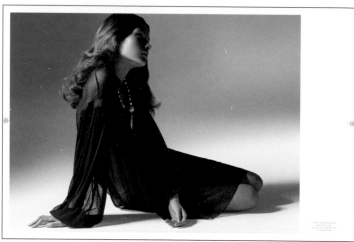

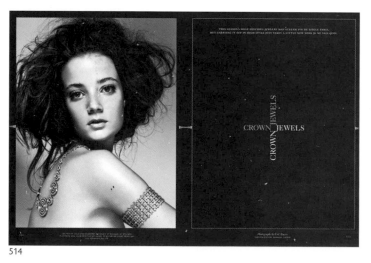

514

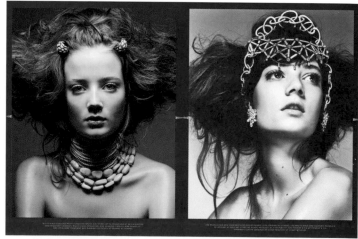

512 ✳ ABSOLUTE NEW YORK
Design Director: Deanna Lowe / *Designers:* Deanna Lowe, Jessica Erixon / *Director of Photography:* Catherine Talese / *Associate Photo Editor:* Hali Tara Feldman / *Photographer:* Anthony Cotsifas / *Publisher:* Absolute Publishing / *Issue:* October-November 2005 / *Category:* Photography Story

513 ✳ ABSOLUTE NEW YORK
Creative Director: Michael Grossman / *Design Director:* Deanna Lowe / *Designer:* Deanna Lowe / *Director of Photography:* Catherine Talese / *Associate Photo Editors:* Hali Tara Feldman, Lisa Marie Fernandez / *Photographer:* Michael Sanders / *Publisher:* Absolute Publishing / *Issue:* April 2005 / *Category:* Photography Story

514 ✳ ABSOLUTE NEW YORK
Creative Director: Michael Grossman / *Design Director:* Deanna Lowe / *Designers:* Michael Grossman, Deanna Lowe / *Director of Photography:* Catherine Talese / *Associate Photo Editor:* Hali Tara Feldman / *Photographer:* Eric Traore / *Publisher:* Absolute Publishing / *Issue:* March 2005 / *Category:* Photography Story

515 ✳ AMERICAN PHOTO
Art Director: Deborah Mauro / *Designer:* John Pamer / *Photographer:* David Leeson / *Publisher:* Hachette Filipacchi Media U.S. / *Issue:* March-April 2005 / *Category:* Photography Story

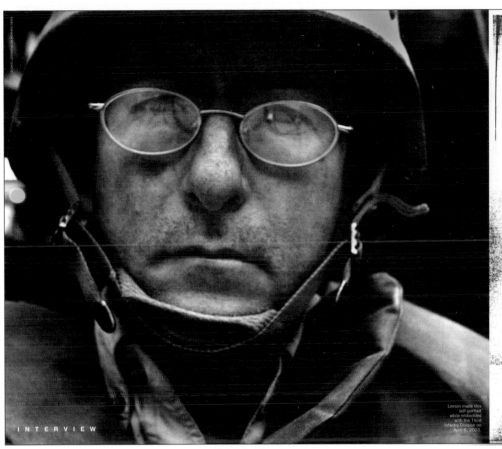

His photographs of the Iraq invasion earned him a Pulitzer Prize, but no one sees what a war photographer sees and walks away without paying a price. **By Dirck Halstead**

DAVID LEESON HAS SEEN HELL

D avid Leeson was sitting in front of his computer at his home in Dallas on a balmy spring day last year, browsing the Internet. Clicking onto The Digital Journalist, a Website he had contributed to in the past, he began watching a video interview with David Douglas Duncan, in which the legendary photographer describes shooting the funeral of a Marine five decades earlier. Suddenly, Leeson started to sob. His wife happened to be watching through the window, and she ran to his side.

Different people have different names for what happened to Leeson that day: an emotional breakdown, or, that all-encompassing term "exhaustion". It might also be called PTSD, or post-traumatic stress disorder, brought on by Leeson's coverage of the invasion of Iraq in 2003 for his newspaper, the *Dallas Morning News*. Embedded with the Third Infantry Division, Third Brigade Combat Team as it fought its way across the desert to Baghdad, Leeson made shattering images of American men and women in the heat of battle. The work earned him a Pulitzer Prize in 2004.

The accolades came with a price, though. According to a study by the *New England Journal of Medicine*, more than 16 percent of U.S. soldiers and Marines who served in Iraq are victims of PTSD. No one has done similar studies of the journalists who have covered the war. Recently, Leeson decided to talk about his experiences with *American Photo* contributing editor Dirck Halstead, who is also the editor of The Digital Journalist. Leeson hopes his story might help other photographers come to grips with their own experiences. Moreover, his extraordinary account paints a vivid portrait of the life of a war photographer grown sick of the sight of war.

To watch the video interview with Leeson online, go to The Digital Journalist at digitaljournalist.org/issue0503/leeson.html.

Leeson made this self-portrait while embedded with the Third Infantry Division on April 6, 2003.

INTERVIEW

AMERICAN PHOTO THE DIGITAL JOURNALIST 77

"I truly believed, deeply and passionately, that there existed a series of photographs, or a single photograph, that could end war. I wanted to find that one photo."

INTERVIEW

For a war photographer, the hardest part of the job isn't going, it's the coming back. **Interview with David Leeson**

RECALLING THE COST

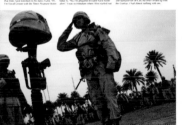

INTERVIEW

"I didn't even want to go to Iraq. I didn't want to sacrifice another marriage, I didn't want to lose myself again, breaking down in the middle of the night."

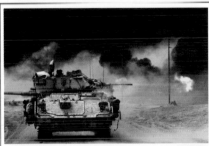

THE LAST PLACE ON EARTH

An exclusive preview of one of the most powerful collections of nature photography ever produced. **Pictures by Michael Nichols,** text by David Schonauer

For more than a decade, Michael "Nick" Nichols of *National Geographic* magazine has been photographing what no one had ever seen or will ever see again: a land where man has not been. In a remote corner of Central Africa, he and conservationist Michael Fay formed a unique partnership with the goal of discovering and documenting one of the world's last undisturbed habitats, a place of "naïve" gorillas and chimpanzees with no experience of man, of wide elephant trails leading to secret congregating areas, of leopards, dwarf crocodiles, vipers, and leeches, of a mythical ape known to Pygmies as *kooloo-kamba,* and a legendary Congo Basin dinosaur called *mokele-mbembe.* Their efforts were capped with a trek like no other in history, a 456-day "walk" that covered some 2,000 miles across a checkerboard patch of untouched Africa, leading them to the Atlantic coast of Gabon, where Nichols photographed yet one more thing he'd never seen before: surfing hippos. Because of the men's efforts, large sections of the area have been turned into national parks, offering this wild place protection from loggers, miners, and other symptoms of modern civilization. And yet, in an irony that does not escape Nichols, it was one of the hallmark acts of civilization, the creation of art, that allowed him to capture and bring this place back to all of us—to see it, to feel it, and know it as he did.

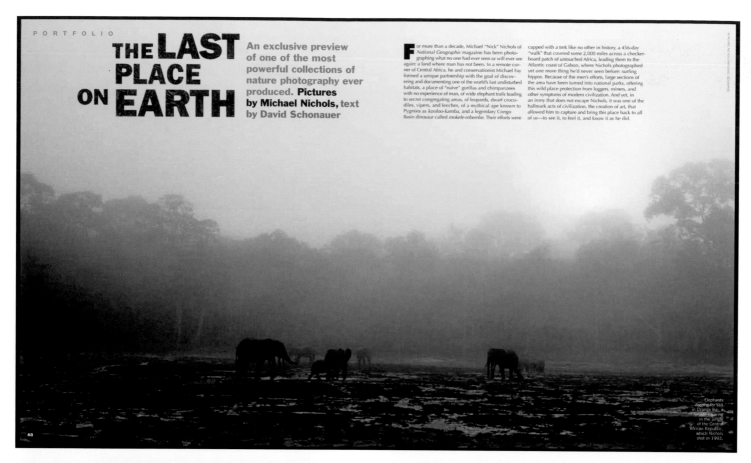

Elephants digging for salt in Dzanga Bai, a remote clearing in the jungle of the Central African Republic, which Nichols shot in 1993.

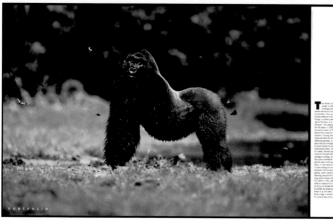

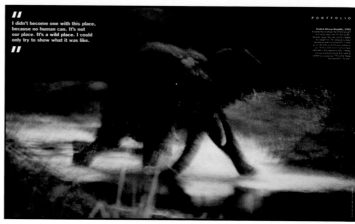

"
I didn't become one with this place, because no human can. It's not our place. It's a wild place. I could only try to show what it was like.
"

2. THE PHOTOGRAPHER

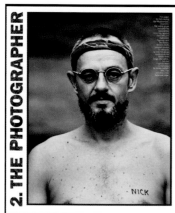

NICK

"I often think that if you could go back to September 10, 2001, and tell people everything that would happen in the next three years—terrorist attacks in America, two wars—no one would believe you."

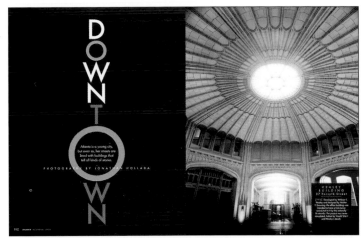

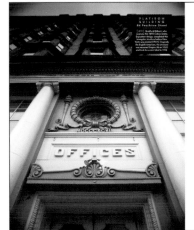

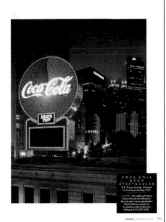

517

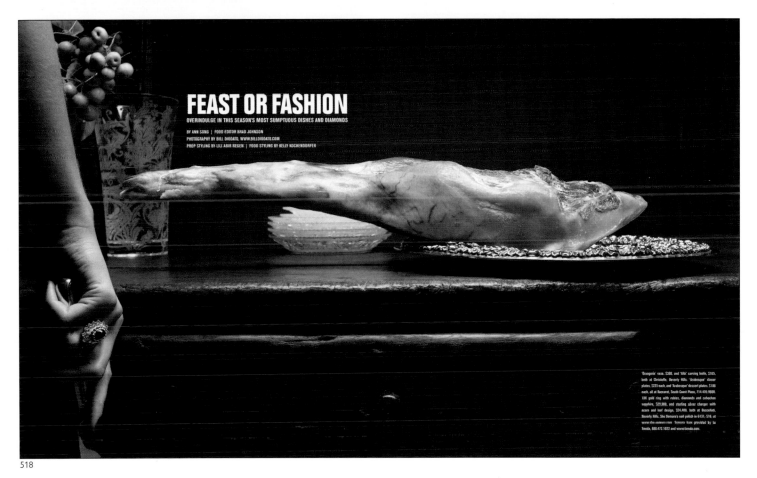

518

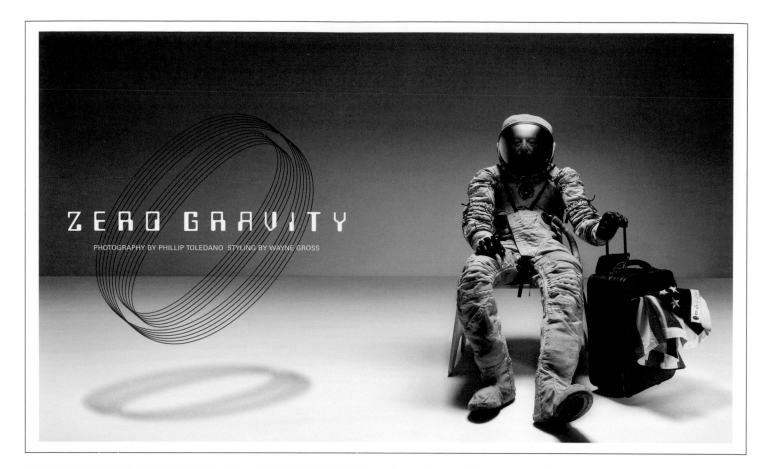

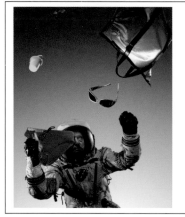
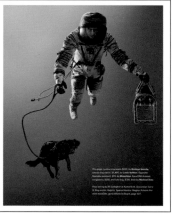
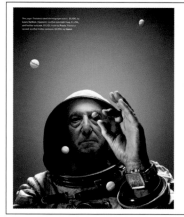
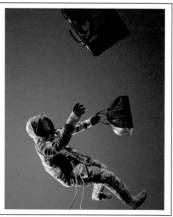

519 ✳ CITY MAGAZINE
Creative Director: Fabrice G. Frere / *Art Director:* Adriana Jacoud / *Director of Photography:* Piera Gelardi / *Photographer:* Phillip Toledano /
Publisher: City Publishing L.L.C. / *Issue:* October 2005 / *Category:* Photography Story

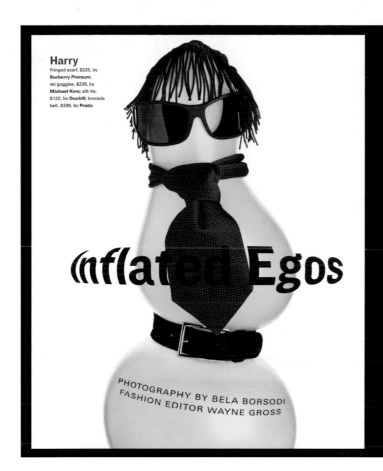

Harry
Fringed scarf, $225, by
Burberry Prorsum;
ski goggles, $235, by
Michael Kors; silk tie,
$120, by **Dunhill;** brocade
belt, $395, by **Prada.**

(nflated Egos

PHOTOGRAPHY BY BELA BORSODI
FASHION EDITOR WAYNE GROSS

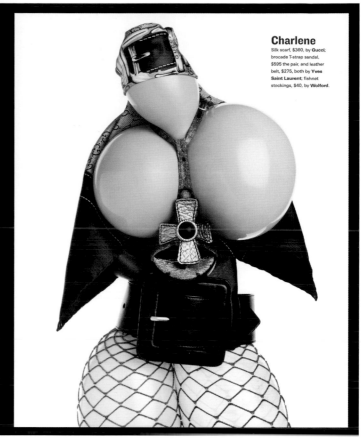

Charlene
Silk scarf, $360, by **Gucci;**
brocade T-strap sandal,
$595 the pair, and leather
belt, $275, both by **Yves
Saint Laurent;** fishnet
stockings, $40, by **Wolford.**

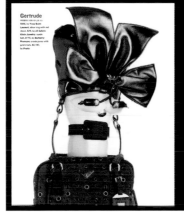

Gertrude

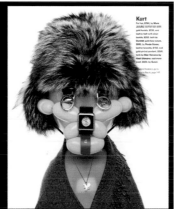

Kurt

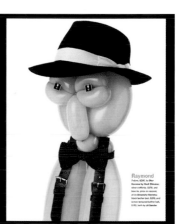

Elvira

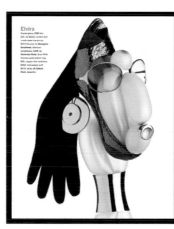

Raymond

520 ✳ CITY MAGAZINE
Creative Director: Fabrice G. Frere / *Art Director:* Adriana Jacoud / *Director of Photography:* Piera Gelardi / *Photographer:* Bela Borsodi /
Publisher: City Publishing L.L.C. / *Issue:* September 2005 / *Category:* Photography Story

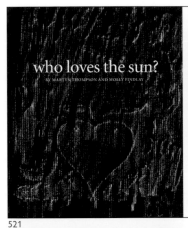
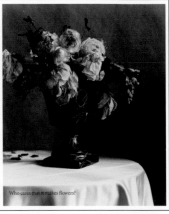
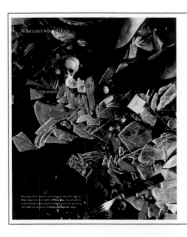
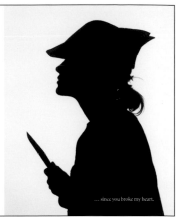

521

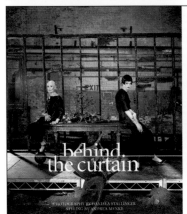
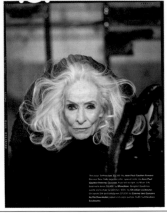
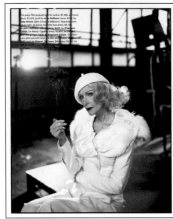
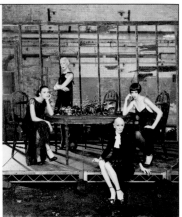

522

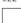
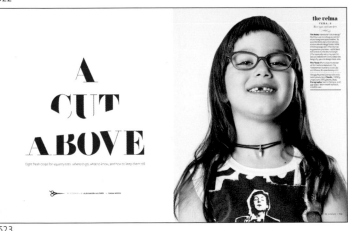
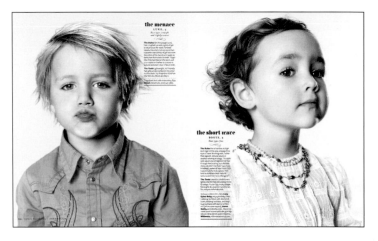

523

521 ✳ CITY MAGAZINE
Creative Director: Fabrice G. Frere / *Art Director:* Adriana Jacoud / *Director of Photography:* Piera Gelardi /
Photographer: Martyn Thompson / *Publisher:* City Publishing L.L.C. / *Issue:* Spring 2005 / *Category:* Photography Story

522 ✳ CITY MAGAZINE
Creative Director: Fabrice G. Frere / *Art Director:* Adriana Jacoud / *Director of Photography:* Piera Gelardi /
Photographer: Daniela Stallinger / *Publisher:* City Publishing L.L.C. / *Issue:* December 2005 / *Category:* Photography Story

523 ✳ COOKIE
Design Director: Kirby Rodriguez / *Art Director:* Alex Grossman / *Designers:* Nicolette Berthelot, Karla Lima /
Photo Editor: Yolanda Edwards / *Photographer:* Alexandra Klever / *Publisher:* Condé Nast Publications Inc. /
Issue: December 2005-January 2006 / *Category:* Photography Story

524 ✳ JEWELRY W
Creative Director: Dennis Freedman / *Design Director:* Edward Leida / *Art Director:* Nathalie Kirsheh /
Designers: Nathalie Kirsheh, Shanna Greenberg, Carmen Chan / *Photographer:* Andrew Bettles / *Publisher:* Fairchild Publications /
Issue: Fall 2005 / *Category:* Photography Story

525 ✳ FQ FASHION QUARTERLY
Creative Director: Michael King / *Art Director:* Bob Makinson / *Designer:* Abel Muñoz / *Photographer:* Geoffrey Barrenger /
Publisher: The Kontent Group / *Issue:* Fall 2005 / *Category:* Photography Story

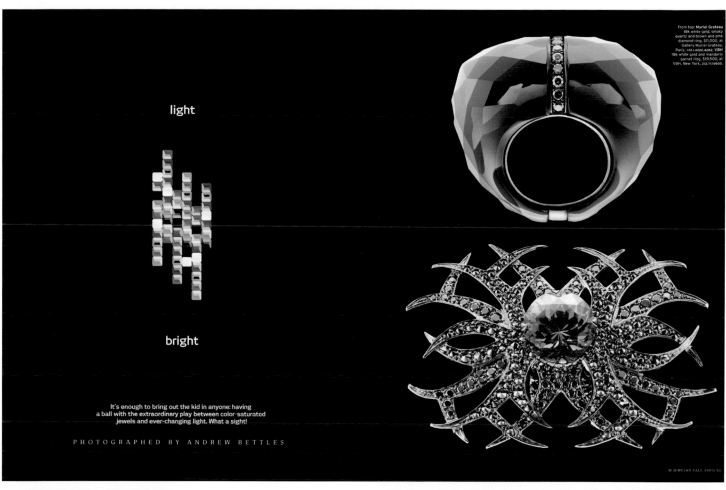

light

bright

It's enough to bring out the kid in anyone: having
a ball with the extraordinary play between color-saturated
jewels and ever-changing light. What a sight!

PHOTOGRAPHED BY ANDREW BETTLES

From top: **Muriel Grateau**
18k white gold, smoky
quartz and brown and pink
diamond ring, $11,000, at
Gallery Muriel Grateau,
Paris, +33.1.4020.4282; **VBH**
18k white gold and mandarin
garnet ring, $19,500, at
VBH, New York, 212.717.9800.

W JEWELRY FALL 2005| 91

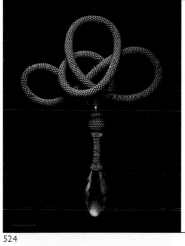

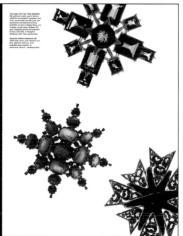

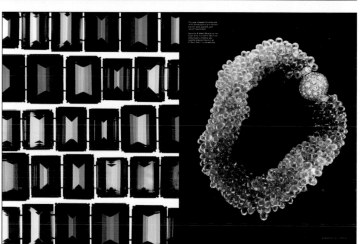

524

high
volume

Think big: this is wear a life bubble, skin by billowing sleeves
and billowing dresses guaranteed to make some noise

PHOTOGRAPHY BY GEOFFREY BARRENGER

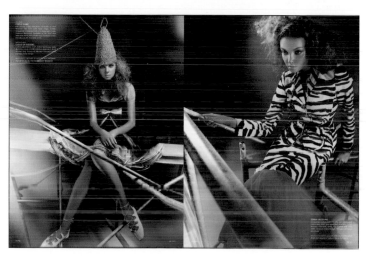

525

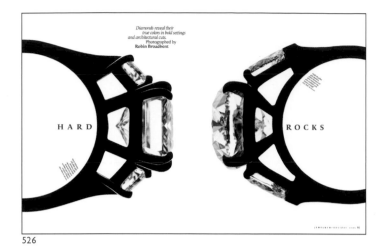

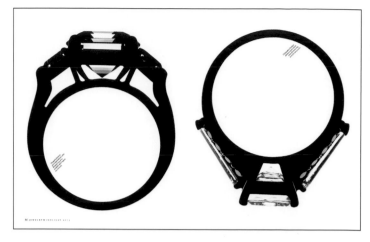

526

527

528

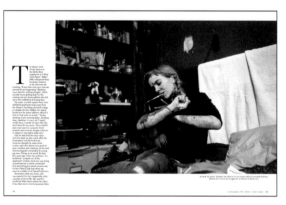

529

526 ✷ JEWELRY W
Creative Director: Dennis Freedman / *Design Director:* Edward Leida / *Art Director:* Nathalie Kirsheh / *Designers:* Nathalie Kirsheh, Shanna Greenberg, Carmen Chan / *Photo Editor:* Nadia Vellam / *Photographer:* Robin Broadbent / *Publisher:* Fairchild Publications / *Issue:* Holiday 2005 / *Category:* Photography Story

527 ✷ NEW YORK
Design Director: Luke Hayman / *Director of Photography:* Jody Quon / *Photo Editor:* Amy Hoppy / *Photographer:* Roger Deckker / *Publisher:* New York Magazine Holdings, LLC / *Issue:* December 19, 2005 / *Category:* Photography Story

528 ✷ NEW YORK
Design Director: Luke Hayman / *Director of Photography:* Jody Quon / *Photo Editor:* Leana Alagia / *Photographer:* Benjamin Lowy / *Publisher:* New York Magazine Holdings, LLC / *Issue:* April 4, 2005 / *Category:* Photography Story

529 ✷ NEW YORK
Design Director: Luke Hayman / *Director of Photography:* Jody Quon / *Photo Editor:* Amy Hoppy / *Photographer:* Jessica Dimmock / *Publisher:* New York Magazine Holdings, LLC / *Issue:* September 26, 2005 / *Category:* Photography Story

530 ✷ NEW YORK
Design Director: Luke Hayman / *Director of Photography:* Jody Quon / *Photo Editor:* Amy Hoppy / *Photographer:* Mitchell Feinberg / *Publisher:* New York Magazine Holdings, LLC / *Issue:* May 30, 2005 / *Category:* Photography Story

531 ✷ LOS ANGELES
Design Director: Joe Kimberling / *Designer:* Joe Kimberling / *Photo Editor:* Kathleen Clark / *Photographer:* Jill Greenberg / *Publisher:* Emmis / *Issue:* April 2005 / *Category:* Photography Story

532 ✷ LOS ANGELES
Design Director: Joe Kimberling / *Designer:* Joe Kimberling / *Photo Editor:* Kathleen Clark / *Photographer:* Dan Winters / *Publisher:* Emmis / *Issue:* February 2005 / *Category:* Photography Story

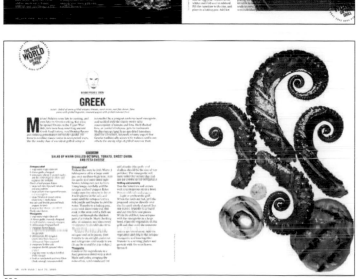

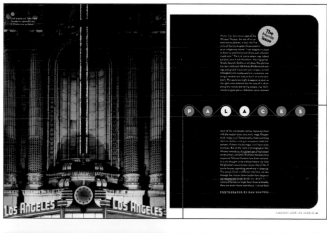

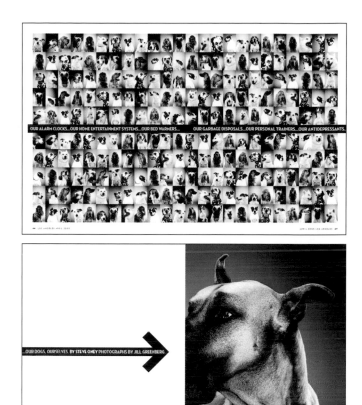

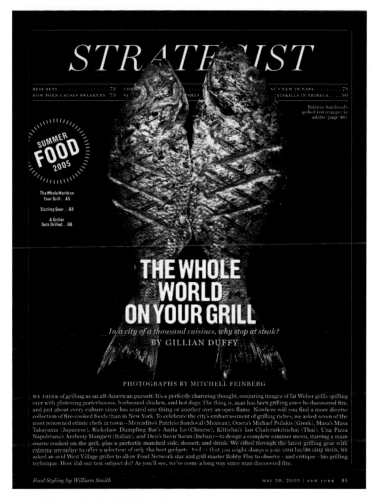

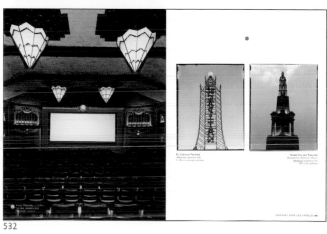

530

531

532

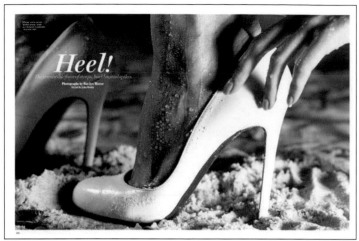

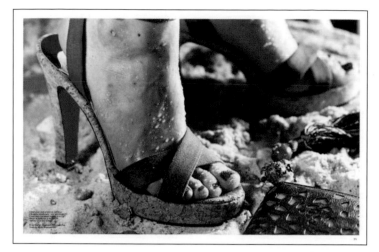

533

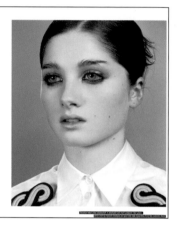

534

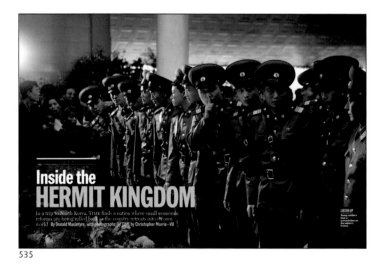

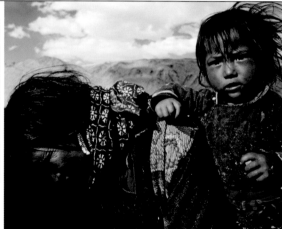

535

533 ✳ NEW YORK
Design Director: Luke Hayman / *Director of Photography:* Jody Quon / *Photographer:* Marilyn Minter / *Publisher:* New York Magazine Holdings, LLC / *Issue:* February 14, 2005 / *Category:* Photography Story

534 ✳ NYLON
Art Director: Andrea Fella / *Designer:* Andrea Fella / *Director of Photography:* Stacey Mark / *Photographer:* Alan Clarke / *Publisher:* Nylon LLC / *Issue:* April 2005 / *Category:* Photography Story

535 ✳ TIME ASIA
Art Director: Cecilia Wong / *Photo Editors:* Lisa Botos, Maria Wood / *Photographer:* Christopher Morris (VII) / *Publisher:* Time Inc. / *Issue:* October 31, 2005 / *Category:* Photography Story

536 ✳ SAN JOSE MERCURY NEWS
Designer: Jonathan Berlin / *Director of Photography:* Geri Migielicz / *Deputy Managing Editor:* Matt Mansfield / *Publisher:* Knight Ridder / *Issue:* September 4, 2005 / *Category:* Photography Story

537 ✳ TEXAS MONTHLY
Creative Director: Scott Dadich / *Art Director:* TJ Tucker / *Designers:* Scott Dadich, TJ Tucker / *Photo Editor:* Leslie Baldwin / *Photographer:* Roberto Guerra / *Publisher:* Emmis Communications Corp. / *Issue:* March 2005 / *Category:* Photography Story

| San Jose Mercury News |

SUNDAY, SEPT. 4, 2005 | SECTION AA

Hurricane Katrina
The week in pictures

NEW ORLEANS: These are the wrinkled hands of Shirley Ward, 40, who spent two days stranded and soaking in water on Rocheblave Street until she was rescued Tuesday.

'A lot of people had nowhere to go. So they stayed. And we have to get them out.'
— LOUISIANA NATIONAL GUARD CPL. JOHN JARREAU

| San Jose Mercury News |

SUNDAY, SEPT. 4, 2005 | SECTION AA

Hurricane Katrina
The week in pictures

PASCAGOULA, MISS.: An unidentified man helps a woman through the floodwaters Monday morning as the hurricane made landfall.

Under siege

The dire forecast of a killer storm proved all too accurate, and now Hurricane Katrina's victims battle to survive amid ruin

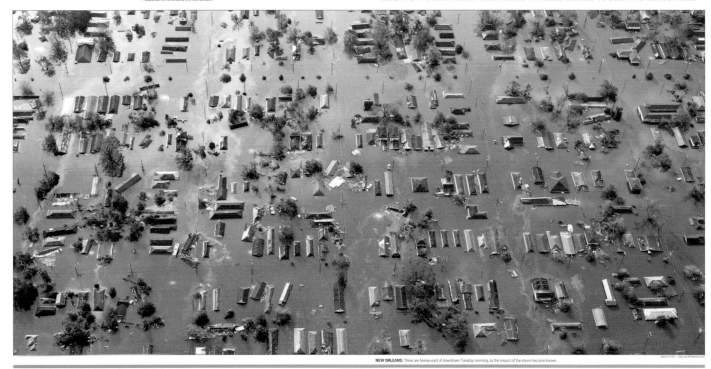

NEW ORLEANS: These are homes east of downtown Tuesday morning, as the impact of the storm became known.

536

inhumane society

(The deluge that went on for years at the San Antonio Animal Care Facility shouldn't happen to a dog. Or a cat.)

537

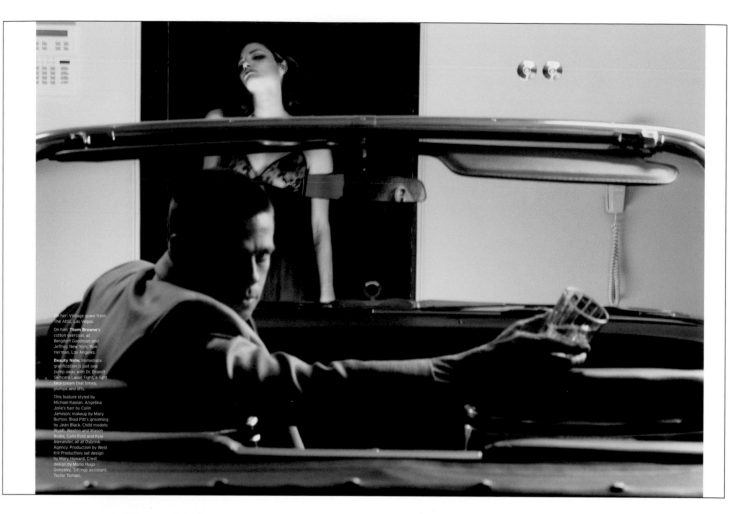

On her: Vintage gown from The Attic, Las Vegas.

On him: **Thom Browne**'s cotton overcoat, at Bergdorf Goodman and Jeffrey, New York; Ron Herman, Los Angeles.

Beauty Note: Immediate gratification is just one pump away with Dr. Brandt Skincare Laser Tight, a light face cream that tones, plumps and lifts.

This feature styled by Michael Kaplan. Angelina Jolie's hair by Colin Jamison; makeup by Mary Burton. Brad Pitt's grooming by Jean Black. Child models: Wyatt, Weston and Mason Bodie, Colin Ford and Kyle Alexander, all at Osbrink Agency. Production by West Kill Production; set design by Mario Howard, Crest design by Mario Hugo Gonzalez. Sittings assistant: Taylor Tomasi.

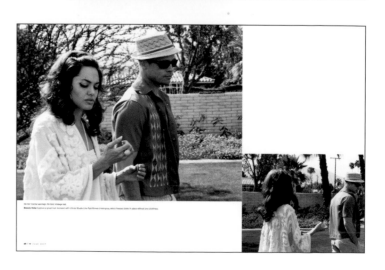

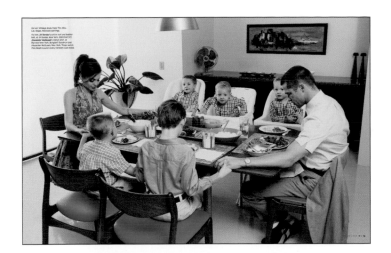

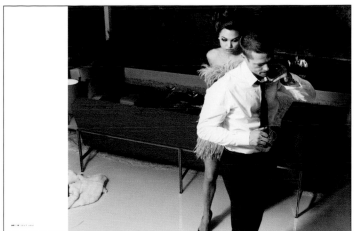

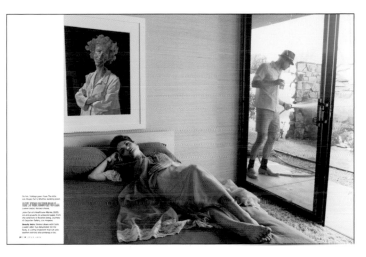

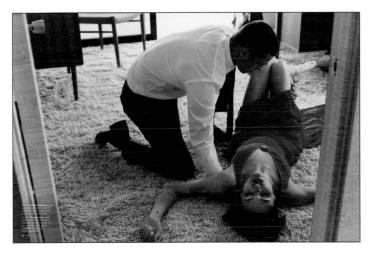

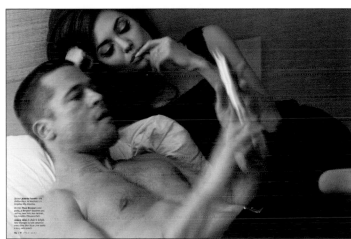

538 ✳ W
Creative Director: Dennis Freedman / *Design Director:* Edward Leida / *Designers:* Shanna Greenberg, Carmen Chan /
Photographer: Steven Klein / *Publisher:* Fairchild Publications / *Issue:* July 2005 / *Category:* Photography Story

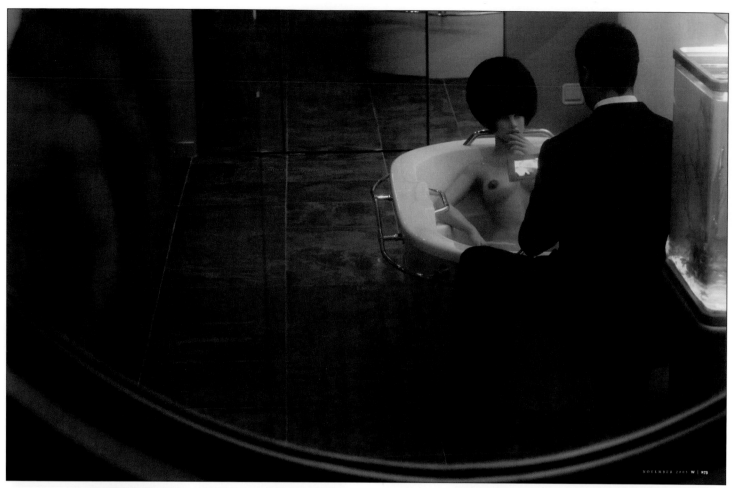

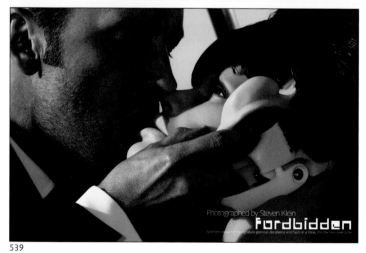

Photographed by Steven Klein

forbidden

539

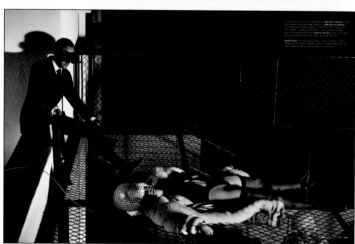

bewitched

540

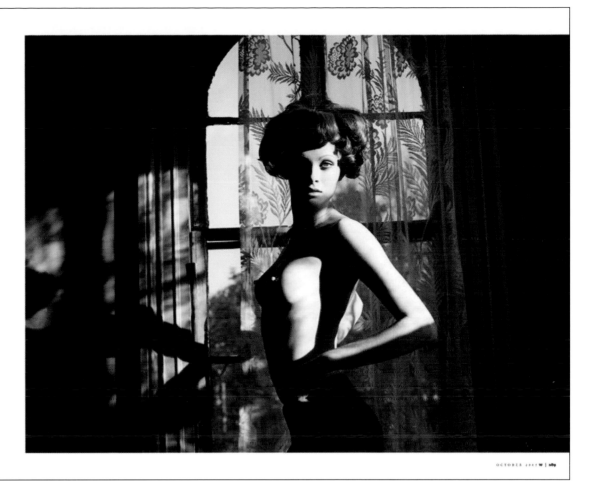

541

539 ✳ W
Creative Director: Dennis Freedman / *Design Director:* Edward Leida / *Art Director:* Nathalie Kirsheh / *Designers:* Edward Leida, Shanna Greenberg /
Photographer: Steven Klein / *Publisher:* Fairchild Publications / *Issue:* November 2005 / *Category:* Photography Story

540 ✳ W
Creative Director: Dennis Freedman / *Design Director:* Edward Leida / *Art Director:* Nathalie Kirsheh / *Designers:* Edward Leida, Shanna Greenberg /
Photographer: Paolo Roversi / *Publisher:* Fairchild Publications / *Issue:* December 2005 / *Category:* Photography Story

541 ✳ W
Creative Director: Dennis Freedman / *Design Director:* Edward Leida / *Art Director:* Nathalie Kirsheh / *Designers:* Edward Leida, Nathalie Kirsheh,
Shanna Greenberg / *Photographers:* Mert Atlas, Marcus Piggott / *Publisher:* Fairchild Publications / *Issue:* October 2005 / *Category:* Photography Story

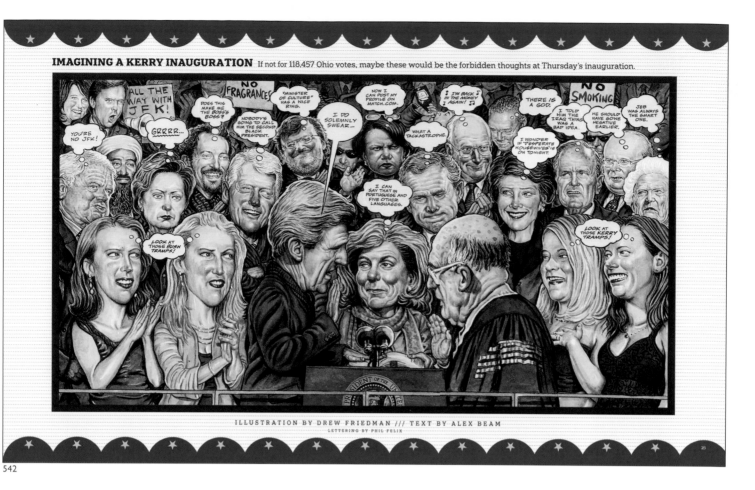

IMAGINING A KERRY INAUGURATION If not for 118,457 Ohio votes, maybe these would be the forbidden thoughts at Thursday's inauguration.

ILLUSTRATION BY DREW FRIEDMAN /// TEXT BY ALEX BEAM
LETTERING BY PHIL FELIX

542

the**Arts**

FILM

Beyond The Pale

The dirtiest joke ever told is the star of the documentary *The Aristocrats* by Steve Erickson

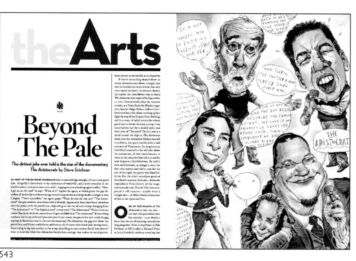

543

the**Arts**

FILM

American Innocent

Johnny Depp is the man of our dreams by Steve Erickson

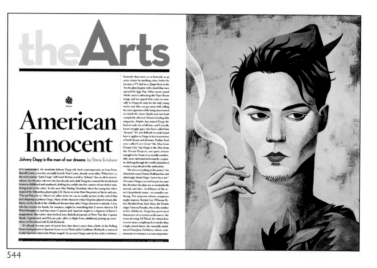

544

THE MOVIE ISSUE

Woise Guys

Painting your tongue is never a good idea. Same with falling down stairs or poking your fingers in a friend's eyes. But that was the genius of the Three Stooges, and with the farrelly brothers making a Stooges film, their slapstick is enjoying a revival that has men, and women, nyuk-nyukking all over.

BY CHARLES P. PIERCE
ILLUSTRATION BY PABLO

545

Exaltation

fiction by Sarah Stonich

546

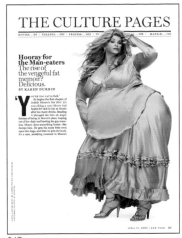

547

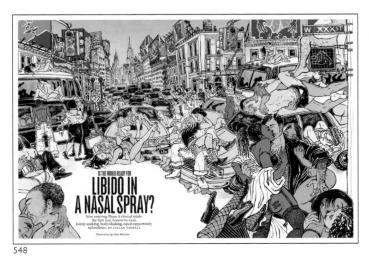

548

549

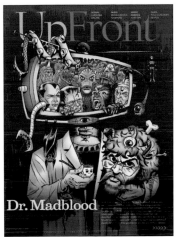

550

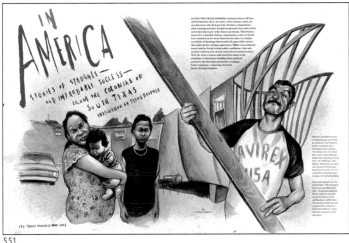

551

552

542 ✳ THE BOSTON GLOBE MAGAZINE
Design Director: Dan Zedek / *Art Director:* Brendan Stephens / *Designer:* Brendan Stephens /
Illustrator: Drew Friedman / *Publisher:* The New York Times Co. / *Issue:* January 16, 2005 /
Category: Illustration Spread-Single Page

543 ✳ LOS ANGELES
Design Director: Joe Kimberling / *Art Director:* Lisa M. Lewis / *Illustrator:* John Cuneo /
Publisher: Emmis / *Issue:* June 2005 / *Category:* Illustration Spread-Single Page

544 ✳ LOS ANGELES
Design Director: Joe Kimberling / *Art Director:* Lisa M. Lewis / *Illustrator:* Jody Hewgill / *Publisher:*
Emmis / *Issue:* January 2005 / *Category:* Illustration Spread-Single Page

545 ✳ THE BOSTON GLOBE MAGAZINE
Design Director: Dan Zedek / *Art Director:* Brendan Stephens / *Designer:* Brendan Stephens /
Illustrator: Pablo / *Publisher:* The New York Times Co. / *Issue:* February 27, 2005 / *Category:*
Illustration Spread-Single Page

546 ✳ MINNESOTA MONTHLY
Art Director: Brian Johnson / *Illustrator:* Brad Holland / *Photographer:* Photos.com / *Publisher:*
Greenspring Media Group / *Issue:* March 2005 / *Category:* Illustration Spread-Single Page

547 ✳ NEW YORK
Design Director: Luke Hayman / *Art Director:* Chris Dixon / *Designer:* Steve Motzenbecker /
Illustrator: Joe Darrow / *Director of Photography:* Jody Quon / *Photo Editor:* Amy Hoppy /
Publisher: New York Magazine Holdings, LLC / *Issue:* April 11, 2005 / *Category:* Photography
Illustration Story/Spread-Single Page

548 ✳ NEW YORK
Design Director: Luke Hayman / *Designer:* Kate Elazegui / *Illustrator:* Yuko Shimizu / *Director of
Photography:* Jody Quon / *Publisher:* New York Magazine Holdings, LLC / *Issue:* November 21,
2005 / *Category:* Illustration Spread-Single Page

549 ✳ REPORT ON BUSINESS
Art Director: Domenic Macri / *Illustrator:* Andrew Zbihlyj / *Photo Editor:* Clare Vander Meersch /
Publisher: The Globe and Mail / *Issue:* November 2005 / *Category:* Illustration Story

550 ✳ VIRGINIA LIVING
Art Director: Tyler Darden / *Illustrator:* Kelly Alder / *Publisher:* Cape Fear Publishing / *Issue:*
October 2005 / *Category:* Illustration Spread-Single Page

551 ✳ TEXAS MONTHLY
Creative Director: Scott Dadich / *Art Director:* TJ Tucker / *Designers:* Scott Dadich, TJ Tucker /
Illustrator: Steve Brodner / *Publisher:* Emmis Communications Corp. / *Issue:* May 2005 /
Category: Illustration Story

552 ✳ REPORT ON BUSINESS
Art Director: Domenic Macri / *Photo Editor:* Clare Vander Meersh / *Photographer:* Dave
Robertson / *Publisher:* The Globe and Mail / *Issue:* November 2005 / *Category:* Design Cover

MERIT

NON-NEWSSTAND

PUBLICATION

553

554

555

556

557

558

553 ✱ BASELINE

Design Director: Nicole White / *Art Director:* Victor Williams / *Designers:* Nicole White, Victor Williams / *Photographer:* Jill Greenberg / *Publisher:* Ziff Davis Media / *Issue:* August 2005 / *Category:* Design Cover

554 ✱ GOVERNING MAGAZINE

Design Director: Jandos Rothstein / *Art Director:* Bonnie Becker / *Illustrator:* Christoph Niemann / *Issue:* December 2005 / *Category:* Design Cover

555 ✱ PCMA CONVENE

Creative Director: Mitch Shostak / *Art Director:* Roger Greiner / *Illustrator:* Peter Hoey / *Studio:* Shostak Studios / *Publisher:* PCMA / *Client:* PCMA / *Issue:* March 2005 / *Category:* Design Cover

556 ✱ PEOPLE HOLLYWOOD DAILY

Creative Director: Rina Migliaccio / *Art Director:* Greg Monfries / *Designer:* Gloria Bang / *Photo Editors:* Christine Ramage, Lindsay Tyler / *Digital Imaging:* Omar Martinez / *Publisher:* Time Inc. / *Issue:* September 16, 2005 / *Category:* Design Cover

557 ✱ ARCCA

Design Director: Bob Aufuldish / *Designer:* Ragina Johnson / *Studio:* Aufuldish & Warinner / *Publisher:* McGraw-Hill-AIACC / *Client:* American Institute of Architects California Council / *Issue:* 2005-3 / *Category:* Design Entire Issue

558 ✱ TRADER MONTHLY

Design Director: 1 Plus 1 Design / *Art Director:* Clare Minges / *Photo Editors:* Stacey Pleasant, Della Desai / *Publisher:* Doubledown Media / *Issue:* October-November 2005 / *Category:* Design Entire Issue

559

560

559 ✳ C F O

Design Director: Robert Lesser / *Art Director:* Jenna Talbott / *Illustrator:* Tim Bower / *Photo Editor:* Carol Lieb / *Photographers:* Robert Houser, Nick Cardillicchio /
Studio: David Armario Design / *Publisher:* CFO Publishing Corp / *Issue:* October 2005 / *Category:* Design Redesign

560 ✳ INSIDE COUNSEL

Creative Directors: Kelly McMurray, Chris St. Cyr / *Art Director:* Rich Cole / *Illustrator:* Joseph Daniel Fiedler / *Photographers:* John Payne, Chris Lake /
Studio: 2 Communiqué / *Publisher:* Wicks Business Information / *Client:* Inside Counsel / *Issue:* December 2005-January 2006 / *Category:* Design Redesign

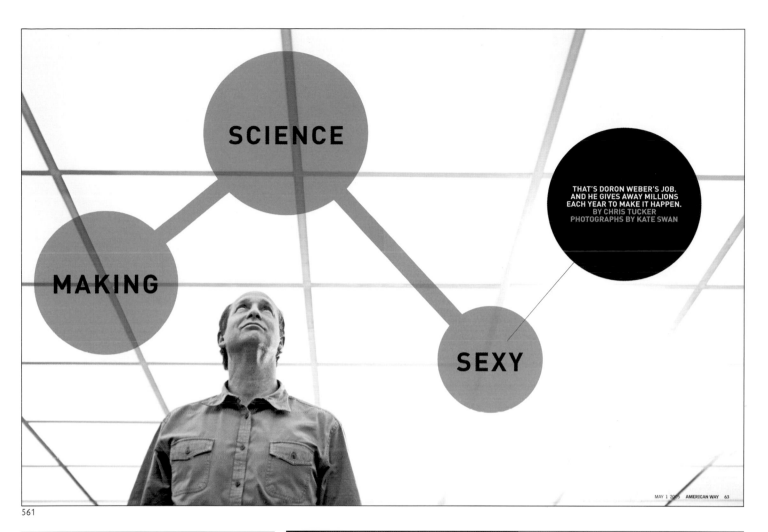

561

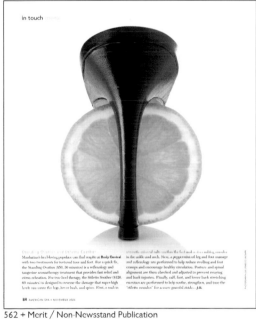

562 + Merit / Non-Newsstand Publication
 (Design Contents / Departments)

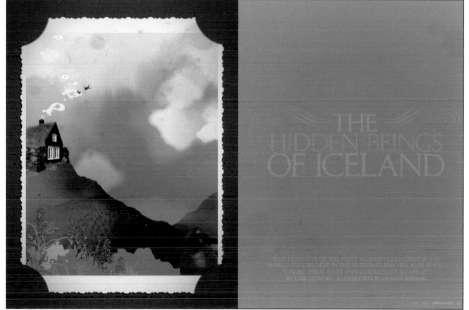

563

561 ✳ AMERICAN WAY
Design Director: J.R. Arebalo, Jr. / *Designer:* Samuel Solomon / *Photographer:* Kate Swan / *Publisher:* American Airlines Publishing /
Issue: May 1, 2005 / *Category:* Design Spread-Single Page

562 ✳ AMERICAN SPA
Design Director: Deena Goldblatt / *Associate Art Director:* Victor Maze / *Photographer:* Luis Ernesto Santana / *Publisher:* Questex Media /
Issue: November 2005 / *Category:* Photography Contents & Departments

563 ✳ AMERICAN WAY
Design Director: J.R. Arebalo, Jr. / *Designer:* Carrie Olivier / *Illustrator:* Oksana Badrak / *Publisher:* American Airlines Publishing /
Issue: July 1, 2005 / *Category:* Design Spread-Single Page

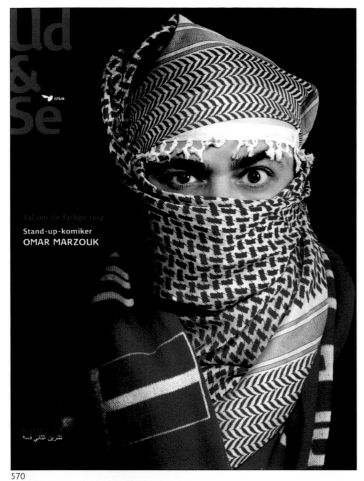

570

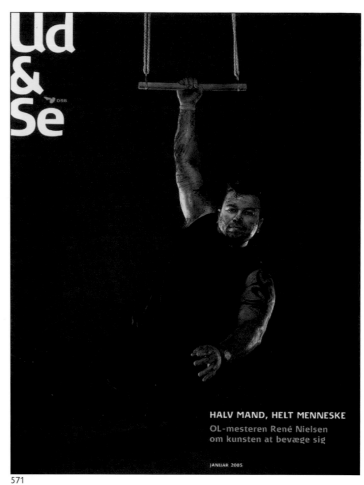

571

572

570 ✳ UD & SE
Art Director: Katinka Bukh / *Director of Photography:* Katinka Bukh /
Photographer: Nicky Bonne / *Publisher:* DSB / *Issue:* November 2005 /
Category: Photography Cover

571 ✳ UD & SE
Art Director: Katinka Bukh / *Director of Photography:* Katinka Bukh /
Photographer: Per Morten Abrahamsen / *Publisher:* DSB / *Issue:* January 2005 /
Category: Photography Cover

572 ✳ PROTO
Creative Director: Charlene Benson / *Design Director:* Alex Knowlton /
Art Director: Amanda Spielman / *Designer:* Amanda Spielman /
Director of Photography: Julie Claire / *Photo Editor:* Ann DeSaussure /
Photographer: Dimas Ardian (Getty) / *Studio:* Time Inc. Strategic
Communications / *Publisher:* Time Inc. Strategic Communications /
Client: Proto / *Issue:* Fall 2005 / *Category:* Design Cover

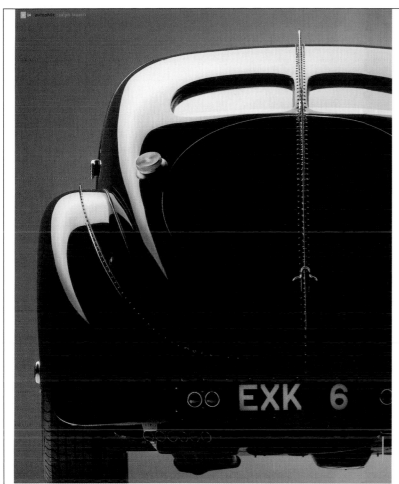

RALPH LAUREN'S IMPECCABLE, TIMELESS SENSE OF STYLE EXTENDS FAR BEYOND FASHION.
Since 1978, he has been assembling one of the world's finest collections of European automobiles—from a 1929 Blower Bentley to a 1996 McLaren F1. Earlier this year, the American public caught a glimpse of 16 of these feats of perfect design and engineering at Boston's Museum of Fine Arts. Individually, their exquisite details conspire to thrill the senses; together, they tell a compelling story. These cars probably have no greater admirer than Jay Leno—who has the daily chore of choosing from 80 or so classic cars to drive to work as host of NBC's *The Tonight Show*. Here, he waxes passionate on Lauren's beautiful machines.

KINETIC SCULPTURE

TEXT :: JAY LENO
PHOTOS :: MICHAEL FURMAN

The 1938 Bugatti Type 57SC Atlantic Coupe combines the masculine and the feminine: an extremely powerful engine inside a sensuous body.

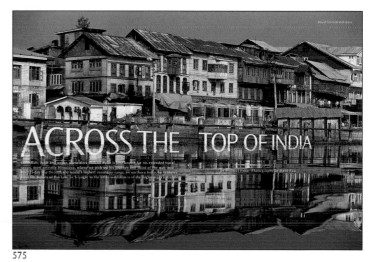

573

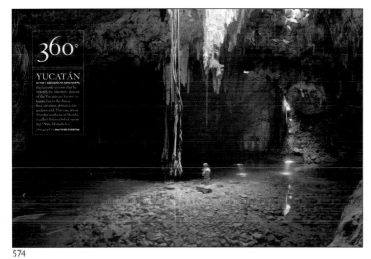

574

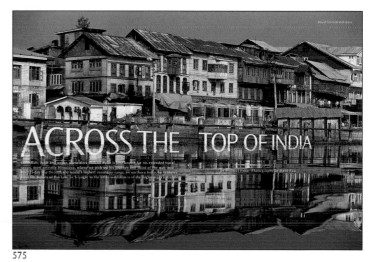

575

573 ✳ DIALOGUE
Creative Director: Charlene Benson / *Design Director:* Chris Teoh / *Photo Editor:* Bess Hauser / *Photographer:* Michael Furman /
Studio: Time Inc. Strategic Communications / *Publisher:* Time Inc. Strategic Communications / *Client:* Metaldyne / *Issue:* Volume 2, Issue: 1 /
Category: Design Spread-Single Page

574 ✳ ENDLESS VACATIONS
Creative Director: Dwayne Flinchum / *Design Director:* Lori Ende / *Art Director:* John Baxter / *Designers:* Lori Ende, Piper Grimsrud /
Photo Editor: Mary Risher / *Photographer:* Macduff Everton / *Studio:* Iridium Group / *Publisher:* Resort Condominiums International /
Client: Endless Vacations / *Issue:* May-June 2005 / *Category:* Design Spread-Single Page

575 ✳ SAWASDEE
Creative Director: Davide Butson / *Art Director:* Teresita Khaw / *Director of Photography:* Maryse Vassalo / *Photo Editor:* Pam Cheung /
Photographer: Basil Pao / *Studio:* Emphasis Media Limited / *Publisher:* Emphasis Media Ltd. / *Client:* Thai Airways International /
Issue: September 2005 / *Category:* Design Spread-Single Page

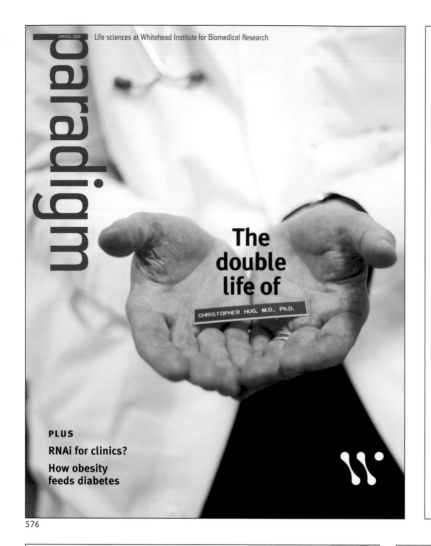

576

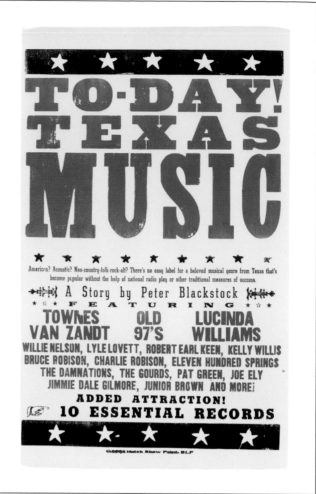

577

578

576 ✳ PARADIGM

Design Director: Eric Mongeon / *Designer:* Eric Mongeon / *Photographer:* Kathleen
Dooher / *Studio:* Red Five Studio / *Publisher:* Whitehead Institute for Biomedical
Research / *Client:* Whitehead Institute for Biomedical Research / *Issue:* Spring 2005 /
Category: Design Cover

577 ✳ BLOOMBERG MARKETS MAGAZINE

Art Director: Carol Macrini / *Illustrator:* Philip Burke / *Photo Editor:* Eric Godwin /
Associate Art Director: John Genzo / *Publisher:* Bloomberg L.P. / *Issue:* April 2005 /
Category: Illustration Spread-Single Page

578 ✳ ATTACHÉ MAGAZINE

Art Director: Holly Holliday / *Photographer:* Serge Bloch / *Publisher:* Pace
Communciations, Inc. / *Issue:* April 2005 / *Category:* Illustration Spread-Single Page

579

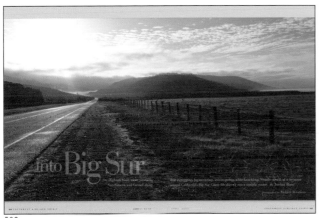

580

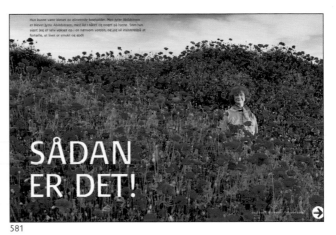

581

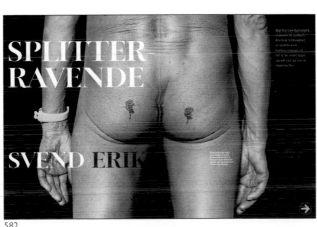

582

579 ✳ SOUTHWEST AIRLINES SPIRIT
Design Director: Chris Philpot / *Art Director:* Korena Bolding / *Designer:* Korena Bolding /
Illustrator: Hatch Show Print / *Publisher:* American Airlines Publishing / *Client:* Southwest Airlines /
Issue: January 2005 / *Category:* Design Spread-Single Page

580 ✳ SOUTHWEST AIRLINES SPIRIT
Design Director: Chris Philpot / *Art Director:* Dianne Bianchi / *Designer:* Dianne Bianchi /
Illustrator: Shonagh Rae / *Publisher:* American Airlines Publishing / *Client:* Southwest Airlines /
Issue: August 2005 / *Category:* Design Spread-Single Page

581 ✳ UD & SE
Art Director: Katinka Bukh / *Director of Photography:* Katinka Bukh / *Photographer:* Nicky Bonne /
Publisher: DSB / *Issue:* August 2005 / *Category:* Design Spread-Single Page

582 ✳ UD & SE
Art Director: Katinka Bukh / *Director of Photography:* Katinka Bukh / *Photographer:* Nicky Bonne /
Publisher: DSB / *Issue:* November 2005 / *Category:* Design Spread-Single Page

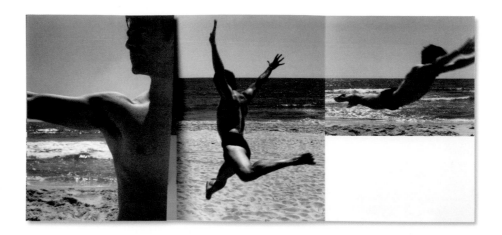

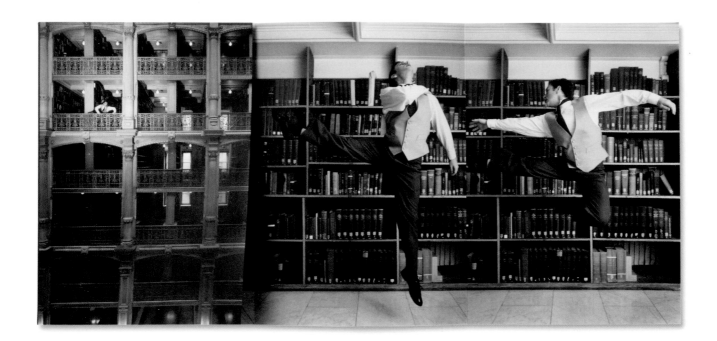

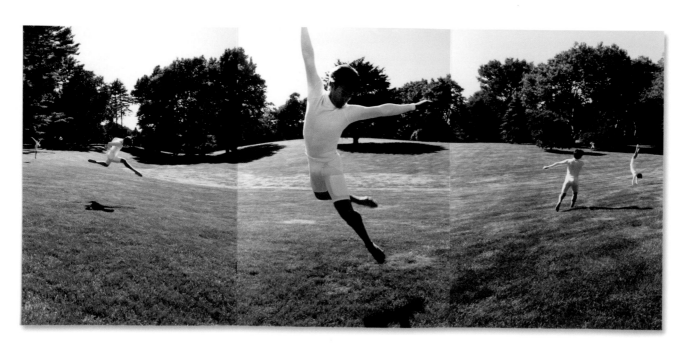

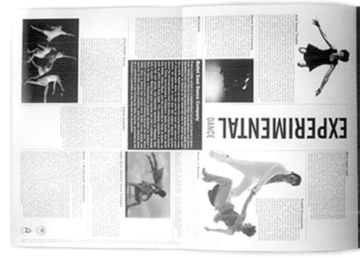

584

583 ✳ 2 WICE
Art Director: Abbott Miller / *Designers:* Abbott Miller, Jeremy Hoffman / *Photographers:* Christian Witkin, Baerbel Schmidt,
Jens Umbach, Philip Toledano / *Studio:* Pentagram Design, Inc. / *Publisher:* 2wice Arts Foundation / *Client:* 2wice Arts Foundation /
Issue: April 2005 / *Category:* Design Entire Issue

584 ✳ AUSTIN ARTS
Creative Director: DJ Stout / *Designers:* Julie Savasky, Erin Mayes, Drue Wagner / *Studio:* Pentagram Design, Inc. /
Client: Austin Arts / *Issue:* 2005 / *Category:* Design Entire Issue

Since Circular 12 my colleagues and I on the Typographic Circle committee have staged a series of great lectures, some of which are featured in this edition. Bringing these lectures to our valued members and followers on occasion presented some real challenges. The night that NoOne spoke, they triumphed over a blizzard and transport meltdown and the night when Fiona Ross' audience arrived to discover that the venue had closed without warning. Incidentally, both talks were extremely well attended and successful, which says something about the determination of typo types in the face of great difficulties.

Everyones' hard work under my chairmanship is starting to bear fruit. Our membership continues to grow, our lectures are always well attended. Thanks to links with other, similar organisations, we can bring the Typographic Circle to our members away from London at The Circle Club in Manchester and Long Lunch in Scotland. Since Circular 12 we have managed to maintain the diversity of subjects, from more eclectic themes like non-Latin type to the quite inspirational work of Brian Webb.

Two events, though, I do hope to make a fixture in our calendar. The Type Directors Club exhibition and our summer party. Both of which are part of my mission to make the Typographic Circle a social organisation. It is for this reason that the Typographic Circle and the Friends of St. Bride's hold a monthly social event, '3rd Tuesday', at the Punch Tavern on Fleet Street. There are no lectures on '3rd Tuesday' but there are plenty of opportunities to discuss typography and voice opinions. It is a forum where experiences can be exchanged and friendships forged.

In 2004 we've had some changes to our committee. John Belknap of Belknap & Co. and Ian Chilvers of Atelier Works both joined our team. They bring with them a tremendous amount of experience which will benefit the Circle. Already they have made an impact. On a sadder note, Domenic Lippa of Lippa Pearce has decided to step down from the committee. He agreed, though, to give his assistance on designing Circular. For Domenic's hard work revising the Typographic Circle as my predecessor and his readiness to argue with me over the typographic merit of lectures I am hugely grateful.

The Typographic Circle is a continually changing beast. And so it should be. The Circle tries to challenge established perception, not by being grungy or radical, but by showing that there is typography beyond Helvetica. It is important to me to show people that type and typography are one of the fundamental elements in design, as much as oxygen is to the air we breathe. But the committee can only do so much. We can provide exciting lectures, we can design beautiful Circulars which are merited at the D&AD, but if our members don't support us it's all in vain. Please continue your memberships, they are the lifeblood of the Circle and provide us with much needed funds. Please carry on attending the lectures because they will show you something that you may not have seen otherwise.

Bruno Maag **Chairman**

_03

585 ✳ CIRCULAR ISSUE: 13

Creative Director: Domenic Lippa / *Art Director:* Domenic Lippa / *Designers:* Domenic Lippa, Bruno Maag, James Alexander, Sally Anne Theodosiou / *Studio:* Lippa Pearce Design / *Publisher:* The Typographic Circle / *Client:* The Typographic Circle / *Issue:* March 2005 / *Category:* Design Entire Issue

586

587

588

589

586 ✳ APP JAPAN+
Creative Director: Hisashi Kondo / *Art Director:* Kevin Foley / *Designer:* Kevin Foley /
Photo Editor: Tadahiro Ohkoshi / *Photographer:* Tadashi Okochi / *Studio:* KF Design /
Publisher: Jiji Gaho Sha, Inc. / *Client:* Jiji Gaho Sha, Inc. / *Issue:* August 2005 /
Category: Design Spread-Single Page

587 ✳ APP JAPAN+
Art Director: Kevin Foley / *Designer:* Kevin Foley / *Photo Editor:* Hisashi Kondo /
Photographer: Hiroshi Ohashi / *Studio:* KF Design / *Publisher:* Jiji Gaho Sha, Inc. /
Client: Jiji Gaho Sha, Inc. / *Issue:* August 2005 / *Category:* Design Spread-Single Page

588 ✳ UCLA MAGAZINE
Creative Directors: Charles Hess, Kim Baer / *Designers:* Allison Bloss, Susan Landesmann,
Ursula Ruthfuss / *Illustrators:* Jeffrey Decoster, Scott Menchin, Ken Orvidas / *Photo Editor:*
Charles Hess / *Studio:* Chess Design & KBDA / *Publisher:* UCLA / *Online Address:*
www.uclamag.edu / *Issue:* Winter 2005 / *Category:* Design Entire Issue

589 ✳ LEARNING THE HEALER'S ART
Art Director: Justin Styler / *Designer:* Justin Styler / *Studio:* BYU Publications and Graphics /
Publisher: BYU Publications & Graphics / *Client:* BYU College of Nursing / *Issue:* 2005 /
Category: Design Contents & Departments

590

591

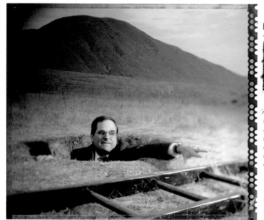

592

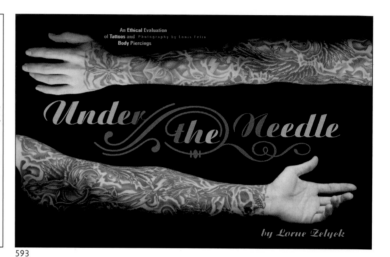

593

590 ✳ CHRISTIAN RESEARCH JOURNAL
Art Director: Dwayne Cogdill / *Designer:* Dwayne Cogdill / *Photographer:*
Louis Felix / *Studio:* Cognition Design / *Publisher:* Christian Research Institute /
Client: Christian Research Institute / *Issue:* Volume 28, No. 6 / *Category:*
Design Spread-Single Page

591 ✳ MARRIOTT ALUMNI MAGAZINE
Art Director: Jon Woidka / *Designer:* Jon Woidka / *Photo Editor:* Rory
Robinson / *Photographer:* Bradley Slade / *Studio:* BYU Publications &
Graphics / *Publisher:* Brigham Young University / *Issue:* Fall 2005 /
Category: Design Spread-Single Page

592 ✳ CLARK MEMORANDUM
Art Director: David Eliason / *Designer:* David Eliason / *Photographer:* Bradley
Slade / *Studio:* BYU Publications & Graphics / *Publisher:* Brigham Young
University / *Client:* J. Reuben Clark Law School / *Issue:* Fall 2005 / *Category:*
Design Spread-Single Page

593 ✳ CLARK MEMORANDUM
Art Director: David Eliason / *Designer:* David Eliason / *Illustrator:* Guy Billout /
Studio: BYU Publications & Graphics / *Publisher:* Brigham Young University /
Client: J. Reuben Clark Law School / *Issue:* Spring 2005 / *Category:* Design
Spread-Single Page

594 ✳ BOYS' LIFE
Art Director: Scott Feaster / *Designer:* Scott Feaster / *Director of Photography:*
John R. Fulton Jr. / *Photographer:* Christopher I. McGrail / *Publisher:* Boy
Scouts of America / *Issue:* January 2005 / *Category:* Design Spread-Single Page

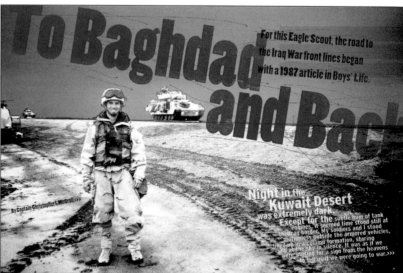

594

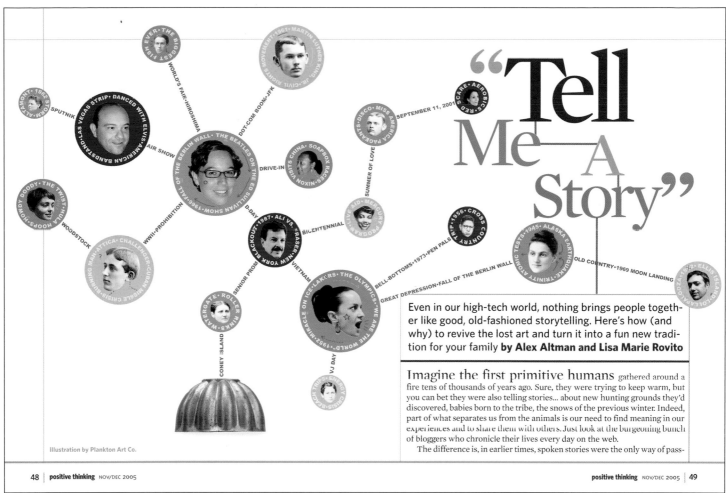

"Tell Me A Story"

Even in our high-tech world, nothing brings people together like good, old-fashioned storytelling. Here's how (and why) to revive the lost art and turn it into a fun new tradition for your family **by Alex Altman and Lisa Marie Rovito**

Imagine the first primitive humans gathered around a fire tens of thousands of years ago. Sure, they were trying to keep warm, but you can bet they were also telling stories... about new hunting grounds they'd discovered, babies born to the tribe, the snows of the previous winter. Indeed, part of what separates us from the animals is our need to find meaning in our experiences and to share them with others. Just look at the burgeoning bunch of bloggers who chronicle their lives every day on the web.

The difference is, in earlier times, spoken stories were the only way of pass-

Illustration by Plankton Art Co.

48 | positive thinking NOV/DEC 2005

positive thinking NOV/DEC 2005 | 49

595

596

597

595 ✳ POSITIVE THINKING
Design Director: Francesca Messina / *Art Director:* Brendan Moran / *Designer:* Glen Karpowich / *Illustrator:* Plankton Art Co. /
Publisher: Guideposts Publishing / *Issue:* November-December 2005 / *Category:* Design Spread-Single Page

596 ✳ ONEARTH MAGAZINE
Art Director: Gail Ghezzi / *Designer:* Gail Ghezzi / *Photo Editor:* Gail Henry / *Publisher:* NRDC / *Issue:* Winter 2005 /
Category: Design Spread-Single Page

597 ✳ REGIONAL REVIEW
Design Director: Ronn Campisi / *Art Director:* Ronn Campisi / *Director of Photography:* Alicia Jylkka / *Photographer:* Debra McClinton /
Studio: Ronn Campisi Design / *Publisher:* Federal Reserve Bank / *Issue:* Q1 2005 / *Category:* Design Spread-Single Page

598

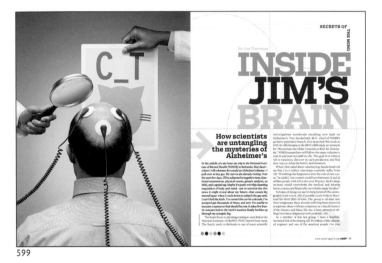

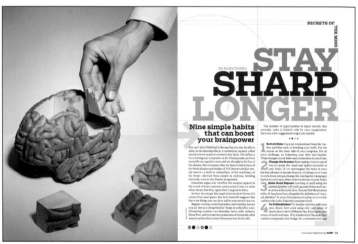

599

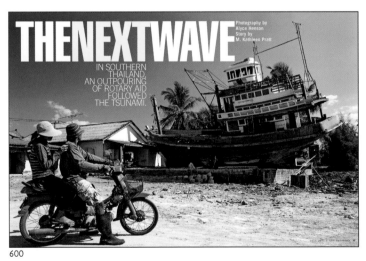

600 601

598 ✳ STANFORD MAGAZINE
Creative Director: Bambi Nicklen / *Art Director:* Amy Shroads / *Designer:* Amy Shroads / *Photographer:* Glenn Matsumura /
Publisher: Stanford Alumni Association / *Issue:* January-February 2005 / *Category:* Design Story

599 ✳ AARP THE MAGAZINE
Design Director: Courtney Murphy / *Deputy Art Director:* Alanna Jacobs / *Designer:* Courtney Murphy / *Director of Photography:* Jessica Day /
Photographer: Mark Hooper / *Publisher:* AARP Publications / *Issue:* September-October 2005 / *Category:* Photography Story

600 ✳ THE ROTARIAN
Creative Director: Deborah A. Lawrence / *Designer:* Deborah A. Lawrence / *Photographer:* Alyce Henson / *Publisher:* Rotary International /
Issue: July 2005 / *Category:* Design Spread-Single Page

601 ✳ ROUGH MAGAZINE
Creative Director: Miler Hung / *Designer:* Miler Hung / *Studio:* Peterson Ray & Company / *Publisher:* DSVC / *Client:* DSVC /
Issue: February 2005 / *Category:* Design Spread-Single Page

602

603

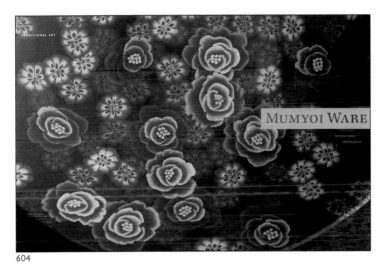

604

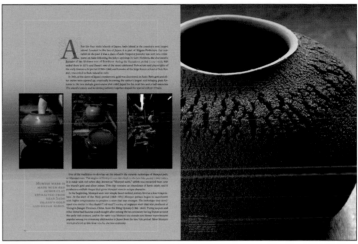

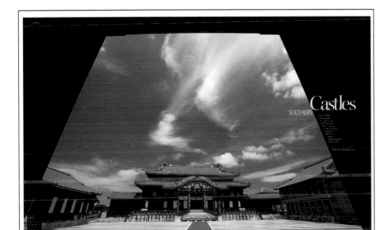

605

602 ✳ DAY JOB
Creative Director: James Nixon / *Photographer:* Edward Gajdel / *Publisher:* Day Job Industries / *Issue:* Spring 2005 / *Category:* Design Cover

603 ✳ SPORTS ILLUSTRATED ON CAMPUS
Art Director: Neil Jamieson / *Photo Editor:* Marguerite Schropp Lucarelli / *Photographer:* Heinz Klutmeier / *Publisher:* Time Inc. / *Issue:* February 3, 2005 / *Category:* Photography Spread-Single Page

604 ✳ APP JAPAN +
Creative Director: Hisashi Kondo / *Art Director:* Kevin Foley / *Designer:* Kevin Foley / *Photo Editors:* Shinichi Okada, Tadahiro Ohkoshi, Mayumi Nakamura / *Photographers:* Tadashi Okochi, Hiroshi Shimabukuro, Shinichi Sato / *Studio:* KF Design / *Publisher:* Jiji Gaho Sha, Inc. / *Client:* Jiji Gaho Sha, Inc. / *Issue:* August 2005 / *Category:* Photography Story

605 ✳ APP JAPAN +
Art Director: Kevin Foley / *Designer:* Kevin Foley / *Photo Editor:* Hisashi Kondo / *Photographer:* Hiroshi Ohashi / *Editor-In-Chief:* Hisashi Kondo / *Studio:* KF Design / *Publisher:* Jiji Gaho Sha, Inc. / *Client:* Jiji Gaho Sha, Inc. / *Issue:* May 2004 / *Category:* Design Story

HERB LUBALIN

AWARD

SPOTS

STUDENT

WINNERS

INDEX

Art Paul

When Hugh Hefner approached Art Paul in 1953 with an offer to design a new magazine, Art was a 28 year-old freelance graphic designer and illustrator, and he had never designed a magazine. Upon accepting Hefner's offer, Art Paul set out on a journey that would blur the distinctions between fine and applied art and created a collection of unorthodox and conceptual images that set new standards for magazine art direction.

From the beginning, *Playboy* provoked outrage and controversy with its mix of "girl-next-door" centerfolds, sophisticated fiction, first-rate articles, interviews and provocative cartoons, combined with features about food, drink, cars and music. Art was a patron to hundreds of artists and illustrators and created an exciting environment that challenged previous notions of art directing a magazine on a 2-dimensional page by using vellum, cut-outs and both sides of a page to create a dimensional environment for visual images that kept pace with the most innovative writers and artists of the time.

Art's collection of work has inspired many of us to embark on a career designing magazines and continues to challenge us to be smarter, to be different and to keep pursuing our next great idea, just for the fun of it.

BY MITCH SHOSTAK

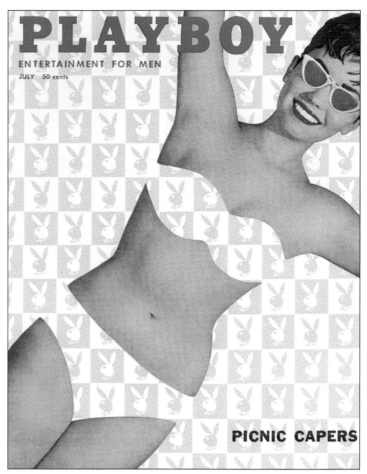

The first issue of Playboy was published in November 1953 and promised a nude Marilyn Monroe inside. There was no date on the cover so the issue could stay on newsstands as long as possible. It was priced at 50 cents and sold over 50,000 copies.

The rabbit appears as both bikini and blanket on this Picnic Capers cover.

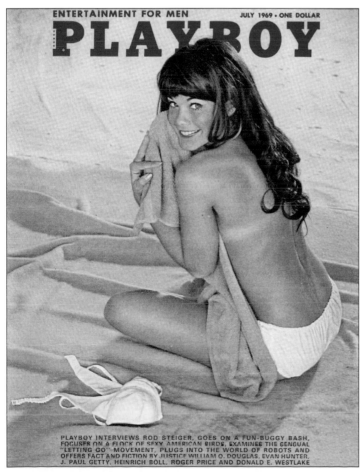

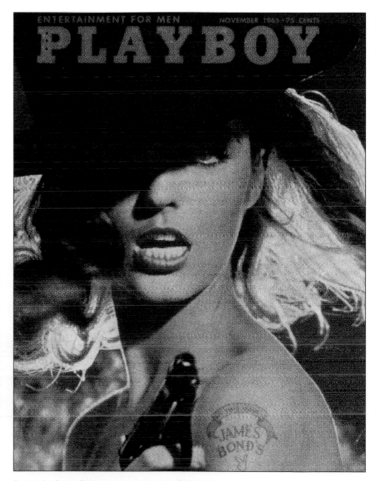

Barbie Benton posed for this July 1969 cover.

During the Sixties Playboy starting hiding the Rabbit Head somewhere on the cover provoking many letters to the editor asking, "where is it?"

Spots

Chairs Emily Crawford and Christoph Niemann led a revitalized SPOTS competition this year, championing the little illustrations that say so much. From over 400 entries, the judges selected a class of illustrations that exemplify the power small SPOTS have to improve the editorial message from a wide spectrum of publications. Winners are featured in a visual index in this volume, and will be celebrated more extensively in a very limited-edition book showcasing both the illustrations and smaller versions of the original editorial pages that originally featured the work.

606
Illustrator: André Carrilho
Title: Portrait of Edmund Wilson
Art Director: Stacey D. Clarkson
Publication: Harper's Magazine
Issue: September 2005
Category: Award of Distinctive Merit

607
Illustrator: Sean Kelly
Title: Lost Subway (Metropolitan Diary)
Art Director: Michael Kolomatsky
Publication: The New York Times
Publisher: The New York Times
Issue: November 14, 2005
Category: Award of Distinctive Merit

608
Illustrator: Jonathon Rosen
Title: Shock + Awe / Radical Fashion
Art Director: Peter Buchanan-Smith
Publication: Paper
Publisher: Paper Publishing Co.
Issue: September 2005
Category: Award of Distinctive Merit

609
Illustrator: Brian Cairns
Title: Dog — Dirt on Slopes
Deisgn Director: Tom Brown
Art Director: Eleanor Williamson
Publication: Ski Magazine
Publisher: Time4
Issue: February 2005
Category: Award of Distinctive Merit

610
Illustrator: Monika Aichele
Title: Alternative Energies
Art Director: Antonio Deluca
Publication: Walrus
Issue: December 2005
Category: Award of Distinctive Merit

611
Illustrator: Sam Weber
Title: Somebody's Watching You
Art Director:s Blake Taylor, Lou Vega
Publication: Inc. Magazine
Publisher: Mansueto Ventures
Issue: September 2005
Category: Award of Distinctive Merit

612
Illustrator: Kagan McLeod
Title: Remain Calm / When Bad Things Happen
Art Director: Chris Dixon
Publication: New York
Publisher: New York Magazine Holdings
Issue: November 14, 2005
Category: Award of Distinctive Merit

613
Illustrator: Jean-Philippe Delhomme
Title: The Style Guy
Design Director: Fred Woodward
Publication: GQ
Publisher: Condé Nast Publications Inc.
Issue: May 2005, July 2005, Sept. 2005, Oct. 2005, Nov. 2005
Category: Award of Distinctive Merit

614
Illustrator: Sean Kelly
Title: Cab Cursing (Metropolitan Diary)
Art Director: Michael Kolomatsky
Publication: The New York Times
Publisher: The New York Times
Issue: November 7, 2005
Category: B&W Single

615
Illustrator: Wesley Bedrosian
Title: The 50-Year Shadow
Art Director: Brian Rea
Publication: The New York Times
Publisher: The New York Times
Issue: May 17, 2005
Category: B&W Single

616
Illustrator: Charles Hess
Title: The Chosen
Art Director: Carol Kaufman
Publication: Los Angeles Times Book Review
Publisher: Tribune Company
Issue: November 13, 2005
Category: B&W Single

617
Illustrator: Sean Kelly
Title: Kindergarten Critic (Metropolitan Diary)
Art Director: Michael Kolomatsky
Publication: The New York Times
Publisher: The New York Times
Issue: December 5, 2005
Category: B&W Single

618
Illustrator: Sean Kelly
Title: Full Mailbox (Metropolitan Diary)
Art Director: Michael Kolomatsky
Publication: The New York Times
Publisher: The New York Times
Issue: November 21, 2005
Category: B&W Single

619
Illustrator: Sean Kelly
Title: Art Party Accident (Metropolitan Diary)
Art Director: Michael Kolomatsky
Publication: The New York Times
Publisher: The New York Times
Issue: December 26, 2005
Category: B&W Single

620
Illustrator: Joan Chiverton
Title: NYC Transit Strike
Art Director: Brian Rea
Publication: The New York Times
Publisher: The New York Times
Issue: December 21, 2005
Category: B&W Series

621
Illustrator: Brian Cairns
Title: Marathon Skier
Design Director: Tom Brown
Art Director: Eleanor Williamson
Publication: Ski Magazine
Publisher: Time4
Issue: December 2005
Category: Color Single

622
Illustrator: Eric Palma
Title: Fired / Hard to Terminate Workers
Art Directors: Blake Taylor, David McKenna
Publication: Inc. Magazine
Publisher: Mansueto Ventures
Issue: December 2005
Category: Color Single

623
Illustrator: Dan Page
Title: Your Riff or Mine?
Art Director: Darlene Simidian
Publication: The American Lawyer
Publisher: American Lawyer Media
Issue: September 2005
Category: Color Single

624
Illustrator: Tavis Coburn
Title: Make IE More Secure
Art Director: Barbara Adamson
Publication: PC World
Publisher: International Data Group
Issue: September 2005
Category: Color Single

625
Illustrator: Brett Ryder
Title: Custom Made for All
Art Directors: Blake Taylor, Lou Vega
Publication: Inc. Magazine
Publisher: Mansueto Ventures
Issue: November 2005
Category: Color Single

626
Illustrator: Harry Campbell
Title: The Surprise Inside the Perfect Investment
Art Director: Davia Smith
Publication: Money Magazine
Publisher: Time Inc.
Issue: October 2005
Category: Color Single

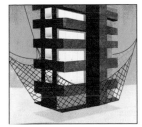

627
Illustrator: Hadley Hooper
Title: Adding Value
Art Director: Judy Neighbor
Publication: Residential Architect
Publisher: Hanley Wood
Issue: January/February 2005
Category: Color Single

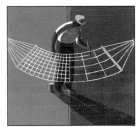

628
Illustrator: Alex Nabaum
Title: Ready, Net, Go
Design Director: Courtney Murphy
Art Director: Wendy Stoddart
Publication: AARP The Magazine
Publisher: AARP Publications
Issue: March/April 2005
Category: Color Single

629
Illustrator: Monika Aichele
Title: Marriage Record
Picture Editors: Jana Hallberg, Sonja Nartey
Publication: Annabelle
Issue: August 2005
Category: Color Single

630
Illustrator: Leif Parsons
Title: Offshore Tutoring
Art Director: Anna Tunick
Publication: The New York Times Upfront
Publisher: Scholastic
Issue: October 31, 2005
Category: Color Single

631
Illustrator: Harry Campbell
Title: Are You Scam Bait?
Art Director: Davia Smith
Publication: Money Magazine
Publisher: Time Inc.
Issue: March 2005
Category: Color Single

632
Illustrator: Jon Krause
Title: Topline
Art Director: Jenna Talbott
Publication: CFO Magazine
Publisher: CFO Publishing
Issue: October 2005
Category: Color Single

633
Illustrator: John Hersey
Title: Conquering the Digital Haystack
Art Director: Blake Taylor
Publication: Inc. Magazine
Publisher: Mansueto Ventures
Issue: January 2005
Category: Color Single

634
Illustrator: Aude van Ryn
Title: Security Lapse
Art Directors: Blake Taylor, Lou Vega
Publication: Inc. Magazine
Publisher: Mansueto Ventures
Issue: August 2005
Category: Color Single

635
Illustrator: Red Nose Studio
Title: Snooze Control
Design Director: Courtney Murphy
Art Director: Alanna Jacobs
Publication: AARP The Magazine
Publisher: AARP Publications
Issue: July/August 2005
Category: Color Single

636
Illustrator: Brian Cronin
Title: Inner Beauty
Art Director: Gina Toole Saunders
Publication: AARP Segunda Juventud
Publisher: AARP Publications
Issue: June/July 2005
Category: Color Single

637
Illustrator: Harry Campbell
Title: Intel's Dominance
Art Director: Barbara Adamson
Publication: PC World
Publisher: International Data Group
Issue: October 2005
Category: Color Single

638
Illustrator: Red Nose Studio
Title: The Leash You Can Do
Design Director: Courtney Murphy
Art Director: Alanna Jacobs
Publication: AARP The Magazine
Publisher: AARP Publications
Issue: July/August 2005
Category: Color Single

639
Illustrator: Marc Boutavant
Title: No Bear There
Art Director: Kate Elazegui
Publication: New York
Publisher: New York Magazine Holdings, LLC
Issue: May 2, 2005
Category: Color Single

640
Illustrator: Harry Campbell
Title: Canadian Flag
Art Director: George McCalman
Publication: Mother Jones
Publisher: Foundation for National Progress
Issue: November 2005
Category: Color Single

641
Illustrator: Zohar Lazar
Title: Sit, Stay, Lose Weight!
Design Director: Courtney Murphy
Art Director: Wendy Stoddart
Publication: AARP The Magazine
Publisher: AARP Publications
Issue: November/December 2005
Category: Color Single

642
Illustrator: John Ritter
Title: The Coldplay Conundrum
Design Director: Fred Woodward
Publication: GQ
Publisher: Condé Nast Publications Inc.
Issue: June 2005
Category: Color Single

643
Illustrator: Daniel Bejar
Title: Monogamy Rules
Art Directors: George Karabotsos,
Davia Smith
Publication: Men's Health
Publisher: Rodale Inc.
Issue: October 2005
Category: Color Single

644
Illustrator: Gary Taxali
Title: The Porn Identity
Art Directors: George Karabotsos,
Mark Hewko
Publication: Men's Health
Publisher: Rodale Inc.
Issue: April 2005
Category: Color Single

Illustrator: Alex Nabaum
645
Title: Capital Pains
Design Directors: Courtney Murphy
Art Directors: Wendy Stoddart
Publication: AARP The Magazine
Publisher: AARP Publications
Issue: November/December 2005
Category: Color Single

646
Illustrator: Tyler Darden
Title: Nippon QB
Art Director: Tyler Darden
Publication: Virginia Living Magazine
Publisher: Capefear Publishing
Category: Color Single

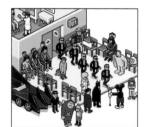

647
Illustrator: Eboy
Title: But Can They Fix a Broken Career?
Design Director: Fred Woodward
Publication: GQ
Publisher: Condé Nast Publications Inc.
Issue: May 2005
Category: Color Single

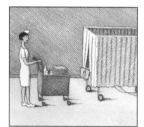

648
Illustrator: Pierre Le-Tan
Title: Medical Tourism
Art Director: Amanda Spielman
Publication: Proto Magazine
Issue: Fall 2005
Category: Color Single

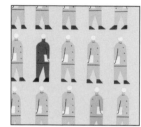

649
Illustrator: Philippe Weisbecker
Title: Board of Directors Insiders
Art Director: Lee Ryder
Publication: D&O Advisor
Issue: Spring 2005
Category: Color Single

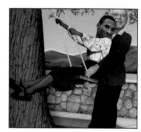

650
Illustrator: John Ueland
Title: Dear Kobe & Phil
Design Director: Fred Woodward
Publication: GQ
Publisher: Condé Nast Publications Inc.
Issue: November 2005
Category: Color Single

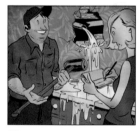

651
Illustrator: Zohar Lazar
Title: 1-800-Got-Junk
Art Director: Hylah Hill
Publication: This Old House
Publisher: Time Inc.
Issue: May 2005
Category: Color Single

652
Illustrator: Arnold Roth
Title: Having a Blast with His Past
Design Director: Courtney Murphy
Art Director: Alanna Jacobs
Publication: AARP The Magazine
Publisher: AARP Publications
Issue: July/August 2005
Category: Color Single

653
Illustrator: Zohar Lazar
Title: Kitchen Redo Nightmares
Art Director: Amy Rosenfeld
Publication: This Old House
Publisher: Time Inc.
Issue: September 2005
Category: Color Single

654
Illustrator: Brian Cairns
Title: Two Better Than One
(Skis vs. Snowboards)
Design Director: Tom Brown
Art Director: Eleanor Williamson
Publication: SKI Magazine
Publisher: Time4
Issue: March 2005
Category: Color Single

655
Illustrator: Jon Krause
Title: Intech
Art Director: Jenna Talbott
Publication: CFO Magazine
Publisher: CFO Publishing
Issue: October 2005
Category: Color Single

656
Illustrator: Roderick Mills
Title: The Survey Says . . .
Art Directors: Blake Taylor, Lou Vega
Publication: Inc. Magazine
Publisher: Mansueto Ventures
Issue: October 2005
Category: Color Single

657
Illustrator: Joel Holland
Title: Going Medium Tech
Art Directors: Blake Taylor, Lou Vega
Publication: Inc. Magazine
Publisher: Mansueto Ventures
Issue: December 2005
Category: Color Single

658
Illustrator: Yuko Shimizu
Title: Before You Pack...
Art Director: Davia Smith
Publication: Money Magazine
Publisher: Time Inc.
Issue: August 2005
Category: Color Single

659
Illustrator: Eric Palma
Title: Jarhead
Art Director: Chris Curry
Publication: The New Yorker
Publisher: Condé Nast Publications Inc.
Issue: November 7, 2005
Category: Color Single

660
Illustrator: Jashar Awan
Title: Beyond Deep Throat
Art Director: Nancy Novick
Publication: Columbia Journalism Review
Publisher: Columbia School of Journalism
Issue: September/October 2005
Category: Color Single

661
Illustrator: Juliette Borda
Title: Dildo Party
Art Director: Randall Leers
Publication: POZ
Issue: October 2005
Category: Color Single

662
Illustrator: Wesley Bedrosian
Title: A Dangerous Cocktail
Art Director: Dianne Sipprelle
Publication: Barron's
Issue: July 25, 2005
Category: Color Single

663
Illustrator: Miguel Gallardo
Title: Season Smarts
Art Director: Lisa A. Sergi
Publication: Brown Alumni Magazine
Publisher: Brown University
Issue: July/August 2005
Category: Color Single

664
Illustrator: Matt Collins
Title: Intelligent Design?
Art Director: Johnny Johnson
Publication: Scientific American
Publisher: Scientific American Inc.
Issue: December 2005
Category: Color Single

665
Illustrator: Zohar Lazar
Title: Road Rules
Design Director: Courtney Murphy
Art Director: Wendy Stoddart
Publication: AARP The Magazine
Publisher: AARP Publications
Issue: September/October 2005
Category: Color Single

666
Illustrator: John Cuneo
Title: Nude in Public
Art Director: John Korpics
Publication: Esquire
Publisher: The Hearst Corporation-
Magazines Division
Issue: March 2005
Category: Color Single

667
Illustrator: John Cuneo
Title: Death of Cupid
Art Director: Lee Caulfield
Publication: The Atlantic Monthly
Publisher: The Atlantic Monthly
Issue: October 2005
Category: Color Single

668
Illustrator: Graham Roumieu
Title: In Persuasion Nation
Art Director: Stacey D. Clarkson
Publication: Harper's Magazine
Issue: November 2005
Category: Color Single

669
Illustrator: Christopher Serra
Title: Radical Judges (Danger of...)
Art Director: Stacey D. Clarkson
Publication: Harper's Magazine
Issue: September 2005
Category: Color Series

670
Illustrator: Jean-François Martin
Title: In Practice
Art Director: Robert Lesser
Publication: CFO Magazine
Publisher: CFO Publishing
Issue: October 2005
Category: Color Series

671
Illustrator: John Ritter
Title: The Essentials
Design Director: Fred Woodward
Publication: GQ
Publisher: Condé Nast Publications Inc.
Issue: September, October, November,
December 2005
Category: Color Series

672
Illustrator: Jean-Philippe Delhomme
Title: Paris Sketchbook
Design Director: Fred Woodward
Publication: GQ
Publisher: Condé Nast Publications Inc.
Issue: March 2005
Category: Color Series

673
Illustrator: Barry Blitt
Title: Documentaries
Art Director: Ann Decker
Publication: Fortune
Publisher: Time Inc.
Issue: November 28, 2005
Category: Color Series

674
Illustrator: John Cuneo
Title: Diet Hint
Art Director: John Korpics
Publication: Esquire
Publisher: The Hearst Corporation-
Magazines Division
Issue: June 2005
Category: Award of Distinctive Merit

675
Illustrator: John Hendrix
Title: Hurricane Toms
Art Director: Sarah Garcea
Publication: Field & Stream
Publisher: Time4 Media
Issue: February 2005
Category: Color Single

676
Illustrator: John Hendrix
Title: Bells & Whistles
Art Director: Soo Jin Buzelli
Publication: PLANSPONSOR
Issue: February 2005
Category: Color Single

677
Illustrator: Zohar Lazar
Title: Sexual Healing
Art Director: Pete Ivey
Designer Jason Blackheart
Publication: Portland Monthly Magazine
Issue: August 2005
Category: Color Single

678
Illustrator: John Cuneo
Title: Girls Get Game
Art Director: Robert Parsons
Publication: Boston Magazine
Publisher: Metrocorp
Issue: September 2005
Category: Color Single

679
Illustrator: John Hendrix
Title: In No One We Trust
Art Director: Darhil Crooks
Publication: Esquire
Publisher: The Hearst Corporation-
Magazines Division
Issue: September 2005
Category: Color Single

680
Illustrator: Stefanie Augustine
Title: A Chicago Story
Art Director: Darlene Simidian
Publication: The American Lawyer
Publisher: American Lawyer Media
Issue: November 2005
Category: Color Single

681
Illustrator: George Bates
Title: Economic Roundup
Art Director: Brian Rea
Publication: The New York Times
Publisher: The New York Times
Issue: October 2, 2005
Category: Award of Distinctive Merit

682
Illustrator: Edel Rodriguez
Title: 9 Songs, a Film
Art Director: Owen Phillips
Publication: The New Yorker
Publisher: Condé Nast Publications Inc.
Issue: April 2005
Category: Award of Distinctive Merit

683
Illustrator: Thomas Fuchs
Title: How Many Calories Are U Burning?
Art Director: Robert Festino
Publication: Runner's World
Publisher: Rodale
Issue: September 2005
Category: Award of Distinctive Merit

684
Illustrator: Josh Cochran
Title: Nascar
Art Director: Jody Churchfield
Publication: The New York Times
Magazine
Publisher: The New York Times
Issue: February 19, 2005
Category: Award of Distinctive Merit

685
Illustrator: Wesley Bedrosian
Title: From the Ashes
Art Director: Brian Rea
Publication: The New York Times
Publisher: The New York Times
Issue: June 23, 2005
Category: B&W Single

686
Illustrator: Edel Rodriguez
Title: Execution
Art Director: Brian Rea
Publication: The New York Times
Publisher: The New York Times
Issue: September 26, 2005
Category: B&W Single

687
Illustrator: George Bates
Title: Blowing Up an Assumption
Art Director: Brian Rea
Publication: The New York Times
Publisher: The New York Times
Issue: May 18, 2005
Category: B&W Single

688
Illustrator: George Bates
Title: A Force for Good
Art Director: Brian Rea
Publication: The New York Times
Publisher: The New York Times
Issue: March 3, 2005
Category: B&W Single

689
Illustrator: Thomas Fuchs
Title: Snoop Dogg
Art Director: Geraldine Hessler
Publication: Entertainment Weekly
Publisher: Time Inc.
Issue: May 13, 2005
Category: &W Single

690
Illustrator: Josh Cochran
Title: Officer Training
Art Director: Catherine Gontarek
Publication: The Pennsylvania Gazette
Category: Color Single

691
Illustrator: Thomas Fuchs
Title: How Much Should You Drink?
Art Director: Robert Festino
Publication: Runner's World
Publisher: Rodale
Issue: October 2005
Category: Color Single

692
Illustrator: Keith Negley
Title: Don't Let the Past Catch Up With You
Art Director: Deb Choat
Publication: Scotsman Guide
Issue: November 2005
Category: Color Single

693
Illustrator: Keith Negley
Title: Want to Be a Multi-State Broker?
Art Director: Deb Choat
Publication: Scotsman Guide
Issue: October 2005
Category: Color Single

694
Illustrator: Carey Sookocheff
Title: The Medium is the Message
Art Director: Cameron Woo
Publication: The Bark
Publisher: The Bark, Inc.
Issue: November 2005
Category: Color Single

695
Illustrator: Edel Rodriguez
Title: Father's Sweater
Art Director: Vicky Nightingale
Publication: Reader's Digest
Publisher: Reader's Digest Association
Issue: December 2005
Category: Color Single

696
Illustrator: Joe Morse
Title: The Travels of a T-Shirt in the
Global Economy
Art Director: Tom Brown
Publication: Money Sense
Issue: November 2005
Category: Color Single

697
Illustrator: John Hendrix
Title: Tommy in Nebraska
Art Director: Devin Pedzwater
Publication: Spin
Publisher: Vibe/Spin Ventures LLC
Issue: February 2005
Category: Color Single

698
Illustrator: Edel Rodriquez
Title: Schizo, a film
Art Director: Owen Phillips
Publication: The New Yorker
Publisher: Condé Nast Publications Inc.
Issue: March 2005
Category: Color Single

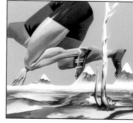

699
Illustrator: Thomas Fuchs
Title: Hill Running
Art Director: Robert Festino
Publication: Runner's World
Publisher: Rodale
Issue: February 2005
Category: Color Single

700
Illustrator: Andy Rash
Title: Wanna Bet?
Art Director: Steven Heller
Publication: The New York
Times Book Review
Publisher: The New York Times
Issue: September 25, 2005
Category: Color Single

Student Winners of the Adobe Scholarship in Honor of B.W. Honeycutt

Established in 1995, this competition honors the life and work of B.W. Honeycutt. It recognizes exceptional design by students with awards and three cash prizes: the Adobe Scholarship in Honor of B.W. Honeycutt, the first-place prize of $2500 and a paid summer internship at *Sports Illustrated*; second-place prize of $1000; and a third-place prize of $500. The winners also receive copies of Adobe's Creative Suite Software. Chaired by Francesca Messina and Linda Root, this juried

competition acknowledges the student designer and the teachers who develop their unique talents. In recognizing the promise of each student, Adobe affirms the creative possibilities inherent in the individual. Throughout its partnership with SPD, Adobe is helping shape the next generation of creative professionals. Together we are building the groundwork that will sustain and further artistic accomplishments within the editorial design community.

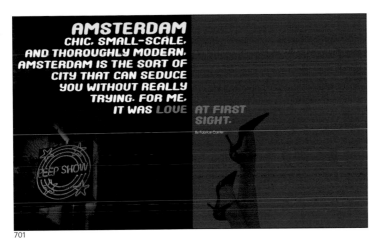

701

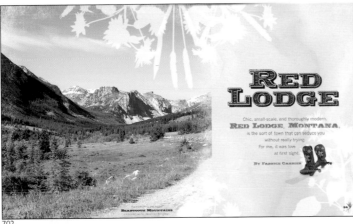
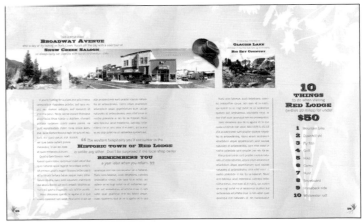

702

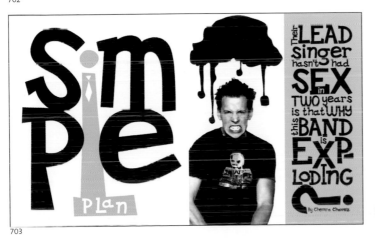
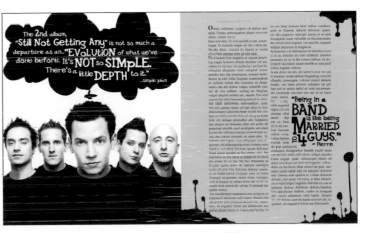

703

701 ✳ WINNER FIRST PLACE — THE ADOBE SCHOLARSHIP IN HONOR OF B.W. HONEYCUTT
Designer: Stephen Skalocky / *Title:* Amsterdam / *Photographers:* Stephen Skalocky, Lindsey Terwilliger / *School:* Rochester Institute of Technology / *Instructor:* Chris Lyons / *Category:* Travel

702 ✳ WINNER SECOND PLACE
Designer: Jennifer McBride / *Title:* Red Lodge / *Photographer:* Jennifer McBride, montanapictures.com / *Illustrator* historyforkids.org / *School:* Montana State University - Bozeman / *Instructor:* Jeff Conger / *Category:* Travel

703 ✳ WINNER THIRD PLACE
Designer: Michelle Moe / *Title:* Simple Plan / *Photographers:* thegate.com, ugo.com, simpleplanonline.com / *Illustrator:* Michelle Moe / *School:* Montana State University / *Instructor:* Ben Meyer / *Category:* Entertainment

Index

41DERFUL

I remember an issue of Harper's Bazaar from decades ago that celebrated women at various ages. At the time, Sophia Loren was turning forty, and the magazine asked her how it was possible that she could look so good at her age. Her blunt answer, "This is what forty looks like!" was a reproach to the implication that being old and unattractive was within her reach.

Alas, even SPD is not immune to the passage of time and like Sophia then, we've gone one better by turning forty-one. Happily, no clever writer is going to ask us how it is that we've managed to hang onto our looks. *Tangentially but germanely, I might mention here that there's no such thing as a "healthy" tan.* If someone did ask though, it's very clear that this is exactly what forty-one looks like, and in reality, we are going out of our way to hold onto our looks. And yet, we manage to make it all look so effortless. *Isn't that infuriating?* You'll find no wrinkles here, only acres of smooth paper. No poor posture. Only perfect binding. *For those who prefer the saddle, we've got that too.* No sallow cheeks. Only the purest pigments, varnishes and fifth colors. And yet, we remain humble. Within each of us, you'll find a little gutter.

Yes, SPD has managed to hold onto its looks and we thank the elite team of art directors, photographers, illustrators and photo editors behind the scenes, making it all possible. They are the young thinkers of any age who provide the perpetual blush of youth and vitality with their ideas and drive. Ultimately, as the preceding pages reveal, as gorgeous as we are on the outside, it's clear that we're equally loved for our minds.

BRUCE RAMSAY, Competition Co-Chair

THE ANNUAL JUDGING would not be possible without the enormous efforts of so many. An enormous thank-you from the Society to all the judges and volunteers for a seamless weekend judging almost 8,000 entries at Parsons: The New School for Design on January 21–22, 2006.

THE CHAIRS

Amid Capeci, AD, *Rolling Stone*
NEWSSTAND CO-CHAIR
Bruce Ramsay, Director of Covers, *Newsweek*
NEWSSTAND CO-CHAIR
Walter Bernard, President, WBMG, Inc.
NON-NEWSSTAND
Lisa Michurski, Director, Creative Development,
Time Inc. Interactive NEW MEDIA
Ina Saltz, Principal, Saltz Design
MAGAZINE OF THE YEAR

THE CAPTAINS

Tom Bentkowski, Director, Tom Bentkowski, Inc.
Christine Curry, Illustration Editor, *The New Yorker*
Arem Duplessis, AD, *The New York Times Magazine*
Luke Hayman, DD, *New York*
Geraldine Hessler, DD, *Entertainment Weekly*
Diana La Guardia
David Matt, AD, *Men's Journal*
Melanie McLaughlin, CD, Schematic
Patrick Mitchell, CD, PlutoMedia
Robert Newman, DD, *Fortune*
Robert Priest, Principal, Priest Media
Rhonda Rubinstein, CD, Exbrook

THE INSPECTORS

Deborah Adler, Designer, Milton Glaser, Inc.
Rommel Alama, AD, *XXL*
Dirk Barnett, Special Projects, *The New York
Times Magazine*
Lee Berresford, AD, *O, The Oprah Magazine*
Phil Bicker, CD, *The Fader*
Melissa Brennan, AD, *Slam*
Peter Buchanan-Smith, AD, *Paper*
Pamela Budz, DD, *Smart Money* | *Barron's*
Karen Caldicott, Illustrator
Daniel Chen, AD, *Child*
Emily Crawford
Paul Davis, Designer / Illustrator / Painter,
Paul Davis Studio
Ken DeLago, AD, *GQ*
Todd Detwiler
Chris Dixon, AD, *New York*

Joe Dizney, DD, *The Wall Street Journal*
Stéphanie Dumont, CD, *Carl*s Cars*
Richard Eccleston, CD, *Automobile*
Nancy Eising, DD, E Design, Inc.
Richard Ferretti, CD, *Gourmet*
Deanna Filippo, DD, *Allure*
Malcolm Frouman, AD, *Business Week*
Craig Gartner, AD, *Sports Illustrated Presents*
John Giordani, Sr. AD, *Funny Garbage*
Matt Guemple, AD, *Time Out New York*
Arthur Hochstein, AD, *Time*
Cynthia Hoffman, Deputy AD, *Time*
Rudy Hogland, Graphic Designer, Red Bird Design
Nigel Holmes, Principal, Explanation Graphics
Mirko Ilic, Designer/Illustrator, Mirko Ilic. Corp
Mark Jarecke, CD, CondéNet
Paula Kelly, Principal, Paula Kelly Design
Ed Levine, CD, *Psychology Today*
Janet Michaud, Deputy AD, *Time*
Wyatt Mitchell, AD, *Vibe*
Michael Mrak
Chris Mueller, Deputy AD, *Vanity Fair*
Florentino Pamintuan, AD, *Elle Décor*
Jodi Peckman, DP, *Rolling Stone*
Devin Pedzwater, AD, *Spin*
Eric Pike, CD, *Martha Stewart Living*
Brianna Pope, AD, *XLR8R*
Brian Rea, AD, *The New York Times Op-Ed Page*
Dan Revitte, Sr. AD, *Newsweek*
Peter Rivera, VP Group CD, America Online
Kerry Robertson, AD, *Condé Nast Traveler*
Frannie Ruch
Paul Schrynemakers, CD, Rodale Interactive
Mitch Shostak, Principal, Shostak Studios
Davia Smith, AD, *Money*
Catherine Talese
Blake Taylor, CD, *Inc.*
Sally Thuner, AD, *Mass Appeal*
Darren Tuozzoli
Andy Turnbull, CD, Dennis Publishing
David Vogler, VP CD, Modern Media
Jenifer Walter, AD, *Lucky*
Genevieve Williams, CD, Six Sisters Design

THE VOLUNTEERS

Thomas Alberty, *GQ*
Alice Alves, *Vibe*
Brian Anstey, *Entertainment Weekly*
Marian Barragan, *Vibe*
April Bell, *Premiere*
Christine Bower, *Billboard*
Scott Lee Cash, *POZ*
Anthony Clarke, *Vibe*
Jackie Dashevsky, *Entertainment Weekly*
Delia Desai, *Allure*
Forest Evashevski, *Broadcast & Cable*
Jesse Fairbairn
Olivia Fincato
Michael Friel, *Popular Mechanics*
Lauren Hickey
William Hooks, *Entertainment Weekly*
Andrew Horton
Angela Howard, *Interior Design*
Andre Jointe, *Premiere*
Lisa Kennedy, *People*
Nathalie Kirsheh, *W*
Laura Konrad, *Popular Science*
Jenny Lai, *Men's Journal*
Tim Leong, *Men's Health*
Laura Maccarone
Gina Maniscalco
William McDermott, *People*
Francesca Messina, *Guideposts*
Clare Minges, *Trader*
Donald Partyka, *Guideposts*
EunJean Song, *Vibe*
Alex Spacher, *O, The Oprah Magazine*
Grace Suhr, *Guideposts*
Vikram Tank, *Men's Health*
Ronda Thompson
Brian Truncali
Chloe Weiss
Hajimey Yoshida, *Vibe*
Liana Zamora, *PC Magazine*

The Society extends a very special thanks to Tavis Coburn, Illustrator, for his work throughout the year illustrating the Call for Entries and spot artwork for the Gala Program, and to Darren Tuozzoli, for designing the Gala Program and the Invitations.

MANY THANKS ALSO TO:

Sean Fenlon, Anne Ferraro, KellyAnn Kwiatek, Mitch O'Connell, David Olivenbaum, Lynn Staley, and Steve Walkowiak for their tremendous help in printing and production of this year's Competition poster.

Mike Lotrecchiano of TanaSeybert, NYC for printing of the Competition poster.

Josh Rothstein for Competition photography and for directing the Gala video, *The Big Idea*.

Tom Wagner for stage management and production the night of the Gala.

Adamba Imports International for providing Bison Grass Vodka and Luksusowa Potato Vodka.

Unisource Worldwide, Inc. for supplying paper for the Gala program.

Heidi Gutman for photography the night of the Gala.

Newsweek for providing prepress production for the Gala program, and the special efforts of Bert Ferguson, Angelo Rivello, Gary Dzurenda, Sebnem Curley, and Mike Helldorfer.

Baum Printing Company for printing of the Gala program.

Gary Cosimini, Ashwini Jambotkar and Courtney Spain of Adobe.

For invaluable help and support throughout the year: Linda Adams, Mary Brown, Ta-Tannisha Brown, Karen Caldicott, PJ Carlino, Susan Cotler-Block, Colleen Macklin, Olga Siroki, Alex Spacher and Katie VanSyckle.

For above and beyond effort on SPD's behalf: Keisha Dean, Olivia Fincato, Diana La Guardia and Melanie McLaughlin.

And most especially: to Bruce Ramsay and Amid Capeci, for co-chairing an entire year of amazing events with most exceptional grace, good humor, and attention to detail. Thank you for 41.

SPOTS

Our thanks to the judges:
Andrea Fella, AD, *Nylon*
Brian Rea, AD, *The New York Times
Op-Ed Page* | Illustrator
Stephen Savage, Illustrator
Yuko Shimizu, Illustrator

The Society thanks its corporate partners for their ongoing support:
Adobe Systems, Inc.
The Heart Agency

The SPD 41st Publication Design Annual was designed and produced by Rob Giampietro and Kevin Smith of Giampietro+Smith, 195 Chrystie Street, No 402-F, New York, NY 10002. Tel: 212.308.7434. www.studio-gs.com

First published in the United States of America by:
Rockport Publishers, Inc.
33 Commercial Street
Gloucester, MA 01930
Tel: 978.282.9590
Fax: 978.283.2742